The Camera Does the Rest

The Camera Does the Rest

How Polaroid Changed Photography

Peter Buse

The University of Chicago Press CHICAGO AND LONDON

Peter Buse is professor and head of performance and screen studies at Kingston University, London. He is the author of *Drama + Theory* and coauthor of *The Cinema of Alex de la Iglesia* and *Benjamin's Arcades: An unGuided Tour*, as well as editor of *Ghosts: Deconstruction, Psychoanalysis, History*. He lives in London.

The University of Chicago Press, Chicago 60637
The University of Chicago Press, Ltd., London
© 2016 by The University of Chicago
All rights reserved. Published 2016.
Printed in China

24 23 22 21 20 19 18 17 16 1 2 3 4 5

ISBN-13: 978-0-226-17638-3 (cloth)
ISBN-13: 978-0-226-31216-3 (e-book)
DOI: 10.7208/chicago/9780226312163.001.0001

Publication of this book has been aided by a grant from the Neil Harris Endowment Fund, which honors the innovative scholarship of Neil Harris, the Preston and Sterling Morton Professor Emeritus of History at the University of Chicago. The Fund is supported by contributions from the students, colleagues, and friends of Neil Harris.

Library of Congress Cataloging-in-Publication Data

Buse, Peter, 1970– author.
 The camera does the rest : how Polaroid changed photography / Peter Buse.
 pages : illustrations ; cm
 Includes bibliographical references and index.
 ISBN 978-0-226-17638-3 (cloth : alk. paper) — ISBN 978-0-226-31216-3 (e-book) 1. Polaroid Corporation—History. 2. Instant photography—History. 3. Photography, Artistic—History. I. Title.
 TR269.B87 2016
 770—dc23
 2015024891

Contents

Illustrations

Preface

Polaroid has provoked some famous passions. Andy Warhol took instant pictures of everyone who passed through the Factory, John Waters of everyone who visited his apartment, and Jamie Livingston a Polaroid-a-day for the last eighteen years of his life. I often get asked if I am also a Polaroid fanatic, a lover of all things instant. Do I take my Polaroid with me everywhere? Do I have a huge collection of cameras in the basement? The truth is, before I started this project, my experience of Polaroid photography was similar to that of many others who grew up in North America in the 1970s and 1980s. My family had a Polaroid OneStep camera that came out of the closet for short bursts of activity before disappearing again for long stretches of time. There are Polaroid snaps of my eighth birthday party and of my high school graduation, and of a few events in between. Every Polaroid snap seemed like an event in itself, but for me, as for most, the Polaroid was an occasional camera.

These pages are not, then, the fruits of a lifetime's obsession. My obsession with Polaroid photography has lasted only about a decade and a half, and I can date very precisely when it began. In June 2002, at the start of a summer vacation, I collected two old friends from their late flight for a long taxi ride back to the hotel. I was in the front seat, my friends in the back. Halfway through this trip there was a small explosion in the back seat—a flash of light accompanied by a strange mechanical wheezing. Immediately after, the product of this explosion was thrust over the shoulder of the startled driver. It was probably fifteen years since I'd seen one in action, and its effect on me was striking. It wasn't nostalgia I felt for this relic, but instead surprise, as if

encountering something out of place. Does that still work? Do they still really make those things?

That same June, in a federal bankruptcy court in Delaware, the final bids were being taken in the auction of Polaroid Corporation. Factories in Mexico and Massachusetts continued to make film packs for my friend's Polaroid Spectra, but the company had been in limbo since October of the previous year. I was completely oblivious to these facts. I was, however, deep into a reading of Walter Benjamin's *The Arcades Project*, a baroque and bewildering meditation on the ruins of modernity. Benjamin saw the key to modern culture in the detritus it left behind—objects, locations, and architectural forms that have gone out of fashion, or become obsolete. He cites at various points grand pianos, once-popular restaurants, a mechanical goose that lays praline eggs, and the arcades of Paris themselves. When these things are new, in the first flush of their fashion, they are too dazzling to see properly. Only when they are decaying or at the point of vanishing, do they begin to disclose their secrets. Without even being aware that the company that made it was in deep peril, I knew I was looking at one of those objects that fascinated Benjamin so much: an anachronism, a time capsule curiosity.

Meanwhile, pixel counts were increasing exponentially, in inverse proportion to the prices of consumer digital cameras; the market for camera phones, already booming in Japan, was about to hit North America and Europe; and the i-Phone was just five years away. The year Apple launched it, I visited—just in time—Polaroid headquarters in Waltham, Massachusetts. A generous archivist at Harvard Business School gave me access to the recently donated, but still uncatalogued, Polaroid archive and its over two million items. Back home, a far-sighted colleague encouraged me to spend a sizeable chunk of my university's money to lay in supplies of instant film against shortages to come. With this stash and my Polaroid 600, I was soon producing on many faces that curious and puzzled look that must have appeared on my own.

The casualties of digital continued to pile up. Polaroid stopped making instant film in 2008, and was joined on the analog scrap heap by a host of familiar and fondly remembered names. Vinyl turntables, the Sony Walkman, the Kodak slide Carousel, the cassette tape—all endangered or made extinct. And with these declining analog technol-

ogies often went the companies that made them. Blockbuster finally capitulated to Netflix in 2010, and in 2012, following close on the heels of Polaroid Corporation into crisis and collapse was its great rival, the inventor of the Carousel.

Then just as prices of Polaroid film packs (10 shots each) on Amazon and eBay were reaching into the hundreds and even thousands of dollars, a strange thing began to happen. In the city where I lived (Manchester, England), in the district where the creative and cultural industries cluster, the neatly packaged if unpredictable Impossible Project film began to appear on the shelves of the main art supply store. This reinvented instant film, brainchild of an Austrian entrepreneur and Dutch engineers from a closed Polaroid factory, took its place on the shelves alongside Lomographic cameras, Dianas and Holgas, and Fuji Instax minis. Shortly after, an Impossible Project Outlet opened across the street, selling film, refurbished Polaroid cameras, and branded merchandise to the hipsters of the Northern Quarter. Not much later, on an adjoining street, the Lomographic Society opened a branch and started holding workshops on the pleasures of analog photography for twentysomethings who had never known anything but digital. At the same time, software start-up companies were scrambling to invent apps that reproduced the look of a slew of vanishing analog film formats. Instagram and Hipstamatic are only the best known, with a whole host of small operations offering to give your digital images the Polaroid look. Obsolete, perhaps, but there is something in the form that stubbornly refuses to die.

At this juncture in the history of photography, the triumph of digital is complete. Vernacular uses of photography are steeped in an immediacy of production, circulation, and sharing that Polaroid once monopolized. Consumers have become comfortable with the dematerialization of snapshots to the extent that photos as objects now seem as quaint as cassette tapes. And yet, as the fashion for retro photography shows, the case of Polaroid holds special interest as the company's technology passes into extinction, trailing behind it a highly visible afterlife in everything from ads to apps. And it is a case full of lessons about the practice of photography and the rise and fall of innovative technologies. The time seems perfect to look back on Polaroid and ask—what did it anticipate about our moment, and what was distinctive in it that we now miss?

Introduction

The Last Polaroid

This is a book about Polaroid photography—its history, its uses, and what it meant and still means to the millions who experienced it. One of the great advantages in writing such a book is that almost everyone already knows what you are talking about. Who, of a certain age, cannot recognize a Polaroid? The click and whirr of the motor, the image sliding out of those familiar jaws, still milky and minutes from completion; the wide white border for pulling it away, an inviting place to write. Even as it vanishes forever from the photographic landscape, and even for those who have never held a Polaroid camera, the original instant photography persists as an image or an idea. But there are disadvantages as well to this kind of universal recognition, which can lead us to assume that we agree about what it is we are recognizing. What is a Polaroid? The question seems simple, but your answer to it might be very different from the one given by your sibling, your parents, or your neighbor.

Let us start at the very end: it would be perfectly possible to miss the last Polaroid camera, to fail to recognize it, because you might not know, to look at it, that the Joycam is an instant camera. Apart from the maker's name on the front, it bears little resemblance to the most widely known versions of Polaroid photography. It is too small and the wrong shape, its curved plastic body perhaps closest in appearance to the disposable single-use cameras of the 1990s. The picture does not jut out the front like some oversized photographic tongue, but instead comes out the side, tugged at the end of a ring pull of the sort you might find at the back of a talking doll.

The print itself is a small rectangle rather than the usual square,

Figure 0.1: Polaroid Joycam.

although like the more familiar format, it is slightly stiff, and black at the back. It does have a white border, but instead of the iconic wider bottom edge, this print's border widens at both the left and right sides (Figure 0.2). It barely looks like a Polaroid, and most people will never have seen one, and yet, for all that, I take the Joycam to be exemplary of Polaroid photography and an ideal way into my subject.

Released in Japan in the spring of 1998 and in North America in the summer of 1999, the Joycam was aimed at teens and college students, and along with its smaller cousin, the more popular I-Zone, briefly revived Polaroid's flagging instant film business, which had been in terminal decline for at least a decade. These novelty cameras were bestsellers for awhile, but novelties are destined to disappear quickly, and the next decade was a very bad one for the former photo giant: Polaroid filed for bankruptcy protection twice, got tangled up in a Ponzi scheme, and stopped making instant film altogether in 2008. The I-Zone and the Joycam are contemporaneous with each other, but by virtue of their staggered introduction to the Japanese market, in April and May of 1998, the Joycam, by a single month, can be counted as the last new analog camera ever made by Polaroid Corporation.

We might be tempted in retrospect to see the Joycam as a feeble

Figure 0.2: Polaroid Type 500 film, 1992.

Figure 0.3: Polaroid I-Zone.

last gasp of a company running out of ideas and abandoning its long-standing commitment to advanced technological research. Polaroid's last new camera is cheaply made, contains no new inventions or technology, and uses a film type (Polaroid 500) originally produced for another camera, the discontinued Captiva. As if to disguise, or even acknowledge, the absence of any genuine innovations, the I-Zone and Joycam were regularly reissued in bright new colors meant to appeal to their target audiences. New colors, old contents: the same principle of repackaging had already been wildly successful with the pink and blue Spice Cam (1997), although it ran aground with the Barbie Cam (pink, blue, and fluorescent green) and the Tasmanian Devil Cam (brown, beige, cartoon teeth), released in the same year as the Joycam. No wonder that the respected technology writer Victor K. McElheny bemoaned the company's dedication in the late 1990s to fads and the female teen market, or that an ex-employee wrote to the *Boston Globe* denouncing the new cameras as "junk" and accusing current management of betraying Polaroid's high-tech legacy.[1] Like the ordinary consumer, then, but for more complicated reasons, those in the know struggled to recognize the Joycam as a Polaroid.

There is, however, another possible story in Polaroid's last camera. Not a story about marketing, business decisions, or technological advances, but about the experience of Polaroid photography. Popular memory may insist that a Polaroid camera is the one that of its own accord pushes a square print out the front, but the Joycam, which requires its user to extract the print from the side by pulling, is in fact much closer to the experience of the original Polaroid camera. From 1948 until 1972, instant photography looked rather different from the second-generation technology that we now think of as Polaroid image-making. In that first version of what was then known as Polaroid Land photography, there was no mechanical motor to expel the film from the camera, no tell-tale grinding of gears, no perfectly sealed print delivered as soon as the shutter had been released. As with the Joycam, early Polaroid photographers had to get the picture out of the camera themselves, either by tugging at a tab and then opening the back of the camera, or by pulling the whole print bodily from an opening in the side. After that, the photographer still had to peel an unusable negative from the finished positive print. In fact, this mode of Polaroid photography did not disappear with the arrival of the second generation of film and cameras, but lived on, especially in professional and industrial applications of instant photography.

My point is not simply that there is more than one kind of Polaroid camera, although that is always worth remembering. Nor am I trying, so early on, to identify categorically some definite end point to Polaroid photography, quixotically pinning my flag to an unremarkable and short-lived novelty item.[2] Judging the Joycam by the usual measures of technological importance—scientific invention, design innovation, new applications—it hardly deserves a footnote. It is a late and unremarkable minor modification to a long existing technology, scarcely recognizable as a Polaroid. The Joycam is as good a place to start as any precisely because it is so unremarkable. However "junky" it may have been, and whatever we might think about its relation to a proud Polaroid legacy of technological research and innovation, the Joycam gives us a window into Polaroid photography in general. It is worth pausing on, not because it is the last Polaroid and deserves to be singled out for solemnities or for scorn, but because there is nothing particularly special about it. The Joycam, then, is an ordinary Polaroid.

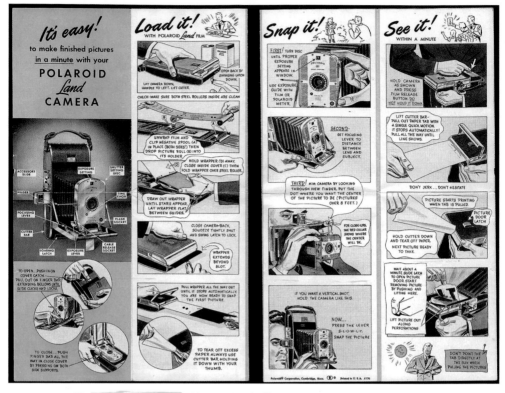

Figure 0.4: Early Polaroid instruction leaflet, ca. 1949.

For an ordinary camera, its name promises a great deal. Too much, some might say. It depends of course how you define enjoyment, but it is a good bet that there would be some sort of gap between how we imagine joy and what the Joycam has to offer. Marketing has its own cynical and exaggerated language, and it would be easiest just to chalk this up as another tired sales pitch flogging manufactured emotion. Along similar lines, the Polaroid VP for global marketing in 1999 was fond of explaining that the "I" in the "I-Zone" "stands for imagination and for 'me.'"[3] This is not to say that the Joycam and the I-Zone did not afford their users specific pleasures. Chief among these was surely the experience of physically pulling the image from the camera, a process which demanded the photographer's bodily involvement more than other forms of photography, and which no doubt gave the enjoyable sensation that he or she was actually generating the image, like a rabbit from a hat. This action certainly featured prominently

in the first TV commercials for the Joycam, where we get a glimpse of what Polaroid had in mind when it named its last camera. Joy in these spots means late teens and early twentysomethings cavorting in pools, throwing food, dancing wildly, all the while snapping and pulling, snapping and pulling, snapping and pulling their Joycam through the mayhem.

That photography in the vernacular mode—meaning nonprofessional photography employed for private purposes—should be reserved for joyous moments is almost axiomatic. As faithful accompaniment to holidays, marriages, new babies, graduations, birthday parties, and celebrations of all sorts, the amateur camera is there to record and validate the event. With the Joycam, though, the act of photographing appeared to be more intimately integrated with the joyous activities. If the commercials are anything to go by, and we should be wary of course of taking them as indicative of actual use, Polaroid photography was a pretext for fun but also the fun itself. What is missing from this model of immersive vernacular photography is any sense of the photograph as an object to be contemplated. The received wisdom about photography, and particularly about popular amateur photography, emphasizes its relation to memory and memorializing, but something else is at stake here. In the Joycam commercials, actors flick prints to the floor, wave them in front of each others' faces, swim through the water holding them in their teeth, but rarely do they actually look at them.

If the Joycam was not primarily a tool for making memories, then what was it for? According to the Polaroid marketers, it was a spur to "photo-play"—an alternative model of amateur image-making where "It isn't really about the photos, it's about what you do with them."[4] Or as the *New York Times* design section put it in a report on the new cameras, "Style Team Reinvents Polaroid as a Toy."[5] For the *Times*, this was a "radical departure" from Polaroid's tradition of technological innovation, but in fact there is a strong continuity between the Joycam, the I-Zone, and the rest of the history of Polaroid photography. Certainly, these were far from the first Polaroid cameras to be labeled toys. To suggest that the Polaroid camera is a pretext for play, that with it the *act of photographing* takes center stage, is simply another way of saying what was true about the Polaroid from its very beginnings—that it was a "party camera." This surprisingly capacious term accounts for

far more than Polaroid's use at parties, and takes us to the heart of what made Polaroid photography different.

Does the Rest

When the Joycam was released in the late 1990s, the boom in amateur digital photography was just around the corner. Looking back on Polaroid's last camera, with its incitement to the playful exchange of images on the spot, it is hard not to think about what was coming next. This book will indulge fully such temptations, accepting from the start that old technology is seen afresh in light of the new. The reverse process is also true, though: we cannot help but understand new technologies and media through older ones. Fleshless cars once had horsepower, the horizontal desktop migrates to the vertical computer screen, and PowerPoint frees us from the Carousel, but not from the slideshow. A technical breakthrough may offer possibilities for entirely new uses and applications, but in the first instance, it will be seen as replacing or complementing the functions of existing technologies, and this is reflected in the language we use to describe it.[6]

Polaroid photography was no exception. When Edwin Land, the founder of Polaroid, gave the first public demonstration of his company's invention in February 1947, an editorial in the *New York Times* the next day announced: "Camera does the rest."[7] The phrase alludes to an already fifty-year old Kodak advertising slogan: "You press the button . . . and we do the rest." The promise dates from 1888 and the first Eastman Kodak amateur camera. The rest, taken care of by Kodak, meant the developing of the 100-exposure film roll and the loading of a new roll into the camera. The user simply sent the camera and exposed film together to the Kodak factory, and received it back again with the developed prints, without ever having to know anything about the process by which those prints had been made or the camera readied again for use. The *Times'* invocation of the slogan in 1947 placed Polaroid's invention in a direct line with the Kodak snapshot model that had freed the photographer from all responsibility but framing and capturing the picture. Now Polaroid, the *Times* implied, had even freed the snapshooter from the camera's manufacturer.

Polaroid itself did not adopt the modified slogan—the Cambridge,

Figure 0.5: Polaroid OneStep (known as Polaroid 1000 in Europe).

Massachusetts, firm was not about to tread on the toes of the Rochester photo giant. In any case, the first Polaroid Land cameras did not in fact "do the rest," but left quite a bit up to their operators. Releasing the film, pulling the tab, tearing it off, opening the camera, peeling, straightening, and coating, all came between the exposure of the film and the completed print. The first Polaroid camera to eliminate all these intermediate steps was the SX-70 of 1972, which mechanically ejected a print and required from its user only three to five minutes of patience while the print developed. By this point Polaroid had already become the second-largest photography manufacturer in the world after Eastman Kodak. Only in the late 1970s did advertising for Polaroid cameras, especially the hugely popular OneStep, begin to announce, "All you do is aim and press the shutter button. The camera does the rest."[8] After a thirty-year wait Polaroid finally felt justified in officially adopting the modified slogan, while continuing to stake its claim to the territory that Kodak had originally pioneered: a popular photography that demanded no special expertise from its users.

The Polaroid process came to be known as "instant photography," a generic term eventually accepted by the company, even if Edwin Land himself initially disliked it. The term risked confusion with the long-

standing ambition of photographic science to achieve instantaneous exposures, an ambition realized in the late 1870s and early 1880s with more sensitive emulsions and faster shutters. An instantaneous exposure took a fraction of a second, so by comparison the one-minute developing time of the first Polaroid prints was very prolonged. (Nor should Polaroid photography be confused with Kodak's Instamatics of the 1960s, thus named for the speed with which their film cartridges were loaded.) Later Land complained that to "allow the term instant photography to subsume our contribution to photography since 1944 is like saying that an airplane is an automobile that flies."[9] Instead, he preferred to talk about what his process had eliminated: "loading, threading, unloading, mailing, reeling off through the multiple steps in control of a factory, re-reeling, mailing back, loading into a 'projector,' threading, hanging a screen, turning out the lights, and at long last looking at what is already a memory."[10] It was for this reason that Land dubbed his invention "one-step" photography. This made another direct allusion to the first Kodak amateur system, which proudly claimed to have reduced photography from ten steps to "three easy motions" (pulling the cord, turning the key, pressing the button), and guaranteed that "every step is simple now."[11]

The OneStep camera that did the rest got its name, then, from Land's original invention, but just to complicate matters, the One-Step was in fact an example of "absolute one-step" photography. Absolute one-step photography was the term Land used for Polaroid cameras and film from the SX-70 onwards. The prints for this later process were sometimes also called "integral" because there was no longer any positive to peel apart from the spent negative, but just a single self-contained picture. For the user, making an integral Polaroid might have appeared to involve only a single simple step, but the absolute one-step process took the camera and film through, as Land put it, "some two hundred to five hundred steps, depending on how you choose to fractionate them."[12] Polaroid photography of the SX-70 generation was of course color film, and between 1947 and 1972 Land and his team of scientists had to solve the problem of how to produce color prints in a single step. This was no small task: up till then the dyes in color photography had been applied after the fact, in specialist film developing laboratories. Kodachrome color transparency film, for example, had to pass through twenty-eight separate steps in process-

ing, including conventional development, bleaching, re-exposure, and further development to replace silver with subtractive dyes in the different layers of the film.[13] In Polaroid color photography, all this had to take place inside the camera and film. The challenge was so great that Polaroid started the research for Polacolor in the late 1940s but only released it on the market in 1963.

How did it work? Whether it was the original Model 95 Polaroid Land Camera of 1948 or a Polaroid Automatic of the 1960s using Polacolor film, the SX-70 or the OneStep, the Joycam or I-Zone, or indeed one of the many specialist professional Polaroid cameras, all one-step photography used the same basic process, a process accompanied by its own distinctive vocabulary. After the exposure of a film, a "sandwich" of positive and negative sheets was moved through a set of rollers on its way out of the camera, either pulled by the photographer or ejected mechanically. The rollers burst a "pod" of developing reagent attached to the film and spread the contents of that pod thinly across the film to set the development going.

In the original one-step camera the viscous reagent caused the unused silver halide on the exposed negative to migrate across to the positive sheet to form the final print (thereby rendering the negative unusable in future). The reagent not only had to act as a "solvent that discriminated directly and effectively between unexposed and exposed grains in favor of the former," but it had also to stabilize or fix the image.[14]

In "absolute" one step photography in the SX-70 camera, the film unit was composed of 17 separate layers, nine of which were the negative. When this unit was ejected from the camera, the rollers burst the pod, spreading through the film a reagent of water and potassium hydroxide in a layer of 26/10,000 of an inch, which made, in Land's words, "all hell break loose" in the chemistry of the film.[15] Thanks to an opacifier which protected the still unformed image, Polaroid photography of this generation could develop even in bright light. This camera contained a complex new network of electronic circuits, but otherwise, the basic system of pod, sandwich, rollers, and reagent, was the same in 1947, 1972, and 1998. For the user it was a dry process, which distinguished it from other direct positive photography such as the daguerreotype or tintype.[16] And of course it required none of the specialist technical skills of those earlier processes, and could be performed

POLAROID AUTOMATIC 100 LAND CAMERA
"How The Film Pack Works"

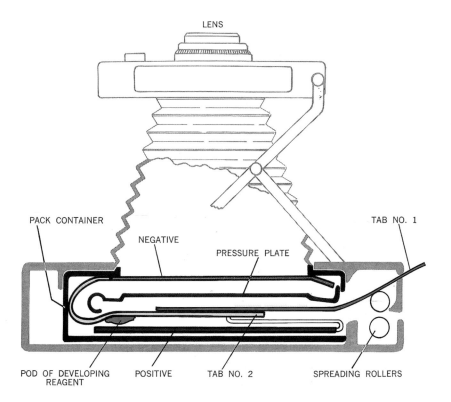

1 The diagram above shows the Polaroid Film Pack positioned in the camera. For simplicity, only one of the eight film assemblies is shown. On one side of a divider (pressure plate), and facing the lens, is the negative. The positive sheet is positioned on the other side of the divider plate. Pod containing the developing reagent is attached to tab number two. Notice that tab number one protrudes from the camera.

Figure 0.6: Polaroid Automatic cross-section including pod, film sandwich, 1963.

with ease by that often-maligned creature, the rank amateur, who need know nothing about "the rest" taken care of by the camera.

A Technology in Culture

This is not a book about the science behind the cameras. It is important to know the basics of how the process worked, but to have a true un-

derstanding of "the rest" that went on inside Polaroid cameras would require an advanced knowledge of chemistry, optics, and electronics.[17] The exact unfolding of the Polaroid process will remain opaque to us, then, just as it was to its average user. This leaves a great deal to consider, even so: everything that happened outside the camera and its microscopically thin sandwich of film, all the effects that followed from its workings. It is not the chemistry, but the consequences of Polaroid photography that are at stake here. Thus, this book asks what difference it made that a camera did the rest, that a unique print could be made immediately and without the need of a darkroom. What sorts of photographic practices did this encourage or allow for? How did Polaroid foresee the camera being used, and what uses were discovered that it did not predict? Who were the cameras marketed to, who bought them, and who used them? What aesthetic experiments and social rituals did they give rise to? How did the photographic industry and the photographic press receive Polaroid and understand it? And, lastly, what can the demise of this distinctive analog medium tell us about its digital successors?

To ask these questions is to venture on a cultural history of technology. It would be perfectly possible to write a purely technical history that treats one-step photography as simply another achievement in the development of photographic science. Such a history might note its similarities to other direct positive processes such as the ambrotype and the tintype, which also yielded only a single image with no negative. But whatever technical similarities there might be between Polaroid photography and these supposed antecedents, those similarities are completely outweighed by contextual factors that shape the technology's significance. To take briefly just one example: tintypes were produced by professionals with special skills, under varyingly formal conditions, and on a relatively small scale. In contrast, most Polaroid photography was in the vernacular, performed by untutored amateurs in a diversity of milieus, and made possible by a single company operating on a mass industrial scale and maintaining a monopoly over the activity. A history of technology might put tintype and Polaroid in the same chapter, but a cultural history of technology will keep them well apart.[18]

Historical accounts of Polaroid photography have tended to be of this technical variety, incorporated into larger histories of photogra-

phy; or they have been filtered through the life of Edwin Land. There are excellent biographies of Land that double as histories of the Polaroid Corporation, two of them published while he was still alive.[19] The most comprehensive account, written after Land's death, is Victor K. McElheny's *Insisting on the Impossible*, which details magisterially Land's contribution to scientific inquiry, and relates the story of Polaroid into the 1990s. There is no need, then, to repeat the story of the company or its founder and main inventor. Of course, when it is directly relevant to my main concerns, I explain key inventions and developments at Polaroid Corporation. This is especially the case with the years not covered by McElheny, when Polaroid's decline coincided with rapid advances in popular digital photography, and you will find some of that background in these pages. It is not, however, my objective to give a narrative of the life of Edwin Land, of the Polaroid company, or of its inventions, many of which were not even photographic. Instead, I concentrate on Polaroid photography, how people used it, and what meanings it had in the broader culture.

Which uses, then, and whose meanings? Depending on whom you asked, a Polaroid camera was sometimes a toy to be disparaged, at other times a luxurious status symbol; on the one hand a technological marvel, on the other a piece of junky plastic; for many a fun party camera, for others a convenient aid to amateur pornography. Among those who contributed to these perceptions were amateur photographers, photographic artists and curators, photo trade magazines, and of course the Polaroid Corporation itself. These different groups did not always agree about the significance or purpose of Polaroid photography, and sometimes these disagreements even took place within the company.

It was perfectly possible to hold two contradictory thoughts about Polaroid at the same time. This possibility was partly the consequence of the contrasting uses to which the film was put, some of which were less known than others. Polaroid was primarily a snapshot company, but it also manufactured many cameras for industrial and professional purposes. From the invention of instant photography onwards the company promoted what it eventually called "the useful image," finding applications in real estate, insurance, law enforcement, fashion, medicine, and dentistry. Many of these applications would have gone undetected by the layman. When you were sitting in a dentist's

chair in the 1980s or '90s, it is unlikely that the first thing on your mind when the pictures came back so quickly was that the film being used to x-ray your cavities was the brainchild of a Cambridge, Massachusetts, genius. An especially curious patient might have made the connection, and for the dentist who ran the equipment, Polaroid was indispensable, but it would never occur to most that this was the same basic format as the famous party camera. Equally, how many spectators of *The Silence of the Lambs* (1991) register that Clarice Starling is using a specialist Polaroid close-up camera when she photographs the corpse of a teenager pulled from a river, or that Leonard Shelby's obsessive use of a Polaroid camera in *Memento* (2000) is given added resonance by his profession as insurance adjustor?

In *The Silence of the Lambs*, seeing the forensic pictures immediately is essential to the plot; knowing that a Polaroid camera makes this possible is not.[20] In *Memento* Leonard suffers from short-term memory loss and relies on a Polaroid camera as a personal note-taking device. Only the insurance professional or real estate agent in the audience would recognize the ironic nod to their trade, in which a Polaroid photograph was handy because quick, and reliable because tamper-proof. Polaroid made a significant contribution to easing daily work in a whole range of fields, but this contribution was not really visible beyond a select group of those in the know. Where such uses uncover specific potentials of the technology, I call attention to them, but the fact is that the specialist applications of instant photography were not substantially felt in the wider culture.

The situation is slightly different for Polaroid photography as an art form—its other major application beyond the mass amateur. The artistic use of Polaroid photography has a high profile in some quarters and no shortage of eloquent advocates. The list of famous names associated with Polaroid is long and frequently rehearsed; by far the most books devoted to Polaroid photography are glossy ones destined for coffee tables; and when Polaroid's demise was imminent, it was above all art galleries that sprang to memorialize the technology.[21] From one point of view, Polaroid as an art medium has been given undue prominence in discussions of instant photography, far out of proportion to its broader cultural impact. In terms of the total volume of Polaroid images, their production as art is tiny, and is dwarfed even by the industrial applications of the form.[22] What is more, when

Polaroid photography is acclaimed as art, the genuinely distinctive aspects of the process are not usually what is at stake, but rather more problematic claims about Polaroid photographs having specific qualities as images (color, texture, resolution) that distinguish them from other kinds of photography. The white border, wider at the bottom, *is* a recognizably distinctive feature of one type of Polaroid film, but that border may not be, strictly speaking, part of the photographic image.

Still, the art Polaroid cannot be ignored. It may be small in number, but gains cultural traction through wide reproduction and dissemination. More importantly, artists who have worked with Polaroid photography have done much to test the boundaries of the form, discovering through their experiments its potential and limits. The distinctive white border could not have been thrown into starker relief than it was by David Hockney in his composite "joiners" of the early 1980s, which also called attention to the Polaroid's capacity to produce a series of images immediately and in the very space being photographed. Nor is there any absolutely clear dividing line between the Polaroid as popular snapshot and the Polaroid as aesthetic object, and artists who have used Polaroid photography have been some of the most insightful commentators on its attributes and possibilities as a vernacular form. The art Polaroid, then, will make many more appearances in these pages than the practical Polaroid does. However, the reader hoping for a chronicle of great Polaroid photographs and photographers should know in advance: in what follows there are more Joycams than joiners. Caveat emptor.

The three main applications of Polaroid photography—the artistic, the popular, and the practical—were well known inside the Polaroid company, which naturally took the lead among the groups seeking to define how Polaroid cameras should be used. Edwin Land was in fact very keen to emphasize the potential overlap between these three realms. When he introduced the one-step process to the Royal Photographic Society in 1949, he claimed

> The purpose of this investigation is essentially aesthetic, although the realm of investigation is, of course, scientific and technical. The aesthetic purpose is to make available a new medium of expression to the numerous individuals who are not given to drawing, sculpture, or painting.[23]

Land's hope, in other words, was that his invention, a product of practical endeavor, would lead to more amateur photographers making aesthetically accomplished images. It is important to pay attention to such claims and to the ways in which Polaroid Corporation tried to shape perceptions of its most famous product, and there are good reasons for weighing the company's own statements when trying to establish what a Polaroid was for. Having developed the technology and experimented widely with it, they knew a thing or two about its likely applications. So, many Polaroid users may have discovered independently that the camera is a hit at parties and a way to meet people, but these uses were already anticipated by Polaroid before the first camera went on the market. With the donation in 2006 of Polaroid's corporate archives—advertising campaigns, publicity and strategy documents, newsletters, annual and other reports, minutes of executive meetings—to the Baker Library at Harvard Business School, it has now become much easier to study Polaroid's contribution to the understanding of its own inventions. As you will see, these archives run right through the tissue and fabric of this book.

To be sure, we need to treat the archive with caution so as not to become hostage to the company's favored stories about itself and its products. But the archive is not monolithic and regularly reveals contradictions within Polaroid's own accounts of itself. It also gives glimpses of how the company was sometimes defeated in its attempts to guard against unintended uses and perceptions. For instance, it will come as a surprise to many, but according to the company, there was "no such thing as 'a Polaroid.'" This startling denial began as a grammatical quibble and rose to the level of strictly observed convention. As a brochure designed for dealers explains, "Polaroid"

> must always be capitalized. Its correct trademark use is as a proper adjective, i.e. "Polaroid Land camera," "Polaroid Land film." "Polaroid" is not the common dictionary name of any of the products of the Polaroid Corporation. There is no such thing as "a Polaroid."[24]

It is easy enough to understand why Polaroid would want to preserve the word as an adjective and warn off those who would turn it into a noun. They manufactured, among other things, sunglasses, desk lamps, and instant movie systems, and did not want the word to be

reserved exclusively for one product. In fact, in the first instance, that strange word, "Polaroid," had nothing at all to do with photography. It was coined to name the new company in 1937 and was meant to reflect the new product around which the company had been formed: artificial polarizers, which Land had successfully synthesized in his makeshift lab in the late 1920s. The "oid" of the strange new word meant "like," so the company was named for the "Polar-like" substance that it had patented. Even if "Polaroid" referred exclusively to a form of photography, there would still be some ambiguity: does "a Polaroid" refer to the camera or to the print? In the end it hardly matters, for this was a tussle that Polaroid lost outright.[25]

This mutation from adjective to noun in a brand name is clearly not a phenomenon limited to Polaroid. Eastman Kodak insisted intermittently that "Kodak" was a modifying adjective, although their advertising regularly used it as a noun to refer to the cameras, or even as a verb—"Kodak as you go"—that made it into Webster's dictionary.[26] However, in the case of Polaroid, there is something especially tenacious about the unauthorized transformation, particularly when the word is used to refer to the prints. While it is perfectly common to talk of a shoebox full of Polaroids, or refer to a wall covered in Polaroids, it is highly unlikely that anyone would say the same of some other brand of photographic film. A shoebox full of Kodaks, a compromising Fuji, a cherished Ilford? And yet, the Polaroid is an exception to the general rule and could appear in any of those phrases without raising an eyebrow. Douglas Coupland can title a book *Polaroids from the Dead*, Mark Ravenhill a play *Some Explicit Polaroids*, Mar Coll a film *La última polaroid*, and Nicky Wire a collection of photos *Death of a Polaroid* when no other brand of film would so neatly fit their purpose.[27] The critic A. D. Coleman notes the same oddity when it comes to the exhibition of Polaroid prints in photographic galleries.[28] It would be unusual to have a show devoted to something as specific as the Kodachromes of a particular photographer, or to the pictures taken on a specific camera, but not at all out of the ordinary to see one on Andy Warhol Polaroids, Robert Mapplethorpe Polaroids, or Chuck Close Polaroids. The explanation for this special status will have to wait until later on in the book, but undoubtedly it has something to do with the Polaroid print's singularity as a physical object. Whatever the reason, popular usage here trumps the attempts of a technology's makers to control its

brand. There is no such thing as "a Polaroid" then, but this book will proceed as if there were.

It is not just at the level of language that Polaroid users ignored the preferences of the technology's designers, or found uses the company did not anticipate or would not endorse. Most notorious among these uses was the contribution that instant photography made to apartheid. In the late 1960s, Polaroid did not have a subsidiary in South Africa, but its cameras and film made their way into that regime through a local distributor. Unknown to Polaroid Corporation, the South African authorities were using Polaroid I.D. technology to issue passbooks that were instrumental in controlling the movements of black South Africans. The same technology had been used in the United States for drivers' licenses since the mid-1960s, and by major government agencies such as the Pentagon. The situation came to light only when two black Polaroid employees, Caroline Hunter and Ken Williams, uncovered the story in October 1970, and demanded that Polaroid discontinue all business in South Africa. The company, proud of its reputation for progressive hiring practices and good labor relations—"don't be evil," in modern parlance—was caught off guard and immediately put on the defensive. Denying in the first instance that it was doing business with a racist regime, it ultimately acknowledged the problem, and in a classic bit of corporate foot-dragging, formed a committee to look into it. The committee eventually agreed to send a delegation of Polaroid employees and managers to South Africa to investigate, where assurances were secured that the retailer in South Africa would no longer distribute the I.D. cameras and film. These assurances were not honored, leading in 1977 to a complete block on the distribution of Polaroid products to the apartheid state. The whole debacle was an early example of the successful political lobbying of a corporation that was forced to respond in the face of a negative and viral media storm, and a key first step in the wider international divestment from South Africa. It is also an object lesson for those manufacturers and inventors who imagine they can determine, or keep under wraps, the uses to which their invention is put.

There are further examples that make the general disregard for corporate rules in everyday naming look like a mild form of rebellion. Polaroid invested millions of dollars and decades of research time into integral SX-70 film which miraculously developed in the light. This

did not prevent users from subjecting the format to all manner of experiments that horrified Polaroid's hard-working scientists. Regardless of the manufacturer's warnings about optimum temperatures for the film development, or perhaps prompted by them, curious SX-70 users popped them in toasters or freezers to see how they would respond. They scratched the image while it was still developing, added thumb-prints and painted on it, or subjected it to manipulations so extreme that the original image was barely discernible. The chemistry of Polaroid integral photography can be manipulated because the prints, when they emerge from the camera, are briefly unstable, although Polaroid's chemists worked hard to close the window of opportunity for vandals intent on undoing their elegant molecular work. Polaroid eventually came round to support such willful destruction of its sensitive emulsions once the results started being hung in art galleries, with the same principle applying to the pornographic Polaroid. This latter was something of an open secret: never formally acknowledged by the company, and perhaps not anticipated by Edwin Land, but an inevitable consequence of removing the darkroom from the equation. In such instances it is a clear case of the consumer leading, and the designer following.

Beyond Memory

What were Polaroids for? The most clear-eyed answer is that Polaroids were, overwhelmingly, for amateur snapshot photography. This inevitably leads us to ask in what way, if at all, Polaroid snapshot photography was any different from other forms of snapshooting, beginning with the products of its great competitor, Kodak, which, after all, "did the rest" first. This is one of the basic questions of my book, and answering it will take me by way of 40,000 roses, corporate showmanship, and paranormal Polaroid performances; functioning room-size and nonfunctioning house-size instant cameras; Instagram and the Banana Photo company; Laurence Olivier, James Garner, and Ali McGraw; and Minnetonka, Minnesota, and the Moscow World's Fair. On this eccentric tour there remains a unifying thread: in Polaroid photography, the *act of photographing* is just as important as, if not more important than, the resulting photograph. There are various ways of saying this: that it is above all the Polaroid process that gives it its

meanings, that the making of the image, rather than the image itself, is what distinguishes this kind of photography from others. The fact that "the camera did the rest" changed the conditions of snapshot photography, the field where Polaroid had its largest impact, and this fact is the starting point for any attempt to define its significance.

This is the lesson of the Joycam, where photography was, in the words of the Polaroid publicists, "not about the pictures." Instead, with the Joycam, taking photographs was to be a pretext for immediate play rather than a prelude to a much-deferred contemplation. As I have suggested, this emphasis on play, on the moment in which the picture is taken, is striking for what it excludes. When the act of photographing takes center stage, memory and memorializing may no longer be the main motivating factor in the activity. This is of considerable importance, because in most writing about snapshot photography it is precisely memory that is taken to be the primary stake. In fact, it is not just to studies of snapshot photography that this rule applies: hardly a year passes without one or more major new books devoted to memory and its vicissitudes in photography in general.[29] Photography critic Geoffrey Batchen has compellingly argued that the greatest obstacle to understanding amateur photography has been the tendency to assess it according to art historical criteria.[30] The turn to memory has done much to correct this situation, but now memory too is in danger of becoming a straitjacket for thinkers and writers on photography.

There are of course good reasons why so much energy in writing on photography is directed towards memory and mourning, trauma and death. All photographs, including Polaroids, bear an ambiguous, complex, even agonized relation to the past, and this makes fertile territory for commentary and analysis. It also helps that Susan Sontag and Roland Barthes, with whom so much of the contemporary study of photography begins, made such compelling cases for the intimate connection between photography and memory.[31] Like any dominant way of thinking, however, this one has the potential to cut off other avenues of investigation. Not the least, it can blind us to a range of photographic practices that are not in the first instance to do with memory. It might, for example, prevent us from seeing the links and affinities between Polaroid and amateur digital photography, in which immediate communication has begun to displace memorializing as

the primary function.[32] If there is an unanticipated dividend from taking Polaroid seriously, from asking what distinguishes it from other forms of photographic technologies, it might be a useful loosening of the grip of memory and mourning as key shaping concepts in the study of vernacular photography.

Finally, it is worth saying something about the status of what I have alternately been calling "snapshot," "vernacular," "amateur," and "popular" photography, since I have stated that my main emphasis will be on this use of Polaroid cameras. I accept that none of these terms is perfect, and that each is problematic in its own way. Whichever term we use, that is only the start of the difficulties. Try searching methodically through Flickr or Facebook, those endlessly and exponentially expanding storehouses of photographic images, for a roadmap of contemporary photographic habits. You would no doubt find a few patterns, some conventional ways of doing things, but you would soon be defeated by the bewildering array of what and how people photograph. Or, as the photographic theorist Catherine Zuromskis puts it, amateur snapshot practice exists "between monolithic photographic conventions and swarming individual practices."[33] It is this "swarming" nature of snapshot activity that sends a chill down the spine of anyone who sets out to generalize about the style or subject matter of vernacular photographs. In writing on snapshot photography, there is almost always a point at which the writer admits to the sheer *multitude* of the objects under investigation. Even before the digital age, scholars talked of the "billions" of amateur snaps taken each year, of a "colossal" number or a "ceaseless tide" of photos, of "trillions likely" when guessing how many pictures have been taken on Kodak amateur cameras, and of an "avalanche" of photo albums.[34] The best studies focus in on small samples, and yet, they are still haunted by that swarming multitude, because they inevitably want to draw broader conclusions on the basis of their samples. Richard Chalfen, the great pioneer of the study of the codes and conventions of popular amateur photography, regularly insists that his interest is in the snapshooting habits of "ordinary people," but also admits that this category is based on a study of the personal imagery of about 200 mainly white families from New England.[35]

There is plenty of evidence that Polaroid photography opened up new subject matter for the amateur photographer unversed in dark-

room skills, and in this book I explore some of these. I do not, however, make any attempts to generalize about the contents of Polaroid snaps or make claims about the average Polaroid picture. Nor have I carried out any sociological surveys to determine the typical content of Polaroid photographs: any such survey would be hopelessly partial. Instead, I mainly sidestep the "swarming" nature of snapshot content by bringing to the fore the process of Polaroid photography. While this process is more or less identical in every case, it is best to concede at the outset that the possible subject matter, or content, of the Polaroid snap is infinite.

A second problem with the study of snapshot photography looms even larger. The treatment of this category of photography is all too often polarized, as Annebella Pollen has pointed out, with some labeling such photos "banal," "sentimental," and "uncreative," while in the opposite camp they are "eulogised as uninhibited, unselfconscious and authentic."[36] My intention in this book is neither to celebrate nor to denigrate snapshot photography. Just because I am taking Polaroid photography seriously does not mean that I am rescuing it from obscurity or from those who have denigrated it. Or rather, I want to rescue Polaroid photography only in the sense that Walter Benjamin defines the term in *The Arcades Project*, where ephemeral phenomena are not rescued from decay and neglect, but from something potentially much worse: "enshrinement."[37] The aim is to steer a careful course between the mockers and the enthusiasts, but to make no value judgments myself, fond though I might be of Polaroid photography.

1 Just a Toy

I'm very excited about that little gadget which I thought was just a toy at first.
WALKER EVANS, 1974[1]

According to the legend, Polaroid photography started with a childish desire. It started with Jennifer's question. Jennifer was Edwin Land's three-year-old daughter, and she put the question to her father in December 1943. Land and his family were on holiday in Santa Fe, taking a break from Polaroid's wartime work, and he and Jennifer had spent an afternoon seeing the sights and taking photos on Land's Rolleiflex. Afterwards, back at the guest house, Jennifer was impatient to see the results, and asked why she could not see the photos right away. As Land told the story, and many others repeated it afterwards, the child's impatience was a spur to invention for the father, who took up the challenge his daughter had set. He stepped back out into the late afternoon and walked around Santa Fe, thinking through each problem and obstacle, figuring out how the chemistry would work, the design and mechanics of the camera. By the end of the walk, Land said, he had more or less answered all the basic questions and had started planning the creation of one-step photography in Polaroid's labs. As luck would have it, his patent lawyer, Donald Brown, was also in town, so Land sought him out at his hotel and dictated to him the fundamentals of the system. From the question being posed, to its full solution being expressed, perhaps six hours had passed, give or take.[2]

It is the sort of story that makes historians of technology throw their hands up in despair. A near perfect example of the "Eureka" school of invention, it comes complete with the solitary inventor, the flash of inspiration, and the solution fully formed. Stories like this are popular precisely because they leave out all the complexity and messiness of invention, which is more often gradual and collaborative and

is usually marked by failures and false starts, not instantaneous break-throughs.[3] Land is often held up as the last of the American inventor-heroes, with this tale as the centerpiece of the legend. But even in his own telling, while he confirms the role of his daughter, he actually underplays the "lightbulb" moment. Instead, he emphasizes the three years of hard collective work that followed, as well as the conditions that existed beforehand at Polaroid to allow the discovery, particu-larly the competence in advanced research developed by the company through its years of work on polarizer technology, and including the work it was doing for the US military at that very moment, produc-ing, among other things, combat goggles, sighting devices, and early heat-seeking missile technology.[4] The Santa Fe story may be neat, but it obscures more than it reveals. If it is of interest to us now, it is not so much for the portrait of the genius inventor, but for the picture of his daughter, the first Polaroid photographer.

Jennifer Land may not have taken any pictures on that day, but in her impatience, in her reluctance to wait, she is the prototype of Po-laroid photographers to come, all of them in a hurry to see the image within a minute, or minutes, of its capture. Before an invention can be conceived, a desire needs to exist, in this case a desire for a scene to yield up its double before the moment has passed or the subject departed.[5] In more recent times this photographic desire—wanting it now—has become a more or less standard expectation. For snap-shot takers, one-hour photo labs in the 1990s were just the advance guard of the digital haste that was nearly upon them. And what dig-ital photographer would show even as much tolerance as Jennifer on that day in Santa Fe, prepared to save the question for the end of the shooting session and the return home, never mind a single hour? If you are patient, and willing to wait until chapter 3, you will find out much more about the connections between Polaroid and digital, but for now it is worth observing that this desire has not always been uni-formly held. Compare Jennifer Land or the photographer operating a cellphone camera with the serene patience of Ralph Eugene Meatyard, the American photographer who ventured into his darkroom only once a year to take in his harvest of images, or street photographer Garry Winogrand, who left behind at his death over 2,500 undevel-oped rolls of film.[6] Meatyard and Winogrand are at the extreme end of the spectrum, but they are far from complete exceptions. The recently

discovered and much celebrated Chicago amateur street photographer Vivian Maier took more than 100,000 photographs, but left many of them undeveloped, possibly because she could not afford the photo-finishing.[7] It is also easy to forget that, for some people, family or holiday snaps are a source of trepidation as much as pleasure: in the days before digital, a friend of mine so dreaded the results of her snapping that she left rolls and rolls of film undeveloped in her sock drawer.

The photographic patience of a Meatyard or Maier may not be widely valued these days, but in one sense at least it is indispensable, even unavoidable. A week or even a month after it is taken, a family snapshot does not yet contain its full charge. It needs to ripen, to ferment. It needs to be put in a shoebox, or forgotten on a hard drive, only to be chanced upon many years later. With the passage of time, the people or places or events pictured take on their retrospective weight. A loved person in a photo may have grown up, died, or moved away, a couple may have gotten together or split up, an object been lost or a building vanished. When the picture is taken, these changes may be anticipated, but they take on their photographic force only much later as an aftereffect, in the moment of contemplation. This is what Roland Barthes calls the future anterior tense ruling the photographic. In the photograph lurks a "what will have been," a meaning pregnant in the moment, but which only becomes available retroactively. It is there in a photo of a youthful Lady Diana outside her job at a preschool: she is dead, and she is going to die, as Barthes would put it.[8] That is, it is there if we know, or imagine we know, the person pictured. This is why the snapshots of others, of people of whom you have no memory, can leave you cold: without the memory, the photograph loses its force.

When Kodak Invented Memory

Unlike Jennifer Land and the impatient multitude that followed her, most writers on photography take memorialization to be the primary function of the amateur snapshot. Whether it is Susan Sontag declaring that "All photographs are *memento mori*," or Roland Barthes reflecting on "what will have been," or Jo Spence constructing imaginative photo-biographies, or Annette Kuhn on family histories, or Marianne Hirsch on narrative and postmemory, or Ulrich Baer on the photography of trauma, or Geoffrey Batchen on photographic memo-

rial objects, or Brian Dillon using snapshots as a spur to memoir, or Jay Prosser on photography and loss, there is a remarkable consensus that photography is a technology of memory.[9] In general, it is the vicissitudes of memory that interest these writers, for whom photography is a fragile and fallible, partial and unreliable repository of the past. Rather than providing a neutral aid to family and other forms of remembrance, photographs are assumed to actively shape memories, often through exclusions and censorship: they are residues, often painful, working by delayed action. In this school of thought, even the most straightforwardly happy of family snaps is shadowed by loss, lack, and death.

Why this almost uniform insistence on the melancholic dimensions of photography? Why the emphasis on photography as a problem of memory rather than a faithful servant to it? The reasons are at least partly corrective: the melancholic consensus seeks to counteract a much more powerful commercial discourse that assures us that the photograph is indeed a reliable guarantor of memory and proof against forgetting. Marianne Hirsch, less melancholic than many, traces that optimism to the late nineteenth century, crediting Eastman Kodak above all with promoting snapshot photography to its privileged position as the main support of modern memory. Nancy Martha West, the historian of Kodak advertising, confirms this in her comprehensive survey of Kodak promotional materials between 1888 and 1932, where she reveals how the company encouraged amateur photographers to treat their memories as objects of nostalgia, and in doing so "purged domestic photography of all traces of sorrow and death."[10] In the rosy Kodak universe, the camera records only sunny days, unified families, happy holidays, and charming trips.[11] Photography critics, whether they have Kodak consciously in their sights or not, have consistently sought to challenge this corporate whitewash and to reinsert the traces of sorrow and death into the photographic. On the vital point, though, they are in agreement with the snapshot giant: memory and the past are the central stakes of the photograph.

There is, however, a striking complication in West's narrative. She shows that Eastman Kodak was well into its second decade in the snapshot business before it began to promote photography as an aid to memory. Between 1888 and 1900 the company focused almost exclusively on photography as a form of play, with its cameras presented as

either toys or fashion accessories. In those years Kodak advertising did not emphasize memory-making, but instead made "the sheer pleasure and adventure of taking photographs [. . .] the main subject" of its advertisements.[12] In this first incarnation, then, snapshot photography was a supplement or accompaniment to leisure activities, fully absorbed in those activities. In fact, even before that, the first camera manufactured by Kodak was a novelty detective camera, and not the Kodak One, as is usually assumed. George Eastman had hoped to profit from the fad for cameras disguised as various everyday objects—parcels, canes, guns, suitcases—but the detective camera failed badly on its release in 1881.[13]

Only between 1900 and 1915 did the work of memory gradually displace play as the main function of photography in Kodak promotional material, although the element of play persisted throughout this period. For instance, the Brownie camera, Kodak's real breakthrough into a mass market in 1900, was aggressively marketed as a toy and was targeted first and foremost at child users. The small size and light weight of the Brownie helped it to be perceived as a plaything, and its bright red, yellow, and green packaging reinforced this perception.[14] The transition of the snapshot camera from toy to tool can then be seen in ads from the later part of this period, when the Brownie starts to be presented as a kind of training device, preparing child photographers for its serious role in future adult memory-work.[15]

West's account of this forgotten prehistory is valuable because it gives a *date* to the link connecting memory and snapshot photography, when that link is normally taken to be natural or obvious. Just as importantly, it offers a window onto a tradition of snapshot practices where memory is not the central preoccupation. It gives, in other words, a context and a background for the instant photography impatiently desired by Jennifer Land. Polaroid, of course, participated fully in the memory stakes, drawing in some of its advertising on the dominant model inherited from Kodak; as a major photographic company, it could hardly be expected not to cover all the bases. A Polaroid, like any photographic image, has a complex and vexed relation to memory and the past; but its memorializing capacities are arguably not its main attraction three minutes after it has been made.

Roland Barthes, so often the first port of call in such matters, puts his finger on this problem in *Camera Lucida*, even if he mentions Po-

laroid photography only to dismiss it. "I am not a photographer," he writes, "not even an amateur photographer: too impatient for that: I must see right away what I have produced (Polaroid? Fun, but disappointing [*Amusant, mais décevant*], except when a great photographer is involved)."[16] Barthes has the requisite impatience for Polaroid, but finds it "Amusant, mais décevant," unless a photographer more accomplished than himself is involved. In fact, the frontispiece of the original French edition of *Camera Lucida* reproduces an enigmatic blue-green photograph by Daniel Boudinet of a bed and a thin curtain, a photo that happens also to be a Polaroid, although in all the commentary on the meaning of this picture and its placement in the text, no one quite manages to explain why Barthes chose a Polaroid, or indeed, if it matters (could it be that a Polaroid is the *chambre claire* of Barthes' title, since it is a little photographic chamber open to light, rather than closed like a dark room?).[17] Polaroid must also be disappointing for Barthes because its immediate arrival on the scene means that it is irrelevant to his book's main concern, which is memory; and of course, if it is fun, then it is the polar opposite of the melancholic spirit that guides his book.[18] Even in this cursory dismissal, though, Barthes may have given us the key to what makes Polaroid different.

Toy Cameras

Polaroid is a small but significant part of the history of photography. What could be more self-evident? Edwin Land's invention finds its rightful place somewhere between the tintype and the digital array, with his company mining the rich seam of snapshot photography first opened up by Eastman Kodak. But this may be to assume too much. If Roland Barthes is right, and the defining feature of the technology is *fun*, perhaps it would make more sense to think of Polaroid as part of the history of toys. If we take as examples two of Polaroid's most successful cameras, the Swinger (1965) and the I-Zone (1999), the case is very strong to consider Polaroid as, at the very least, a point where the histories of photography and toys overlap.

At the time of its introduction in July 1965, the Polaroid Model 20 Land Camera, or Swinger, was the smallest, lightest (at 21 ounces), and cheapest ($19.95) camera that Polaroid had yet made. It had a plastic body, a single-element plastic lens, and a semiautomatic exposure sys-

tem, with the word YES appearing in the viewfinder when exposure was correct. Although it did not look like one, it was in effect a box camera, like the Brownie. When in 1964 Land announced the development of this camera, he explained that it marked Polaroid's entry into the mass market of cameras "priced in the range where perhaps 70 percent of families buy."[19] The Swinger performed even better in this market than Polaroid's most optimistic projections, not only becoming the company's highest-selling product, but catapulting the company from an 11% share of US camera sales in 1964 to a 30–35% share in 1966, and this at a time when the market for still cameras in the United States had trebled in six years.[20] The key to this success was getting the Swinger and its film into drugstores, where it could clear far more than in photo specialty shops.[21] In fact, Polaroid's whole publicity effort for the camera was geared away from conventional photo retailers. One of the main ambitions of the campaign was to get Type 20 film stocked in the "'general store' type of outlets frequently found at beach and ski resorts, yacht clubs and marinas, campgrounds, and similar 'non-traditional' outlets."[22] Polaroid followed up the Swinger with the simpler Swinger Sentinel, which had no built-in flash, and the Big Swinger, which in spite of its name, was even lighter, at 17 ounces.

The size of the Swinger, its weight, its plastic body and bright red shutter release, as well as its promotion outside of conventional photography sales sites, all contributed to the camera's status as a toy. Polaroid itself encouraged this view, announcing in a brochure in 1967 that "Polaroid's in the toy business," and that the Swinger is a "juvenile status symbol."[23] As this brochure makes clear, advertising for the Swinger was aimed primarily at teenagers and what one press release identified as "the younger set."[24] Youth magazines were saturated with Swinger ads, with, for example, every issue of *Boy's Life* and *American Girl* containing one during 1967. For television, a young Ali McGraw cavorted with friends on a beach to a jaunty jingle sung by Barry Manilow. This and other Swinger ads were shown on programs such as *Batman, Daniel Boone, Voyage to the Bottom of the Sea, 12 O'Clock High, Lost in Space, The Flintstones,* and *Hullabaloo,* clearly with a youthful audience in mind. Polaroid also produced the "Swinger Fun Book," a comic full of suggestions on ways to use the camera, and in a tactic reminiscent of Kodak's packaging of the Brownie, used bold

POLAROID®

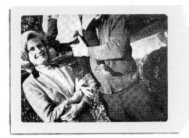

If you know any students of elementary photography,

you can recommend a great teacher.

The same features that have made The Swinger so popular with the average photographer, make it ideal for the beginner.

To begin with, he gets the fun of seeing his picture 15 seconds after he snaps the shutter. (One of the hallmarks of a great teacher is the ability to mix fun with the lesson.)

But the beginner gets more than that out of a Swinger. He gets a chance to see what he did wrong on his first picture while he's still on the spot.

Did he aim too low? Or stand too far from his subject? Does the background fight with his center of interest?

Since he gets his pictures immediately, he gets his answers immediately. So he can correct his error 15 seconds after he makes it. That teaches him how to compose a picture and improve its content.

And while he concentrates on *this* basic aspect of photography, he has the satisfaction of getting a crisp, sharp, 2½x3¼ black and white print on every shot. Because The Swinger takes over all of the problems of more advanced camera work.

He doesn't have to worry about light meters and f-stops. Because The Swinger's photometer shows a bright, clear YES when the exposure knob is turned to the correct position. (An unusually accurate exposure device.)

He doesn't have to think about subject motion, either, because The Swinger uses Polaroid 3000 speed black and white film. So the camera can freeze most action, indoors and out, with a single shutter speed of 1/200 of a second.

By the time a beginner gets his picture in focus, he's probably lost it. But The Swinger's high-speed film does away with this frustration, too. It permits the use of such small apertures, that the depth of field is great. So he never has to focus. Pictures are sharply defined from infinity to as close as 2 feet in bright sunlight.

For flash pictures, there's no calculating to fuss with. In fact, there's no flashgun to fuss with. You simply drop a bulb *into the top of the camera*, turn the knob to the correct distance, and you're ready to shoot. The camera's faceplate acts as the flash shield. And the smallest, cheapest flashbulbs made give enough light for a portrait from 2 feet, or a group shot 20 feet away.

The Swinger is one of the lightest cameras around. Which is a help if the beginner is a 9-year-old kid.

And it sells for $19.95.*

Which is also a help.

POLAROID SWINGER

"Ah-h."

*suggested list price

Figure 1.1: Polaroid Swinger advertisement, 1967.

blue, green, and purple colors for its Swinger boxes, and encouraged retailers to construct displays that made the boxes look like children's building blocks.

Everything about the Swinger, then, suggested that it was a companion to play, beginning with its name. As the "Hi, Swinger," leaflet puts it, the term refers to "a modern, hep person," one who is "on the ball [. . .] in rapport with modern thinking."[25] Beyond this allusion

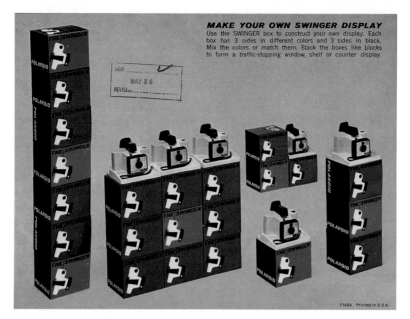

Figure 1.2: Polaroid Swinger display, 1965.

to popular subculture, the name "Swinger" simply described the motion of the camera as it hung from the user's wrist. The Swinger's wrist-strap was absolutely central to the camera's promotion, with still imagery from the campaign just as often showing it hanging fashionably from a wrist as in active use as a camera. The famous ad with Ali McGraw begins and ends with her strolling down the beach, Swinger dangling by her side, like a purse or other fashion accessory. The jingle's lyrics also bring out the animated qualities of the object: "Meet the Swinger, the Polaroid Swinger / It's more than a camera / It's almost alive / It's 19 dollars and 95." Nothing in the ad is oriented towards the preservation of the past or the anticipation of nostalgic reminiscence—the pleasures of this toy-like camera are purely in the present tense of play.

The Swinger was probably the Polaroid camera in which the element of play came out most clearly, but this dimension was present in most Polaroid photography. In 1972 Charles and Ray Eames were commissioned to make *SX-70*, a short promotional documentary about the eponymous camera, showing how it worked, and taking a tour of its circuits, lenses, and moving parts. The Eames connect the camera

with toys right from the start: the first demonstration picture is taken of a small boy peering through a set of building blocks.[26] The link between the camera and children continues throughout the ten-minute film, which shows a girl taking pictures on a rocky beach, a group of children in an art gallery, and a boy photographed falling backwards through cardboard boxes. A girl plays hopscotch to show the camera's capacity to take multiple exposures in sequence, a couple takes pictures of their young daughters. The Eames made over a hundred short films, but perhaps one of the best known is *Toccata for Toy Trains* (1957), a tribute to the design of antique toy trains. *SX-70* is overall more sober and stately, but the building blocks at the start are almost certainly the same ones that a train passes under at the beginning of the sprightly *Toccata*.

Children were in fact central to the promotion of the SX-70—they were taken to be the most natural participants in instant integral photography, credited with understanding it spontaneously, instinctively.[27] When *Life* magazine put Edwin Land on their cover in October 1972, he was surrounded by a clutch of urchins eagerly reaching out as a single mass to grasp the print at the very moment that it emerged from the new camera.

In its efforts to find new markets for cheaper versions of SX-70 technology, Polaroid also targeted cameras at child users. In the late 1980s, the brightly-colored Cool Cam was developed for the 9–14 age range, or "tweens." In order to convince "tweens" to covet the Cool Cam, and their parents to part with money, Polaroid claimed that "kids see a radical [. . .] camera," which "will make them the envy of their friends," while "parents see a learning tool that can help children view their surroundings in ways never thought of."[28] Within the same breath the ad appeals to the two main strands in toy manufacture in the twentieth century. On the one hand, there is the dominant trend that sees toys as novelties, the must-have possession of any given buying season. On the other hand, there is the possibility of the toy as educational, as an object that prepares its owner for adult life.[29] This dual function of toys was already present in advertising for the Swinger. While the main television campaign emphasized leisure and fun, print ads in magazines such as *Popular Photography* and *Scientific American* promoted the Swinger as "a great teacher" and asked the reader "If you know any students of elementary photography."[30]

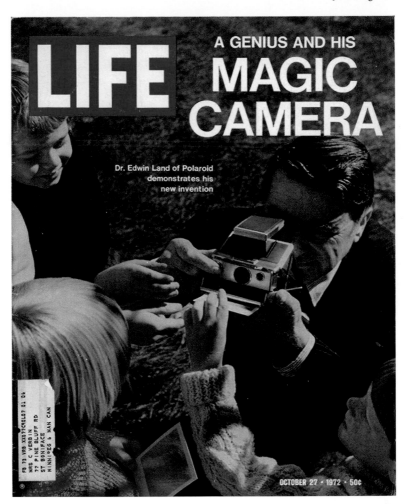

Figure 1.3: *Life* magazine, October 27, 1972.

By the time of the Cool Cam, Polaroid's status as toy-maker had been well and truly cemented: in stock and product listings in *Business Week* and *Forbes*, it appeared grouped alongside Hasbro, Mattel, Fisher-Price, and Tyco Toys.[31] It was a listing confirmed by *Top Gun* (1986), in which the boyish Goose treats a Cold War encounter as a game, snapping a Polaroid of his Russian counterpart after Maverick decides to "have a little fun" by flying upside down. In sentimental remembrance of the 1970s in popular culture, users of SX-70 cameras are regularly immature, fashion-conscious, or playfully flirtatious, as

Figure 1.4: I-Zone prints, ca. 2002.

in the case of Rollergirl in *Boogie Nights* (1997) or Penny Lane in *Almost Famous* (2000).

Polaroid's final foray into the toy business was also one of its most successful, although the I-Zone was not actually made by Polaroid. The US company provided only the film and its name, while the pocket camera was manufactured by the Japanese toy-maker Tomy (see Figure 0.3). Like its stable-mate, the Joycam, the I-Zone required its user to pull the developing film from the side of the camera. It took tiny pictures of 1.5" × 1" that came on a festively decorated strip, and there could be no doubt about its market placement—its US launch was at the New York toy fair in February 1999.

During the run-up to Christmas 1999, the I-Zone was promoted in

magazines alongside Furby babies, Pokemon cards, and Sega Dreamcast rather than as a form of photography, and was sold in Toys "R" Us, Warner Bros, FAO Schwarz, Noodle Kidoodle, and Kay-Bee Toys. It was advertised during episodes of *Buffy the Vampire Slayer* and *Dawson's Creek*, and was the official camera of Britney Spears' 2000 concert tour. All this gives a good indication of the market Polaroid was trying to capture, and indeed, half of the camera's buyers were girls between 14 and 17.[32]

Just as with the Swinger, the element of fashion was as important as any photographic qualities of the I-Zone. Following the successful strategy established by Swatch watches, Polaroid issued the I-Zone in a wide range of bright colors with brash names: Phat Blue, Blaze, Wicked Wasabi, Go Grape, Sorbet, Concrete Jungle. It was not just the camera that was an accessory—the photos themselves became objects of adornment. Nike made a special shoe with a window for I-Zone prints, Todd Oldham designed clothes that accommodated the photos, and one popular version of the film had an adhesive back, turning the I-Zone images into instant stickers. "Where will you stick it?" was one of the main slogans of Polaroid's I-Zone campaign. The idea came originally from Japanese print clubs in which photo kiosks produced mini-snapshots that could be stuck anywhere; it also explains the popularity of the I-Zone (or Xiao) in Japan, since the camera effectively miniaturized the photo-sticker kiosks. According to historian Sharon Scott in *Toys and American Culture*, "toys are differentiated from games in that they have no specific instructions for play."[33] Children's stickers can come with designated books to receive them, but in practice the only limit to the invention and playfulness of sticker-users is the finite number of surfaces in the world. In this emphasis on the tactile, object-like qualities of the image, the I-Zone diverted the snapshot from its supposedly primary purpose as a tool for memory, exploiting instead its potential for decoration and adornment.

Luxury Cameras

The Swinger and the I-Zone were some of the cheapest cameras Polaroid ever made, but something does not have to be colorful and made of plastic to be a toy. Toys have little utility beyond a dedication to play, which is why they are valued by the idle rich, whose indulgence

in a range of nonproductive activities amounts to luxuriating in an extended childhood. Not quite speedboats or sports cars, many of Polaroid's cameras were nevertheless luxury items, and so toys for adults.

In 1977, the plastic-bodied OneStep with its bright stripes retailed at $39.95 and 40% of all US camera sales were in instants; while a Photo Marketing Association survey in 1980 found that 43% of US households owned either a Polaroid or a Kodak instant camera.[34] However, this was far from the case in 1973 when the SX-70 was launched, and even less so in the early years of Polaroid cameras. The Model 95 may have been marketed as a snapshot camera in 1948, but retailing at $89.75, it was well beyond the reach of the average snapshot enthusiast, who in the same year might have acquired a Kodak Brownie Hawkeye for $5.50.[35] As the media analysts Risto Sarvas and David Frohlich point out, an inflation-indexed Model 95 would have cost just shy of $900 in 2010.[36]

In a letter to specialist dealers in 1955, Polaroid Sales Manager Robert Casselman describes the Land camera as "America's Number 1 camera in the fine camera field," which gives a sense of how Polaroid positioned itself in a market to which it was a newcomer.[37] The reviewers agreed, doubting it would displace the box camera as "a standard household item" since it "costs too much to attract the legion of camera users who place a top limit of $15 on their shutter boxes."[38] Mark Olshaker claims that the first cameras were defined by their "exclusivity" and were primarily a product for the "well-heeled."[39] This is confirmed by some of the earliest Polaroid ads, one of which shows an affluent-looking group, the central figure in pearls, enjoying the fruits of their picture-taking.

Instead of being sold through camera distributors, the first Polaroid cameras were available only in high-end department stores, generally just one in each city, starting with Jordan Marsh in Boston, and progressing to Macy's in New York and so on. "We went to department stores," explains J. H. Booth, "because we had the kind of item that department stores value as prestige merchandise."[40] Booth, who led the promotion campaign for the Model 95, also arranged for Miami to be the second launch city after Boston. His rationale was simple: the presence in Miami of large numbers of affluent vacationers with plenty of time and money on their hands.[41] There were clearly enough wealthy customers willing to pay for the novelty, since the Polaroid

More *FUN* with a *Camera*

There's no thrill like seeing your pictures 60 seconds after you shoot them

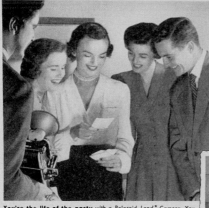

You see your pictures at once, can improve pose and lighting.

You're the life of the party with a Polaroid Land* Camera. You snap the shutter . . . a minute later get the finished picture for all to enjoy then and there! Big, clear, lasting prints (3¼ x 4¼).

You are always sure of once-in-a-lifetime shots.

Just drop the film in your Polaroid picture-in-a-minute camera and you're ready for a great new experience in photography. Almost everything is automatic. No tanks . . . no liquids . . . no delays. The whole photographic process is at your fingertips.

Picture-in-a-minute photography gives you an entirely new opportunity to use your ingenuity. You can make better pictures because you see your results at once and vary lighting, pose and composition as you go along.

Think of the fun! You can enclose in your letters snapshots that are still news.

You can build a better vacation album because you get just the pictures you want before you leave the spot. You need never again miss those once-in-a-lifetime shots. Ask your photo dealer for a demonstration tomorrow.

Lifetime Guarantee. During the lifetime of the camera, any defects in workmanship and material will be remedied free (except for transportation charges). A nominal charge is made for damage resulting from mishandling, accident or wear.

Free Booklet 16 pages . . . fully illustrated . . . answers the 45 most frequently asked questions about the "Picture-in-a-minute" camera. Write Polaroid, Department C-7, Cambridge 39, Mass.

*Named for its inventor, Dr. Edwin H. Land Polaroid ®

POLAROID *Land* CAMERA
"60 seconds from snap to print"

Weekend or vacation pictures ready to show immediately.

Figure 1.5: Polaroid Model 95 Land Camera advertisement, *Camera*, February 1950.

110B, or Pathfinder, released in 1952, was almost three times as expensive as the Model 95 at $249.50. The exclusivity of the Pathfinder was sealed when Dwight Eisenhower was pictured in newspapers using it, beginning a long association between Polaroid photography and American presidents.[42]

Similar strategies were deployed for the launch of the SX-70, which, as well as containing extraordinary advances in chemistry and optics, was something of a small miracle of design, the way that it folded into a pocket-sized book shape when not in use. For its limited launch in November 1972, Polaroid returned to Miami and its wealthy vacationers, who could be counted on to carry out nationwide publicity when they returned home with the new gadget. As it turned out, photo dealers descended on the city and bought SX-70 cameras in bulk, selling them at twice the recommended $180 to photo stores around the country.

Anticipating an elite customer, Edwin Land had demanded that the camera be covered in cowhide—"Expensive, hard to handle, difficult to bond to the surface of the camera"—and instructed the design team to leave in the wrinkles in the leather so that buyers would know that it was real.[43] The leather theme was extended to the special presentation sets made for the SX-70, including an Executive Attaché by Hartmann, made from high quality belting leather and sold with the "deluxe SX-70" for $385. This was no one-off expenditure though, since each pack of ten pictures cost a hefty $6.90. Around the same time packs of peel-apart film for Polaroid Automatics went for around $3, but as Patti Smith reports, even this was prohibitively expensive for Robert Mapplethorpe, who had just acquired his 360 Land Camera. Only through subsidies arranged by curator John McKendry could Mapplethorpe afford to continue making Polaroid prints.[44]

There were sometimes tensions within Polaroid's marketing division on how and whether to distinguish its cheap toys from its expensive ones. The Swinger may have gotten them into the drugstores with their high-volume sales, but this was a far cry from Jordan Marsh and Macy's.[45] The Swinger was then followed in the late 1960s by the even cheaper Colorpack II. Marketing chief Stan Calderwood was well aware of the risk the Swinger posed to Polaroid's image, and claimed that they were not "forsaking Bergdorf-Goodman for Woolworth. Instead we're bringing Bergdorf-Goodman style, sophistication, and quality

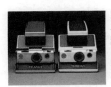

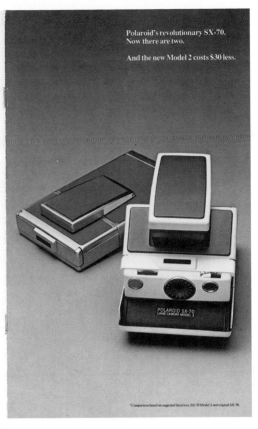

Polaroid's SX-70.
There are two models to choose from.

The deluxe SX-70's body is plated by a unique process which layers nickel on top of copper and it is finished in luxurious brushed chrome with panels of top-grain leather. Model 2 is styled for economy. The body is ivory plastic with Porvair trim. Model 2 can do everything the deluxe SX-70 can do. The differences are skin deep. The deluxe SX-70 is $194.95.* SX-70 Model 2 is $149.95.*

The SX-70 Presentation Set.

The SX-70 Presentation Set is an impressive gift. An attractive black presentation box contains the deluxe SX-70 in brushed chrome and real leather, and a new top-grain leather Ever-Ready carrying case in which you can open and operate the camera in a moment. In addition there is a tripod mount and remote shutter button (especially useful for steady time exposures). Plus the accessory holder and close-up lens. The SX-70 Presentation Set has a suggested list price of $240.

The SX-70 Executive Attaché by Hartmann.

This prestigious attaché is made from high quality belting leather by Hartmann Luggage. It comes with the deluxe SX-70 in brushed chrome and top-grain leather and has compartments for business papers, film and FlashBars and a pocket calculator.

The SX-70 is a wonderful business machine because it can go anywhere and make instant records of high fidelity and permanence. The Executive Attaché is the perfect way for the discriminating executive to own the SX-70. The suggested list price of the Attaché, complete with deluxe SX-70, is $385.

*Suggested list prices.

Polaroid's revolutionary SX-70.
Now there are two.

And the new Model 2 costs $30 less.

*Comparison based on suggested list prices, SX-70 Model 2 and original SX-70.

Figure 1.6: SX-70 product information, 1974.

down to a mass level."[46] By 1982, Bergdorf-Goodman had been well and truly forsaken, with SX-70 film the top-selling product in American drugstores, outperforming Oil of Olay and Crest in dollar sales.[47] In 1986, just thirteen years after the SX-70 launch, the *New York Times* could confidently state that "Polaroid cameras have gained a reputation as blue-collar products."[48]

In the same year as the blue-collar comment by the *Times*, Polaroid made one final attempt to return to the luxury end of the snapshot market with the introduction of the Spectra System. Priced at $225, the Spectra was a folding camera that did away with the SX-70's fragile collapsible bellows, contained a sophisticated Quintic lens, had advanced viewfinder technology, and produced rectangular images 10% larger than the SX-70 print. In addition to the price, Polaroid found

a number of means to make clear that it had a wealthier consumer in mind for the Spectra. For starters, they recruited a besuited Englishman to lead the campaign, in the form of Ben Cross, fresh from *Chariots of Fire*. Cross was from a working-class Irish background, but Polaroid clearly wanted him for the upper-class sophistication an English voice was still then assumed to bring. The brochures and user guides for the System drove home the point. They featured wealthy-looking holiday-makers in a number of genteel New England locales such as Nantucket, Martha's Vineyard, and Newport, Rhode Island. Another promotional brochure entitled "Welcome to the Photography of the Future" featured images of exclusive Caribbean islands St. Lucia and St. Barthélemy.[49] Further promotional images pictured the camera among strings of pearls, jeweled cuff-links, and fine crystal glasses and decanter.[50] Polaroid also harked back to the early days of the Model 95 by making the "Spectra System Portfolio Gift Set" available only in a select number of upscale department stores such as Bloomingdale's and Jordan Marsh.[51]

The fact that the Spectra was not just a camera, but a "system" was also significant. Unlike many other Polaroid cameras available around this time, the Spectra came with a large range of possible accessories that the company saw as key to the profitability of the system.[52] Where the SX-70 had the Executive Attaché case by Hartmann, the Spectra Gift Set came with a cordovan leather portfolio, a tripod, and a bemusing array of special effects filters (motion, red center spot, starburst, multi-image 3, multi-image 5). It is impossible to know how many Spectra owners actually made use of these elaborate filters, but we would do well to remember sociologist Pierre Bourdieu's assessment of such expensive kit in domestic photography. Multiple accessories may suggest greater functionality on the part of the camera and greater skill on the part of the photographer, but that is generally all it is—a suggestion, an outward sign.[53] To look at another user's guide featuring a man posing with a sports car, a yuppie couple on holidays, and a woman playing tennis, it is hard not to conclude that the Spectra was a prime example of Reagan-era conspicuous consumption. Reagan's Vice President George H. W. Bush was a high-profile fan of Polaroid products, and was pictured with his Spectra Onyx once he assumed the Presidency.[54]

Figure 1.7: Polaroid Spectra prints, 1986, 2004.

Figure 1.8: Polaroid Spectra booklet, 1986.

A Beguiling Toy

On one level, the Spectra and the I-Zone could not be further apart. One was a high performance machine packed full of innovations, the other the most basic of photographic devices. The line of continuity between the two can be seen in their promotion as accessories to play. Marketing cameras as toys in this way may help sell them in the short run—the I-Zone was the world's best-selling camera in 1999 and 2000—but it is also a risky strategy, for the designation is far from neutral. Most commonly, in everyday discourse, "toy" is used as term of disparagement, with all its connotations of childishness, lack of practical purpose, triviality, and amusement with no real value. The label "toy," in this pejorative sense, as well as associated terms such as "novelty," in fact dogged Polaroid from its entry into the photo-business and continued to plague it even when it was well established as a respectable manufacturer of a huge array of both amateur and professional products. Consider this typical response to the SX-70 by photo-writer Robert McDonald:

> Let's face it, I'm a professional photographer, and the first thing that comes to mind when I hear the word "Polaroid" is "toy." The new SX-70, however, is something else. To begin with, the very thought of standing in bright sunlight and watching your pictures develop is unbelievable [. . . .] Okay. So it is still a toy, perhaps, but I also still want one.[55]

McDonald's response is a mix of awe and condescension: awe at the technical achievement, condescension at its application. Inside the company, there were concerted efforts to counteract this sort of attitude, with Ansel Adams one of the main figures concerned that Polaroid's products should not be considered frivolous. Adams, who served as a consultant to Polaroid from 1949 until his death in 1984, recalls in his autobiography,

> In the early days of Polaroid, I found that the majority of professional and creative photographers dismissed the process as a gimmick. I was considered by my colleagues a bit eccentric because of my enthusiasm and championing of what they considered a beguiling toy.[56]

He wrote this near the end of his life, but his memos to Polaroid in the 1950s confirm that this concern was long-standing. For example, writing in 1953 to the head of the Black and White research lab, Meröe Morse, about the directions taken by Polaroid advertising, he complained, "It has served to place emphasis on the casual, amateur use of the camera and process which has, I think, minimized the more important aspects. Most people think of it as a semi-toy."[57]

With Adams in the lead, Polaroid campaigned hard to clear the slander, but this campaign was at best partially successful, mainly because there were clear commercial advantages in producing beguiling toys, as the case of the Swinger demonstrated. The irony was that Polaroid had produced the Swinger only in order to subsidize its expensive research work on the SX-70. When the SX-70 did not recoup its costs, Polaroid had to quickly push through cheaper and cheaper versions of the technology, culminating in the OneStep in 1977, which went on to be the world's widest-selling camera for four years, and which, with its plastic body, inevitably looked like . . . a toy.

It was this integral instant photography that finally awoke Kodak to the threat from the Cambridge upstart to its dominance in the snapshot business and drove it to infringe Polaroid's patents and produce its own integral instant cameras in the 1970s. Peter Wensberg reports in his insider's account of Polaroid that the company had actually benefited for a long time from Kodak's view that instant photography was no more than "a novelty, a scientific curiosity" and therefore unlikely to disturb its market share.[58] As the patent dispute heated up between the two companies, Edwin Land, in his Chairman's Letter in the annual report of 1981, turned on the competition the very word that had so often been leveled at Polaroid, accusing Kodak of "introducing cameras of unfortunate bulk, films of unfortunate expensiveness, and propaganda directed towards treating this most elegant of arts as a toy."[59] But the label was hard to shake, and by the time of the I-Zone, fifteen years after Adams' death, and eight years after Land's, Polaroid had long given up trying. It is hard to avoid the conclusion that Polaroid, by producing so many fun cameras, had simply picked up where Kodak left off in the early twentieth-century when it abandoned play in favor of memory as the main function of snapshot photography.[60]

Adams and Land tried to defend Polaroid cameras against the toy label, but it might be more productive to embrace some of the older,

more positive connotations of the word, connotations which are already present in the Eames' admiration of SX-70's clever and elegant design. In his study of the evolution of optical toys, film historian Ian Christie points out that the current meaning of a toy as an object that lacks any genuine purpose or utility is a relatively recent development, dating from the second half of the nineteenth century.[61] Prior to that, the toy, or more broadly, "mechanical marvel" possessed a certain philosophical value as "a precision instrument designed to impress with its craftsmanship and ingenuity, while demonstrating some basic principles which might be scientific but also moral."[62] In other words, with this earlier meaning, toys were not despised simply because they offered no tangible end product, but rather were valued as illustrative of some process. Walker Evans comments that he at first thought the SX-70 was "just a toy," and then goes on to explain how it nevertheless stimulated him to make unexpected photographic discoveries; but if we invoke the earlier meanings outlined by Christie, then we can see that those discoveries are possible not in spite of the camera being a toy, but precisely because it is one: a new process that demands play and experiment.

Evans took over 2,600 pictures with the SX-70 in the two years before he died, glad to be freed from the rigors of the darkroom.[63] Others found that the absence of a darkroom was itself the main spur to play in this new toy because of what it prevented them from doing. Polaroid called film of the SX-70 generation "integral" because it emerged from the camera fully formed and in a single discrete unit, unlike earlier versions of instant film. Also unlike those earlier versions, which at various points had faded or curled if they were not treated with a special coating, or were vulnerable to scratching, the SX-70 print was a tough little package. An ordinary snapshot will meekly surrender to crumpling or tearing, but it requires scissors or fire to vandalize the stiff and sturdy integral print.[64] Its most extraordinary bit of armor was its transparent top layer of opacifying mylar which allowed the photographically impossible—an image to develop in direct strong light. For the creatively inclined, this apparent invulnerability, combined with the camera's elimination of the usual site of postexposure creativity—the darkroom—might have been a deterrent. To some, though, it was a challenge to find the holes in the integral print's defenses.

In the first years of SX-70 photography there was one major hole: the photographic emulsion took up to 48 hours to harden, and while it remained soft, it was possible to work upon it with a sharp implement such as a dental tool. The print was tough enough to withstand scratching, but firm pressure applied to its surface would break down into lower levels in the layers of dye and change the color and texture of the image. The emulsion could even be worked upon in this way without initially exposing the print. The effect was an object that looked like a strange hybrid of photograph and painting. New York artist Lucas Samaras was a pioneer in these manipulations in his *Photo-Transformations* series (1973–74), sometimes rearranging the SX-70 dyes so radically as to nearly obliterate the original photographic image in a swirl of colors. Les Krims, John Reuter, and Norman Locke also ingeniously found ways to interfere with the surface of the developing print.

These assaults on the integrity of the integral print took a range of additional forms. In their explorations, Reuter and others attacked the print from the back, inserted materials into it, painted directly on the exposed surface, and discovered the Polaroid transfer process, a violence to the image that has found widespread popularity. Experiments with the technology also led to testing it with extremes of heat and cold, since the film materials were very sensitive to variations in temperature. Reuter put them in a toaster to separate the dyes from the polyester backing; when they rejoined, it left a shattered, splintered image.[65] James Welling found that refrigerating prints from his Polaroid 450 shortly after exposure gave them a greenish cast, and also heated developing prints over a gas stove to give them richer colors.[66] This is the logic of the trial: the resistant materials are put through a series of demanding tests to determine their limits. The same logic is operative in other Polaroid work as well. Ellen Carey, for example, describes her work with large format 20 × 24 inch Polaroid film with a language of physicality: "pulls," "lifts," and "drops." In her *Pull* series (1996-) she too is testing the limits of the form, pulling the print out of the camera and past its usual 24-inch stopping point; lifting the negative from the positive and dropping it back down as if to subject it to an ordeal by height, with the result a looping parabola.

If a toy comes with no specific instructions for use, the only option is to try things out, and test the possibilities of the object. Sometimes

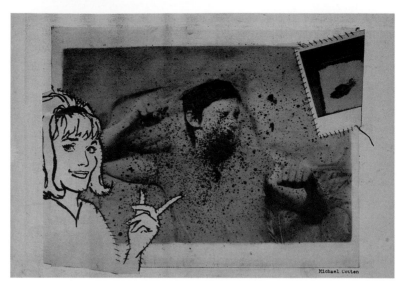

Figure 1.9: Study for Tubes album cover, 1977.

this may mean dismantling the toy to see the gears inside, or lovingly wrenching the head from a doll. Many other Polaroid users also engaged in acts of experimental mutilation, from the mundane vandalism of cutting an SX-70 print from its frame to Michael Cotten of *The Tubes*, who stitched a Polaroid into artwork prepared for an album cover. Robert Mapplethorpe was not among those who deliberately abused the Polaroid image in this way, but Patti Smith reports that the format "was perfect for his impatient nature."[67] It also suited much of his subject matter, which was often explicit and which opened a window onto the New York sexual underground of the early 1970s. Mapplethorpe had no darkroom training and was taking pictures that could easily offend intolerant eyes, so the Polaroid process came in very handy.

The practice was not limited to the underground. In 1963, at the other end of the social establishment, a high-profile divorce case between the Duke and Duchess of Argyll had included as evidence Polaroid pictures of the Duchess naked with a man whose face could not be seen. The identity of the "headless man" was never revealed, but it was reputed to be Duncan Sandys, the UK Minister of Defence, on the grounds that the Ministry of Defence had been lent this rare object, "the only Polaroid camera in the country at the time."[68] Although the

Polaroid Corporation was never very keen to broadcast the fact, many users of its cameras made the same discovery as the Duchess of Argyll and Robert Mapplethorpe, who were neither the first nor the last to answer "dirty pictures," after contemplating the question "What is a Polaroid for?"

2 Intimate, One of a Kind

Polaroid made photography fun. Or, in the language of the historian of technology, experiment and play were key affordances of instant photography. "Affordance" is not the most elegant of words, but it conveys the key idea that a technology allows us to do certain things, but does not require us to do them. According to Susan J. Douglas, to ask what a technical device "affords" is to ask, "what do certain technologies privilege and permit that others don't?"[1] One answer might be that it is all very well to talk about Polaroid cameras as toys that allow for play in a way that other kinds of photography do not, but that this neglects the outcome of that play: the pictures themselves. Isn't there much more to it than just fun? And isn't it the case, continues this line of argument, that what Polaroid permitted was photographs that looked strikingly different from all other photography? Legions of former users will swear that there was nothing like it, and the widespread public dismay over the film's discontinuation in 2008 attests to the strength of their feelings. Feelings, however, are not always the best guarantees of facts (and there is much more to fun than its frivolous reputation suggests). Still, the question needs to be asked: if Polaroid really was different from other types of photography, was it because of the way it looked, or was it down to something else? My answer will not please all of the diehards: it was mainly something else.

Of Singularity, Size, and Saturation

The Polaroid difference, its strangeness even, was on display in April 1973 at the company's annual meeting in a converted warehouse in

Needham, Massachusetts. The SX-70 had been demonstrated at the 1972 meeting, and had its limited commercial debut in Miami the previous November, but this was the first time most shareholders were able to try out the camera themselves. That April, cameras and film were still perilously scarce, with Polaroid factories stretched to capacity, and unable to come close to satisfying demand for the gadget of the moment. Nevertheless, no expense was spared at the ostentatious event, including in the provision of precious film. Perhaps the most extravagant act was to attach to the front of every single shareholders' report an SX-70 print of a red rose. There were about four thousand in attendance, but ten times as many reports printed: 40,000 annual reports, and so 40,000 SX-70 prints of a rose. If you are in possession of one of those rose prints now, it is a collector's item, a piece of photographic history. In the official Polaroid archive at Harvard, there are no roses attached to the numerous copies of the annual report in stock.

The rose was ostensibly chosen to show off the film's handling of tricky reds and delicate detail, as well as the close-focusing capacities of the SX-70 camera.[2] Forty years on, it is not these features of the rose print that give us pause. It is instead the thought that every single one of these 40,000 prints had to be individually produced. That meant 4,000 packs of film, not counting quality control, and a team of photographers, led by Inge Reethof, making images on an industrial scale. Today, when at the press of a button a single image can be sent instantaneously to ten or a hundred times as many screens, it seems a kind of madness to take 40,000 separate exposures in order to attach one to each and every Annual Report. Unlike the photo sent immediately as code around the globe, of course, each one of those rose prints was a singular image. Even if the prints were made under controlled lighting with SX-70 camera on a tripod, each one must have been infinitesimally different from the next, taking into account minute variations in chemistry and the inevitable wilting of the rose or roses.

A kind of madness, then, but also a perfect lesson in what an extraordinary device Polaroid had invented: a machine for making unique photo-objects, every print one of a kind, because not easily subject to the normal processes of photographic reproduction. Nor did Polaroid stop with the 40,000 roses. Later that year 26,000 SX-70 prints were made of a bowl of fruit for a publicity package for dealers; in early 1974, 90,000 prints of bowls of fruit were made for the inter-

national launch of the SX-70. This multiplication of fruit and roses was a matter of company pride, a display of confidence in the new product. Still, there is no getting around the paradox of these expensive and time-consuming promotional acts. What is a new technology, after all, if not a device designed to *reduce* human labor? What is the point of a machine if it is not replacing the toil of human hands, rather than adding to it?

The goal of "one-step" photography was of course to reduce the number of steps in the production of an image, and Edwin Land's invention achieved this, but there is still a sense in which it cuts across the main historical trajectory of photographic progress. If the first great triumph of the photographic arts was the capture of an image, and the second was the fixing of that image, then the third must have been making it possible to reproduce that image. This was William Henry Fox Talbot's great contribution when he invented the positive negative process in 1839, but the provision of a negative was only part of the challenge. To make use of that negative in an efficient way in order to enable the mass reproduction of photographic images was the scientific puzzle that faced succeeding generations of photographic experimenters. In the half century or more following Talbot's discovery, there were numerous solutions to this problem: photoglyphic engraving, mass printing on albumen paper, photolithography, the Woodburytype, photogravure, and the half-tone process for press photos. It is fashionable nowadays to claim that digital photography has permanently changed the photographic landscape, but in many ways it is simply the latest solution to an age-old problem: how to exploit the *potential* for a single photographic image to be turned into multiple copies.

Like digital, Polaroid photography allows us to see an image quickly, and removes from the equation the intermediate steps in the darkroom. However, Edwin Land's invention is in other respects a sharp deviation from the continuous development of photography's capacity for mass reproduction, a development that took it from photo-engraving to half-tone to JPEG. This is because Polaroid is, in effect, if not precisely in practice, a positive-only process. The SX-70 print may contain layers of negative, but those layers are fully integrated with the positive and are in no way usable in any traditional sense for making copies, a limitation it shares with the earliest pho-

tographic image, the daguerreotype. Present it though they might as a revolutionary form of photography, with the SX-70 camera and film Polaroid in fact harked back to a kind of photography that had long been obsolete.

Rather than marking a natural stage in the history of photographic progress, then, the SX-70 and its one-step predecessors might be thought of as discontinuities in that history. One word to describe this peculiar backwards turn is anachronism. Another is perversity. The term need not have negative connotations. If we take "perversity" to be any departure from an accepted norm, and agree that by the mid-twentieth century, and certainly in 1973, the norm was for photography to be negative-based, then Polaroid photography is technologically and photographically perverse.[3] It is perverse, in 1973, to invent a photography that *cannot* be copied without great difficulty. It is perverse to take 40,000 separate exposures of a rose or roses when it is infinitely more economical in time and effort to take a single exposure and reproduce the image using modern and convenient processes. It is perverse to make work where no work should be necessary.

Polaroid's perversity extends further. As photographer Chuck Close has observed, just as cameras and films were getting smaller, Polaroid was making them bigger. The main direction of travel in photographic history, Close points out, has been from plates to sheets to rolls, and then to increasingly smaller canisters, culminating in 35mm film.[4] Precisely because the laboratory for developing Polaroid film had to be contained entirely within the camera, that camera needed to be large enough to accommodate the final print. There was simply no getting around the fact that some part of a Polaroid camera had to be as wide and as tall as the picture that came out of it. This meant either large cameras or small prints, and even when the prints were small, the cameras were still pretty big. The Swinger, for example, was small and light compared with early models such as the Model 95 or the Pathfinder, but it still dwarfed the Kodak Instamatics of the same era, which could fit neatly in the palm of your hand. Even then, the Swinger's print, at 2 inches by 3 inches, was smaller than the standard 3 × 3 print made by Kodak from its 126 film for Instamatics.

The main alternative to the Swinger in the 1960s was the Polaroid Automatic series, an elegant bellows camera that folded down into

Figure 2.1: Prints, Polaroid Type 20 film for Swinger.

a 5 × 8 × 2½ inch rectangular shape, complete with hard plastic casing. Unfurled, it was striking and stylish, but definitely not the sort of thing you could conceal about your person. This was why the SX-70 was such a great advance. Closed, it looked like an oversized whisky flask. Polaroid even claimed that it was pocket-sized, and while it is true that you could slip one into a large pocket of an overcoat, you needed something else on the other side for ballast. It was Land who insisted that it should fit in a pocket, and it took heroic feats of engineering and design to get it to fold as it did, but when he gave a glimpse of a prototype at the annual meeting of 1972, what the audience didn't know was that he was in a specially tailored suit with oversized and heavily reinforced pockets. When he later scorned Kodak's

integral instant cameras for their "unfortunate bulk," Polaroid's own nonfolding versions of SX-70 technology were looking rather bulky themselves.

By the 1990s compact 35mm and disposable cameras were widespread, making the Swinger and Polaroid Automatics of the past look gargantuan both in size and weight. The Joycam and I-Zone may both have been light and easy to carry, but they were still bigger than most cheap amateur cameras on the market, even if Polaroid touted the I-Zone as a "pocket camera."[5] They had to be, because the final print had to come out of them. In the case of the I-Zone, this print was very small indeed, about the size of a 35mm negative (see Figure 1.4). With digital cameras the pattern has been the same, with photographers growing accustomed to light and mobile devices, which often double up as something else, usually a phone, but still produce images dense in information, and viewable in a number of sizes. Even very advanced compact digital single lens reflex cameras have bodies (not including the lens) as small as a Kodak Instamatic. You could squeeze two or three of them into the Fuji Instax camera, the last instant camera still being made, and one that still uses what is in effect plate film.

All this is a way of saying that the Polaroid camera is not the most practical of inventions, taking one step forward by dispensing with the labor of the darkroom, only to take two backwards by rendering reproduction virtually impossible and by requiring a relatively heavy and cumbersome apparatus. For Chuck Close, this perverse turn was part of the appeal of Polaroid photography. He was particularly drawn to the large format films, and especially the 20 × 24 inch film on which he did an extended sequence of self-portraits, including collages of extreme close-ups of his bearded face. The 20 × 24 format requires a very large camera, and this fact places limitations on any photographer using it, since it cannot be easily moved about. Most photographers who used the camera did so in special studios in New York and Cambridge set up for the purpose. Restricted to a studio and limited to the unvarying size of a positive-only print, many photographers resorted to overtly theatrical subject matter, staging elaborate scenes for their pictures. At the other end of the scale, the SX-70 print, with its small square image, places restrictions on the photographer which inevitably have consequences for choice of subject matter and for decisions about framing (see figure 2.2). The same principle applies for

Figure 2.2: Polaroid 600 prints, 2008–10.

all size formats of Polaroid photography, from the tiny image space of the I-Zone, through the small rectangle of Polaroid 500 film and the slightly enlarged SX-70–style print of the Spectra (and with the exception of the professional Type 55 P/N film that yielded a negative as well as a positive).

The fixed size of most Polaroid images has a further implication. In non-Polaroid photography a 20 × 24 inch print would normally be the result of enlargement, but this is not the case with the Polaroid 20 × 24. As *Modern Photography* pointed out shortly after the introduction of the format, 20 × 24 Polaroids are for all intents and purposes contact prints, and so they have extraordinary sharpness and detail.[6] Chuck Close claims that one of these prints "contains an infinite amount of information," and that if he digitally scans one he can blow it up to the size of a building.[7] This is why Close's beard is so essential to his 20 × 24 Polaroid self-portraits: each hair and bristle comes into its own in these high-resolution images. A film that picks up every hair will also magnify every blemish, but *Studio Photography* magazine also gushed about the format on its release, calling it "virtually grainless."[8]

Polaroid was proud of its high-resolution film right from the start. Early on, Ansel Adams, in his consultancy role, praised the black and white Types 42, 43, and 44 films. In his own distinctive vocabulary, he claimed that they were "high-fidelity films" offering a "greatly extended *dynamic range*, the ability of the 'picture-package' to translate into effective density differences, the brightness-differences of the scene."[9] Later it was mainly Polaroid's larger formats that sustained this reputation for high resolution: not just the 20 × 24 film but also the 4 × 5 (introduced 1960) and 8 × 10 (1977), both of which were "loaded with silver," in Close's words.[10]

According to the 1972 *Polaroid Annual Report* (the one with the rose), the SX-70 print also has excellent resolution, showing "no evidence of grain or structure."[11] Today, grainlessness is not usually the first thing that comes to mind when we think of the image qualities of the SX-70 print. Instead, it is the supposed color saturation of the SX-70 print and its integral successors that provokes the most rhapsodic tributes. Ben Lifson writes that artists like the SX-70 print because of "its deep, saturated, gem-like color," which "gives each scene a jarring voluptuousness."[12] Peter Conrad says of SX-70 prints by Ansel Adams: "The world according to Polaroid has what Adams called 'a

subtle "glow". Its pigmentation is dense, saturated, making a lichen-coated rock or a scrap of oxidised metal softly luminous."[13] Geoff Dyer notes the "peculiar colour saturation of the Polaroid" which "appears as memory-drenched as Super-8 film."[14]

Saturation is a technical, scientific term, before it is an aesthetic one, but in these writers' hands it takes on a metaphorical and subjective cast. There is nevertheless some chemical evidence to support these strongly felt statements about Polaroid saturation. According to Richard Benson, Edwin Land and his team "chose dyes that sharply cut portions out of the color spectrum," and that "intense saturated primaries" were the result, although he adds that in SX-70 prints these colors were sometimes submerged by a yellow tinge, and that Polaroid colors were shown best in the larger format 4 × 5, 8 × 10, and 20 × 24 images.[15]

It is true that the chemists at Polaroid invented a whole new color process to make the SX-70 system possible, using metalized dyes rather than the organic ones of conventional color photography. If Polaroid color images after 1972 have a distinctive saturated look, it may be down to these new dyes. In its own promotional materials, Polaroid claimed that the metalized dyes "make possible prints of a brilliance and intensity that create a new standard for amateur photography" and that "because the pictures are framed against a highly reflective chemical background, they have a remarkable luminous quality, as if lit from behind."[16] This may just be a fancy way of saying that the SX-70 images are glossy rather than matte (Kodak's instant prints, introduced a couple of years later, had a matte finish, which is much more forgiving of poor resolution). In any case, the main virtue of the new dyes appears to have been their stability and fade-resistance rather than their high color saturation.[17]

The Polaroid Difference

High resolution, strong saturation, and fixed size restrictions in a perversely singular print. Do these four qualities add up to make the Polaroid print substantively different from other kinds of photography, or to give it a distinctive "look"? The jury is out. None of these qualities is exclusive to Polaroid photography, and some of them do not or may not apply to all Polaroid images. For instance, it is so rou-

tinely claimed that Polaroid film is highly saturated that rarely does anyone bother to ask whether it is true, or, if it is true, whether this is in any way remarkable. The fact is, the science on Polaroid saturation is inconclusive. In a detailed survey, *Popular Science* in 1963 found that the new Polacolor film was deficient in the saturation levels of its reds.[18] In 1973 professional photography expert Norman Rothschild carried out a systematic comparison of SX-70 with other color formats and determined that Kodacolor outperformed SX-70 prints on saturation, brilliance, and fidelity.[19] And in his manual on color photography, Henry Horenstein, otherwise positive about Polaroid, claims that integral instant films have lower sharpness and color quality than conventional films.[20]

More confusingly, the popular mythology about Polaroid prints' propensity for fading would appear to be at odds with their color saturation. It was presumably this reputation for fading that led the curator of an exhibit at the Royal Academy in 2011 to add a caption to nine SX-70 prints by André Kertész saying that the photographer had "responded to the . . . muted colours of the process."[21] Clearly there is some uncertainty about the nature of SX-70 color when it is possible to see in it both mutedness *and* saturation. Even if it is true that much Polaroid film of the post-1972 variety is saturated, it is very doubtful that this differentiates it radically from other photography. If we accept the received wisdom about the high color saturation of SX-70 images, it would still be highly problematic to claim that this saturation was a property specific to Polaroid photography, and that no other film type had highly saturated colors. The mundane fact is that all major film producers manufacture a range of films, some of which have higher levels of saturation (for Kodak it used to be Kodachrome, for Fuji, Velvia). (See Figure 2.3 for comparison.) Nor is saturation purely a quality of film: lighting and temperature conditions are critical as well.

The same sort of qualifications apply to the high resolution of Polaroid film. Just as Polaroid was far from being the only photographic company to manufacture highly saturated films, it was not alone in making high-resolution ones, and so this cannot be a property that decisively distinguishes Polaroid photography from other forms of photographic image. At the same time, for every claim made about the high resolution of Polaroid film, it is possible to find someone

Figure 2.3: Polacolor (right) and Kodacolor prints compared, 1960s.

stating the opposite. For example, Henri van Lier, like Ben Lifson and Peter Conrad, turning to metaphor in his celebration of the SX-70 image, seems to suggest that it is the opposite of grainless, attributing it instead with a "depth that is turbid, watery, wooly or fluffy, stagnant, half-coagulated, glaucous."[22] Van Lier may be praising the film, but this account of it is closer to the low-fidelity qualities Polaroid film has in the popular imagination of those who produced the vast majority of Polaroid snaps on cheap cameras than it is to silver-rich large-format prints beloved of professional and art photographers.

As for size, Polaroid is not the only film whose dimensions pose specific challenges for photographers, even if the positive-only process makes it a special case where no darkroom work on the negative is possible. Nor can the theatrical tactics provoked by 20 × 24 film be considered unique, given the widespread phenomenon of the "directorial mode" in art photography since the 1970s.[23] Nevertheless, along with the singularity of the print, the size and shape restrictions of the Polaroid are the features that contribute most to its distinctiveness as an image. Or we should say instead, to its distinctiveness as an *image-object*, since size and singularity do not strictly speaking affect the look of the photographic part of the image.

Overall, there are two main problems with attempts to find the specificity of Polaroid photography in the way it *looks*. Firstly, it is

impossible to generalize about "the Polaroid image," since there is no such thing. Instead, there are many different formats and film types, ranging from the early sepia and black and white, through Panchromatic, Polacolor, Time-Zero, Spectra HD, and numerous other specialized high-speed, x-ray, and forensic films, to name but a few. Those who make claims about this or that quality of "the Polaroid image" usually do so on the basis of just one of these many formats, most often the SX-70 print. In addition, the qualities of any given Polaroid film are not uniform, but vary depending on the camera in which the film is used, whether it is SX-70 film in the original folding or later cheap box-type camera, Polaroid 600 film in an SLR 680 or a basic Pronto 600, or Polaroid 500 film in a high-end Captiva or low-end Joycam. And in any case, is it really possible to isolate the look of an individual film independent of variable intervening factors such as light conditions, filters, lenses, and exposure values? Does Polaroid film really give a ghastly hue to the faces of its subjects, or is this just a function of the context in which the party camera is so often used: flash photography in poorly lit spaces?

The second main problem with attempts to find the distinctiveness of Polaroid photography in attributes of the image is the extent to which these attempts must pass off minor differences as major ones. For the sake of argument, let us accept that Polaroid color film of the SX-70 generation has its own peculiar identity, some special amalgam of saturation and "turbid glaucousness," to borrow Van Lier's words. Do these qualities of the Polaroid image distinguish it from other film formats in a truly significant way? The resort to metaphor to account for the unique qualities of Polaroid color is a vital clue that we are in the hair-splitting territory of what Freud called the "narcissism of minor differences."[24] It would obviously be foolish to say that SX-70 film is identical to Kodachrome or Ektachrome, to Fuji Provia or Instax; but it is equally tendentious to claim that it is radically different from them.[25]

A Singular Process

Instant film fanatics may protest otherwise, but it is not possible to generalize about the Polaroid image as a single thing with a specific

look. The white border of the SX-70, Polaroid 600, and Spectra prints makes them easy to spot, but that border is part of the object as much as it is part of the photographic image. Many other Polaroid film types do not have the iconic border and are much harder to spot. And even that white border is far from unique. Kodak instamatic prints of the 1960s were regularly printed with evenly sized white borders, and the dimensions of the square image were virtually identical to those of the SX-70 image. It has a different look from the back, and a unique heft in the hand, but carefully trim the bottom edge of an SX-70 print and frame it in an album, and it could pass for an Instamatic print.

It is another matter if we look to the Polaroid process, which changed remarkably little over time: in 1947 a pod of developing reagents was burst by a set of rollers and spread over photo-sensitive paper; in 1977 and 1997 this was still the case. If there was anything that distinguished Polaroid as a form of photography, and applied to virtually all Polaroid film formats and camera types, it was the way it was made, not the way that it looked. Distilled, this comes down to the combination of three essential properties. First, the instant appearance of an image: its *speed*. Second, the elimination of the darkroom. Third, the singularity of the image—there is no usable negative, therefore the image is not subject to mechanical reproduction. All three of these properties need to be qualified in light of the history of the technology.

Speed

What exactly is instantaneous? The original sepia and then black and white peel-apart film, under appropriate climatic conditions, was ready in approximately sixty seconds, hence Polaroid's advertising slogan in the 1940s and '50s for "Pictures-in-a-Minute." By 1963 this was reduced to ten seconds for black and white film, while the new Polacolor took about 50 seconds to develop. The image from the SX-70 type integral film will materialize more or less completely after four to six minutes (although Time-Zero SX-70 film of 1979–80 brought this down considerably). By contemporary standards this is agonizingly slow. Expectations about speeds of website access or how long it should take for an image to form in a mobile phone after

capture give a sense of the relativity of any concept of the "instant": if it were invented now, Polaroid film would have to be called "delayed" photography.

No Darkroom

In the first generation of Polaroid cameras—1947–72—there was in fact considerable work to be done (and done carefully) by the camera operator to ensure the proper development of the image. Pulling the film smoothly through the rollers to burst the pod; timing the development according to climatic conditions; peeling the positive print from the negative, which was thrown away; ensuring no dirt between the rollers, and so on. Only SX-70 film eliminated all of this procedure. Nevertheless, all Polaroid cameras dispensed with the need to pass the photos through a public realm (or through a private lab). This short-circuiting of the conventional path of development, perhaps even more than instantaneity, has given the Polaroid its most striking uses.

Singularity

Most Polaroid film of both generations produces only a single unique print with no usable negative. As I have pointed out, this goes against the main trajectory of photographic progress, and, from a purely practical and commercial standpoint, proved something of a drawback for Polaroid, which struggled to attract professional photographers to its film.[26] This led the company in 1958 to introduce Type 55 P/N film that produced a usable negative as well as the instant positive print. Polaroid also ran for many years a Copy Service that allowed photographers to send their prints to a special lab at company HQ. It is also worth remembering that for vast numbers of family snapshots from the pre-digital era, only a single print exists. Some people kept negatives, others had doubles made, but negatives get lost or discarded and many snapshots are ever printed only once. In this sense, millions of Kodak snaps *are* Polaroids, since there is only one of them in existence.[27]

Combined in a "dry" photographic system, these three properties decisively differentiated Polaroid from other forms of photography. They are also what made Polaroid cameras such popular toys—toys

which encouraged all sorts of play beyond the childish. This includes of course what Lady Argyll got up to with the headless man, but goes well beyond Polaroid's affordances for do-it-yourself erotica. The perverse technology made for an intimate camera.

Intimate, Immediate, Expedient

Consumer Reports *had a lot to say a while ago about the SX-70 Land Camera but never did explain what the SX stood for.* JOHN UPDIKE, *Rabbit Is Rich*

In 1977 Polaroid gave supplies of SX-70 film and cameras to a select group of photographers and asked them to experiment with it, the results going into the first formal exhibition of SX-70 photography, the "One of a Kind" show in 1978. One of these photographers, Sharon Smith, took her camera to Coney Island in Brooklyn and snapped bathers there, discovering that the instant process generated its own distinct protocols:

> Watching the image develop enhances the potentially intimate relationship between the picture-maker, the picture, and the pictured. Since the picture is literally delivered toward the pictured, since it develops itself into an attractive piece of information with no input from any particular person, since this process takes place in whoever's hand is holding the image, questions about ownership of SX-70s taken in public places continually arise [. . . .] The SX-70 encourages me to have as well as to record experience.[28]

The speed with which the image is produced, the fact that it requires no intermediary in its development, and the uniqueness of the print, all help to blur the borders between picture-maker, picture, and pictured. Smith calls this *intimacy*, a word that has long been used to describe the subject matter and aesthetic codes of snapshot photography.[29] But Smith is not talking so much about the content of the images as the process of taking them, and she is not the only one to use this term about Polaroid photography. A fellow contributor to the "One of a Kind" show, Harvey Stein, uses it to explain why the camera is good for photographing friends, and Peter Conrad uses it to describe SX-70 photos by Ansel Adams.[30] Alan Woods employs it in his account

Figure 2.4: The "picture is literally delivered toward the pictured" (Sharon Smith).

of the Polaroid work of British situationist Ralph Rumney, and Max Kozloff claims that "the SX-70 incites an intimate, egocentric probing of experience."[31] Peter Schjeldahl claims that Polaroid prints have "a particular intentness, a congested warmth, a hanging on to the moment, above all an intimacy."[32]

The Polaroid company also got in on this language of intimacy to describe its products. Speaking at Faneuil Hall in 1981 to promote the 600 series cameras, Richard W. Young, director of worldwide marketing, offered to his listeners the slogan "intimate, immediate, expedient" as a way of summing up the advantages of Polaroid photography.[33] Unlike Smith, Young did not explain exactly what makes Polaroid photography intimate. At Polaroid, answers were found in surprising places: as part of advice given in the *Polaroid Newsletter* on taking Halloween snaps, readers were counseled to "Stay close to your subjects. Four to six feet is a good distance for flash pictures with all Polaroid cameras. The most common error made with Polaroid cameras is that the photographer is too far away from the subject."[34]

If intimacy implies closeness, then Polaroid photography is inti-

mate through necessity: the small image size of much of the film and the very limited focal depth of many of the cheap cameras discourages the photographer from keeping at a distance from the subject. Polaroid's own research showed that its customers learnt this lesson, and that a very large proportion of images taken on Polaroid cameras were made from between two and four feet.[35] Intimacy, then, is a function of duration—the time shared waiting together for the image to appear—and also of proximity, but not just spatial proximity, for as Smith points out, the closeness in time between the taking and the seeing of the image raises interesting questions about who should own the picture.

In their attempts to capture succinctly the closeness encouraged by their cameras, Polaroid often spoke of the way it removed barriers. In that same speech in 1981 Young claimed that "Since our earliest days in this field, our credo has been that time is an undesirable barrier to communication between photographer and subject," and that "mechanical obstacles should be as removable as the barrier of time."[36] Young knew his Polaroid history: when Edwin Land spoke to the Royal Photographic Society in 1949 about the Polaroid process, it was exactly this vocabulary that he used:

> By making it possible for the photographer to observe his work and his subject matter simultaneously, and by removing most of the manipulative barriers between the photographer and the photograph, it is hoped that many of the satisfactions of working in the early arts can be brought to a new group of photographers.[37]

Later, in the Eames film that officially introduced the SX-70 in 1972, the narrator's first words about Polaroid photography affirmed this ethos: "Since 1947 Edwin Land and Polaroid have pursued a central concept, one single thread: the removal of the barriers between the photographer and his subject." And in a retrospective piece on Polaroid's progressive simplification of camera technology, Land's replacement as Polaroid president, Bill McCune, confirmed in 1991 that Land's "basic philosophy" was to "eliminate concern about the mechanical aspects of the camera" and "remove barriers between the photographer and the subject."[38]

There are good reasons to be suspicious of this rhetoric, which

promises, or at least aspires to, the elimination of all obstructions and all delay. It is one thing to remove technical obstacles to image-making, quite another to liquidate all the cultural conventions that govern any photographic practice and mediate the relations between picture-maker, picture, and pictured. Land wanted to leave only the "content and composition" of the photo up to the photographer, but as feminist scholars Jo Spence and Patricia Holland and many other commentators on domestic photography have shown, these are far from neutral categories. Whether they learn them actively or unconsciously, amateur photographers more often than not follow a fairly narrow set of choices in content and composition. Writing in the early 1990s, Spence and Holland showed how the rules of domestic photography ensure that photo-album families are almost always happy, nuclear, and on holidays, even if the truth is that they are complex, contradictory, and in conflict.[39] Such rules of course change over time, while remaining rules: more recently, for example, the high angle, arm's length small group portrait or "selfie" has become an automatic choice among an entire army of amateur photographers. Polaroid's removal of the barrier of time cannot simply sweep away such codes of picture-taking. People take certain kinds of photos, because certain kinds of photos are taken.

Even so, with Polaroid an opportunity presented itself, and the opportunity was grabbed by the "home porno-enthusiasts," as John Waters fondly calls them.[40] There was no hint of innuendo when Edwin Land spoke of removing barriers or when his marketing chief sang the praises of Polaroid's intimate cameras, but it is an open secret that Polaroid can take credit for another kind of intimacy, allowing the unschooled amateurs who used it, in a less ubiquitously pornographic age, to take explicit pictures of themselves. The fact that the film developed itself and did not require the intervention of a professional developer radically lowered barriers of censorship and self-censorship. The instant appearance of the image on the scene meant that it could be appreciated right away. And the fact that there was no negative ensured the picture would go no further, as long as it was safely stored away. What could go wrong?

The legend of the explicit Polaroid is strong, but the evidence, understandably, is anecdotal or apocryphal.[41] It tends to come second-hand, some of it from artists who have turned the private practice

into public art. Most notable among these is Lucas Samaras, who in his Autopolaroids (1969–71) produced a series of ostentatious self-portraits in various assumed guises and states of undress.[42] He remarked at the time, "The speed with which a result is obtained without outside help and the complete privacy available afforded me an opportunity of doing something impossible with regular photography."[43] Samaras had no training as a photographer, and did not want to pay one to do such personal work, so found Polaroid the perfect solution.[44] Ralph Rumney has remarked more bluntly of his nude Polaroids that the great advantage of the technology is that "you can take all those photographs that you wouldn't dare take round to the corner shop to have developed."[45]

The explicit Polaroid has left its trace in fiction and films as well. In *Smile* (1975), a film contemporaneous with the release of the SX-70, a boy borrows the new camera and takes a picture of a naked girl changing in a locker room; the picture is confiscated by a policeman, who keeps it tucked away in the sun visor of his patrol car. Around the same time, in the surreal pornography of Walerian Borowczyk's *La bête / The Beast* (1975), an SX-70 camera features prominently, as does the picture of an horse's erect penis that emerges from it. Less provocatively, Alice Munro's short story "Lichen" (1986) revolves around a faded Polaroid of a woman's pubic hair; and more comically, in *Infinite Jest* (1996), David Foster Wallace's hero Don Gately burgles the associate district attorney's house, sending the victim only later the Polaroids he and his partner took, "each with the enhanced-focus handle of one of the couple's toothbrushes protruding from his bottom."[46] In DBC Pierre's *Vernon God Little* (2003), Vernon entraps and blackmails a pedophile, using a compromising Polaroid for evidence.[47]

What could go wrong? Cultural theorist Lauren Berlant has observed that intimacy is everywhere sought after, coveted, and yet at the same time, shadowed by its reverse. For every intimate scene, there is the potential for "troubles . . . distractions and disruptions" because intimacy is always more easily imagined than realized.[48] In the idealized snapshot scenario envisioned by Edwin Land, Polaroid intimacy is cozy and comfortable. In the hands of novelists and filmmakers, outrage, transgression, and embarrassment are the order of the day, and a Polaroid is no less compromising for being one of a kind. Take for example John Updike's *Rabbit Is Rich* (1981), in which Harry "Rab-

bit" Angstrom envies his wealthy neighbor, Webb Murkett, and covets Webb's wife Cindy. At a party at the Murkett home, a drunken Harry finds himself in the master bedroom where he pulls out a half-open drawer in a bedside table; at the back he finds a "little stack" of eight SX-70 prints, showing Cindy naked, Webb naked, Cindy performing oral sex on Webb, and Webb "fucking her from behind, his prick vanished in the fish-white curve of her ass and his free hand steadying her."[49] Downstairs again, Harry sees the final two shots in the pack on the fireplace mantel, "one each of the Murketts' little children."[50] Webb blithely contaminates family snaps with sex shots, and this audacity is precisely what Harry envies in him: the snaps are yet further evidence to Harry of Webb's potency, making him "the king of the Polaroid pricks."[51]

Updike seized on the gadget when it was new, but it was not long before the explicit SX-70 became a cliché, an easy shorthand for sexual activity recorded but hidden from the public gaze. In Thomas Harris' *The Silence of the Lambs*, and in its film version, a stash of sexual Polaroids is a key plot device, uncovered by Clarice Starling in the hidden compartment of a jewelry box. More recently, the force of the cliché has been brilliantly exposed and turned on its head by Joyce Carol Oates in "The First Husband" (2011), which revisits Updike's SX-70 primal scene. Searching for the passport of his wife, Valerie, Oates' protagonist Leonard Chase finds at the back of a drawer a packet of Polaroid prints. They are holiday snaps, the reverse of one giving the subjects as Valerie and Oliver, the first husband. In the pictures, Val and Oliver look young, tanned, contented. On the face of it, the Polaroids are innocuous, but Leonard takes them to be evidence of Valerie's sexual life before him, a sexual life he begins to imagine and obsess about, with Oliver featuring as potent, priapic. He does not confront Valerie about the snaps, but his imaginings become increasingly lurid. What starts as a "packet of photographs" becomes from his perspective "the secret cache of Polaroids," then "her cherished sexual secret," and finally "the lewd Polaroids."[52] Feverishly distracted by the jealousy set off by these Polaroids, Leonard loses his job, traces Oliver to Denver, and eventually murders him in half-premeditated fashion. Just as in *Rabbit Is Rich*, a stash of explicit Polaroids reveals to their finder a set of perverse pleasures from which he is excluded. Except that the Polaroids in "The First Husband" are not explicitly sexual, nor "lewd":

they do not need to be. The reputation of the explicit Polaroid is so well established that even a collection of innocent holiday snaps can take on perverse dimensions.

"The First Husband" twice calls the packet of Polaroids Leonard stumbles upon a "cache." What is it about Polaroids that they get stashed away, or stowed in a cache? In *Rabbit Is Rich* and *The Silence of the Lambs* the intimate Polaroids also take this form. A cache is something of great value that has been concealed, secreted, for later use. Someone who sets up a cache is party to an exclusive knowledge, but the nature of a cache also means that it is subject to accidental discovery by another. And this is exactly what happens in each of these fictions: the cache is chanced upon by some third party who is left out of the intimacy embodied by the Polaroids. This may even tell us something about intimacy in general: that it is not confirmed as such until it is interrupted or invaded. For that matter, the Polaroids themselves are a kind of third party, a supplement to the scene of intimacy that betrays it after the fact.

A cache usually contains weapons, treasure, or food, and there is a good chance that whoever has put it there is up to no good. This gets at another potential use of Polaroids that Edwin Land may never have dreamed of, but that fiction frequently has. If novels and films are to be believed, after the sexually explicit it is the criminally illicit Polaroid that is most common. The use of Polaroids by police at crime scenes is well known, but the same qualities that make Polaroid good for dirty pictures—speed, secrecy, no compromising negative—make it ideal for the one committing the crime. So, *Memento*, a film whose protagonist carries an instant camera everywhere, starts and ends with a Polaroid recording of a murder, and the same camera documents other acts of brutality that could never pass through the semipublic realm of the photo-finisher, and which in any case would lose their resonance if they were not "one-of-a-kind" trophies (mementos) of those acts. It is an idea that director Christopher Nolan picks up from crime writers, who often put Polaroid cameras in the hands of their criminals. James Ellroy is particularly adept at Polaroid primal scenes, such as the snaps of mutilated corpses in *American Tabloid*, or the gruesome evidence of a hit taken by two killers in *The Cold Six Thousand*. Just like the police, the one who orders the hit prefers Polaroids because they cannot be doctored in the darkroom.[53] There is even a whole subgenre of the Po-

laroid kidnap photo, which can be found in places as diverse as *Buffy the Vampire Slayer*, *Toy Story 2*, *Amélie*, and *Sympathy for Mr. Vengeance*. In each case, the Polaroid proves just the "intimate, immediate, expedient" device needed by the kidnapper.

A Magical Process

We have a similar, if more viscerally expressed, conclusion in what is perhaps the most startling portrait of a Polaroid user. In the first version of *The Texas Chainsaw Massacre* (1974) a van-load of callow youth pick up a hitchhiker on the way to their doom. After describing in detail the workings of the slaughterhouse and the parts of the cow which are boiled down into head cheese, the hitchhiker borrows the knife of wheelchair-bound Franklin in order to cut himself on the forearm. He then displays a razor blade pulled from the fur pouch around his neck before opening up the Polaroid Automatic also hanging around his neck. Pointing it in turn at all the occupants of the van, the hitchhiker eventually snaps Franklin. Shortly afterwards, he produces the finished picture, demanding two dollars for it. Franklin declines, and the hitcher pulls from his medicine pouch a piece of tin foil; places the indistinct image on the tin foil; heaps what must be gunpowder on it, and sets the pyre alight. While it is still blazing, he crumples the foil up, print and all, and stuffs it into his fur pouch. Thrown out of the van, he wipes his bloodied hand along the side, so that it might later be identified by his brother Leatherface.

With his little fur pouch, his ritualized cutting and burning, his relation to blood, the squatting position he adopts, his excitability and incoherent speech, it seems pretty clear that the hitcher is a sort of pastiche of the modern primitive, a motley shaman with his little medicine bag. Indeed, the source of horror in this film is not so much the prospect of death by chainsaw, but the primordialism of the family of slaughterhouse workers who turn their modern industrial profession into a sacrificial rite conducted on humans. They are terrifying because of the intimacy they have with the natural world and with their fellow creatures.

It is a version of this concept of intimacy that French theorist Jean Baudrillard is getting at when he reflects briefly on the Polaroid in *America*, his book on what he calls the "last primitive civilization."

Baudrillard sees Polaroid as part of the arrival in the 1970s and '80s of the "video phase" of technological history:

> The ecstasy of the Polaroid is of the same order: to hold the object and its image almost simultaneously as if the conception of light of ancient physics or metaphysics, in which each object was thought to secrete doubles or negatives of itself that we pick up with our eyes has become a reality. It is a dream. It is the optical materialization of a magical process. The Polaroid photo is a sort of ecstatic membrane that has come away from the real object.[54]

The cover of *Life* magazine on which Edwin Land appeared surrounded by children in 1972 invoked magic in its modern secular sense to describe the ingenuity and trickery of the camera—"A Genius and His Magic Camera"—but here Baudrillard invokes magic in its stronger, archaic sense, as a fundamental structure of belief. It is this kind of magic that is at work in the ecstatic pleasures of the hitchhiker in *The Texas Chainsaw Massacre*, who also holds "the object and its image almost simultaneously."

In Chapter 4 I will explore the secular magic of the Polaroid in the hands of its showman inventor, Edwin Land, but as the case of modern telecommunications paraphernalia demonstrates, Baudrillard's stronger magic tends to haunt its weaker successor. We need only to look at the anguished psychical investment exacted by the new media apparatus in our interactions with it to realize that in Joyce Carol Oates' "The First Husband," Leonard is not the only one susceptible to the lures of magical thinking. Technology, in the standard thesis of Max Weber or Keith Thomas, drives out the witches and wizards and their claims over nature, which it can manipulate with much greater superiority. In this argument, technology, and the capitalism that nurtures it, is instrumental in the disenchantment of the world, even if its ingenuity tempts us to call it magical in the weak sense because we don't know exactly how it works.[55] However, the intimacy promised by social media and by instant imaging in general suggests that magical thinking in the stronger sense is never far away, in spite of what Weber's rationalization thesis might tell us.

If it has become more urgent now to analyze instant photography's magic, precisely at the point when its technology advances towards

obsolescence, it is because we have not so much left behind the cultural frame of instantaneity opened up by the Polaroid as become absolutely immersed in it. As Retort, the San Francisco–based writers' collective, has argued, contemporary consumer society, with its "gadgetry of instant objectification,"

> has built an extraordinary apparatus to enable individuals to image, archive, digitalize, objectify, and take ownership of the passing moment. The here and now is not endurable, it seems (or at least, not fully real), unless it is told or shown, immediately and continuously, to others—or to oneself.[56]

The Polaroid may be dead, but its logic is infinitely multiplied in our own age of instant-imaging in which, in Retort's nightmare scenario, a complex array of amnesia-machines masquerades as aids to memory and memorialization.

Like so many others, Retort assumes that cameras are only for making memories, but we do not need to endorse their bleak and far-reaching conclusions to recognize the actuality of the drive to instantaneity that characterizes our present. The virulence of their attack is something of a tonic when compared with the bland utopianism of the many disciples of a digital dawn, but it also shows the difficulties of trying to diagnose the present in all its mirror-ball trickery. In its semi-fossilized state, by contrast, the recently obsolete technology not only stands more or less still, but also gives us a relatively serene point from which to contemplate our contemporary immersion in what Retort calls "instantaneous objectification." And even if the Polaroid instant photograph did not constitute part of the prehistory of our own accelerated digital era, that experience is the background against which any exploration of the technology's history necessarily takes place.

3 Polaroid and Digital

In the summer of 1993, when Polaroid released the Captiva camera in the United States, Polaroid Chairman Mac Booth announced that it was the last such camera the company would develop. He meant by this that Polaroid would never again dedicate a huge research budget and unlimited laboratory time to a single photographic project that took many years to complete.[1] Captiva, which had been in the works at Polaroid since the late 1980s under the code name Joshua, was the last in the line. Its development followed the pattern that had been long established at Polaroid for new products: massive investment; long run-in time; thorough-going innovation in optics, chemistry, and electronics; and a strong set of new patents to protect a camera that had no direct equivalent on the market. It fulfilled, in other words, the criteria set by Edwin Land for Polaroid's inventors—that they should seek not to imitate or compete directly with existing products, but rather to make "things that people didn't know they wanted until they were available."[2]

This strategy nearly crippled Polaroid financially in the early 1970s because the company had to build an entire new infrastructure of factories to support manufacture of the SX-70, a camera that eventually paid handsome dividends when cheaper models went on sale. Things did not work out so well in the case of Polavision, Polaroid's instant movie system, which debuted to much fanfare in 1977, failed to compete against video and Super-8, and was written off to the tune of $68 million.[3] The principle was the same in both cases: Polaroid made new technologies, based on original research and invention, and if it took time, so be it. In accounts of the company's history, this outlook

is usually exemplified by the story of Howard Rogers, the lead scientist in the development of Polacolor. Just as the first instant sepia prints were being made in 1947–48, Land set Rogers the problem of how to make instant film in color, asking him to sit and watch the work of the sepia lab for as long as he needed before tackling the entirely different problem of color. Depending on the account, Rogers spent two years or several years simply observing in Land's lab before getting down to the business of actually trying to produce the first prototype film.[4] Polacolor was not perfected until 1963. It was this ethos of deep research that Booth alluded to in his statement, and which by implication had become too slow for a company that was trying to diversify in the face of a shrinking demand for instant film. But old habits died hard at Polaroid, and the research team for Captiva was obviously proud of its achievements with the new camera. When it was introduced at Photokina '92 in Cologne (as the Vision camera, its name in Europe) the press kit accompanying the launch was stuffed with documents detailing all the new patent-worthy features crammed into the device.

The Captiva was a single-lens reflex camera, and had the look of the compact 35mm SLRs popular in the late 1980s and early 1990s. A folding camera that expanded for picture-taking, it produced rectangular "wallet-size" prints, smaller than the iconic SX-70, at around 3 × 2 inches (see Figure 0.2). The same Polaroid Type 500 film was later used for the much cheaper Joycam. Shutter speeds, lens opening, and automatic fill-in flash were all controlled by a microcomputer designed especially for the camera. The Captiva's most striking design feature was its picture storage chamber, or "pouch," as it was described in some reviews.[5] All of Polaroid's consumer cameras since the SX-70 had noisily ejected the print from the camera into the open air, to be disposed of by the awaiting hand of photographer or photographed. But the Captiva kept the developing print inside the camera, sending it on a 180-degree journey through the machine's guts, leaving it snug in the pouch facing outwards from the bottom of the camera (or the back if the camera was closed). Up to ten prints could be stored in this fashion, or removed at any time. The engineering is elegant, the route taken by the print improbable, but to look now at promotional images of the Captiva, one would never suspect what went on inside it. This is because the side of the Captiva containing a

Figure 3.1: Promotional image, Polaroid Vision (Captiva) press kit, 1992.

developed print looks at first glance no different from any number of affordable consumer digital cameras with LCD displays.

The first preview screens in digital cameras date from 1995, three years after the Captiva's introduction, but they were not standard gear in amateur cameras until the following decade. In retrospect, the all-too-analog pouch of the Captiva has the look of an illustrative model, a cardboard mock-up to be discarded once the technology is

fully realized. An uncanny double of cameras to come, the Captiva contains in miniature the story of Polaroid's relation to the new digital technologies that displaced it: not an outright substitution of new for old, but an incomplete and yet oddly prescient anticipation in the old of the new.

This chapter is about the relationship between Polaroid and digital. On the one hand, Polaroid the company, faced with wide-scale technological change, and on the other, Polaroid photography as a distinctive way of making pictures. The first part of the chapter tells the story of Polaroid's response as a company to developments in digital imaging and its ultimately doomed hard-copy wager in the face of these developments; the second part considers the continuities and discontinuities between Polaroid and digital snapshot practices.

The Hard-Copy Wager

Did Polaroid sleepwalk into the digital era, fatally giving "the nod to the pod"? As I explained in the Introduction, the "pod," found in every Polaroid print, was a little pocket filled with chemical reagent, which burst open when passing through the camera's rollers to start the development of the picture. Some analysts felt that Polaroid was too attached to this key invention, even as chemically based photography was well into its decline.[6] There is some substance to this view, but the picture is more complicated. To begin with, Polaroid was more than alert to advances in what was then called "electronic imaging," and worked right through the 1980s under the assumption that consumer ESCs (Electronic Still Cameras) would one day come to market, and that they therefore needed to be actively exploring the area. As early as 1980, when the OneStep was the world's best-selling camera, and Polaroid was reaping the benefits of simplified SX-70 technology, the company applied for patents for an electronic camera. It was based on a CCD (charge-coupled device) that would become a standard feature in digital cameras, but was to use tape for data storage. For this electronic camera Polaroid foresaw "a large luminescent screen at the back [. . . .] about the size of the finished picture" where the user "can preview his picture [. . .] and decide to print it, reject it or store it";[7] in other words, a preview screen of the kind later modeled in the Captiva and eventually found in most digital cameras.

Right through the 1980s, Polaroid's annual reports featured announcements, or promises, of advances in electronic imaging. In the 1981 report President Bill McCune wrote, "We are devoting increasing effort and resources to this field," and in 1983 he referred to "our future electronic 'cameras.'"[8] In 1984 Polaroid commissioned a 63-page report entitled "Birth of the Electronic Image Processing Industry: The Road to Electronic Photography." In a section entitled "Reasons to Take ESP Products Seriously," the report stated in no uncertain terms that "the direction of amateur still photography is (electronic) image processing, TV display, optical disk storage and optional hard copy output."[9] By the late 1980s, when Polaroid had a foothold in the floppy diskette market and was producing a full range of digital scanners, but still no Electronic Still Camera, the annual reports had begun to use the language of "convergence" that was to become popular with new media theorists. The 1986 report observed that "electronic image recorders, computers and cameras that expose silver halide seem to be converging upon one another" and the 1989 report claimed that "as photochemistry, electronics and computing technology converge, the art and science of imaging are evolving with astonishing rapidity. Polaroid is in the forefront of this evolution."[10] The company had set up a special research unit devoted to electronic imaging in 1981, and by 1990, the "Electronic Imaging" division was one of four at Polaroid (the others were Business Imaging, Family Imaging, and Industrial Imaging). And yet, in spite of this head start and huge experience in the photographic industry, Polaroid did not produce its first consumer digital camera until 1996, by which time there were over forty competing firms already selling digital cameras.[11]

Why did Polaroid take so long to bring out a consumer digital camera, especially when it was promising to do so year on year? The most obvious answer is that they could not find a way to make digital photography as lucrative as conventional film, where the profit margin on each film cartridge was always very high. This "razors and blades" model was central to Kodak's sales strategy as well. Cameras (razors) tended to be sold heavily discounted because the aim was to push through repeat sales of film (blades).[12] This bottom line argument is compelling, but there were other factors at work. For instance, the Polaroid labs produced digital camera prototypes before 1996, but the evidence suggests that they were always dissatisfied with the reso-

lution of the images obtained. As I explained in the previous chapter, Polaroid traditionally prided itself on the high resolution of its silver halide films, but this view was not always shared by the wider photographic community, where Polaroid film was often reputed, unfairly or not, to have lower photographic values.[13] In other words, this was a sensitive issue at Polaroid, and as long as the resolution of digital images was inferior to chemically based films, it hesitated to bring its prototypes to market. Combine that hesitation with the residual model of perfectionist deep research so central to Polaroid's ethos, and you have a fine recipe for delay.

Strikingly, in 1991, when Polaroid released a new chemically based film for its top-of-the-range Spectra camera, touting its "heightened clarity and definition" and "reduced granularity," they chose to call it Spectra HD.[14] HD, for High Definition, was at this stage a term used mainly in anticipation of yet-to-be-realized digital imaging. As with the Captiva, the digital is imitated before it has arrived: its language is borrowed even if its procedures are not.

It is also possible that the development of an amateur digital camera was simply not the top priority for Polaroid. An overdependence on the fluctuating market in amateur cameras—novelty items with sharp peaks and troughs in sales—had led to a feast and famine pattern for Polaroid in the 1970s and early 1980s. Wall Street consistently criticized Polaroid for failing to diversify beyond this reliance on the amateur market, and under McCune's stewardship, the company had steadily expanded its presence in less volatile industrial and business markets. So, they did have a presence in the burgeoning digital field, but rather than in digital cameras, Polaroid had concentrated its energies on developing peripherals: high-end scanners, film recorders, and sophisticated medical imaging, such as the Helios X-Ray system. But even in the more stable environment of industrial imaging, Polaroid found itself on deeply unfamiliar terrain. Accustomed to holding a monopoly over instant photography, protected by a wall of patents, they held no such advantage in digital imaging. There were over forty competitors when they finally arrived on the digital camera scene in 1996, and the peripherals field was just as crowded.

Advanced Imaging's "Buyers Guide 1992," which lists manufacturers and suppliers of electronic imaging products, shows that Polaroid was only one of thirty making "Film Recording Devices," while there were

more than a hundred other makers of CCDs, and Polaroid did not even do color.[15] The independent commissioned report of 1984 had predicted, rather ominously for Polaroid, that smaller, flexible companies were much better placed than large bureaucratic ones to respond to opportunities in the digital market, a prediction subsequently borne out by the flowering of digital start-ups.[16] Not only that, but as *Forbes* reported in 1993, it was companies with strengths in computing (Sony, Canon, Toshiba, Hitachi) that made it into digital before conventional camera makers such as Minolta, Pentax, Olympus.[17] *Forbes* argued that Polaroid had "a long way to go" because it was lacking a major computing industry partner to help it with chip-fabrication technology.[18]

Polaroid executives knew what was coming, even if circumstances were not entirely in their favor. And they had a plan. The formal strategy for the coming technological changes was spelt out at the 1991 Annual Meeting, where Polaroid distributed, as part of its shareholders' package, a series of loose sheets devoted to "Desktop Presentation," "Photo-Document Integration," and the "Photographic Workstation." Each sheet featured a flow diagram predicting the future of image-making and processing. The Photo-Document Integration diagram depicts a Polaroid camera, a scanner, a computer, and a laser printer above text explaining that "image-dependent businesses" in the future will rely on "converting [...] images into digital data files that can be easily integrated with other computer data."[19]

By any measure it is a melancholy document. It accurately portrays the increasing convergence of media on the computer hard drive, but it assumes the continuing existence of intermediate steps on the journey of the photographic image from camera to computer. Unfortunately for Polaroid, those intermediate steps—the hard copy print and the scanner—were precisely the steps on which they had placed their wager. A similar scenario is found in the "Desktop Presentation" diagram, which promotes the Polaroid Digital Palette CI-5000, a "film recorder" that rapidly generates 35mm slides for business presentations. Again, the assumption is the continued use of hard copy (the slides) and dependence on complex peripherals, when within the decade PowerPoint allowed business presenters to dispense with both.

An earlier flow diagram, dating from 1985, makes this strategy even clearer. A series of colored boxes representing different types of image formats—computer graphics, 35mm film and slides, digital

Photo-Document Integration

Computer

Network

600 Business Edition Camera

Laser Printer

CS-500 Scanner

Data Storage

The Application

Many image-dependent businesses have a need to merge images with documents. For example, the insurance industry, relying heavily on images to document loss or damage, must also merge its photographs with written information or computer data.

These businesses would like to convert instant hard copy photographs into electronic images to reap all the benefits of full computerization – instant access to complete files, on-line data exchange and nationwide information sharing.

The solution is to continue the current practice of taking Polaroid instant images and then, using a fast, high-resolution scanner, converting the images into digital data files that can be easily integrated with other computer data.

These files can be stored locally or centrally, transmitted electronically to any location and printed in black-and-white or color, as needed.

The Process

Creating and using photo-document integration is a five-step process:

1. The subject is photographed with a Polaroid hand-held instant camera.

2. The photographer confirms the results, makes appropriate notations on the hard copy and attaches the images to the standard forms.

3. Off-line (perhaps at the end of the day) the images are detached from the forms, scanned into the computer using the high-speed, high-resolution Polaroid Digital Scanner CS-500, and then can be reattached to the forms for permanent storage of the original hard copy.

4. The images are merged with the text in the computer. Software automates the scanning process and indexes the digital data files.

5. In this application the digital files are incorporated into a compound electronic document and can be printed locally.

The Polaroid Advantage

The CS-500 scanner and software system offers speed, automation and image quality that makes the transition to electronic imaging both practical and cost-effective.

All the well-known advantages of Polaroid instant photography remain: a) easy-to-operate cameras; b) low-cost hardware and film; c) instantly confirmed results; d) full-color, high-quality original images, and e) on-the-spot attachment to documentation.

In addition, the insurance company experiences the new benefits of electronic imaging: faster transmission of information and multiple and immediate access to images.

The Polaroid Digital Scanner CS-500 is one of the fastest, highest-resolution desktop scanners available, ideally suited for scanning Polaroid instant images or other reflective prints up to 4 x 6-inches in size. Developed in Polaroid's electronics laboratories, the system's proprietary linear array permits 24-bit scanning, at 500 dpi, in 10 seconds; 250 dpi in 5 seconds.

Polaroid

Figure 3.2: Photo-document integration memo, 1991.

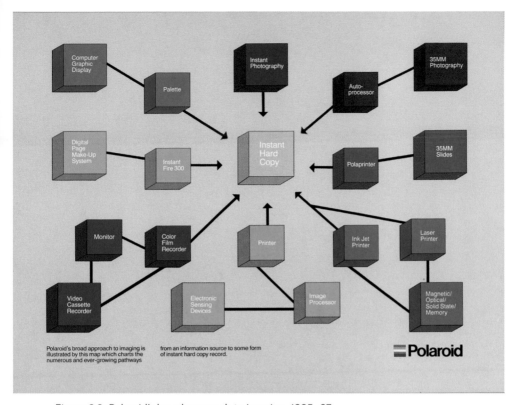

Figure 3.3: Polaroid's broad approach to imaging, 1985–87.

"page make-up," videotape, electronic sensing devices—all converge on a single gray box containing the words "Instant Hard Copy."[20] Camera-maker Konica also had one for their "Digital Still Video Image System" in 1991. But on Konica's flow chart, there was no hard copy to be found, just a memory card linked to a digital image processor.[21]

That the hard copy would endure was almost an article of faith at Polaroid in the late 1980s and early 1990s. Interviewed in *Electronic Photography News* in 1990, Conrad Biber of the Engineering and R&D division insisted, "We are convinced that you will still need hardcopy prints. So I think our basic strategy relies on the fact that people do require prints in the end, and they are not happy just looking at a television screen with a still image and then flip to the next one."[22] Also in 1990, Sheldon Buckler of Industrial Imaging told *Boston Business* of "the almost insatiable desire of people to have a hard-copy record of images they use."[23] Upping the ante even further, Peter Kliem, VP

for Electronic Imaging, invoked that same year in his address to the annual stockholders' meeting a "basic human need" for hard copies of images.[24] The hymn sheet from which they were all singing had been set out in the previous five years. A document from 1987 entitled "Polaroid and electronic imaging: Questions and Answers" sums up the basic stance:

> We agree with those who say that images viewed on screens will be the fastest growing segment of the total imaging market. But we are convinced that the need to have permanent, accessible, shareable images—and to have them instantly—is fundamental and will persist.[25]

For millions of Facebook users who may never have so much as touched a Polaroid camera, but who instantly share accessible images, the need identified here is immediately recognizable; its mode of satisfaction is not.

The difficulty for Polaroid was the same that is faced by writers of mission statements the world over: identifying some kernel of distinctiveness in a field of great homogeneity. In his statement to shareholders, Kliem argued that the "hard copy emphasis will differentiate us from our major electronic competitors,"[26] a view echoed around the same time by Chairman Mac Booth, who claimed that the "unique hard copy strategy for growth differentiates Polaroid from other imaging companies."[27] In a crowded market with many competitors, Polaroid would stand out by specializing in hybrid systems that brought together analog and electronic imaging methods.[28] This meant scanners that converted hard copy to digital code, and film recorders that made hard copy from computer graphics, but it also helps to explain the development at this time of such false hybrids as Spectra HD film and the Captiva. Still lacking the capacity to produce a consumer digital camera, but well aware of their imminent arrival, Polaroid took to aping the language and forms of the digital even while remaining firmly analog. With its "preview screen," and prints sized at a 4:3 ratio to match the (then) proportions of computer screens,[29] the Captiva was meant to be some sort of crossover, a promise of hybrids to come, even if it was not really one itself.

Polaroid after Digital

For Polaroid to cling to the hard copy as its element of distinctiveness may, in retrospect, look like plain bad forecasting, but it was understandable that they took this tack. After all, Polaroid had, for decades, been *highly* distinctive, as the only company in the instant photography business. Even if Kodak made inroads in the 1970s, they were battered back to Rochester by Polaroid's patents, and Polaroid enjoyed a level of brand recognition that most firms could only dream of. From 1972 onwards, this distinctiveness surely owed a great deal to the highly recognizable Polaroid print, with its white border, wider at the bottom. As I argued in the previous chapter, the Polaroid *image* may not be radically different, but the print, an image-object, could not be easily confused with any other form of photography, not least because it was unique, a hard copy positive without any negative. The Polaroid image is stubbornly attached to its material support in a way that even conventional negative-based photography never was. It is easy to scan an SX-70 print into a computer, but this is only ever a partially complete operation. When these pictures are scanned in, the built-in white frame, with its wider bottom edge, is invariably included in order to identify the Polaroid image as such.[30] This frame, however, is not strictly speaking part of the image, but rather part of the object. In fact, as Peter Schjeldahl puts it, the SX-70 print is "an image that is also a *thing*," "both sculptural and pictural," and any convergence with computers will always leave an untransmittable remainder, because, counter to the plural logic of technical reproducibility, the Polaroid is always only singular.[31]

But the situation is by no means straightforward. While fewer and fewer Polaroid prints were made as the technology slowly disappeared, the distinctive white borders began to experience a striking digital after-life. You might not have been able to find any film in 2009, but you could get t-shirts emblazoned with oversized and stylized Polaroid images, or tote bags decorated with an SX-70 camera, print jutting out the front. There were Polaroid-shaped postcards, Polaroid notepads, and picture frames you could slip a photo into to make it look like a Polaroid. DOIY Design released the Pola Roll, an imitation One-Step camera delivering sheets of toilet paper instead of instant

photos. The police may have long stopped using them for forensic purposes, but in crime movies and cop shows the tradition lived on.[32] My local community newsletter uses simulated Polaroids for picture stories, as does the alumni magazine of my alma mater, with both of them beaten to this idea by the *New York Times*. It is common enough for researchers to see their subject everywhere, but suddenly mine was looking back at me even from cartons of cranberry juice and boxes of teabags.

PGTips and Oceanspray were joined by among others Peugeot, the Co-operative Bank, the Manchester Tourist Board, Virgin Megastore, ScreenwritersStore.com, and Passoa Brazil cocktail mix in using the familiar white-bordered print for advertising purposes. National Rail in the UK did a series of Polaroids of a garden gnome pictured on day trips around the country. Clearly none of these companies used actual Polaroid technology to produce the images for their campaigns, but instead enhanced images after the fact with the iconic white borders in the simplest of Photoshop operations. The borders are then usually written on (digitally), just as popular practice dictated that the original prints would be captioned at the bottom. Just to drive home that the images of screenwriters in the ad for ScreenwritersStore.com are Polaroids, the simulated prints are stuck to the background of the ad with digitally simulated cellotape.

The capacity to make digital Polaroids also got into the hands of the general public. There is "Poladroid" software that lets photographers create and print-off "Polaroid-style" pictures from digital images. And there are of course many applications for camera phones that allow users to take simulated Polaroid pictures on their phones, or for that matter images mimicking the supposed "look" of other obsolete analog photographic film types such as Kodachrome. The makers of the ShakeIt Photo app for the iPhone promised the following for 99 cents:

> ShakeIt Photo is the most realistic instant photo experience for the iPhone. Works just like a real instant camera. Watch the photo develop. Shake your iPhone to make it develop faster. Our Perfect Processing makes your photos look just like the real thing.[33]

As a faithful recreation of the Polaroid print, the first generation of the ShakeIt app fell short of the mark. The white border around the

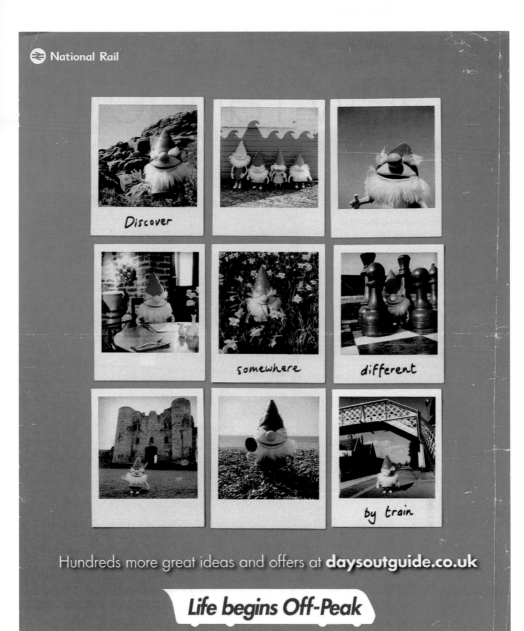

Figure 3.4: National Rail advertisement, 2009.

image was of uniform width rather than thicker at the bottom as it should be, although the programmers at the Banana Camera Company later fixed this. In addition, in the original film, shaking the image had no impact at all on the speed of development. This is not to criticize the app—its point is obviously not genuine authenticity (it is a simulation, after all), but an authenticity-effect, and in such circumstances it is essential to print the legend.

By reproducing common conceptions about the process, the ShakeIt app gives us clues to the popular idea of Polaroid in the digital age. In their choice of name, the app's designers were riding on the back of the Outkast hit song of 2003, "Hey Ya!," which urged listeners to "Shake it, shake it, shake it . . . like a Polaroid picture," and brought that ritual back into popular consciousness. Two other features of ShakeIt Photo tell us that it is just like a Polaroid image. One is the characteristic delay of instant photography: the image does not appear more or less immediately, as in digital photography, but emerges gradually from an inchoate gray mist. This gray starting-point, along with a faded color palette and a general murkiness, would seem to be the other key element in the recreation of the Polaroid image.[34] Reimagined for the iPhone, then, a Polaroid picture requires a ritualized action and displays idiosyncratic image qualities, and quirky imperfections (but in this case not saturated colors).

What motivates this widespread simulation of instant snapshot photography in advertising and apps by the very technology that supposedly did away with it? Was Sheldon Buckler of Polaroid's Industrial Imaging Division right all along? Is there "an insatiable desire of people to have a hard-copy record of images they use," just that it hardly matters to those people if the hard copy is simulated or not? Or is it simply a case of nostalgia that will soon pass? Media theorist Susan Murray speculates that when Polaroids are scanned and posted on Flickr, they are valued for their "low end look" as a sort of reaction against the "move towards clarity, improvement or perfection in the image" offered by digital imaging technologies.[35] Christopher Bonanos agrees, suggesting that analog fans are "craving something unpredictable."[36] Certainly, with its slightly murky image and loss of detail in shadings of faces, the ShakeIt app would appear to confirm this hypothesis. We could take this a step further and say that Polaroid prints are a useful shorthand for the photograph, any photograph, as

a physical object. In both advertising and apps, we are clearly meant to understand that these are actual prints—photos as objects—that we are looking at, and the Polaroid print, with its white border, leaves us in no doubt about this.

In the National Rail ad promoting days out, there are nine "Polaroid" images of a red-hatted gnome in different locations—at the seaside, in the mountains, in front of a castle. These days such photos would most likely be captured on a camera phone and circulated through social media, and yet the advertisers chose an antiquated photo-format rather than showing the images, for example, in a series of phones. The ads are composed entirely on the basis of digital imaging technology, and yet they want us to see their images as if they were singular material objects and not just bits of code. The photographic, especially the vernacular snapshot format alluded to by these ads, is being gradually dematerialized with digital technology, but the digitally produced Polaroid border—a marker of nonconvergence—suggests a lingering regret for the passing of the photo as material object. The simulated white border could, therefore, be read as a kind of compensation for the absence of the photo as tangible and tactile. The very embodied shaking of the iPhone to materialize an image also suggests a lost pleasure in the rituals of the photo as a physical object.[37]

But there is another way to look at this return of the analog in digital: as a form of triumph, rather than regret or nostalgia. What do ShakeIt and other filter programs such as Hipstamatic do if not place a layer of film over the digital image? I mean film in the sense of light-sensitive chemical emulsion, but also film as a membrane. This membrane may be digitally generated, it may be the thinnest imaginable, but just like the artificial delay of the ShakeIt image, it adds a layer to the process of photo-making. Rather than expressing a fondness or mourning for lost forms, these applications confidently reassure us that *normally*, there is no such intervention, no mediation or membrane between the digital image and what it pictures. The retro photo-apps tell us, in other words: even if we regret it, we have surpassed the imperfections of earlier photography, and here is a reminder of how far we have come.[38]

It is this sort of logic that is at work in *Le Fabuleux Destin d'Amélie Poulain* (2001), Jean-Pierre Jeunet's hymn to a timeless and quirky Paris, and the immediate reference point for the traveling gnome in

the National Rail ad. In *Amélie* Jeunet uses all the tricks of new media technologies in order to construct a world which apparently pre-dates those technologies. In this digitally manufactured environment we find such outmoded media objects or sites as an ancient cathode-ray tube television, photo-maton booths, old-fashioned video sex shops, and, of course, Polaroid prints. In an effort to reengage her father with life, the protagonist Amélie arranges for his cherished garden gnome to be kidnapped. An air stewardess friend then takes the gnome on her voyages, photographing him with a Polaroid camera in front of world monuments, the resulting prints being sent like kidnap notes to the distressed father. He eventually recovers the gnome, and is inspired by the trauma to depart on travels of his own. The miniaturization and mass reproduction as replicas or on postcards of iconic architectural sites is often taken as the classic instance of kitsch. When the Sphinx or the Statue of Liberty are juxtaposed in *Amélie* with that purest exemplar of kitsch imaginable—the garden gnome—Polaroid's paradoxical fate has been most economically summed up.

Thus the trick of the film is to distract us from what is really being idealized—modern digital filmmaking technologies—by the sentimental remembrance of now obsolete forms. In this way we can regard with complacent condescension the derelict technological idols that block our view of our contemporary ones. And yet, the insistent return of that white-bordered image seems to tell another story, one in which Polaroid lives on, and not just on t-shirts and teabags.

Polaroid into Digital

When Polaroid stopped manufacturing its white-bordered integral film in 2008, the commemoration of the technology that followed tended to emphasize its very material difference from the new technologies which displaced it. Michael Kimmelman in the *New York Times* called Polaroid prints "glossy talismans," noting that they were much harder to delete than a digital image.[39] In the *Observer*, Sean O'Hagan invoked its "one-off quality," arguing "it is hard to imagine a digital camera capturing this sort of raw immediacy"[40]; and Michael Bywater in the *Independent* called it "a physical artefact" with "an inherent texture," a texture supposedly lacking in digital photography.[41] The healthy appetite for post-Polaroid simulations suggests that there is

something to this view, and it helps to explain why Polaroid was so reluctant to give up on its investment in hard copies, even if a wide sentimental attachment to them was not enough to save instant (chemical) photography from obsolescence.

In addition to expressing a general dissatisfaction with digital photography, the tributes paid in the press to Polaroid between 2008 and 2010 were often written as obituaries. With titles such as "The End of Polaroid?," "Elegy for the Polaroid," and "Goodbye Polaroid,"[42] these articles announced "the end of an era," or that "today is the day that Polaroid died"; they wrote of a "dead technology" and of a Mapplethorpe exhibition as "a memorial to the medium."[43] Even if one of them wondered whether "it's rather foolish to mourn the passing of a technology," the basic assumption was still that technologies die and that Polaroid had just done so.[44]

To memorialize a technology like this is implicitly innovation-centric. This outlook, according to David Edgerton, dominates histories of technology, and is marked above all by an emphasis on novelty and invention, that is, it makes the supposed point of arrival or impact of a technology—its newness—the main measure of its cultural importance.[45] What this overlooks is the question of what Edgerton calls "technology-in-use," which often means not new technologies at all, but old ones, which have a tendency to linger and overlap with new ones rather more than is generally assumed.[46] We would have a fuller picture of technology in culture, he maintains, if we paid more attention to mundane things like routine maintenance of old tech rather than the latest invention.[47] Edgerton does not comment specifically on the commemoration of disappearing technologies, but given that obsolescence is in many ways the flip-side of novelty, he might note that to memorialize a technology such as Polaroid is to draw a false line, to put a convenient date-stamp, where the temporality is far more muddled.

As many of the newspaper articles were quick to point out, no sooner had Polaroid stopped manufacturing its famous film, than the joint Austrian-Dutch venture, the Impossible Project, stepped in to take over one of its factories and attempted to revive it. And at the time of writing, Fuji continues to make chemically based instant cameras in its Instax series, with a range of print sizes. The smallest of those Fuji cameras, the Instax Mini, was even repackaged in late 2010 as the

Polaroid 300 Instant Classic, so even Polaroid remained nominally in the conventional instant film business, obituaries notwithstanding.

The point is not just that Polaroid's end has not yet quite arrived, or that it lingers on in a diminished half-life under Fuji's name. As media historian William Boddy has argued, digital imaging did not spring into existence fully formed, but developed by accommodating itself to already existing practices and cultures.[48] The importance of technological media lies not only in its arrival on the scene or departure from it, but also in the uses that embody it. Taken from this perspective, it is possible to see lines of continuity between technologies, rather than radical breaks. In other words, Polaroid's business strategies may have failed, and its film-making factories closed, but the uses associated with its products do not simply disappear; they are instead modified and re-embodied in later technologies. It is not a question of when digital did in Polaroid, but of what remains in digital of Polaroid.

As the memorializing newspaper articles demonstrate, Polaroid's displacement by digital photography was noted by many; and was noted long before Polaroid shut its factories. In fact, the observation was usually not limited to Polaroid, but applied to all chemically based photographic technologies. The exact details vary, but it would be difficult to find someone who did not agree in principle with Graham Clarke's observation that

> Despite the difference between a daguerreotype and a polaroid print, the photograph has always been based on a chemical process. Images are now being generated on the basis of electronic processes which fundamentally change the terms by which we relate to the photograph, retrieve, experience, and read it.[49]

Perhaps in 1997 it was too early to tell, but Clarke did not go on to elaborate *how* exactly things had changed, how "the terms by which we relate to the photograph, retrieve, experience, and read it" had been modified by digitalization.

From the early 1990s a number of media analysts attempted to answer this question. The debate was animated, but restricted by a fixation on what we might call the Photoshop factor. Discussion of digital photography, especially at its height in the mid- to late 1990s, tended to focus disproportionately on a single issue: the manipulation

of images. What was to become of the evidentiary status of photographs when their truth content was open to digital tampering? How could photo-journalism ever be trusted again if images captured on the scene could be altered after the fact? Would photography even survive into the twenty-first century if its function as an accurate recording surface was so thoroughly undermined? These were some of the questions that agitated cultural critics in the feverish early days when many digital possibilities were predicted, but not many of them had yet been realized.[50]

For some, advances in digital image-making, far from being unsettling, were a welcome development, an opportunity to break with reality once and for all. One of the key celebrants, William J. Mitchell, trumpeted the arrival of the "post-photographic era," when the distinction between the imaginary and the real would dissolve, and photographs could no longer be held up for their truth status.[51] Mitchell distanced himself from the notion that photographs ever were in fact "truthful reports about things in the real world," but this did not prevent him from being chastised on all sides for the supposed naivety with which he welcomed the digital revolution. For a while it was almost obligatory to take him to task in subsequent commentary on digital photography, such was the preoccupation in the mid-1990s with the issue of manipulation, or the supposed impact of Adobe Photoshop software, first launched in 1990, on the "truth" of the image.[52]

As a result, a good deal of energy was expended on pointing out that chemically based photos had always been manipulated, so there was nothing particularly new about digital touching-up.[53] Equally necessary reminders were given that photographic images, just like digital images, are far from unmediated in their relation to the world; that they are coded and therefore read, that they are selected and framed and given meaning by context and caption, that an uncritical positivism lies behind the notion that photos are evidence, and that in any case realism is an elaborate ideological construct and not a transparent window onto reality.[54]

The discussion rumbled on into the next decade, with film historian Tom Gunning offering one of the most convincing arguments that the shift from chemical to digital had not radically transformed the basic status of the photographic image. He accepts that visual information is now captured, stored, and reproduced differently: pho-

tographic film produces its images through the action of light on a chemical emulsion, while in the digital photograph light is turned into data, processed as a complex sequence of numbers.[55] What remains in the photographic, irrespective of mode of capture, is the fact that the photo is relatively undiscriminating in what it registers, and that there is consequently a profusion of visual detail to be found in it, detail the image-maker was often not aware of in the first place.[56] Gunning concludes that "Like [. . .] earlier transformations in photographic history, the digital revolution will change how photographs are made, who makes them, and how they are used—but they will still be photographs."[57]

There are two main reasons for the caution and skepticism with which so many academic commentators approach digital photography: a perceived need to act as a balance to the speculative flights of fancy of the popular press and specialist digital hype-merchants; and a pulling back from early enthusiasms on the utopian possibilities of new technologies, before the dot-com bust and before the dreary realities of white-collar e-mail serfdom became clear. Indeed, it became hard after the bust to find an academic article or book on digital culture that did not distance itself from new media hype. One of the best contributors to this genre, Jeffrey Sconce, reflects wryly on the failures of digital culture to fulfill its early promises and notes "a disconnect between the increasingly banal applications of digital media in the 'real world' and the favored objects of digital study in the academy."[58] But if, as Sconce says, the real world applications of digital technology are banal, surely it is to the banal that we should be directing our attention. The heady possibilities that we might one day be strapped into magic goggles transporting us to wondrous new virtual worlds may have receded (Google Glass notwithstanding), but digital imaging has flourished beyond all anticipation in that most everyday of activities: snapshot photography.

What could be more banal than the ubiquitous digital snapshot cameras wielded at every birthday party and in front of every tourist attraction; what more commonplace than the presence of camera phones at every celebrity sighting or public event? And what more prevalent than the near-instantaneous recirculation of these images through social networking and photo-sharing sites and applications? As Gunning suggests, it may be not the basic ontological status of

photography that is changed by digital, but "how photographs are made, who makes them, and how they are used." As we know from Polaroid Corporation's gradual two-decade capitulation to the advance of digital technologies, these technologies were for a long time theoretical before they became practical. When debates in the mid-1990s raged about the manipulation of digital images and the profound effect this would have on their truth-status, digital technologies still had the veneer of the extraordinary. Now that the mundane and everyday applications of digital photography have become more settled in the form of camera phones, photo-sharing, and social-networking, attention can turn to what people *do* with digital images.

Scholars are beginning to ask what new habits emerge on photo-sharing sites such as Flickr and thisMoment[59]; they are analyzing the impact of camera phones on "personal photographic practices"[60]; giving sociological accounts of "sexting" among American teens,[61] and attempting to understand how domestic photography is being integrated into networked computing habits.[62] In most of this commentary, it is not the possibility of the *manipulation* of the image which is at stake. Instead, what matter more are the speed with which the image appears after it has been taken, the fact that its taker no longer makes use of a professional photo-finisher, the new possibilities for the circulation and distribution of those images, and the virtually unlimited number of images that can be made at no extra cost. These *are* relatively new developments in relation to conventional snapshot photography, but in the case of first two, not in relation to Polaroid image-making. And this is why, even as they identify what is new in digital snapshot photography, these commentators are obliged to add footnotes or asides about the original instant photography.

So, Richard Chalfen argues that one of the key new features of the camera phone is the elimination of the need to go to the corner drugstore, but then concedes that this already was the case with Polaroid.[63] Digital photographs give "a sense of [. . .] immediacy to the photographic image that was never there before," writes Susan Murray, who then provides a footnote that says, "Of course, the Polaroid provides immediate access to photographs."[64] Daniel Palmer comments on how photo-sharing sites allow their users to annotate images with text, and then adds, "Of course, Polaroid cameras also reserved a space for a user to write onto the print" (the space was actually there to house

the "pod," even if users quickly realized it was a convenient space for captions).[65] Just as the wider culture seems reluctant to let go the Polaroid image, so it is a nagging memory for those addressing what is new in digital practices. In each case, the apparent novelty of the digital snapshot is compromised by a sixty-year-old technology that got there first, or at least got partly there.

Part Convergence: Polaroid with Digital

In concentrating on the question of manipulation and the supposed changing "truth-effect" of digital images, early commentators focused disproportionately on the finished image. Yet, as far as Polaroid and digital snapshot culture are concerned, the resultant image should not be considered separately from the practice of its making, from the act of photographing. At this level Polaroid and digital share two crucial features: the speed with which the image appears, and the elimination of the darkroom. Compare the experience of the Polaroid or digital snapshooter, who can "shoot and show," as Andy Warhol put it, to the original mass amateur photography of Kodak, where the photographer needed to take 100 exposures before returning the camera and film for processing, or to the photographer who might take months to finish a roll of 24 or 36 pictures before taking it to a commercial developer.[66] As early Polaroid ads enjoined possible users: "Take and show party pictures while the fun's going on"; "see results at once [. . . .] with no intervening delay for processing."[67] Amateur Polaroid and digital image-making could not be further apart in their technologies of production and dissemination, but the speed with which the image appears and the way in which it "develops" on the spot mean that their users share a relation to the photographic image fundamentally different from other forms of snapshot photography.

In what ways do speed and the elimination of the darkroom change our snapshot practices? One way of telling is by measuring Polaroid and digital against Don Slater's classic model of pre-digital snapshot practice. In his analysis of the ways in which snapshot culture contributes to domestic ideology and leisure activities, Slater identifies an odd discrepancy. He notes the importance of the family photo-album as a device for regulating identity and ordering memory, citing a survey that found that "39 per cent of respondents rated their family

photos as the possessions they treasure most and would least like to lose."[68] However, he goes on to observe that

> this hypervaluation of the family album sits oddly with our actual use of photographs: the same piece of research indicated that 60 per cent of respondents and their families looked at their family snaps only once a year [. . . .] Moreover, it is unclear how many people actually organise their photos into anything approximating a family album: most of them remain in the same envelopes in which the processing company returned them. Thus the family album [. . .] is hypervalued yet plays little part in everyday life. *Taking* pictures is a taken for granted part of leisure activities; but *looking* at them is marginal.[69]

It may be obligatory to pull out the camera at Thanksgiving, weddings, or birthdays, and those family snaps may be deeply cherished, but chances are that they rarely get contemplated in any formal way. In Slater's data, of course, this apparent apathy accounts for only 60% of respondents, which leaves another 40% unaccounted for. Writers such as Richard Chalfen, Jo Spence, Geoffrey Batchen, and Martha Langford have all tried to account for the photographic habits of that missing 40%, showing how family histories are meticulously narrated through the careful construction of albums following well-established conventions.[70] The basic assumption of these studies is that the album is part of the work of memory, that a family photograph primarily has a retrospective value. So, whether we follow Slater or those who insist on the importance of the family album, a photograph is either something to be reflected upon long after its making, or not at all.

As part of their push to bring the new generation of camera phones to the UK market, in 2005 Sony Ericsson screened a television advertisement that suggested a mode of snapshooting rather different from the one outlined by Slater or the analysts of family albums. Under the tag-line "take your best shot—with a phone!," the new Sony K750i was promoted by an improbably handsome young couple strolling along the side of a lake. He is on his phone, ignoring her, when she spots something and snatches the phone out of his hand. It is a water lily and a dragonfly. She gets a picture of them with the phone, shows him. He's unimpressed, quickly snapping the next manifestation of

nature, a fish leaping to eat the dragonfly. He shows her the result, triumphant, she now downcast. Next a roaring grizzly materializes to devour the fish; he holds the camera paralyzed, she pushes down on the button. Thus reconciled in their snapshooting partnership, with beatific looks they admire the resulting image of spontaneous nature, whilst an eagle comes down to lift the bear away. Here there is virtually no gap between "taking" and "using" the snapshot image, if we invoke Slater's distinction. Rather than a delayed or indefinitely postponed activity, the looking at the image has become coterminous with its taking.

Writing before the explosion in affordable digital cameras and camera phones, Slater argued that taking photographs was a highly structured activity, whereas looking at them, or using them, was not.[71] As the Sony Ericsson pair demonstrate, something different seems to be happening with digital photography. Now taking and showing are near-simultaneous, and the production and consumption of the image are collapsed into a single action.

To put it another way, Sony Ericsson have discovered Polaroid photography. For Sony Ericsson's outdoor adventures, substitute Polaroid's 1940s slogan "It's like taking your darkroom on location." For the back and forth contest between the young couple, read Polaroid's promise that "no other camera would give me a second chance like this."[72] And for their shared gaze at the freshly born image, see the cover of the 1954 Polaroid Annual Report, depicting an admiring group huddled around the recently developed image that has been peeled away from the spent negative. There they are, absorbed, like incipient digital camera users, in the immediacy of the image-making experience. They are simultaneously subjects and viewers of the photograph, a tableau mirrored in the image they are consuming. This sort of image of image-consumers became a genre in and of itself in all Polaroid picture-making.

Curator Nat Trotman notes that most photographic theories presume a split between the act of making a picture and the act of observing it, but that

> over the course of a minute, a photograph does not concern remembering or forgetting [. . . .] The party Polaroid is not so much an evocation of a past event as an instant fossilization of the present.[73]

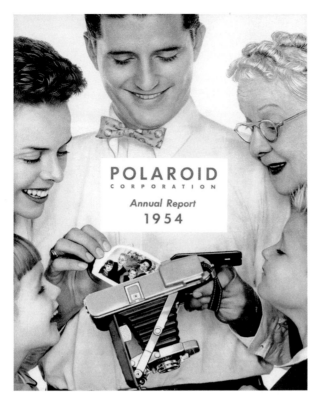

Figure 3.5: *Polaroid Annual Report*, 1954.

Figure 3.6: Polaroid squared, 1980s, 2002.

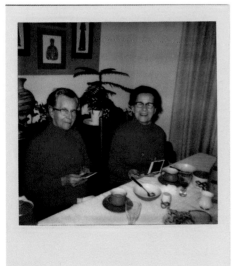

He could just as easily be writing about the pictures people take with their cellphone cameras, and indeed analysts of digital snapshot practice have noted a similar abolition of the distance between taking and observing in their object of study. Susan Murray claims that "photography has become less about the special or rarefied moments of domestic family living [. . .] and more about an immediate, rather fleeting display of one's discovery of the small and mundane."[74] In the same vein, Daniel Palmer argues that the "instantaneous feedback and sharing of everyday experience is quite clearly at odds with the traditional function of personal photography, around preserving memories of meaningful events."[75]

There is no reason why the image generated on the spot without a darkroom should not in the long run act to preserve memories, but before that happens, the instant image—Polaroid and digital alike—can do other kinds of work. Most notably, when taking photos is collapsed into using them, opportunities are opened up for feedback, obscenity, and exchange.

Feedback

As photo-historians Daniel Rubinstein and Katrina Sluis point out, amateur digital cameras give their users the "ability to take a picture, look at the screen, readjust the composition and correct the camera settings until the image is perfect," with an attendant acceleration of the learning process.[76] For Rubinstein and Sluis, one of the consequences of the opportunity to shoot, check, and re-shoot is a loosening of the grip of the professional expert on photographic competence, or at least a blurring of the line between untutored amateur and highly trained expert. Early advocates of Polaroid photography also identified the learning potential of a camera that allowed instant access to images; drawing on the language of cybernetics of the 1950s, they called it feedback.

Ansel Adams was one of the main proponents of this quality of the cameras, but his colleague Minor White also explored it, wary though he was of the threat to the "thoughtful side" of photography posed by what he called "the immediate image."[77] In a project he carried out for Polaroid at Rochester Institute of Technology, White experimented with students in a portraiture class and concluded, "With the feed

back technique and pictures on the spot, the photographer uses the pictures themselves to mold and shape, carve and chisel, and otherwise organically develop an idea from a rough sketch into a final product."[78] This is a more elaborate way of restating the Polaroid advertising slogan that the camera gave every photographer "a second chance."

With digital photography, the photographer does not have to wait to complete a whole roll of film before he or she discovers a mistake or an interesting effect, but this potential for shooting, seeing, and shooting again was already present in Polaroid image-making. There were also consequences for commercial photography, since the immediacy of the Polaroid image made it popular for testing lighting and exposure on professional shoots. Photographers would generally not use a Polaroid camera for these purposes, but instead attach a specially adapted "Polaroid back" or film holder to their own camera. After getting a quick sense of the conditions with the Polaroid film, they would then switch to traditional film that they would develop later in the darkroom. If the subject was human, the Polaroid image was feedback for them also, and a way of bringing them into a photo-shoot as active participants. If the shoot was on large format Polaroid film for final art, the feedback effect could be even more powerful, as photographer Joel Meyerowitz discovered when improvising with 8 × 10 film in a Manhattan nightclub in 1983. Hanging each instant portrait on the wall of his makeshift studio, Meyerowitz built a crowd of curious onlookers, and willing posers, who shouted approval or applauded as each new image appeared.[79] The associations of Polaroid photography with fashion photography remain strong: they feature regularly, for instance, in television's *Ugly Betty*.

Obscenity

There is nothing new about vernacular erotic photography—it was a major genre of that figure of satire, the "serious amateur," with his darkroom in the basement. Polaroid photography, by eliminating the darkroom, simply opened up the practice to a much wider range of casual amateurs. Freedom from the monitory gaze of the photo-chemist means what might have been taboo now becomes picturable. Peggy Sealfon, author of a popular manual of instant photography, euphemistically sums up:

No longer did picture-takers have to wait a week for local drugstore processing, and no longer did they have to be concerned about the film's contents passing under the scrutiny of the druggist's eye. Instant pictures of lovers and spouses became quite common.[80]

This practice has already been addressed in the previous chapter in relation to Polaroid "intimacy," and is put more bluntly by Sean O'Hagan, who notes the name of the Swinger of 1965, and adds, "with the advent of the now familiar SX-70 camera, the Polaroid became the film of choice for actual swingers whose X-rated bedroom snapshots did not have to be sent off to be developed."[81]

Richard Chalfen has begun to explore the parallels with popular digital snapshooting, where the easy transmission of images means that private photographic practices more frequently spill into public. It is, however, a different sort of obscenity that has captured the most attention: the photographing of abuse, torture, and acts of violence. Such photography comes to light when it circulates through mass media, but is surely enabled in the first place by a technology that allows it to be produced privately without passing through the semipublic realm of the professional photo-finisher. It is not just that the technology allows the event to be safely recorded, but that the event has been staged and might not have taken place without the presence of the camera. Commenting balefully on the proliferation of such images, the Retort collective observes "it has to be recorded, since experience without instant doubling is no experience at all. 'Here's me third from the left at Thanksgiving in Abu Dhabi; and here's me on top of a pigpile of Terrorists.'"[82] Retort implies that in the relentless drive to instantaneity the digital camera user hardly distinguishes between Thanksgiving and a pigpile, but surely one difference is that the image of a pigpile would never have been sent to the local drugstore photo-lab by the amateur snapshooter.[83]

Exchange

Don Slater claims that in conventional snapshot practice, taking photos was generally divorced from looking at them, with images often remaining in the envelopes of the developing company. There are notable exceptions, such as the narration of the family album or the for-

malized slide show, but even then, there is a time gap between taking and showing. When that gap is closed, opportunities open up for the instantaneous exchange of images. Dragonflies, grizzlies, and eagles may not be the most common subjects of such exchanges, but the ad for the Sony K750i anticipated well the "shoot and show" habits of camera phone users. A British reviewer in 1976 noted very similar possibilities for the SX-70:

> Polaroid Land photography generally is a much more communal pursuit, since the photographer does not need to leave the scene with a promise to send the pictures on later. With the SX-70, that moment of revelation when the picture begins to appear, and which has made so many of us into photographers for life the first time we saw it, is no longer limited to the darkroom and may be shared with any who care to gather round and watch.[84]

Not only does the Polaroid camera allow for the immediate sharing of images, it can even demand it. Many Polaroid photographers have remarked on the difficulty of keeping their prints once they have emerged from the camera, such is their status as ready-made gifts. The potential for exchange residing in the Polaroid was also instrumental in making it a favorite at parties; to put it in contemporary vocabulary, it was the first social networking camera. So important, in fact, were the Polaroid's functions as a party camera, that the next chapter is dedicated to exploring the history and implications of this practice.

As for the death of Polaroid at the hands of digital, I hope it has become clear that it is not simply a case of one technology being displaced by another. It would be foolish to argue that Polaroid and digital are identical: their main differences—their mode of circulation and dissemination, and their relative costs—are enormous differences indeed. The digital image's basis in binary code has led to a whole array of new practices at the level of the dissemination and circulation of photographic images *after* their making. In addition, not even the wealthiest of Polaroid photographers would be as profligate in image-making and image-deleting as the average digital snapshooter, who rarely stops to calculate the cost of film and developing, even if those costs are real and often considerable.[85] But while there are clearly historical and technical discontinuities between the SX-70 and the cam-

era phone, it is also the case that the ways of using the latter took shape in a cultural field in which there were already existing social practices based around the former. And while digital cameras, particularly in phones, have massively increased the recruitment levels of casual snapshot takers, this process had already been accelerated by Polaroid.

4 **Polaroid Attractions**

Polaroid, the party camera. For most, the phrase conjures memories of one version or other of the SX-70 camera being passed from hand to hand at social gatherings, a communally owned piece of 1970s and '80s magic. For me it was embodied in a close acquaintance, a Polaroid enthusiast, who carried his I-Zone with him everywhere, using this little gadget, a late and last success of Polaroid Corporation, as a kind of social lubricant, a way of meeting people, a playful party accessory, complete with festively colored film tabs (see Figure 1.4). Fearlessly he would thrust it in the face of someone he barely knew, risking irritation or rebuke, a risk that usually dissolved after he had tugged the developing film from the camera and with a flourish deposited it in the hand of his new friend. Here, if anywhere, was the key to the attraction and appeal of Polaroid photography: there could be no understanding Polaroid without understanding the intrusions of this insistent photographer. But the logic of Polaroid as party camera reaches far beyond its use at parties. It takes in the peculiarly American phenomenon of "ice-breaking" and includes the Polaroid as instant gift. It extends to Polaroid cameras as products ideal for public demonstration, and also stretches to the Polaroid showmanship of figures as different as Edwin Land, the camera's inventor, and Ted Serios, psychic photographer.

A Photo Is an Object, but Also an Action

A photograph is not just an image, but also a tangible, touchable thing. In the words of art historian Margaret Olin, photographs "can be, and even demand to be handled."[1] Olin's view is shared with a

Figure 4.1: Birthday party Polaroid, 1970s.

growing group of "photo-materialists," who study what they call photo-objects. As Geoffrey Batchen puts it, photo-materialists try to find "a way of talking about the photograph that can attend to its various physical attributes, to its materiality as a medium of representation."[2] This means taking into account the way a photograph has been painted or written on; the way it is arranged alongside other photographs, in albums or collages; its juxtaposition with other materials, such as locks of human hair; and the different ways it is framed. A photograph is an image, so goes this school of thought, but it is also an object, it has a physical being in space and time.

Another historian, Elizabeth Edwards, has argued forcefully that photographic images should not be isolated from their everyday uses.[3]

Writing with Janice Hart in *Photographs Objects Histories*, Edwards asserts that "it is not merely the image *qua* image that is the site of meaning, but that its material and presentational forms and the uses to which they are put are central to the function of a photograph as a socially salient object."[4] Edwards and Hart might have written more neutrally that a photograph is "more than an image," but the phrase "not merely" signals a polemical intent: a call to arms to take note of that which in the photograph exceeds the photographic image. They call this neglected excess the materiality of the photograph and they identify three key forms that it takes: the paper or other material the image is printed on; its "presentational forms," such as albums, mounts, and frames; and "the physical traces of usage and time," which is to say, signs of handling and evidence of decay.[5]

Photo-materialism has a corrective impulse. It is a response to histories of photography that focus solely on images without taking into account their original material form and the way they interact with the world as objects. But the neglect that photo-materialists seek to correct is hardly limited to the world of photography criticism and history. It makes its way as well into our casual daily use and reuse of photos. You might, for example, unstick from a family album a scratched and curling snapshot of skaters in an ice-rink, scan it, and reproduce it in a book devoted to winter sports, or on a Facebook page dedicated to old ice-rinks. In reproducing the image in a new context, something is lost, argues the photo-materialist: the physical thing that was the snapshot, its presence in a worn album, the other snapshots that surrounded it there, perhaps an inscription on the back.

It is not by chance that this critical turn coincided with the rise of digital photography. Photo-materialism seeks to render corporeal and singular the photographic in an epoch when its material supports are increasingly screens rather than photographic paper and its singularity doubtful when it can be transmitted as code to any computer or network.[6] Edwards and Hart admit as much when they state that their work "reinvests photographs of all sorts with their own 'aura' of thingness."[7] More recently Edwards has extended this photo-materialism further, arguing for attention to be paid to the full range of sensory and performative engagements that people have with photographs.[8] In the same vein, visual anthropologist Christopher Pinney has coined the

term "corpothetics" to try to account for the ways in which our bodies are connected with images rather than contemplatively detached from them.[9]

The Polaroid print, jutting out of the camera, demanding to be handled and held, seems to call out for the photo-materialist treatment. This is certainly the view of Nat Trotman, who makes a strong case for the unique materiality of instant photos:

> The images contain a density unlike any other snapshot medium. They have [. . .] truly a physical depth and presence [. . . .] The pictures have interiors, viscous insides of caustic gels that make up the image itself. Users are warned not to cut into the objects without protective gloves—these photographs can be wounded, violated. Their frame protects and preserves them like clothing around a vulnerable body.[10]

As we have seen already in the work of artists such as Lucas Samaras, the vulnerability of the Polaroid has been taken by some as an opportunity to transform the photographic object, to work on it, to bend what Trotman calls a body into new shapes. But there is more to the materiality of the Polaroid than these postexposure manipulations. Edwards and Pinney and other photo-materialists focus on the ways that we hold, look at, and alter photos after they have been made, but their mode of thinking can also lead us to think about the act of photographing itself, the process of taking of the picture.

What sort of photo-object is a Polaroid print? What does it encourage us to do, and how does it engage senses other than our sight? Trotman begins to answer these questions when he identifies the special temporality of instant photography: "Taking a Polaroid is an event unto itself, contained within the party atmosphere [. . . .] the picture does not commemorate the past party, but participates in the party as it occurs."[11] In Polaroid photography the material activity of making the image, the fact that it develops on the spot rather than later in a darkroom, is, as Trotman suggests, something that *happens*. As Polaroid promotional material proclaimed in 1980 for new Time-Zero film, instant photography "is more than just a means of recording a special event—it becomes a part of the event. It even becomes an event

itself."[12] To put it another way, the Polaroid print, in addition to being an image and an object, is also a *photo-action*.

Breaking the Ice

As the previous chapter showed, the decline of Polaroid Corporation coincided with the gradual drying up of sales of instant film through the 1990s. By the time of the round of bankruptcies and buy-outs between 2001 and 2008, instant photography had very much dropped from view, eclipsed in the popular imagination by rapid advances in amateur digital snapshooting and online photo-sharing. However, the final, public collapse of the company and the abrupt end to manufacture of its film brought a wave of press attention and reminiscence about the disappearing form. Paradoxically, just as it was passing out of public consciousness, Polaroid photography came back into public consciousness. In this Polaroid twilight, visibility was so poor that familiar figures could be mistaken for the strange and new.

This was the case with Jeremy Kost, a joint precipitate of the New York celebrity party circuit and the dying photo-technology. Kost, a self-dubbed "anti-paparazzo," dealt in a product—celebrity photographs—for which the demand is high, but the supply is too. As an amateur with no formal photographic training who used a Polaroid camera to take pictures of the stars, Kost was sufficiently distinctive to establish a profitable niche in the market. Comparisons made with Warhol (by curator Eric Shiner) were rather hopeful, but Kost's 15 minutes did extend to solo shows, short features in fashion magazines, and a regular column in *Elle Accessories*.[13] He published his mission statement on MySpace as well as his commercial site, Roidrage.com:

> Jeremy Kost has developed a unique approach to celebrity portrait photography [....] He doesn't hound them on the red carpet, nor does he sneak around outside their hotel rooms. He captures these stars in their own relaxed environment, being who they are naturally. He finds beauty in their reality. He looks for truth in natural light even when it is exposing [....] He does not rely on lighting, make-up or styling, but rather plays with the moment to create magnificence in a hedonistic smile or true exhaustion.[14]

The promise is an old one, and is of course integral to the fabrication of the star-image, to the process of mystification: the unguarded moments, layers of obstruction peeled away, the stars down to earth, and so on and so forth. Kost in turn became an astral by-product, a third- or fourth-order celebrity in his own right, "known on the New York circuit as 'the Polaroid artist.'"[15]

Kost's social success would have been impossible without the Polaroid camera, which had an apparently alchemical function in relation to the stars. The key word here is "access": "the un-intimidating camera has earned him access to some of New York's most exclusive gatherings"[16]; it gives him "the kind of access most photographers can only dream of."[17] The camera acts as guarantee of safe passage to the inner sanctum of the skittish and suspicious star, protective of her image, fearful of those who would take it unasked. But here is Kost, bartering successfully with her, not keeping the image inside his camera and to himself (or worse, transmitting it electronically to a scandal sheet), but handing it over instantly, or at least in exchange for a few more that go into his pocket. He explains that he first used the camera to meet people in bars in an unfamiliar city: "'Since I didn't really know anyone in New York at the time, the camera served as a sort of social catalyst,' [. . . .] He found that he made friends wherever he snapped photos."[18] In other words, he had belatedly stumbled upon the basic insight that Polaroid photography makes things happen. In a sort of unwitting funeral oration Kost revisited as if for the first time an attribute of the camera discovered long ago by its users and by the Polaroid advertising department.[19]

From the very beginning, the Model 95 Land Camera was promoted as a "party camera." Some of Polaroid's earliest print advertisements in 1950 contained the phrase that became permanently associated with instant photography: "You're the life of the party with a Polaroid Land Camera." Also in 1950, in the very first issue of *Polaroid Minute Man*, a magazine mailed to owners, it was claimed that "hundreds of Polaroid Camera users have told us how their cameras turned out to be the life of many a party."[20] The earliest occurrence of the phrase that I have been able to find is in a brochure of 1949, "What Owners Say NOW about the Polaroid Land Camera." In it, J. R. Hayes of Champaign, Illinois, testifies that "the first 7 days I took 64 pictures, all flash. I was

the 'life of the party' [. . .] very good for my ego. Everyone I show it to wants one."[21] Polaroid may have seized on a phrase spontaneously uttered by a genuine user, but they had in any case already anticipated the camera's party appeal.

Another early publicity brochure called the Model 95 "the party-hit of the year"[22] and print advertisements suggested "You can hold photographic parties with a prize for the best picture made by a guest."[23] Polaroid clearly also floated the idea at early press conferences announcing the process, since photo magazines duly mentioned the possible use at parties. Both the practice and the famous phrase endured, supplemented and renewed from time to time, as in the case of the Squareshooter 2 (1972), which was dubbed "the Good Time Camera," or the Joycam (1998), which I discussed in the Introduction.[24] Even as Polaroid teetered on the brink of bankruptcy, there was a vogue for using their cameras at weddings, where they provided some competition for the disposable camera industry.[25] More inviting to use than disposables, they were also risky, since the prints could easily end up in a guest's pocket or purse.

It has long been obvious that Polaroid cameras should be an accompaniment to festivities, even the heart of those festivities. But is it the camera that is the "life of the party," or the one who wields it? Who brings the camera to the party and what do they stand to gain? In the case of Jeremy Kost, the Polaroid camera is evidently a curiosity item, its retro charm guaranteeing his free pass to exclusive celebrity gatherings. But Kost is also an interloper, not present on his own merits, but by virtue of his party piece. He is also set to profit socially, and presumably financially, from his party camera. J. R. Hayes of Champaign, Illinois, is refreshingly candid about what the camera brings him—the admiration ("very good for my ego") and envy ("Everyone I show it to wants one") of others. The implication, of course, is that without his Model 95 he receives neither.[26] In this context, it is worth remembering that Kost's use of the camera originated in his friendlessness in New York. He testifies that the camera worked for him as a "social catalyst," helping him overcome the anonymous solitude of the metropolis.

By using his Polaroid to meet people, Jeremy Kost had hit upon what was long known in the Polaroid lexicon as "ice-breaking." "Break-

ing the ice" is an idiomatic phrase from American English. Mark Twain uses the phrase ironically in *Life on the Mississippi* (1883), but any ironic undertones have more or less vanished by the time it comes to be applied enthusiastically to the Polaroid camera. "There is no question about it—when you want to 'break the ice,' nothing can match the Polaroid Land camera," claims John Wolbarst, author of *Pictures in a Minute*, the first handbook of Polaroid photography. "There is no faster, surer way of meeting people than to unlimber a Polaroid Land camera and start shooting," Wolbarst assures his readers, advising them, "Start flashing away at a party or dance and you'll be overwhelmed by people who were strangers just a few moments ago."[27] Polaroid how-to guides are full of this kind of advice. In "27 Summer Picture-in-a-Minute Ideas," *Popular Photography* in 1959 gave a step-by-step guide to making new friends on the beach: "Take a candid picture of anyone you'd be interested in meeting. Break the ice by handing him or her his photo [. . . .] If that doesn't work, the Polaroid camera itself can be a great conversation piece."[28]

In her book *Suspended Conversations*, photo-historian Martha Langford has shown how a family album is incomplete without an accompanying explanatory narrative, is in fact brought to life by the conversation of the people leafing through it. To show an album is to point, to talk, to explain who is in the picture, what they are doing, and where they are now.[29] By producing the print instantly in the very scene where it was taken, the Polaroid camera brings forward this familiar process, inviting or even demanding comment from those present.

The Polaroid is a social camera, it gets people talking, and the Polaroid user, at least in *Popular Photography*'s version, is willfully persistent, possessing an unshakable conviction that his approach will be welcomed, that the device is fail-safe. This confidence and certainty of success is strongly in evidence in a Polaroid brochure from 1971 that contains a breathless testimonial from a user:

> I'm not kidding. All I do is show up with my Polaroid Land camera and I'm the center of attention. Even strangers pose for me. They watch when I shoot. They hold their breath when the picture's developing. And when I peel it off—*wow!* It's a great ice-breaker, that camera. Whenever children are around, I feel like the Pied Piper.[30]

The Pied Piper's stock may have subsequently fallen, but the promise of ice-breaking continued. Peggy Sealfon, in her 1980s handbook, makes the familiar connection between parties and Polaroid:

> Parties are also marvelous times for candid photography, and an instant camera often becomes a helpful ice-breaker. In fact, an instant camera often will motivate people to do unexpected things, just to see the immediate record of their behaviour.[31]

Where Wolbarst and others make much of the Polaroid photographer as the center of attention, as the gregarious life of the party, Sealfon credits the camera alone as the source of ice-breaking, the focal point of interest. Either way, it is not so much that the Polaroid records the party, but that it *is* the party, the main attraction that gets things going.

These examples are all taken from Polaroid promotional material or from one sort or other of how-to guide, and they all paint a rosy picture of broken ice. Even so, the potential pitfalls of the whole operation cannot be concealed. It is one thing when the party camera comes out on occasions when everyone knows each other; but strangers, after all, are the target of the enthusiastic ice-breaker, and there are no guarantees, the charms of the amazing camera notwithstanding, that these strangers do not wish to remain so. It is with precisely this possibility in mind that Michael Freeman praises the virtues of the camera in travel and street photography in the "Breaking the Ice" section of his handbook, *Instant Film Photography*. Freeman claims that "instant film can actually help to change the *situation* in which pictures are being taken: few things give such immediate pleasure as the gift of a photograph [. . . .] It is the gentlest bribe you can offer someone whose cooperation you want."[32] He is especially keen to emphasize the value of instant photography in the face of cultural barriers. In a section titled—without irony—"Overcoming Resistance," he warns that "photography without permission is, after all, a form of invasion of privacy, and whether this is offensive or not depends on the mood of the people, and on any cultural or religious objections they may have [. . . .] If you sense wariness or hostility, however, the instant film gambit may save the day."[33] One very literal such proof of frostiness overcome is given by Jack Parry, writing a feature on Alaska in the late

1950s, and making little progress with the locals: "Several times the Polaroid camera actually helped me in getting columns. One old Alaskan sourdough was as talkative as a clam before I shot his picture and gave him the print. Then he opened up like Old Faithful, spilling out stories of bygone mining days."[34] With the same sort of situation in mind, Sealfon notes that the camera can be "useful in foreign lands."[35] It is advice that Jeremy Kost takes instinctively in his dealings with celebrities, who are also alien beings, separated from us by their own impenetrable observances and rites.

In chapter 2, I showed how the apparent immediacy of the instant print has contributed to its characterization as an "intimate" form. This experience of intimacy has partly to do with the ambiguous status of a picture that comes into existence on the scene where it is exposed and in the presence of the subject, if it is a person, who is photographed. There is, therefore, some doubt over who owns the image—the photographer who takes it, or the one photographed, who is still there, and who, in the case of the SX-70, literally has the print thrust towards them by the mechanical motor of the camera.[36] (See Figure 2.4.) In both the pre- and post-SX-70 eras, many Americans traveling with Polaroid cameras discovered this and made a virtue of necessity by giving away large numbers of prints. The camera may almost insist that its products be given freely as gifts, but the canniest of these travelers turn this insistence to advantage by bartering with the gift. The Polaroid archive at Harvard Business School contains many examples of such exchanges: a Polaroid press release of 1956 tells of Murray Melbin, a graduate student from Michigan who traded pictures for food, shelter, transport right across Africa; tourist Catherine Motz used them to gain access to off-limits sites in Greece; professional photographer Bill Burke photographed Khmer Rouge on Polaroid P/N film, handing the positive to the guerillas and keeping the negative for himself; Spencer Nebel, an early visitor to post-Soviet Russia, swaps prints for vodka, wedding invitations, cockpit tours, and more vodka; and so on.[37]

There is even a whole subgenre of such stories where Polaroid gift-giving takes on an explicitly ideological dimension, as ice-breaking finds its natural metaphorical milieu during the Cold War. With the logic of the party camera simply transferred to the political field, one Polaroid document from 1960 reports on a State Department briefing

in Washington where a group of industrialists set for a visit to Russia are advised "to take along a Polaroid Land Camera. 'Nothing,' they are told, 'will break the cold reserve of people behind the iron curtain like handing over 60-second pictures.'"[38] Similar claims were made during the Nixon-era thaw in relations with Communist China. Journalist William Attwood, joking in 1971 that it is usually impossible to give anything away in China, and failing to make any satisfying contact with "ordinary" Chinese, snapped two pictures of girls in a park, with great results: "Pandemonium! Half the park converged on us."[39] After another trip in 1975, John C. Quinn, VP of Gannett News, reported back on "the vanity diplomacy of an instant photograph," which generated "the first and one of the few examples of human emotion not specifically inspired by Chairman Mao."[40]

There is something of Graham Greene's Alden Pyle in these friendly Cold Warriors, so convinced in their belief that the ingenuity of American technical invention will overcome obstacles as significant as language, culture, and hostile political systems. In these anecdotes, however, there is never really any question of negotiating differences so challenging or insuperable as language, culture, or political ideology. With the Polaroid camera, the slow traversal of such obstacles is replaced by the speed of the image.[41] As Edwin Land always emphasized, Polaroid's aim was to make cameras that progressively removed the technical barriers between the snapshot photographer and the successful photo, and in the case of the party camera this policy has simply been extended to the realm of social exchange. It may even be that it marks a different form of exchange, one mediated not by language, but by the pleasure and play of images, which act, in Jeremy Kost's words, as "social catalysts."[42] Whether the barriers have really been breached is another question.

Photography of Attractions

Children, 1970s communist Chinese, post-Soviet Russians, Khmer Rouge soldiers: what common ground is shared by this otherwise disparate group? There is a good chance they will not have seen a Polaroid camera in action before. In all the tales of ice-breaking, *novelty* is a key element to the success of the encounter, however that success is measured. The Polaroid photographer seeks to astonish and amaze

with the mere fact that an image should appear instantaneously, and astonishment and amazement inevitably diminish with familiarity. Even Jeremy Kost's activities are taken as novel because the outmoded Polaroid technology has been forgotten, but then at the very point of its extinction, briefly flares up again into visibility, starkly different from the instant digital imaging that has displaced it. That it produces an image immediately and also a hard copy makes it fleetingly seem an innovation that comes *after* digital photography. No wonder that Polaroid's laboratories restlessly pursued yet more innovations and variations on the original discovery. They knew perfectly well that the fascination of their products dwindled rapidly, and that Polaroid cameras had a much higher "decay rate" in year-on-year use than other amateur cameras.[43]

The *Sunday News* in 1971 hit on this vulnerability when it gave advice for meeting members of the opposite sex over the summer holidays: "The most successful gimmick this season for striking up new friendships is to take a picture of fellow travelers with a Polaroid and hand them a finished photograph on the spot."[44] A "gimmick" by its very nature is only a temporary ploy, from which the sheen quickly fades. It is also worth remembering some of the negative press that accompanied the arrival of Polaroid photography and continued to dog it for years, much to the dismay of such high-profile promoters as Ansel Adams, who regretted in his autobiography that most "professional and creative photographers dismissed the process as a gimmick."[45] Percy Harris, then president of the Royal Photographic Society, gave a typically damning assessment in the *Photographic Journal* in 1949, concluding that "the whole business seems nothing but a de luxe model of the old seaside 'while-you-wait' snapshot camera."[46]

But why should the seaside camera be an occasion for scorn, and why need "gimmick" be a term of dismissal? The *Oxford English Dictionary* tells us that a "gimmick" is "an article used in a conjuring trick; now usu. a tricky or ingenious device, gadget, idea, etc., esp. one adopted for the purpose of attracting attention or publicity" and also notes that one of its early users claimed the word was formed as an anagram of magic. With this definition in mind, and taking into account the Polaroid's status as party camera and multipurpose attention-grabber, instant photography can be seen as part of what historians of early cinema call a system of "attractions." The term "cin-

ema of attractions" was introduced in the mid-1980s by Tom Gunning and André Gaudreault as a way of distinguishing early cinema (1896–1906) from the classical narrative cinema that later became the dominant mode. Rather than taking storytelling as its main organizing principle, the cinema of attractions emphasized sensation and shocks, with display, or what Gaudreault called "monstration" as its defining characteristic.[47] This cinema therefore holds close affinities with the fairground in the way that it serves up a series of exciting spectacles for the curious and distracted spectator.[48] One of its other main antecedents is the magic theatre of the nineteenth century in which charismatic magicians often relied on new technologies to generate their spectacular effects.[49]

If we accept Dulac and Gaudreault's hypothesis that attraction is at work in more technologies than cinema,[50] we might then speak of a photography of attractions, beginning with the stereography craze of the nineteenth century. From there, we could draw a line of continuity running between the seaside while-you-wait camera, the automated amusement park photo booth (complete with theatrical curtain), the Polaroid camera as "ice-breaker," the Kodak Carousel slide-projector, and Jeremy Kost's infiltration into the New York celebrity party scene.[51] In her handbook, Peggy Sealfon actually calls the camera an "attraction" and notes that

> another special advantage of traveling with an instant camera is the way it provokes people's interest. People often gravitate to watch the "magical" photo machine at work.[52]

Again there are strong parallels with early cinema, where film projection *technology* was what pulled in audiences, as much as anything that it showed.[53] Certainly, in all the tales of Polaroid ice-breaking, the contents and qualities of the image are rarely the focus of attention. Attention is usually reserved for the striking novelty of the process, not the image itself. In Kost's hands, in other words, the Polaroid camera has recovered its importance and value precisely as a gimmick, as a mode of attracting attention and publicity. Unlike the illicit snappers who seek out sunbathing stars, it is essential that Kost *not* be surreptitious, and the explosive whir and click of the Polaroid camera, its Polaroid noise, is a boon in the din in which he seeks to be noticed.

"One of the Most Demonstrable Products in the World"

Polaroid's early advertising campaigns, which encouraged buyers to use the camera at parties, showed that the company had anticipated well the camera's potential as attraction. At the same time, the company recognized that this potential could be exploited in the actual selling of the cameras. If a demonstration of the astonishing device was enough to break ice, why should it not also work on the sales floor? A salesman selling a conventional camera could explain its technical specifications, let the customer handle the camera, make claims about the ease of use and quality of images produced, but could not take a picture and show the outcome. With a Polaroid Land camera suddenly this was possible, and retailers were quick to realize that they were dealing with a different sort of commodity, one that demanded a different form of display. In the summer of 1949, A. A. Goessling, camera department manager at Macy's, one of the first stores to stock the camera, wrote to J. Harold Booth, Polaroid's VP for marketing, to report on how well sales of the Model 95 were progressing, adding that "at no previous time, has a window been taken out to demonstrate an item being sold within the store."[54] If so venerable an institution as the Macy's window yielded to the attractions of Polaroid photography, then demonstration—a standard practice in retail culture—had clearly taken on a different dimension. This lesson was very quickly learnt by the Polaroid marketing division. By 1955 sales manager R. C. Casselman was writing to new dealers that "this is the first camera in history that can be completely demonstrated—and history shows that it's the demonstration that clinches the sale—providing it's a good one!"[55] In 1960 alone, Polaroid sales staff gave away approximately 1.5 million images at such demonstrations.[56]

The same principle was applied to television advertising, still in its infancy when Polaroid secured regular slots on the *Dave Garroway Show* in 1952 and the *Steve Allen Show* in 1954. As the *Polaroid Annual Report* for 1952 noted, the camera was a natural for television, because the sixty seconds of developing time matched the length of a commercial.[57] On live television, the demonstrating was done by the program host or one of his co-hosts and there were attendant risks, and not just because Jerry Lewis and Groucho Marx were among the demonstrators. As Casselman implies, a demonstration could easily go wrong in

what was still far from a foolproof process. In one script from the *Garry Moore Show* in 1960 Moore alludes to botching a print on a previous transmission. A ten-year-old called Diane is immediately brought in to take a picture and show that the failed demonstration was an exception, and even someone with no photographic experience could operate the camera.[58] It was this risk of failure that led Polaroid through the 1950s to develop a formal Demonstration Plan and Demonstrator Program.[59] The art of demonstrating Polaroid cameras was eventually reduced to a clear and efficient drill, as attested by the "Polaroid Corporation Demonstrator Checklist" of 1965, complete with Report Form FD3752. The same checklist refers to the Polaroid Camera Girl Banner.[60] In an industry dominated at the photo counter by male experts proudly guarding their technical know-how, Polaroid's regular use of female sales staff was yet further indication of the way in which they were positioning themselves as purveyors of spectacle. From the same era, the booklet "Meeting the Public: A Handbook for Demonstrators of Polaroid Land Cameras" is addressed to the Polaroid Camera Girl, one of whom appears, mini-skirted, on the cover.[61]

It was into this well-established culture of demonstration at Polaroid that the SX-70 made its appearance in 1973. In addition to convincing Laurence Olivier to do his first ever television commercials for the cameras, Polaroid rented out space in department stores, airports, major hotels, and shopping centers, installing 12-foot stages on these sites to show the SX-70 in action.[62] They also encouraged retailers to make use of the specially designed SX-70 "Demonstration Center." Photographs in the Polaroid archives of one such Center set up in a Milwaukee department store in 1973 show two separate convention-style booths fully occupying a central aisle of the store. Demonstrators would photograph passing customers against a special backdrop, while a separate counter was set aside for the developing images to be scrutinized, and other prints were posted up on the columns of the Demonstration Center. The Center generated crowds of interested spectators, who lined up to have their photos taken and watched others do so as part of the show. Polaroid clearly considered the tactic successful: "A Salesman's Guide to Polaroid SX-70 Land Cameras" emphasizes the importance of setting up such a Center and proclaims that "the SX-70 is the one of the most demonstrable products in the world."[63]

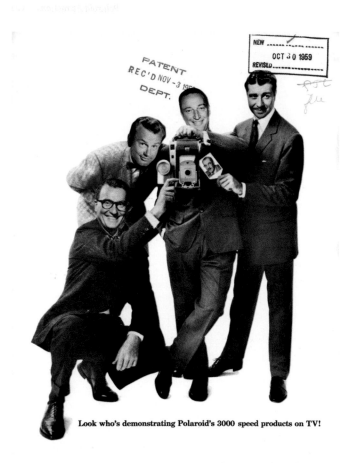

Figure 4.2: Polaroid television demonstrators, 1959.

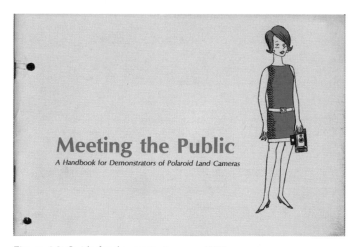

Figure 4.3: Guide for demonstrators, ca. 1967.

Figure 4.4: SX-70 demonstration center, Milwaukee, 1973.

Not only did this most demonstrable product sell itself, as the marketing lingo would have it, but it was also promoted by Polaroid as a traffic-builder. According to Gunning, attractions are not usually experienced in isolation, but rather as a series, in a "discontinuous suite."[64] The giant rollercoaster may be what catches the eye in the first instance, but once inside the fairground, the pleasure-seeker encounters an entire sequence of rides, foods, and games. In this assemblage of attractions there is no correct order of consumption, but each attraction acts as a complement to the next. Following this fairground principle that attractions belong together, and that they flourish through *exhibition*, Polaroid photography was used to sell other things. In the 1950s Polaroid offered a "Convention Package" to exhibitors seeking "showmanship" to attract "weary convention goers"[65] to their stalls with a "personalized give-away"[66] in the form of an instant photo taken against the backdrop of a company name or logo.

At the heart of Polaroid's Convention Bureau was another incarnation of the Camera Girl. The brochure "Steal the Show: Polaroid's

Convention Service Can Pack Them In at Your Next exhibit," promises the following: "Trained personnel. Attractive young college graduates who have taken thousands of Land Pictures at all types of conventions operate the cameras. In selecting these young ladies, emphasis was placed on tasteful appearance, pleasing personalities."[67] These trained personnel were very much in evidence at the most significant convention participated in by Polaroid in the 1950s.

The American National Exhibition of 1959 in Sokolniki Park, Moscow, is best remembered for the "Kitchen Debate" in which Soviet leader Nikita Khrushchev and US Vice President Richard Nixon argued the relative merits of communism and capitalism in the setting of the model American home. But Polaroid photography was also on show in the model home, as well as in a separate demonstration area in the pavilion and as part of a "before and after" beauty treatment exhibit.[68] The camera was officially present as representative of American achievements in science and industry, but it was clearly a powerful exemplar of consumer culture in general. Commodities require display and the magical illusion of autonomy: what better instance than the gimmick camera that astonishingly develops film of its own accord?[69]

Attractions attract other attractions. The affinity between instant photography and other forms of attraction was pursued even further by Polaroid from the late 1970s. In a diversification beyond the immediate amateur snapshot market, the company attached itself to a range of entertainment sites. It agreed with Disney in 1979 to become the official photographic company of the Parks, where it set up its "Camera Loaner" program to push sales of film units, and opened "Photo Fun Centers" where visitors could be photographed on 4 × 5 film dressed, for example, as Pirates of the Caribbean.[70] This was only the most high-profile of such links, as Polaroid worked right through the 1980s to get a foothold in major theme or amusement parks—Busch Gardens, SeaWorld, Six Flags over Mid-America, Dorney Park, Great Adventure, Jungle Habitat, Marine World, Africa USA[71]—or near other attractions, such as the "For Instants" store opened in Atlantic City in 1984.[72] Related ventures were Polaroid's Special Events picture promotions and the Polaroid Face Place. The former was designed for shopping malls seeking to increase traffic during low seasons and would give shoppers the opportunity to be photographed

with anything from baby lions to the Dallas Cowboy Cheerleaders.[73] The Face Place was a photo booth that dispensed SX-70 prints and that was widely located in shopping malls, amusement parks, and arcades as well as other high-profile tourist attractions such as the Space Needle in Seattle[74] and the Empire State Building Observatory, jokingly referred to as "the highest earning location in the US" by an industry magazine.[75] The mutual attraction of theme parks and Polaroid reached its natural conclusion in April 1986 with the launch of the Spectra System. For this occasion Polaroid built a house-sized replica of the camera and unveiled it at Century City, Los Angeles, toured it around the country, and finished by depositing it at the foot of the World Trade Center in Manhattan. Inside this 30-foot structure was a sound and light theater where up to 75 spectators could witness the inner workings of the new marvel.[76] The photography of attractions was now its own self-contained traveling theme park.

This symbiotic relation between Polaroid and other forms of attraction underlines even further its affordances as a party camera, in the widest sense of that term. Neither the company nor its customers could have anticipated to what extent the *event* of the instant photo mattered, or how many variations on that event were possible along the axis demonstration-exhibition-display. What is clear is that much of Polaroid photography is inseparable from its site and occasion of making—from the act of photographing. Photo-materialists argue that to consider a photograph solely as an image is to ignore all its properties as a photo-object, but to consider the Polaroid print in isolation as a photo-object is to miss its power as an action.

Edwin Land's Big Top

No one recognized better than Edwin Land the gimmick potential in the cameras he invented, and in a company where demonstration was so central a practice, Land was undoubtedly the demonstrator-in-chief. For each new camera technology or film format developed by Polaroid's research laboratories, there was invariably a carefully choreographed public unveiling. For the biggest breakthroughs—Polacolor, 4 × 5 film, SX-70, 20 × 24 film, Polavision—Land himself took responsibility, introducing the new product at the company's annual shareholder meetings. During the 1960s and 1970s, these an-

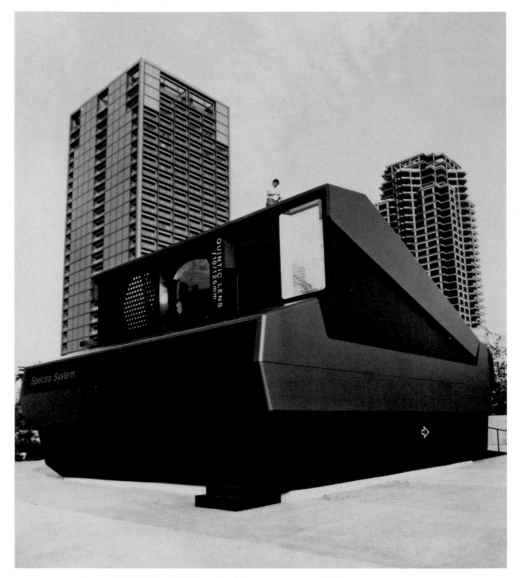

Figure 4.5: 30-Ton building-sized Spectra camera, 1986.

nual meetings became so elaborate that Land gained a reputation as the great showman of corporate America.[77] For one spring day each year during these decades Polaroid would convert a space among its buildings—a cafeteria, a warehouse—to accommodate audiences that steadily grew in size and hit peaks of nearly 4,000. According

to reports, many who attended did so not to hear the obligatory read-
ing of financial statements delivered on such occasions, but to see the
performances of Land, who not only would reveal new inventions kept
until that moment top secret, but also would prowl whatever stage
he was on, holding forth about science, aesthetics, the philosophy of
Polaroid Corporation, and even philosophy in general (Henri Bergson,
a fellow theorist of color vision, was a favorite).

"What is it about this meeting that brings out the stockholders in
such hordes?" asked the *Boston Globe* in 1966. "One of the many attrac-
tive women present put it this way: 'Well, I guess it's a glamor com-
pany and we always expect something to happen, but—well, it's Dr.
Land. He's beautiful.'"[78] The stages on which the headliner performed
were at first small, as in the case of the slightly raised podium from
which he announced advances in instant color film in 1960, but gradu-
ally took on a grander scale, until Land was in some instances alone on
a huge dais, surrounded on all sides by spectators, and equipped with
a lapel microphone.[79] Polaroid's expert knowledge of visual technolo-
gies was fully exploited on these occasions, with massive screens, slide
shows, and film projection supplementing Land's talks. The special
status of these meetings can be dated to the late 1950s when the com-
pany first staged them in-house. In a letter in the *Polaroid Newsletter* an-
nouncing the first such meeting in 1958, Land says that they want "to
make even more of it than we have in the past," adding that the meet-
ings are already "unusual, possibly unique, in American industry."[80]

The most notable of these meetings was the sequence 1971, 1972,
1973, where the SX-70 system was hinted at, revealed, and then fully
launched. In 1971, Land stood on stage and pulled a closed SX-70
prototype camera out of his suitcoat and showed it to the audience
without opening it or explaining what it was except to suggest that
"the tantalizing object in his hand" would be disclosed at some future
date.[81] That disclosure was made at the 1972 meeting, when Polaroid
converted 32,000 square feet of warehouse into a complete in-the-
round theater space for the occasion. The foreman for this under-
taking, Bob Chapman, explained that his team built an entirely new
facility, adding fans, installing theater lighting, as well as making
stages and demonstration platforms, and erecting a huge four-sided
projection screen in the middle of the shareholders meeting room.[82]
Influenced by, or perhaps even in advance of some of the radical

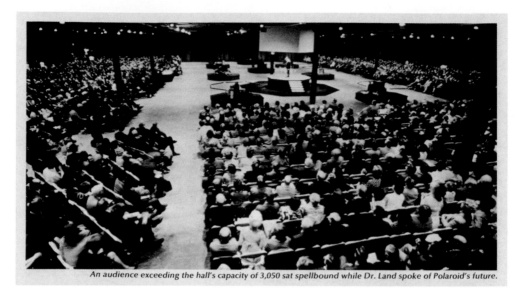

An audience exceeding the hall's capacity of 3,050 sat spellbound while Dr. Land spoke of Polaroid's future.

Figure 4.6: Polaroid annual meeting, 1972.

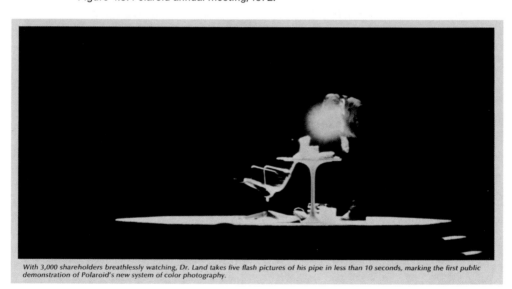

With 3,000 shareholders breathlessly watching, Dr. Land takes five flash pictures of his pipe in less than 10 seconds, marking the first public demonstration of Polaroid's new system of color photography.

Figure 4.7: Edwin Land, annual meeting, 1972.

site-specific theater of the early 1970s, this elaborate mise-en-scène was all laid out to display the SX-70 camera and film, which were still some months from the consumer shelves. The very first demonstration fell of course to Land, who was illuminated alone on stage in the darkened warehouse and took in rapid succession five pictures of his pipe on a table.

The audience were then free to circulate around twelve separate stages to observe the SX-70 at work photographing such scenes as a child's birthday party, a painter at her easel, live ducklings in a pond, floral arrangements, and specimen slides under a microscope.[83] In that same year Land ended up on the covers of both *Time* and *Life* demonstrating his new gimmick. The following year, with the camera now available from a limited number of suppliers, shareholders at the annual meeting were encouraged to try the device for themselves. Polaroid shipped in 12,000 tulips from Holland for this purpose, turning them into centerpieces for each table of nine spectators to test out the color range of the film.[84] Land himself made his way round these tables, taking pictures and discoursing on the camera and film.

As an exercise in marketing and product promotion, Land's performances at the lavish annual meetings were a great success, attracting wide coverage in a largely positive media. For reporters the Meetings were a dazzling fusion of magic show and circus. *Fortune* magazine in 1970 said that Land "has onlookers believing in fairy godmothers who can convert pumpkins into carriages" and *Time* in 1972 wrote of his "now legendary appearances at Polaroid's annual meetings, at which he stages a modern magic-lantern show."[85] Richard Kostelanetz in 1974 called the annual meetings "Dr. Land's Annual Magic Show" and Land himself "a dashing imperial wizard," while in the same year Jack Murphy highlighted Land's "photographic legerdemain" and "technological wizardry."[86] And lest anyone forget why Polaroid was a glamor stock during the 1960s when its value never stopped going up, there were what Donald White called in 1966 the "magic statistics."[87] White, a regular reporter on the annual meetings for the *Boston Globe*, was also alert to the "Barnum and Bailey setting" of an event held "in a big top at the company's Waltham headquarters," and which had "every appearance of becoming the Greatest Show on Earth." Commenting on the way in which Polaroid rented clowns, jugglers, and live animals for the meetings, Tom Ehrenfeld remarks that they "resembled

circuses more than financial events," while David Warsh compares the gathered shareholders to "a circus crowd" and Land to a "ringmaster."[88] *Modern Photography*, meanwhile, with some of the deflationary impulse found in White's laconic reports, downgraded the annual meetings in 1979 to "Land's annual 'dog and pony' show."[89]

Whether Land is depicted as ringmaster or magician, these reports on the conduct of the annual meetings place them firmly within earlier traditions of popular entertainment. Tom Gunning makes the case that the early cinema found its immediate roots in the nineteenth-century magic theater, which turned popular science into spectacle, and this was surely also the appeal of Land: a genius inventor who was able to convert that genius into a charismatic stage presence, and more importantly, into wondrous gadgets that anyone could use, even if they did not understand all the chemistry, optics, and mechanics behind them.[90] For the gathered shareholders, the thrill of seeing extraordinary inventions for the first time was undoubtedly amplified by the promise they contained of thrilling dividends and stock price rises.

An even more immediate link to the system of attractions in the early cinema is the way in which Land spoke charismatically about the technology he was demonstrating or displaying. Gunning has emphasized the importance of the early filmmaker as a "monstrator, one who shows, a showman."[91] In the absence of a soundtrack in early cinema, a film lecturer, who was often the filmmaker, would speak over the film, both to heighten what was new in the experience, but also to explain and narrate, to provide spectators with a frame for what they were seeing. As Gunning puts it, the film lecturer "builds an atmosphere of expectation, a pronounced curiosity leavened with anxiety as he stresses the novelty and astonishing properties which the attraction about to be revealed will possess."[92] It is to this tradition that Land clearly belongs. His role at the annual meetings was to present new technologies as dazzling and unanticipated, but also ultimately as commodities ready for market. Gaudreault traces the figure of the film lecturer directly back to the impresarios who put on magic lantern shows, so it is entirely appropriate that *Time* dubbed Land's performances "a modern magic-lantern show."[93]

The circus ringmaster and the stage magician, like the film lecturer, use words to seduce and guide their audiences through the stages of the attraction. But they also use gestures, punctuating key moments—

the wild cat passing through hoops, the assistant sawed in half—with bodily signals. The outspread arm, the open palm, these gestures wordlessly instruct the spectator to behold a wonder or marvel that has just unfolded. Here again, Edwin Land's entertainment pedigree is evident. One of the most frequently reproduced images of the inventor is from the 1979 Annual Meeting where he demonstrated for the first time the ultra-fast Time-Zero SX-70 film. In this photograph Land cups the open camera in his left hand whilst holding overhead in the right an already developed print of a bunch of flowers. By this stage, the gesture and the image were immediately recognizable, having been repeated many times by the Polaroid Chairman. Whether it was a prototype SX-70 camera slipped out of his jacket in 1971, or the first SX-70 prints in 1972, or the first 20 × 24 print in 1976, Land was the master of the "here it is" gesture. Two separate writers for *Modern Photography* put their fingers on the meaning of this typical action when describing Land's introduction of 20,000 speed film in 1968 and his performance at the annual meeting of 1979. At the event in 1968, a team of technicians on stage at the Sheraton Boston ballroom exposed, pulled, peeled, and mounted two oversize prints, and then, "Almost in triumph, Dr. Land held them aloft."[94] In his regular column on instant photography, Weston Andrews in July 1979 wrote of how "the good doctor dramatically announces the new goodies, then triumphantly waves them aloft before an adoring assemblage."[95] These writers are surely correct to use the grand phrase "holding (or waving) aloft" and to identify the element of triumph in the act. For this is what the gesture signifies. Just as the ringmaster with outstretched hand indicates his mastery of the animal world, or the magician his control of appearances, so Land embodies in that holding aloft the triumph of commercial scientific endeavor.[96] "Atavistic" was apparently one of Land's favorite words,[97] and it is hard not to see in this triumphant gesture the secular remnants of ritual, of which the magician and the ringmaster also claim their share.

The image of Land as conquering hero is difficult to reconcile with one other aspect of his public persona as developed by business reporters. So successful were the meetings at dazzling with their technological magic that they apparently also required a Cinderella-like transformation from the central protagonist. Land is thus taken to be "the otherwise retiring scientist," "the reclusive genius scientist,"

Figure 4.8: Land demonstrates one-step process to press, 1947.

"the reticent, publicity-shy inventor," the "shy scientist," who emerges just once a year, to turn briefly into "spellbinding showman" before retreating again into the secluded space of the laboratory.[98] This is the popular myth of Land, but it does not square well with the evidence. Far from making only the one public appearance a year, he was frequently to be found in the media spotlight receiving honors and awards, making teaching and lecturing visits at nearby Harvard or MIT, and attending scientific congresses, such as the one in 1968 where he presented the 20,000 speed film. In fact, his predilection for public demonstration and *coups-de-théâtre* started long before the extended sequence of bows before the annual meetings. In February 1947 when he demonstrated the one-step photographic process in front of the American Optical Society, he made sure to precede that event with

a less specialist show for the gathered press at the Hotel Pennsylvania in New York City.

Images of that demonstration were reproduced widely and ensured immediate public awareness of the new technology, while one observer called Land "the chief wand-waver" having pulled "something besides a rabbit out of the hat."[99] And even before that, Land was in the showing business. In July 1934 he and his partner George Wheelwright rented a south-facing suite in the Copley Plaza Hotel in Boston for the visit of a representative of the American Optical Company, makers of sunglasses. It was a bright sunny day and it was impossible for anyone entering the room to make out the fish in the bowl Land had positioned on a windowsill. He handed to the visitor a square of artificially synthesized polarizer, and asked him to look through it towards the bowl. By way of that most fundamental of magic-show pleasures, the game of appearance-disappearance, he had made six fish visible, as well as theatrically demonstrating the properties of his new product.[100]

With Land's talent for theatrics evident so early and so often, it is hard to see how he developed a reputation as some sort of scientist-hermit, wary of the public gaze except on one special day each year. It may be that his reluctance to give interviews and his careful guarding of his family life were contributory factors, but not enough to explain the persistence of the myth. It seems more likely that commentators just automatically read Land in terms of the popular image of the scientist as lab-bound, socially awkward, and preoccupied with his experiments to the exclusion of all else. This may have been the default setting for the image of the scientist in the 1960s and '70s, but to apply it to Land was to obscure the ways in which he was really a throwback to a previous model of the scientist-inventor as charismatic public figure.

As Ruth Cowan Schwartz explains, the patent system in the United States in the nineteenth century contributed to a cult of the inventor, of men who were "household names either in their own right or because of the names of the companies they founded. Newspapers quoted their opinions; popular magazines recounted their exploits; huge crowds turned out to hear them lecture."[101] Thomas Edison, who eclipsed even Land's patent-count, was of course the purest instance of this type, combining the science of invention with the arts

of self-promotion. As Schwartz points out, however, by the 1920s the independent star inventor had been more or less displaced by the anonymous corporate inventor—a scientist on the payroll, whose discoveries are assigned as patents to a big company, not an individual.[102] Plenty of this more modern sort of invention went on at Polaroid, with its huge team of research chemists, mechanical engineers, and optical experts; but through events such as the annual meetings and with the assistance of products that called out for public demonstration, Edwin Land managed to maintain his anachronistic position as celebrated and celebrity inventor.[103]

Through his many performances Land showed that in the photography of attractions, the representational value of the image is not entirely negligible, but it has receded in importance, giving way to what might be called its "demonstration-value," where it is the process of making and not the resulting image-object that takes precedence. Any gasps of amazement elicited by an SX-70 print seen for the first time were more likely to be due to the fact that there should be any image there at all, than for any specific qualities of the image itself. Or, to put it another way, the Polaroid image is a representational form, but one in which there is a heavy residue of liveness.[104] Taken out of a shoe-box after thirty years, it shares with other photographs that odd temporality of belatedness so well described by Roland Barthes in *Camera Lucida* as "that-has-been." At the same time, in the process of its making, there is an element of duration, a live moment. This is why it finds productive companions, or analogues, in the circus and the magic show, which are spectacular, nonrepresentational forms, where display and demonstration predominate.[105]

Given the cameras' potential for showmanship, it is unsurprising that when Polaroid built its camera to produce 20 × 24 prints, self-publicist Andy Warhol posed on the stage of the Waldorf Astoria's grand ballroom in February 1978 for a series of instant portraits.[106] It was appropriate that Polaroid image-making should have a theatrical setting in Land's and Warhol's use of it, because in their hands it functions above all as spectacle: it is the astonishing display of the technology's workings which is most important; and attracting attention is a main aim of the operator. But just as Land himself was anachronistic as inventor-hero, so the elements of the circus act and the magic show he mobilized in the 1960s and 1970s were rapidly dating as forms of

public spectacle. They were leftovers from the nineteenth century that had been almost completely displaced by more fully technologized forms of entertainment (above all the cinema). The great era of the American circus, of the Ringling Brothers and Barnum and Bailey, had been the decades around the turn of the century, and the film *The Greatest Show on Earth* (1952) and its television follow-up (1963–64) were exercises in nostalgia for what was effectively a dying form. It was no doubt this feeling of datedness that prompted *Newsweek* to label the annual meetings "an uncanny mixture of drama and corn-pone."[107] Land may have deployed his company's cameras as a form of grand public spectacle, but this model of attractions suited much better a smaller and more intimate scale. There is, after all, a striking incongruity in standing on a massive stage in front of an audience of 3,000 and photographing an object as small and mundane as a pipe. A kind of magician, Land in fact helped to kill the magic show by making its technological supports available to the uninitiated, miniaturizing magic and placing it in the hands of millions. That the domestic sphere was the more natural milieu for Polaroid attractions is shown by the strange case of Ted Serios, who made great claims for the *contents* of his instant images, but for whom the real show was, once again, the event of their making.

Ted Serios, Psychic Photographer

If Edwin Land, with his theatrical displays to gathered press and shareholder meetings, is the original and prototype of Jeremy Kost and innumerable other party photographers, then Ted Serios is his occult double. While Land was the photographic scientist turned per-former and showman, Serios was a photographic showman subjected to the scrutiny of science. Between them they illuminate the sources of technological attractions in earlier traditions, with Serios' paranormal performances with a Polaroid camera echoing the spiritualist séance and bringing into focus Land's roots in the magic theater.

Ted Serios came to prominence in parapsychological circles in the 1960s, thanks largely to Jule Eisenbud, a classically trained psycho-analyst and part-time psychical researcher, who wrote up Serios as a case in *The World of Ted Serios: "Thoughtographic" Studies of an Extraor-dinary Mind* (1967). Serios, as described by Eisenbud on his first en-

counter with him, was "a poorly educated Chicago bellhop in his early forties, who was alleged to be able to project photographic images onto Polaroid film by simply staring into the camera lens with intense concentration."[108] Initially skeptical and dismissive of Serios' powers, Eisenbud proceeded to subject the Polaroid "thoughtographer"[109] to a series of tests under controlled conditions. More often than not the results of Serios' Polaroid photographs were failures or simply prints that were entirely black, but there were also occasions when he produced distorted or blurred images of buildings, monuments, or vehicles, even though he had been pointing the camera lens at his own face. Encouraged, and later convinced, Eisenbud recruited colleagues at the University of Colorado in Denver as witnesses in a series of trials, often held in the houses of these colleagues, using their cameras, as well as film which they had purchased independently. Invariably, such intimate domestic events produced better results, from a parapsychological point of view, than larger public ones such as a demonstration held in the main auditorium of the University of Colorado Medical School. Having satisfied himself as to the veracity of Serios' talents, Eisenbud then went in search of its source, hooking the thoughtographer up to an electroencephalograph, placing him in a Faraday cage (for the attenuation of radar and radio waves), and testing whether he could produce images through lead-impregnated glass. His continued successes under strict conditions have led his case to be described as "one of the most impressive in the history of psychokinesis" by those who remain convinced by its authenticity.[110] Skeptics, meanwhile, point to the sudden dwindling of his powers in the wake of an exposé in 1967 by a team of photographers and magicians sent to investigate him by the magazine *Popular Photography*.

When images produced by Serios were shown as part of an exhibit at the Metropolitan Museum of Art in 2005 devoted to the history of spirit photography—*The Perfect Medium: Photography and the Occult*—Michael Kimmelman wrote in the *New York Times* that, "These are creepy, blurry, off-kilter Blair Witch-like pictures of automobiles and hotels and shadowy men in uniform, which have yet to be fully explained away."[111] The Serios photos were "yet to be . . . explained away," Kimmelman writes, meaning yet to be proven fraudulent, as spirit photographs inevitably turned out to be. But to assume that debunking or believing are the only options when faced with such

phenomena is simply to endorse a way of thought that presupposes that the image world answers only to questions of true or false. A different approach to Serios has been proposed by Mark Durant, who suspends the question of the veracity of the images and simply considers them *as* images, noting how they are "bland and generic," and without any overt supernatural message.[112] This view is echoed by María del Pilar Blanco, for whom the Serios thoughtographs are "excruciatingly mundane, democratic, and openly quotidian" in content, regardless of their putatively extraordinary or parapsychological origins.[113] If the Serios pictures are of interest, Blanco argues, it is because they render the everyday strange, whether it is a bicycle wheel or a passing car.[114] The very ordinariness of Serios' images is further emphasized, Blanco claims, by the "mundane" Polaroid camera used by the thoughtographer.[115]

Blanco is right that Serios is strikingly mundane rather than extraordinary, irrespective of the title of Eisenbud's book which granted him fame. The question remains, however: did it make any difference that Serios used a Polaroid camera for his thoughtography? This is not to ask whether the technology of instant photography was particularly helpful in perpetuating a fraud (it may very well have been), but instead, what Serios had in common with other Polaroid users.[116] Whatever the claims made for the other-worldly provenance of his photographs, in many respects Serios was the most ordinary of Polaroid photographers, one who realized that the party camera can be used to entertain people.

The Serios Show

In chapter 7 of *The World of Ted Serios*, Eisenbud remarks of Serios that

> Children, far from disturbing him, seemed to draw him into his finest flights of improvisation. For one thing, the feedback, communicated on their part by uninhibited shrieks of astonishment and delight when a clear picture emerged [. . .] seemed far more direct than with adults.[117]

Taken within the context of Eisenbud's narrative, the "astonishment and delight" of the children acts as an index of the extraordinary

events witnessed and for which there is no obvious explanation. Taken in isolation, however, that second sentence might have been plucked straight from a handbook of Polaroid photography, or even Polaroid promotional materials, both of which made much of the magic of an image appearing instantaneously, and regularly invoked children as the ideal consumers of this magic. So, for example, in her handbook of Polaroid photography, Peggy Sealfon writes of her childhood experience of the technology in a way that can hardly be distinguished from the children mesmerized by Serios:

> I remember the funny little machine with great vividness. It would be pointed at our smiling little faces and then, in a feat like some magician's sleight-of-hand, it would deliver a rectangular piece of paper that was peeled apart to reveal to us a picture of ourselves. It was a kid's delight. It still is.[118]

The response of the children to Serios is what Eisenbud calls "feedback," reminding us of another quality for which instant photography was always praised (see chapter 3) and echoing again many Polaroid manuals that pointed out how photographers valued the potential to see quickly a picture they had taken and make immediate adjustments to improve the next one. In other words, there may have been no immediate explanation for the images that Serios had taken, but his use of the Polaroid camera in fact had close parallels with the ordinary experience of many other users: its success with children, its interactivity.[119]

The astonishment and delight of the child spectators, and their "uninhibited shrieks," as well as Serios' "improvisations," mark out the Serios phenomenon as a kind of attraction, worthy of the fairground. Polaroid photography, meanwhile, has always traded heavily on what Sealfon describes as the "thrill of seeing one's photograph fully developed in a matter of seconds."[120] Sealfon inherits the word "thrill" directly from early Polaroid advertising campaigns, where it featured prominently as a selling point in every ad. "Outdoors or in, you'll enjoy a thrill every minute with your new Polaroid Land Camera"; "Here's the thrill of truly modern photography"; "There's no thrill like seeing your pictures 60 seconds after you shoot them"; and "This Christmas thrill your family with the world's most exciting camera":

these were just some of the variations on the original tag-line "You'll enjoy thrills you never dreamed of with your Polaroid Camera."[121] *Sensation*, in other words, rather than sense, has always been at the heart of Polaroid photography.

This puts into a different perspective the astonishment and delighted shrieks of the children watching Serios. The thrill of Polaroid picture-taking places it firmly in a cultural sequence of shock, interruption, and discontinuity (the original meaning of the verb "to thrill" is to penetrate or cut through) and Serios, far from being an exceptional case, is continuous with this tradition, even bringing it into sharper focus. The thesis of the cinema of attractions, as outlined by Gunning and others, shows not only how scientific discovery and technological innovation provide a new vehicle for representation and entertainment, but also how science and its technological products become objects of entertainment in and of themselves, as elements in the circulation of signs and sensations. In the case of Ted Serios, the scientific minder, Eisenbud, admits to a certain unease when he finds himself in the position of ringmaster for what is meant to be a purely scientific enquiry. Eisenbud arranged for Serios to be presented to a district branch of the American Psychiatric Association in a large auditorium, and he jokes that he "felt a little like Mr. Garrick of the Royal Nonesuch, rafting down the Mississippi and ready to get my Shakespearean posters out at the next sucker town, but justifying the action to myself on the grounds of my certainty that everybody would have a riproaring time no matter what."[122]

This allusion to Serios as a sort of touring attraction is by no means an isolated instance. Not only does Eisenbud refer to his charge's "improvisations," but regularly refers to the theatricality of the situation, whether he is doing "everything possible to have a steady stream of people [. . .] privately witness his performances," comparing Serios to famous recitalists such as Heifetz and Horowitz, or calling him "a virtuoso performer" or "master of magic ceremonies."[123] The debunkers from *Popular Photography*, otherwise at odds with Eisenbud, also describe Serios as "a great performer" and admire his "fascinating and compelling style."[124] The consistency of this language pinpoints precisely Serios as showman, and the Polaroid camera as his technological aid.

In his account of secular magic since the eighteenth century, Simon During notes how heavily reliant it was on mechanical devices such as mirrors, lenses, and automata; and how this produced a "technologized and exteriorized show business magic" of magic lanterns and optical illusion.[125] It is tempting to place Serios directly in this tradition; in his narration of one of the early sessions with University of Colorado faculty, Eisenbud more or less does so. The session, held at Eisenbud's house, was for the first three hours a complete failure, with an increasingly inebriated Serios failing to produce a single image of note. Then, just as the assembled worthies were preparing to depart, Serios grabbed one of the many cameras available and shot an image of a double-decker London bus. "Its effect," Eisenbud writes, "was electrifying to an audience which, including me, had been just a moment before restless, bored and irritated."[126] Eisenbud goes on to describe the astonishment of one Dr. Conger, who had been entrusted with guarding the "gismo" that Serios always placed in front of the lens to take his pictures. The magically named Conger was now staring at this object "still hanging from a thread around his neck, as if he half expected to see Aladdin's genie materialize from it."[127] Whether he intends it or not, Eisenbud alludes to a tradition—the Aladdin story—popular in both the magic lantern show and in early cinema.[128] By coincidence, at this same moment Edwin Land and Polaroid were deep into a long-term project code-named Aladdin, which was eventually to result in the SX-70 camera in 1972. Perhaps less coincidentally, Serios had a pedigree in attractions: his father had been a successful professional wrestler.[129] Later, Serios introduced Eisenbud to a new thoughtographic talent, one Willi Schwanholz, whose previous employment had been with traveling circuses.[130]

Paranormal Party Camera

Serios may have relied openly on a technical prosthesis for his paranormal performances to be effective, but as During points out, the secular magic of optical technology was always candid that its effects were illusory.[131] When Edwin Land demonstrated the SX-70 to assembled shareholders at the 1972 annual Polaroid meeting, their astonishment at the extraordinary new integral film that developed directly in the light was secular: they accepted that the marvel that they

were witnessing was the result of scientific endeavor, and not some otherworldly agency. This is clearly not the case for Serios. Whether or not his "thoughtographs" were based on some form of illusion or trickery, he did not present himself as a prestidigitator, but as a genuine psy-phenomenon. However theatrical Serios' performances may have been, they cannot be considered exclusively as a late entry in the lists of the magic theatre. Indeed, the fact that they were largely private, domestic affairs suggests that Serios had stronger affinities with the great rival of the secular magician—the medium—and that his thoughtographic displays might be considered as a form of séance.

Steven Connor has noted the distinctive dramaturgy of spiritualism and emphasized how reading it as a cultural form means paying attention to "its acts and enactments, its affects, practices and embodiments" in order to try "to understand what séances were *like*."[132] His point is that the material practices of the séance are just as important and revealing as any claims that might be made in the séance about communication with the dead, transportation to other worlds, and so on. What exactly went on in the Denver sessions with Serios? On the one hand these were conducted by Eisenbud on a strictly scientific basis, with a series of control measures to ensure the validity of the experiments: cameras, film, and "gismo" were inspected by witnesses, affidavits were signed by all present verifying what they has seen. At the same time, these events could apparently be quite rambling and drawn out, with definite evening starting times, but an end point very much dependent on how "hot," or drunk, Serios was at any given moment; and even though the sessions were held in Eisenbud's consulting office or in an auditorium of the medical school, Eisenbud says the witnesses were "like guests at a dinner party."[133]

At some unspecified point the Serios sessions moved out of the professional space of Eisenbud's office, and began to go on a tour of the homes of University of Colorado faculty. With only one exception, Eisenbud's wife was also present at these sessions, along with the children and wife of the host, as well as on occasion the children of neighbors. The witnesses at these sessions were also regularly participants in them, being asked or directed by Serios to pass him a camera, hold it, even trigger it. This was especially the case for the children present, who, as already noted, were particularly attuned to the Serios show.

The similarities between the "thoughtographic" scene and the spir-

Figure 4.9: At a Ted Serios party.

itualist séance are numerous: the domestic setting; its character as a social event; the physical participation of attendees, some of them regulars; the presence of a mediumistic or "sensitive" figure; the dependence on technological prostheses.[134] And just as in the spiritualist séance, where "some spirits put on a rousing good show,"[135] so the soirees with Serios frequently featured boisterous activity, at least on the part of the central attraction, who consumed alcohol in heroic proportions. This disorderliness reached a peak when Serios was in "hot," picture-making mode. Eisenbud variously describes him as "squirming," "staring wildly," "hands running frenziedly through his hair," "snapping his fingers and incanting, in best crap-game fashion, sometimes with a chorus of children and adults chiming in, 'Be there, baby, be there!'"[136] At other times, with children absent, Serios would drunkenly strip for his audience as an "open-hand-see-I'm concealing-nothing flourish," and kept Eisenbud alert with regular run-ins with the police of Denver and Chicago.[137] In other words, even if he produced very few definitively paranormal pictures, Serios still provided his audience with plenty in the way of distraction.[138] But none of this entertainment would have been possible without the instant film

technology that allowed for the results of Serios' psychic photography to be checked immediately on the scene. And what secured the Eisenbuds all their party invitations if not the attraction of Polaroid photography, that surefire ice-breaker?

Far from being extraordinary, Ted Serios was in many ways a typical Polaroid photographer in his exploitation of the camera's potential as attraction. And just as in the case of Jeremy Kost, there is also the question of what the Polaroid camera allowed Serios to do, the kinds of access and boundary-crossing it permitted him. As Michael Freeman has said, the gift of an instant picture can change a situation and a gift of a photo can ensure the "cooperation" of its receiver.[139] What sort of cooperation did Serios extract from Eisenbud by turning the Polaroid camera into an attraction; or rather, by realizing, as many ordinary Polaroid users had already done, the camera's capacity for attracting attention? Above all, it afforded him mobility: not only in terms of gaining entry to the assorted homes of the Denver psychiatric and medical community, but airfare to and from Chicago and unlimited gas for his car. Eisenbud provided him with hotel rooms and then room and board in his own house for over a year. He took the thoughtographer shopping for clothing and other necessities, as well as keeping him in a continual supply of beer, scotch, and cigarettes. Eisenbud also reports that Serios "ignored every hint I dropped about the great advantages of his holding a part-time job."[140] And as Stephen Braude, one of the main defenders of the authenticity of the Serios phenomenon, reveals, "Because Ted's alcoholism frequently interfered with his holding down a job, Jule established a foundation to provide him with a modest monthly income and a reasonable measure of security."[141] This is more than the ordinary Polaroid photographer might hope for, but Serios gave back more than the ordinary photographer.

5 Polaroid Values

Polaroid was well aware of the exploits of Ted Serios. In 1962, Stan Calderwood, vice president for marketing and sales, replied politely to a letter from Curtis Fuller, president of the Illinois Society for Psychical Research, who had investigated Serios before Jule Eisenbud got hold of him. Fuller wanted to know how easy it was to tamper with Polaroid film. Calderwood confirmed that it might be done in advance, but that he knew no way of doing so with fresh film purchased at random with the subject watched while loading and shooting.[1] The marketing man was remarkably indulgent of the enquiries from the Illinois outpost of Psychical Research, but Polaroid was not about to sign Serios on as a consultant, or provide him with a supply of film to continue his experiments. They already had plenty of reliable professional consultants on the books, including of course Ansel Adams. We have no record of what Adams thought of Edwin Land's theatrical turns with new products at the annual meetings, but he would certainly not have been impressed with the Chicago bellhop's paranormal variations on the party camera, given his dismay that the camera was so often considered no more than a gimmick.

For those unfamiliar with the history of Polaroid, it invariably comes as a surprise to hear of the company's longstanding, intimate, and fruitful affiliation with Adams. At the height of Polaroid Corporation's success, Adams was the jewel in the crown of the cultural wing of its operations, and 700 of his unique prints formed the backbone of the now dispersed Polaroid Collections. As a longtime employee, Adams was far from shy in his promotion of Polaroid and its film, and dedicates a chapter of his autobiography to his friendship with

Edwin Land.[2] Why then do Adams and Polaroid seem such strange bedfellows for those who do not know about the connection? No doubt it has something to do with the very contrasting popular public images that the photographer and the company enjoy. In the canon of twentieth-century American fine art photographers, Adams figures in the very first ranks, whereas the term "Polaroid" mainly carries associations of mass snapshot photography. Adams, a photographic interventionist, is perhaps best known for his complicated Zone system and the infinitesimal adjustments he made to aperture, shutter speed, focus, pre-exposure, and so on, in controlling the making of the image; Polaroid consistently took the lead in the photographic industry in automating all aspects of picture-taking, gradually removing responsibility from the camera operator for all functions except selection and framing of subject matter. Adams was a fetishist of the "perfect print," strongly advocating the importance of darkroom skills in the production of the final image.[3] Polaroid, in contrast, did away with the darkroom, or at least miniaturized it and made it portable, eventually excluding all possibility of the photographer's intervention in the developing process. However, far from being some sort of special case or exception to the rule, Polaroid's relationship with Adams simply crystallizes a theme that runs right through the history of instant photography: its simultaneous association with both high and low levels of social and cultural value.

Perhaps nothing sums up this odd situation better than Polaroid film's reputation for deterioration. As Billy Bragg's "St. Swithin's Day" (1984) has it,

> The Polaroids that hold us together
> Will surely fade away
> Like the love that we spoke of forever
> On St. Swithin's day.[4]

Bragg is by no means the original source for this prejudice, but he gives voice to a common perception that a defining feature of the Polaroid image is its transience. It is as if, just as it magically fades up from a gray green murk after exposure, the Polaroid image is destined to return to that formless slime. Given the date of Bragg's song, he clearly has integral instant photography in mind, like most others who

subscribe to this widely shared view. But all color film fades, especially if exposed to light or humidity, and SX-70, or Polaroid 600, or Spectra images, if stored under suitable conditions, will retain their original colors perfectly well. There is even evidence that SX-70 prints have greater fade resistance and image stability than many other types of color film.[5] This is thanks in large part to their metalized dyes, which were much less susceptible to deterioration than the organic dyes usually used in color film. In addition, the mylar screen of integral Polaroid prints offered them further protection not enjoyed by conventional color prints.[6] What is certain is that SX-70 images were infinitely superior to the competing instant prints from Kodak, which under rigorous testing were shown to have very poor light fading stability.[7] Kodak PR10 images (1976) were so subject to fading that Polaroid executives would tape them to their windows and show them to visitors, "all but obliterated" in a few days.[8]

Cultural perception easily trumps scientific evidence. The fact that Polaroid images fade no more quickly than other kinds of color print is much less important than the persistence with which they are taken to do so. Whether or not Polaroid snapshots actually fade is almost beside the point: their meaning in culture is as that which fades, and a collective hallucination of their fading follows on from this. The reasons for the hallucination are not hard to find. Polaroid images, generated quickly and consumed on-the-spot, have been judged against the principle that living fast means dying young. This and other unfounded slanders were a source of immense frustration to Polaroid's highly innovative team of research chemists and camera designers, who since the late 1940s had been at the very forefront of developments in film technology *and* image preservation.[9] But as Bragg's lyrics make clear, to accuse something of fading is not necessarily an insult. In fact, quite the opposite, for it is the supposed fragility of the Polaroid image in Bragg's song that makes it an ideal metaphorical partner for a love valued even more because it was doomed not to last. The fact that most Polaroid prints are positives with no usable negative, and therefore unique artifacts not subject to mechanical reproduction, can only add to their perceived fragility: ephemeral, they are also irreplaceable. Here, summed up in a familiar paradox of love poetry, is the basic double bind of cultural value as it relates to instant photography: an extraordinary scientific and technological achievement results in a

consumer product so simple and efficient in its uses that it comes to be thought of as the lowest common denominator of photographic skill.

Of course, photography has always had a precarious relation to cultural value. As Walter Benjamin put it, those who argued for photography as an art were bringing it to a tribunal it was in the process of overthrowing. For Benjamin, the technological basis of photographic reproduction ruled out of court any conventional appeal to its aesthetic dimension.[10] In the long run, Benjamin lost this argument, with photography fully enshrined in the art gallery. Leaving aside aesthetics, and outside the art gallery, there have traditionally been two main methods for endowing photography with value. In general, photography can claim a higher status when it is expensive, or when it is difficult. At the outset it was both, and therefore the exclusive realm of either the wealthy amateur or the professional photographer. Photographic pioneers not only needed to make a considerable financial investment in the activity, but required a basic knowledge of chemistry as well as a commitment of "patience, resourcefulness and exertion" to a process involving delicate and awkward materials.[11] As George Eastman said of his early youthful forays into outdoor photography, "the entire procedure was complex and cumbersome, and also very costly."[12] Eastman's company was dedicated to removing these obstacles of cost and expertise by providing an affordable snapshot camera "that makes the practice of photography independent of special technical skills," as the first Kodak Primer put it.[13] Obstacles, however, are also guarantors of cultural value, and by removing them, Kodak ensured from 1888 the devaluation of amateur photography, or at least of the snapshot photography practiced by the vast majority of nonprofessionals. That devaluation, Nancy Martha West has shown, went hand in hand with an increase in women photographers, for whom Kodak assumed that technological simplicity was a prerequisite.[14] Technical skill and high cost did not disappear from photography: in the twentieth century they were the privileged terrain of the professional photographer, and less securely, of the hobbyist or "serious amateur."

After Kodak and prior to digital, Polaroid contributed most to the mass-amateurization of photography, and therefore, one might expect, to its cultural devaluation. In fact, Polaroid value has always been unstable, protean. Like fast food, the Polaroid image is defined

by its speed of appearance—the proximity of its production and consumption—and is accordingly devalued; and yet at the same time it produces a single, unique print, and so possesses artifactual qualities. The professional photographic press, arbiters of photographic value, were often rapturous about the technical breakthroughs achieved by Polaroid, but dismissive of the potential non-amateur applications and anxious about the implications for the expert photographer of a camera that replaced the expert's functions. Just as Kodak's technological simplifications were taken to be a feminization of photography, so Polaroid's advances threatened the masculine competences of professional and hobbyist alike, although Polaroid's relation to its female users was by no means straightforward and evolved considerably over fifty years. For obvious marketing reasons, Polaroid itself was always keen to emphasize what the experts scorned in its products (simplicity of operation), and yet, equally, for long stretches of its history the company positioned itself at the luxury end of the camera market, and was associated with affluent users. What is more, Edwin Land insisted from the beginning on the aesthetic potential of Polaroid photography, even if his understanding of the aesthetic often had kitschy undertones.

Polaroid and the Photo Experts

Classes start tomorrow and the members of the group have been trickling in all day. I have as a roommate a Mr Shorey from somewhere in the Midwest who has the most phenomenal collection of camera gear I have ever seen in my life. I sit on my bed clutching my [Polaroid Land] 110 and saying, "But I like it."

NICK DEAN to MEROË MORSE, June 13, 1957[15]

One of the most effective ways to gauge what the guardians of photographic expertise—professional and hobbyist photographers—thought of Polaroid photography is to survey their responses to the two most striking Polaroid inventions: the original "one-step" photographic process of 1947–48, and the SX-70 system of 1972–73. At their point of introduction, and before their commercial success, the understanding of these novel processes was up for grabs. The initial reactions of photo-experts, at their most intense at this stage, and guided by prevailing assumptions and prejudices, were crucial in es-

tablishing future perceptions of the technologies. During the epoch of major Polaroid innovations, roughly the third quarter of the twentieth century, the main forum for such opinions was in specialized periodicals, usually published on a monthly basis. Magazines such as *Modern Photography*, *Popular Photography*, *Industrial Photography*, *British Journal of Photography*, *Camera*, and *U.S. Camera* were part of a long tradition of periodicals acting as repositories of useful knowledge.[16] Directed at an informed and expert readership, they also functioned to constitute their audience as experts.

As Carolyn Marvin has argued in relation to advances in electricity in the late nineteenth and early twentieth centuries, a group that has privileged knowledge of and access to rapidly developing technology tends to form "a self-conscious class of technical experts seeking public acknowledgement, legitimation, and reward in the pursuit of this task."[17] And as she notes, even if technology is a product of scientific and rational endeavor, it is often to the advantage of these experts to cultivate an aura of mystery around their expertise.[18] The judgments on photographic matters issued by specialist magazines may not be entirely intelligible to the uninitiated, but for that very reason they carry weight and authority. At a mundane level, photo-magazines serve to publicize and assess the latest developments in shutters, lenses, film types, light meters, darkroom chemicals, photographic paper, and so on. At the same time, the fetishizing of camera and film technologies in specialist photo magazines is an absolutely essential exercise in the definition of the photo-expert's domain and his difference from the non-expert, or snapshot photographer. To the photo-expert, the snapshooter is a figure of gentle condescension, at best just an eye and a finger, unable to bring to bear on the image-making process the array of technological controls that the professional or serious amateur masterfully manipulates. And yet, as John Szarkowski has pointed out, the third quarter of the twentieth century saw a rapid and marked erosion of this divide between the professional photographer and the amateur, with the amateur assuming responsibility for a whole range of photographic tasks that at one time required the special skills of a professional photographer.[19] The erosion of this divide was largely thanks to developments in camera technology, and has been accelerated even further by digital photography, which, as Rubinstein and Sluis argue, "made it possible to *see intuitively as the lens/*

camera sees without years of training."[20] If the response of the expert magazines to Polaroid announcements in 1947–48 was largely benign, whereas in 1972–73 it was decidedly ambivalent, even anxious, it is because the intervening years saw so many threats to the sovereignty of the expert photographer.

One-Step: 1947 and After

Edwin Land's choice of the Optical Society of America as the venue for a first public demonstration of his one-step camera made perfect sense, since up to that point, Polaroid was a company known primarily for its research in polarizing filters, with only a limited foray into photography during the war with "vectograph" technology—stereoscopic prints for monitoring troop movements. Although Land and Polaroid had no photographic pedigree, what they did possess already in abundance was scientific legitimacy. By definition worshippers of science and technology, the photo-expert magazines in 1947 were almost unanimously rapturous about the invention and often just reproduced verbatim Polaroid's own press copy about potential uses of the new camera. *Camera* hailed a "spectacular discovery which marks a great advance in the photographic process," calling it an "apparent miracle."[21] Ralph Samuels in *Minicam Photography* was "convinced that this one-minute innovation is far from being just another photographic novelty," predicting "it will render many pages of instruction in photographic handbooks as obsolete as tin-types."[22] *U.S. Camera* gushed that "not since the close of the last century when George Eastman first promised popular-priced cameras, daylight-loading film and a processing service has any photographic development caused such a stir in the camera field," concluding that Land's invention was "one of the most promising innovations in photographic history."[23] In a more bucolic vein, *American Photography* anticipated the camera's party function: "One can easily foresee a festive group on a picnic or some other joyous occasion producing dozens of snapshots."[24]

When Polaroid released its first camera for the consumer markets in late 1948, the reviews were also generally positive, but there was a marked cooling from the uniform admiration that greeted the purely technical announcement of 1947. There were instead clear indications of the reputation that Polaroid Land cameras would develop

for requiring little skill and allowing for little expert manipulation. *American Photography* noted that "the operator does not have to know anything about the mechanical processes involved. All he does after the usual focusing and shutter setting, is to push the button and pull a tab"; and the reviewer of the Model 95 for *U.S. Camera* sniffed at the camera's lens and its operation: "a bit disappointing in this day and age of fine lenses and shutters. The method employed takes it out of the 'professional class' of equipment."[25] *Camera* also felt that the new process, which provided only a single print, would be off-putting to more advanced photographers, anticipating that the "pictorialist who likes to manipulate his prints will bemoan the lack of a negative."[26] The most damning evaluation came from the British-based *Photographic Journal*, which was unhindered by the boosterism infecting American magazines, and complained, "The user gets just the one photograph he has taken, and there is no negative from which further prints can be made, nor can the pictures be enlarged."[27] The complaint about no negative was repeated by most magazines, which invariably noted that this absence more or less excluded the camera from commercial and professional applications. It was not by hazard that reviewers should focus so uniformly on the question of the negative and its manipulation. Darkroom skill was one of the key areas of difference between the professional or hobbyist and the unskilled snapshooter, but "one-step" photography had done away with the darkroom, and therefore threatened this marker of distinction.

Polaroid, with one of the most ambitious research programs in the photo industry, addressed many of the complaints and criticisms of the experts, producing in short order a copy service, a high-resolution panchromatic film (1955), a camera back allowing instant film to be used with non-Polaroid (i.e., professional) cameras (1957), Type 55 P/N film, which provided a reusable negative (1958), and an ultra-fast 3000-speed film (1959). Nevertheless, the original doubts of the experts stuck, and Polaroid continued to be thought of as a manufacturer of ingenious devices with limited applications. When the photo-magazines expressed their admiration for Polaroid products, it was often for their "foolproof" qualities, especially once the company started introducing electronics into their cameras with the Automatic series in 1963.[28] Polaroid itself encouraged this view of its cameras, as can be seen from a key tag-line in its television advertisements:

"Here's the gift for the man who knows nothing . . . about cameras."[29] The photo-magazines duly reviewed all Polaroid's new products, and in general thought highly of their research achievements (instant color film in 1963 was especially lauded) but the latent prejudice always lurked. For example, in its March 1969 issue, *Modern Photography* featured on its cover an image of the "Kookie Camera," a bizarre-looking novelty camera from the Ideal Toy Co., which was composed of plastic hands, pipes, nozzles, and a soup can. Inside, Herbert Keppler, under the title "Kookie Camera: Ideal's Answer to Polaroid?????," speculated tongue-in-cheek that the camera might pose a threat to Polaroid's core business.[30]

As I showed in chapter 1, Polaroid was not shy in promoting its cameras as toys, opening up their products to the sort of satire practiced by *Modern Photography*. However, Polaroid's reputation for producing clever but trivial machines did not square well with its intellectual ambitions, strongly devoted as it was to primary research and physically located directly between two of the country's most prestigious educational institutions, Harvard and the Massachusetts Institute of Technology. MIT was a stone's throw from Polaroid's Main Street Cambridge headquarters, and Harvard a short walk, and the company's relation with these two institutions was not just geographical. Many of its employees were graduates of one or the other, or moved between the company and the universities. Edwin Land was a Visiting Professor in Physics at Harvard between 1949 and 1966 and was Institute Professor at MIT from 1956, as well as making major donations to both, while William McCune, president and chairman after Land, graduated from MIT in 1939.[31] In other words, commercial imperatives may have dictated that Polaroid play along in its advertising with the image of its products as idiot-proof playthings for novice photographers, but there was a strong countervailing force within the company that insisted on more ambitious goals.

One of the ways for Polaroid to shape the expert discourse on instant photography rather than simply accept it passively was to get a direct foothold within the photo-magazines. From the very beginning Polaroid placed advertisements in the pages of all the major industry publications—*Modern Photography, Popular Photography, U.S. Camera, Camera*—and increasingly in prominent and expensive spots such as the inside covers. These placements were supplementary to Polaroid's

Figure 5.1: Cover, *Modern Photography*, March 1969.

main advertising strategy, which was geared towards national circula-
tion magazines such as *Atlantic, Harper's, Reader's Digest, Vanity Fair*, or
specialist periodicals such as *Boy's Life*, with the largest portion of the
budget directed towards television. These venues were where Polaroid
products found their most natural audience of consumers, but there
was clearly also a strategy to reach an expert audience more skeptical

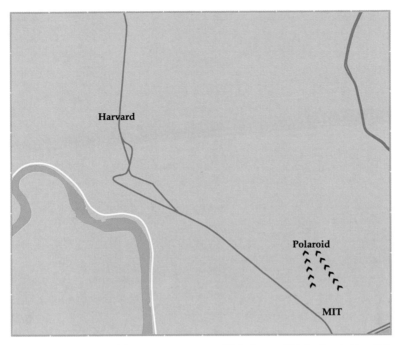

Figure 5.2: Polaroid buildings at intersection of Windsor and Main, Cambridge, MA.

about instant cameras and less likely to buy them. Apart from any-thing else, such is the symbiotic relation between magazines and ad-vertising that a strong Polaroid advertising presence no doubt went a good way towards ensuring a fairer reception for Polaroid products on adjacent pages. It may also have been what secured for John Wol-barst, a long-time Polaroid employee, a regular column on instant photography in *Modern Photography*. Running from 1955 to 1966, the column started as "Pictures in a Minute," changing in 1961 to "Pictures in a Moment" when Polaroid introduced film that developed in 10–15 seconds. Wolbarst's column, although nominally a neutral space for evaluating new instant photographic products or advising on their use, was really just another publicity site, where Polaroid products were uniformly praised, and Wolbarst habitually wrote such things as "The geniuses of Cambridge, Mass. have done it again."[32] Regardless of whether or not Wolbarst's was an independent voice, his column meant that there was an advocate for Polaroid at the heart of the photo-expert domain.

Another mode of infiltration into the expert camp was the book-

length manual. Along with Wolbarst's *Pictures in a Minute* (1956) and John Dickson's *Instant Pictures* (1964), Ansel Adams' *Polaroid Land Photography* (1963) acted as a sort of counter-blast to the slanders of triviality leveled at Polaroid photography. As a genre, book-length camera manuals might be thought of as one-off by-products of the specialist photo magazines, with a similar implied readership. Most cameras come with instruction guides, but not all have entire books dedicated to their use, and only more serious and dedicated users of a camera will turn to such literature. Each of these three manuals is addressed to a slightly different user: Wolbarst's is the most populist, aimed at the potentially "creative" photographer unskilled in the darkroom; Dickson's technophilic volume invokes "the expert user" as its audience; and Adams addresses his glossy book to "all photographers, and especially to the serious amateur and professional."[33]

Each in their own way, these user's guides emphasize the range of skills necessary to successfully operate a Polaroid Land camera, that is, they convey the very *complexity* of the whole process. For example, while the early reviewer in *American Photography* wrote dismissively of "pulling the tab," Adams, Dickson, and Wolbarst devote entire sections to this action and how it must be carried out very precisely in order to ensure high image quality. Wolbarst in particular is alert to his role in counteracting the scorn of the experts, acknowledging that "some people may hoot at the idea of doing creative photography with a camera as simple to operate as this one."[34] In other places he goes more on the offensive, arguing in an announcement of a Polaroid photo contest in his column that Polaroid photography makes demands that other formats do not: "Polaroid users are the only ones who *must* do every step correctly, otherwise, no picture [....] no stranger's darkroom skills, no intermediate manipulations can change the picture."[35] If photography needs to be difficult and demanding in order to deserve the respect of the experts, then what these writers show is how well Polaroid image-making meets these criteria.

And yet, despite these attempts to recover for Polaroid photography some of the supposed dignity of the serious amateur, the three writers, and especially Wolbarst, admit, implicitly or explicitly, that the simplicity of operation of the camera is its defining feature, even its main attraction. As Dickson puts it at the very start of his book, "A

process so startlingly simple might not, at first thought, seem to need a book, nor even a solitary paragraph, since it can all be summed up in a single sentence."[36] All three of these texts were written before the introduction in 1972 of the SX-70, the extraordinary ingenuity of whose chemical processes made redundant many of the elaborate skills Adams, Dickson, and Wolbarst painstakingly detail. So simple was its operation that it might seem ludicrous to have a specialist manual dedicated to SX-70 photography, and as the reactions of the expert press to this new camera testify, it only underscored the ways in which technical skill in Polaroid photography was devolving increasingly from the photographer to the machine.[37]

Absolute One-Step: SX-70 and the Redundancy of the Expert

Thanks to the "damning with faint praise" of the SX-70 by Messrs Goldberg, Rothschild, and Kirkland in the April issue, I state without hesitation that I wouldn't touch one of those things with a 40-ft barge pole.

A. L. ODLE, "Thumbs Down," letter to the editor,
Popular Photography, July 1973

In 1972–74 the technophilia of the specialist photo press was given full voice in its reception of the new SX-70. The *British Journal of Photography* called it "one of the crowning technological marvels of an age," *Popular Photography* said "the camera is truly an example of the kind of instrument we might have cradled in a time capsule so that our progeny can know what our state of the art was in the field," and *Rangefinder* hailed "one of the most impressive milestones in camera system design."[38] But the praise was deeply qualified by doubts as to the usefulness of the camera for the serious photographer. For Norman Rothschild, the SX-70 "lacks certain features that could make it a fully creative tool for some advanced amateurs and pros. The lack of any control over depth of field, due to the practically idiot-proof exposure automation, is one problem [. . . .] The other is lack of control over shutter speed [. . . .] The Polaroid SX-70 appeals to, and is eminently suited to, a mass market."[39] Rothschild implicitly equates "idiots" and the "mass market," and the same thing was implied by a leader comment in the *British Journal of Photography*:

The interest in the new self-developing material will be centred on two extremes in the photographic world. The first, the mass market at which it is directed, is interested in the freedom which such systems provide [. . . .] There is little or no interest in the mid-range of the photographic community until one arrives at those who are curious about the scientific and technical nature of the invention and who, indeed, may not themselves make much practical use of it.[40]

As this comment reveals, for the photo-expert, there is a clear division of skill and status in the world of photography, with the snapshooter using the SX-70 without understanding how it works, and the expert understanding how it works, but having little interest in using it.

The policing of boundaries between experts and snapshooters continues then, but there are also signs that the camera threatens to place the unskilled amateur on an equal footing with the expert. Hal Denstman, for instance, confesses, "I was embarrassed at times to admit how simple picture-taking could really be," and he is echoed by Douglas Kirkland, who writes, "I also found that the camera handles easily. As I jokingly remarked to one of my models, 'There's so little for me to do, it's almost embarrassing.'"[41] As this little anecdote of imperiled virility demonstrates, when the professional photographer looked into the SX-70, he could see figured there his own potential redundancy. And in the publicity in advance of the camera's launch, the specialist magazines, normally barometers of technological change, were themselves made redundant, as Polaroid gave the story directly to mass circulation magazines. Simon Nathan in *Popular Photography* reported: "*Time* magazine and then *Life* scooped the world's photographic press, each with cover stories on the new SX-70 Polaroid Land camera. Photowriters were able to read about this dandy new camera before they even got a preview model to try." Norman Goldberg, in the same magazine, found it difficult to contain his irritation that nonspecialist publications had been shown the camera first, alluding to "those who were privileged to break the news for the first time to the public."[42] The photo expert's prestige is predicated on advance knowledge of new technical apparatus, of being ahead of the curve, even prescient in such matters. For *Time* and *Life* to make the announcement of SX-70 was certainly a blow to that prestige. But the marketing and publicity people at Polaroid knew what they were doing: not only did the cover

stories in national magazines ensure a much wider audience, they also showed that SX-70 was not just a story about photography. The new device was first and foremost a sort of technological marvel requiring spectacular public display rather than sober expert assessment.

As Carolyn Marvin has observed, the expert's jealous guardianship of the secrets of technological know-how has usually been a gendered affair, and it was no different with the specialist photo magazines, whose addressee was almost uniformly masculine in the period 1945–80.[43] In this context, it hardly needs stating that when the expert photographer is impotently left with "so little ... to do," the technology has stopped serving as obedient guarantor of masculine competence and instead threatens to supplant that competence entirely. This is not to say that Polaroid technology heralded a new age of egalitarian thinking in photography. In fact, in their early strategizing and advertising campaigns for the first cameras, the company tended simply to reproduce standard stereotypes about photographic skill. Land reportedly nagged his design team that the camera was meant for "the mothers of America" and therefore "must be kept simple, mother-proof."[44] A Polaroid publicity brochure from 1954 explains that "many women who have been baffled by the complexities of other high-quality cameras get perfect results on their very first pictures" and goes on to note that children also have much success with the camera.[45] In *Pictures in a Minute*, meanwhile, John Wolbarst invokes Land's fantasy mother as the ideal target for the easy-to-use Polaroid, since "she may not have the time or desire to master the technicalities of conventional photography."[46]

From the mid-fifties to early sixties, Polaroid had on their payroll as a consultant one such exemplary mother, Laurie Seamans, who, just like Ansel Adams, received regular supplies of new cameras and film in order to test them out. Her feedback was taken very seriously by Polaroid, as attested by her detailed correspondence with Meroë Morse in the Black and White laboratory. Six of Seamans' Polaroid photos are among the illustrations for *Pictures in a Minute*; under the title "Housewife's Album," her images of pets and children appeared in Wolbarst's *Polaroid Portfolio #1* (1959), as well as in the *Polaroid Minute Man*; and she was invited to New York to appear on the *Garry Moore* show in 1961. Around that same time, Marion Lorne and Carol Burnett were regularly playing up their supposed technical incompetence and terror of

photo-technology on the Moore show whenever they were roped into live demonstrations. After some standard business to show their inexperience with such a masculine activity—such as holding the camera the wrong way round—these female cast members duly demonstrated that even they were capable of using a Polaroid camera. Twenty years later trash films director John Waters continued the tradition in a different key in *Polyester* (1981), putting one into the hands of another iconic "mother of America," his heroine Francine Fishpaw (Divine), who uses it to document the infidelities of her husband, Elmer.

By emphasizing the simplicity of use of their cameras, Polaroid's marketers were sticking to the tried and tested path already laid out by Kodak, which had consistently promoted the ease of picture-taking by pointing out that even women and children could do it well.[47] Polaroid was also keen to hit as many "price points" as possible with its cameras, and wanted male as well as female users, so it made sense to push its cameras along gender lines.[48] The company subscribed to Kodak's assumption that cheaper cameras would be used by women and children, with father drawn to the more expensive and advanced gear.[49] In the 1950s its top-of-the-line camera, the Pathfinder—"deluxe, precision-built [. . . .] a magnificent photographic instrument," as a publicity brochure put it—was aimed at men with its $249.50 price tag.[50] In the same brochure, the cheaper ($69.95) and lighter Highlander, was aimed at women consumers: "It's so easy to operate, women use it with pleasure."

Internal Polaroid instructions for Highlander marketing urged publicists to stress the ways in which the "female point of view" had been taken into account in the design of the camera, and how Meroë Morse had been consulted throughout the process as a representative of this point of view.[51] With such mixed signals flying around—that more complex cameras are for men, but all the cameras are easy enough for women—it was no wonder that the message sometimes failed to get through and default positions about technical competence were assumed. For example, Polaroid heavily geared its advertising for the Swinger in 1965 towards female users, but prevailing assumptions were not easy to shift. In December 1965 issues of young women's magazines, the Swinger appeared in pages devoted to gift ideas for men, along with tennis rackets, electric razors, cuff links, and velour sweaters.[52]

By the late 1970s and early '80s, when various models of SX-70 technology had come to dominate snapshot camera sales, and women were known to be heavy users of instant cameras,[53] Polaroid had abandoned the myth of masculine competence with technology, or rather, radically reconfigured it. Its new model of photographic gender roles can be found in a long-running series of popular television ads starring James Garner and Mariette Hartley as husband and wife. These ads mainly featured the OneStep camera, touted by Polaroid as "the simplest camera in the world." In the ads, Garner was always the photographer and was given responsibility for outlining the features and functioning of the cameras, such as they were; Hartley would make dry and skeptical quips from the sidelines. The success of this ad sequence is usually attributed to the chemistry between the two leads, but it might have as much to do with the way it retains photography as a male preserve even in the absence of any need for supposedly masculine technical savvy. Garner's character has no special photographic skills; Hartley's remarks even draw attention to this. In fact, the dialogue between the two often gives the appearance of undermining male privilege, with Hartley regularly bursting the bubble of Garner's smooth and seemingly knowledgeable spiel about the cameras and film. Harry Falber at Polaroid, one of the designers of the ads, confirms that the aim was to make Hartley's character intelligent, perceptive, acute, but that they didn't want to "put her in eyeglasses or a three-piece suit" to make the point.[54] But this appearance of undermining privilege is just that: it never extends to Garner giving up the camera, as she invariably poses and he snaps the picture. What is more, vex him though she may, Garner never loses his composure or relaxed dignity. In other words, he is too easygoing to worry about being an expert.

The Garner and Hartley ads offer a model of a male photographer *comfortable* with a lack of technical skill. The photo experts, meanwhile, remained unconvinced. As Bill McCurry, president of McCurry Cameras, reported to a photo-dealers' roundtable in 1979, he sold plenty of Polaroid cameras, but had problems getting his expert staff to promote them. This staff, trained in fine lenses and professional gear, looked down on Polaroid customers, and McCurry found that staff on the photo-finishing counter did a much better job selling instant products.[55] As a British television advertisement in 1986 for Polaroid starring the comedian Hugh Laurie made clear, it was now

the male expert who was dispensable, an endangered being. In the ad, Laurie, a bumptious figure who fancies himself something of a master photographer, brings out the various trappings of photographic gear—light meter, tape measure, spotlight—only to be disappointed in each case by a patient voice-over that tells him the camera itself will do all these tasks for him. If the simplicity of Polaroid cameras drew the scorn of the photo experts, it may have been because they implicitly recognized the threat the cameras posed to their expertise.

Mass Consumption and "Prestige"

In spite of the best efforts of Adams and others to lend them legitimacy, Polaroid cameras were treated for the most part with condescension by the photo-writers of the world. A familiar pattern saw these experts dazzled by the sheer technical brilliance of Polaroid's scientists, but contemptuous of anyone who might use a camera in which the technology did all the work. That technology had of course been developed at great cost, a cost that was handed on to the consumer. If the sheer simplicity of Polaroid photography contributed to its cultural devaluation, then its great expense—when it was new—endowed it with another sort of cultural value. As an ad for the Model 350 appearing in the *New Yorker* and similar titles in October 1970 had it, "The privilege of doing practically nothing has its price."[56]

Looked down upon by the experts, some Polaroid cameras were nevertheless extremely expensive. There is no contradiction here; in fact, for sociologist Pierre Bourdieu, the one is the corollary of the other in photographic practice:

> possession of equipment, even a considerable range of equipment, seems to be an effect of income rather than a sign of dedication; precisely because of their accessibility, the most expensive cameras and accessories are not necessarily associated with an enthusiastic practice.[57]

In other words, the symbolic value of an expensive representative of the fine camera field matters as much to its owner as any purely photographic functions it may be capable of performing. A wealthy person cannot risk being seen with a cheap camera, but equally, must not

dedicate too much energy to using the fancy camera, which is mainly for show. If we return briefly to the Hugh Laurie ad, Bourdieu helps us to understand what is being mocked there. The would-be expert flummoxed by a camera that does it all for him is in fact part of a tradition of satirical censure of the "vulgarity" of the "passion for photography," a censure "which reprimands the naïve enthusiasm of photographic fanatics and gibes at their ridiculous paraphernalia."[58]

The SX-70 came with plenty of paraphernalia for anyone with deep pockets, and Polaroid's glossy literature on the camera also made claims for its profound cultural significance. Land's introduction to "The SX-70 Experience" asks, "Is it magic that our magic device in its technological innocence appears on the scene suddenly as an invaluable instrument for discernment of prehistoric bonds to each other? Or does the race simply await the random arrival of technologies that prove benign, interspersed amongst those that prove to be evil?"[59] In retrospect this sounds rather grandiose, but there is no reason to believe Land was not genuine in his hopes for the camera. It was with such ambitions in mind that Charles and Ray Eames were enlisted to make their short film about it, complete with score by Elmer Bernstein and a concluding commentary by the eminent physicist Philip Morrison. That the leading designers of the era agreed to make the film shows the extent to which SX-70 was considered a cultural as well as a technical achievement, even if, as I showed in chapter 1, the film brings to the fore its toy-like qualities (Charles Eames went on to make a promotional short about the Polavision movie camera, and the couple made a number of "Vignettes" using Polavision).[60]

Perhaps the greatest coup by Polaroid in the marketing of SX-70 was the recruitment of Laurence Olivier to work in his first and only television ad campaign. Olivier was performing in Paris at the time, and so took to the stage at the Théâtre Nationale to film the four spots. Announcing the "age of miracles" and describing the camera as "quite simply doing the impossible," he proceeded to photograph bunches of flowers in one ad, an antique clock in another. The flowers were to illustrate the color palette of the film, the antique clock to suggest fine craftsmanship and cultural value, but more important was the absence on the Parisian stage of those old standbys of snapshot photography: children, pets, birthday parties. Polaroid might have sought out a more recognizable American face to front the SX-70 campaign, but

the choice of Olivier, whom they considered the world's finest actor, made clear the intended associations of the SX-70 with high culture.[61] As with Charles and Ray Eames, the fact that Polaroid convinced Olivier to do the ad gives a sense of the cultural cachet of the SX-70. Candice Bergen, who was also part of this campaign, when asked why she agreed to do the ads, replied, "Polaroid seemed to be very compatible with my interests in terms of photojournalism. And then I'm a sucker for prestige."

In spite of all these efforts, Polaroid's prestige status was always fragile. No mass-produced consumer object can consistently lay claim to exclusivity, and even Polaroid's spokespersons undermined the case. Olivier stipulated that his ads not be shown in England, and within three years, Bergen could be seen parodying her own Polaroid ads on *Saturday Night Live*, where she wielded an "FX-70" that delivered processed cheese slices directly into the hand.[62] Polaroid's official line may have equated the SX-70 with intricate hand-made artifacts such as antique clocks, but they were fighting a powerful public assumption that their products were no different from other mass-produced and synthetic objects. It may even come as a surprise to many that Polaroid cameras should ever have been considered top of the fine camera field. If you were to ask five people at random whether they think of Polaroid cameras as expensive and sophisticated or cheap and junky, you would no doubt get five different answers, but chances are more of them would plump for the latter than the former. It would depend on whom you asked, and it would depend on the camera, but both types of answer would be perfectly possible.

The pressures of the market and the imperatives of growth are rarely compatible with an emphasis on exclusivity, even if it is the job of advertising in mass culture to tread the fine line between populism and the promise of luxury. Polaroid cameras were no different from most consumer technology, which tends to be highly expensive at first, but drops rapidly in cost as it becomes established. The history of Polaroid cameras follows a pattern of expensive early models (the Model 95 in 1948, Pathfinder in 1952, SX-70 in 1973) then cheaper simpler versions in due course (Swinger in 1965, OneStep in 1977). As might be expected, the fluctuations in cultural value of Polaroid photography are intimately linked to the fluctuations in its cost. The added complication is that the expensive and cheap forms often overlapped, and it

is for this reason that the class associations of Polaroid photography were rarely entirely stable. So, for example, in Carlos Saura's *La caza* (1966), the Polaroid photographer Enrique (Emilio Gutiérrez Caba) is upper-class and modern; while around the same time in Bob Rafelson's *Five Easy Pieces* (1970), when Rayette (Karen Black) uses a Polaroid Automatic it is just more evidence of her vulgarity and lower social class, placing her in stark contrast to the piano-playing Robert (Jack Nicholson).[63] Francine Fishpaw, meanwhile, seems to be wielding a top-of-the-range SX-70 Sonar, just the sort of prestige camera you would expect to find in the rich suburbs of Baltimore.

"Creativity" and Cultural Value: Polaroid Kitsch

Polaroid's prestige camera of the mid-1980s was the Spectra Onyx, among whose notable owners was George H. W. Bush. President Bush's favored Onyx came with a large-format glossy booklet that strained to convey the camera's classiness. Its cover is simply a close-up cross-section of black marble. Inside, color Spectra prints of a woman in evening wear and jewels are reproduced against the background of a Mediterranean villa in black and white. Classical statuary, ceramics, and columns are prominently visible, but in case the connection between the Spectra Onyx and ancient art is not clear enough, the text spells it out: "As you can see, engineering can be considered an art form in more than one sense of the word. Classic lines and a sleek black body; Onyx combines technological innovation with elegance, in a style all its own."[64] Although it is evidently not meant to be, the juxtaposition of *Dynasty* and Doric is, in retrospect, rather jarring.

The designers of the Onyx booklet may not have been aware of it, but their disconcerting mixing of high and mass culture had a strong precedent, for at Polaroid the links between photography and ancient statuary were longstanding. From 1934 Land had collaborated with Clarence Kennedy, professor of art at Smith College, on projects in three-dimensional photography, including the war-time vectograph technology. Kennedy was an important innovator in the photography of ancient and Renaissance Italian sculpture for teaching purposes, experimenting in particular with stereoscopy in order to give students a sense of depth in statuary. The word "Polaroid" was Kennedy's coinage, and he not only brought Land into research on photography, but

Figure 5.3: Spectra Onyx promotional booklet, 1987.

also acted as a talent scout at Smith College for Polaroid, recruiting for them such key employees as Meroë Morse and Eudoxia Muller, as well as having taught Terre, Land's wife. Ansel Adams included a number of pictures of statuary in his *Polaroid Land Photography Manual*, which also contained a chapter devoted to "Reproducing Works of Art." After Kennedy's death in 1972, Polaroid founded a photography gallery in his name at company headquarters in Technology Square, Cambridge, and the 1978 *Polaroid Annual Report* honored his work in photographing ancient statuary.

Kennedy's influence on Polaroid company culture and ideals cannot be underestimated. His close friendship with Land implanted artistic ambitions and the artistically trained at Polaroid from very early on. If simple economic realities ensured that the Polaroid camera oscillated between cheap and steep in its commodity identity, within the company itself there was a fairly consistent expression over the years of its aesthetic vision. When Land introduced the one-step process to the Royal Photographic Society in 1949, he claimed that Polaroid's aims were "essentially aesthetic," and that the objective was to encourage artistic creativity in its users.[65] Almost thirty years later, in a letter to Shareholders in 1977, Land reaffirmed this stance, writing

It is gratifying [. . .] that with the ever increasing simplicity of our cameras combined with the present characteristics of the film, the

population of aesthetically competent photographers is expanding rapidly. Thus some 15 billion pictures after we first expressed our hope [. . .] our dream is being realized.[66]

The same basic ambition—to open the possibilities of creative expression to a broader portion of the population—is echoed by Polaroid literature throughout its history. This might all be dismissed as so much standard boilerplate (after all, more photographers equals more sales, and Polaroid relied on film sales for the majority of its turnover) except that Polaroid always had a clear set of activities backing up its official corporate theory. For example, the company ran numerous photographic workshops for its own employees, many of these led in the 1950s and '60s by Ansel Adams. This training often resulted in non-photographer employees becoming professional photographers, and for many years from the mid-1970s Polaroid ran annual photo competitions among employees, events that also produced new photographers and exhibitions at the Kennedy gallery, some of which went on national tours.

The corporate encouragement of creativity in photographic practice was extraordinarily flexible in its application and open to many interpretations. Adams, the fine art purist and head ideologist at Polaroid, tended to insist on the special formal properties of the film, its high ASA speed, its high resolution, and its unique tonal qualities, and the images he produced on Polaroid film were marked by their departure from vernacular norms of composition and subject matter and a tendency towards abstraction. Creativity, from this point of view, emphasizes the unique vision of the individual photographer. A very different understanding of the term can be found in Wolbarst's *Pictures in a Minute*, which confidently announces that the Polaroid "is the most creative camera of them all."[67] He means by this that with a Polaroid camera, you can achieve the same sorts of technically competent picture-taking that the serious amateur would expect to achieve with a more complicated camera. His technical advice on shadow, lighting, close-up, exposure, and framing is as conventional as the themes that he picks out for possible subject matter: "People and windows," "Tips on group shots," "Still life, hobbies," "Pets around the house," and a long section devoted to those staples of everyday photography, babies and mothers.[68]

Baby and pet photographs are sentimental and highly convention-alized; to subject them to aesthetic judgment is to risk accusations of kitsch. If, as art historian Tomas Kulka suggests, kitsch happens when mass forms pretend to the aesthetic distinction of the elite forms that they have displaced, then the whole Polaroid-Landian project, with its uneasy oscillation between low and high levels of distinction, begins to look like a monumentally kitschy enterprise.[69] According to Theodor Adorno, the typical kitsch product attempts to fuse "the art of a former time" onto a present object. This definition captures perfectly the awkward juxtapositions of ancient statuary, modern imaging technology, and eighties fashion in the Spectra Onyx booklet.[70] Adorno goes on to say that "by serving up past formal entities as contemporary, [kitsch] has a social function—to deceive people about their true situation, to transfigure their existence."[71] By placing the Spectra Onyx in a classical Italian villa, the promotional booklet makes it out to be an aristocratic device, when in fact the Spectra, like any object of mass culture, is readily available at a price, and is therefore just another symptom of the disappearance of genuine luxury. As Jenny Diski puts it, an object "is no longer a luxury if hundreds of thousands have it, no matter how expensive it is."[72] It is also in this light that we should consider the high-quality leather on the SX-70 of which Edwin Land was so proud. For what is it but an attempt to bind the values of a long-extinct artisanal culture onto a mass-manufactured object?

Another way in which Land sought to fasten the values of high culture onto Polaroid photography was through the company's work with museums and art galleries in the reproduction of artworks. Following the path pioneered by Kennedy in his photography of sculpture, Polaroid established a program in the 1970s to produce high-quality close-ups of paintings. In the first instance this was done in collaboration with the Museum of Fine Arts (MFA) in Boston, where works in the collection were photographed using the large 20 × 24 inch camera which had been developed in 1976 for this purpose. Polaroid eventually took this show on the road, making photographic reproductions of Goya in Madrid and Da Vinci's *Last Supper* in Milan, proceeding on to the Vatican, where Raphael frescoes were reproduced in 1986. An even bigger "room-size" camera was built and housed at the MFA to produce ultra-large-format 40 × 80 inch prints, allowing for single paintings to be reproduced in great detail and to actual size.

In the first instance, the Museum replica program was driven by the desire to conserve and educate—fragile artworks were copied in high resolution, and magnification could reveal to scholars details previously unseen by the naked eye. For example, in 1977 MFA curator Jan Fontein asked Polaroid to photograph the unfaded back of a tapestry so that the original colors and construction could be publicly displayed.[73] But this program must also be seen as part of a wider culture of enthusiasm for the copy that both Umberto Eco and Jean Baudrillard diagnosed around this time. In cultures of simulation or hyper-reality it becomes increasingly difficult to distinguish the original from the copy, and the copy may even be valued more than the original, may take on an authenticity of its own.[74] In the case of Polaroid copies of classic artworks, the distinction is even further blurred, since the Polaroid print is itself a singular object, a direct positive with no usable negative. Recognizing the kitschy potential in its reproduction of artworks, Polaroid in the mid-1980s established with the MFA the Polaroid Museum Replica Collection. Presumably aimed at the same market as the Spectra Onyx, the Replica Collection offered clients the chance to "Experience the Magnificence of these Masterpieces in Your Own Home!":

> you can enjoy superbly executed reproductions of these extraordinary masterpieces right in your own home [. . . .] unlike a typical reproduction which is printed by the thousands in a location far from the original [. . .] each Polaroid Replica is created in limited quantities and compared *directly* to the original right at MFA [. . . .] many feel the replicas are virtually indistinguishable from the original.[75]

There were series of replicas devoted to American and French paintings, as well as a special Monet sequence. A customer of the Replica Collection could get *Water Lilies I* for $890; *Field of Poppies Near Giverny* for $695.

This discordant mix of high and low culture was perfect for John Waters' purposes in *Polyester*, and Waters was not alone in exploiting the kitschy potential of Polaroid photography. In what is best described as an operation in meta-kitsch, artist William Wegman in the late 1970s and early 1980s posed his weimaraner, Man Ray, for a series of large-format Polaroid portraits. As Wolbarst's manual makes clear,

"pets round the house" is a key sentimental category of popular photography. Wegman gives a nod to this sentimentality in the title of a volume in which the Man Ray portraits appear—*Man's Best Friend*—and in such images as "Actor's Nightmare" where the dog poses with a baby against a traditional studio portrait backdrop.[76] Anthropomorphized dogs are of course a notorious subject of the kitsch tradition (as in C. M. Coolidge's series of paintings, *Dogs Playing Poker*) and Man Ray appears in many of his portraits in various bits of human garb, or, for instance, in bed with another dog in "Ray and Mrs. Lubner in Bed Watching TV."[77] In a later image once held by the Polaroid Collection, "Serving Trout," three weimaraners pose in a bucolic fantasia of a bygone American backwoods life.

As the photo credits for *Man's Best Friend* tell us, the images "are all one-of-a-kind 20 × 24-inch Polaroids, made on Polacolor II and Polacolor ER film."[78] In 1979 Polaroid had opened the first dedicated 20 × 24 studio in Cambridge, MA, and subsequently installed the cameras in similar studios in Boston, New York, San Francisco, and Prague.[79] Because of the unwieldiness of the camera, artists and photographers who wanted to make use of it were obliged to come to the dedicated studio and operate the camera with the assistance of a team of technicians. So, just as Polaroid cameras, in cheaper versions of the SX-70 technology, were saturating the photography market, here was an instant photography system whose scarcity and expense of use meant that the pictures produced on it were automatically endowed with the aura of the art object. Even though they have undergone reproduction and re-sizing to appear in book form, Wegman's images, we are reminded, are one-of-a-kind, and so the double bind of cultural value and Polaroid remains operative: the name of the dog may be Man Ray, but the pretensions of high culture must be invoked tongue in cheek, for if not, the kitsch is purely unintentional.

6 Just for Snapshots?

William Wegman's weimaraners featured prominently in June 2010 at Sotheby's auction of a select group of photographs from the Polaroid Collections. His "Avalanche," showing Man Ray being showered in flour, was first on the block, selling for $30,000, well beyond the estimate price of $7,000 to $10,000. There were more Wegmans to come in the sale, but the money they commanded was dwarfed by others. A single artist record was set for Lucas Samaras, whose "Ultra-Large (Hands)" went for $194,500. At $254,000, Andy Warhol's "Self-Portrait (Eyes Closed)" was also an artist record (for a photograph), and the five Warhol images on offer together made $486,000. In total Polaroid's creditors netted $12,467,638 over two days. The sale was controversial, since it dismantled for good a historically important collection of photographs over which the photographers, who had officially donated them to Polaroid in return for free film, might still have had some claim.[1] Nevertheless, by the crudest of measures, the auction was confirmation of Land's hope that Polaroid would open up new opportunities for artistic creativity. In fact, if you had followed closely the many column inches devoted to the story of the sale, you could be forgiven for forgetting that Polaroid was primarily a snapshot form and not a technology expressly devoted to producing expensive artworks.

Polaroid, it is true, was not always a snapshot company. At the beginning, in the 1930s and 1940s, its revenue came from artificial polarizers and war contracts. Near the end, it had diversified away from the amateur snapshot market to the extent that two-thirds of its business was industrial or commercial.[2] In between, from the late

1940s to the 1980s, by far the largest portion of its income came from sales in the amateur field. Between the introduction of instant photography in 1947 and 1960, sales in all other fields were static, with the exception of one "freak" year, 1953, when Polaroid sold $6 million of 3-D movie glasses (the technology, based on polarizing light, was pioneered by Polaroid).[3] In the early 1960s, just before the great boom set off by the Swinger, two-thirds of Polaroid's business was already in amateur photography, and in 1970 *Fortune* reported that 80% of Polaroid sales were in this field.[4] According to a Merrill Lynch study of the corporation in 1979, from the launch of the SX-70 till the end of the 1970s sales of amateur products were highly volatile, swinging wildly from year to year. Nevertheless, the same report showed that sales of non-amateur film remained steadily at about 20% of overall units sold throughout that period.[5] Compare this with Polaroid's great photographic competitor, Kodak. In 1960, only 28% of Kodak's business came from amateur photography, a market in which it was by far and away the world's leader.[6] Kodak had a half-century head start in the diversification game, but even it was considered overdependent on its photo-business in 1993 when 35% of its revenue came from sales of film and paper.[7] In the same year, depending on the figures one quotes, 85–90% of Polaroid's revenue was from instant photography, either amateur or professional-industrial.[8]

In its peak years, then, Polaroid was a snapshot company, and this fact was reflected in its popular public image. But it was also a big company, which made major contributions to non-amateur fields as varied as law enforcement, I.D. photos, insurance adjustment, medical imaging, micrography, and professional proofing. For reasons I have outlined in the introduction to this book, these practical applications of instant photography, however significant they may have been in their respective fields, had very little impact on how Polaroid photography was perceived in the wider culture. Inside the company, it was another matter. Polaroid did not always recognize itself in its popular image, and sometimes even downplayed the importance of the snapshot business to its identity, whatever the financial spreadsheets might have said. For example, in 1979, a prospectus aimed at potential employees went to great lengths to detail Polaroid's credentials outside the amateur field:

Polaroid is best known for the fun images our cameras create [. . . .]
But there are other Polaroid photographs [. . .] millions each year [. . .]
that are taken for more utilitarian purposes. A brain scan. X-rays.
Dental photography. To document a report. Photograph valuable
jewels. Take mug shots. Make instant color passport photos. Sup-
port insurance claims. Sell real estate. Professional photography.
Ultrasonography. Tomography. Thermography. Photo-micrography
[. . . .] Instant photography is a very serious business at Polaroid. On
the one hand, we are a snapshot company. On the other, a company
dedicated to furthering the art and science of instant photography
for the sake of function.[9]

This document was published at the absolute height of the OneStep
boom that had sent revenues skyrocketing, and yet it nearly slanders
the golden goose. It is all very well to make a fortune selling fun cam-
eras, it seems to say, but don't assume that Polaroid doesn't take pho-
tography seriously.

We do not need to look far to find the sources of this dissatisfaction
at Polaroid with its public image, and its express desire to be taken se-
riously as a photographic company. The explanation is partly financial.
Polaroid had too many eggs in the snapshot basket and was keen in
the late seventies to diversify into less volatile fields. There were also
less tangible but equally powerful cultural reasons for this desire. The
Cambridge setting, the emphasis on primary research, the influence
of Ansel Adams, Clarence Kennedy and a host of Smith College art
history graduates, and above all Edwin Land himself, all contributed
to a cultural ambition in the company at odds with the low social sta-
tus of a camera that "did the rest." As Sam Yanes, vice president for
corporate communications in the 1980s, puts it, "This was a very in-
tellectual place!"[10]

The ambition to be more than just a snapshot company was shown
when Land spoke of freeing, through technological assistance, the
artistic competence latent in untrained photographers, or when Po-
laroid attached itself to high culture through such projects as the Mu-
seum Replica Program. It was also evident in all the practical applica-
tions of instant photography. As the long list in the 1979 prospectus
makes abundantly clear, instant photography was applied to a huge

variety of purposes beyond the amateur snapshot. This strand of work at Polaroid had been formally dubbed, in a special supplement to the 1967 Annual Report, "The Useful Image." There were many circumstances under which it was useful to have an image quickly and without needing a darkroom. Police used them at crime scenes to preserve the chain of evidence, with the added advantage that the images were difficult to tamper with. Professional photographers used them regularly to test lighting before a photo-shoot, and increasingly as final art after Polaroid introduced its Type 55 positive-negative film. Polaroid manufactured a range of photo I.D. systems which could quickly produce a high volume of I.D. cards, and the MP-3 and MP-4 (for Multi-Purpose) cameras were used across the range of science and industry.

Polaroid's experience in making useful products pre-dated its involvement with photography. Unlike Kodak, which had begun as a business dedicated to amateur photography before expanding massively into allied fields in cellulose derivatives, distillation products, and other industrial chemicals, Polaroid had started with more utilitarian objectives before moving into consumer amateur photography.[11] Well before Polaroid's contribution to the war effort, Edwin Land's first major business idea had been an eminently useful one. In the 1930s he took to the American auto-industry an offer to make glare-less headlights which would greatly reduce nighttime crashes caused by blinded drivers. The intransigence of Detroit car-makers meant that the project failed, to Land's lasting disappointment, but the commitment to utility remained.[12]

It is a commitment that has been recorded for posterity in a series of high-profile advertisements, usually glossy double-page spreads, that ran in *Scientific American* from 1961 until 1981, when Land was about to leave the company. These ads were designed by Doyle Dane Bernbach in their minimalist house style, with plenty of white space, and the company name a discreet presence. Many of them contained a didactic element, fitting to the magazine, although not as pedantic as the ads run in the same periodical by Eastman Kodak. They promoted key new inventions—infrared and 10,000 speed film, positive-negative film, close-up and industrial view cameras—and trumpeted the many practical applications of Polaroid's freshly patented products, sometimes with short narratives about actual users. An educated reader might not have understood every single one of the twenty-five

Figure 6.1: Polaroid advertisement in *Scientific American,* March 1964.

applications listed in the March 1964 ad, but would have been left in no doubt as to the usefulness of Polaroid film. These ads were something of a pet project for Land, who had a longstanding friendship and collaboration with *Scientific American* publisher Gerry Piel, and they stood out in the pages of the magazines, strikingly stylish among more mundane publicity.[13]

Aesthetics and utility: these were the twin pillars upon which Polaroid felt its "serious" reputation should rest. By calling Polaroid "a company dedicated to furthering the art and science of instant photography," the 1979 prospectus combined this ambition in a single phrase. It was a formulation that Land had offered in a key interview with *Time* magazine in the build-up to SX-70 in 1972:

It bothers us at Polaroid to see a world that could be ever so much more tender and beautiful if the full potential of science were realized. We think photography is a field through which that potential

can be achieved. That's the wonderful thing about photography—
you can have an inner world of science and an outer world of
aesthetics.[14]

A decade earlier Land had said that "industry at its best is the inter-
section of science and art," but from the early seventies, the emphasis
on symbiotic "art and science" really comes to the fore in official Pola-
roid documents.[15] What did art and science, or aesthetics and utility,
have in common that separated them from Polaroid's main business in
snapshot photography? They both promised something that Polaroid
snapshots struggled to lay claim to: *permanence*.

Polaroid film was, as I have noted, widely accused of fading.
Rather than accept these accusations at face value, I suggested that
the reputation for fading is a byproduct of the cameras' association
with parties and fun, with play rather than memory-making. In many
hands, the Polaroid is a photographic toy, and toys run counter to
permanence: having no objective beyond play, they are consumed by
it, and so looked down upon. This problem is less acute in the Kodak
tradition, where memory, since the early twentieth century, had been
promoted as the main function of snapshot photography. There is no
reason why Polaroid photographs should not also function in this way,
and undoubtedly they do, but instant photography has still found
it hard to shake off the reputation for impermanence and frivolity.
Aligned with "art and science," on the other hand, the lasting power
of the Polaroid would not be in question. As the *Scientific American* ad
for March 1964 challenged its readers, "Do you still think 60-second
Polacolor film is just for snapshots?"

This final chapter takes up the issue of the useful and the beautiful
at Polaroid by continuing the theme of the previous chapter—cultural
value—but this time concentrating on Polaroid's interactions with the
art world. Those interactions are widely written about, with some well-
known protagonists. Polaroids were cameras of choice for Andy War-
hol and Robert Mapplethorpe, two prominent figures in the New York
art scene of the 1960s and 1970s, and in the same city Lucas Samaras
built a career around his manipulations of a range of Polaroid film
formats. David Hockney and others discovered that the SX-70 print
was perfectly designed for making collages, and Walker Evans, André
Kertész, and Minor White all produced a flurry of activity with the

SX-70 camera late in their lives. Polaroid's 4 × 5 and 8 × 10 inch large format films attracted many photo-artists who admired their near-grainless surfaces, and the very large studio-based 20 × 24 camera was exploited innovatively by a wide array of photographers, including Ellen Carey, Chuck Close, David Levinthal, and William Wegman. And of course Polaroid Corporation enjoyed a long and fruitful relationship with such familiar fine art photography figures as Ansel Adams and Paul Caponigro, as well as nurturing many others, including Marie Cosindas, Rosamond Purcell Wolff, Carrie Mae Weems, and many more.

Most accounts of Polaroid in the art world understandably concentrate either on these famous artists and photographers who made use of instant film, or on the work of the Artist Support Program and the Polaroid Collections, and how the former so fruitfully fed the latter from their formal establishment in the early 1970s. The impressive roll call of names, many of which have already featured in this book, shows how far Polaroid went in fulfilling Edwin Land's hope for the artistic potential of instant film, but it does not tell us much about the way in which this art intersected with science, to use Land's phrase. If anything, when we look at Polaroid pictures on the walls of a gallery or in a glossy photography book, the connection between the beautiful image and the useful image vanishes entirely from view. It may have seemed obvious to Land and Polaroid that the fusion of aesthetics and utility was what marked them out and gave them permanence and cultural value, but that fusion was no simple operation. For much of the twentieth century, the dominant models of photography as art tended to proceed by first separating aesthetics and utility, art and industry, the beautiful and the useful. Photography historian Anne McCauley has gone as far as to argue that when photography is hailed as an art, the science is generally repressed, "its defining characteristics ... ignored."[16] This separation was deliberately sought in the early and middle parts of the twentieth century by those who were trying to establish photography as an autonomous art-form, and for whom, in critic Peter Bunnell's words, what mattered most was "creativity in photography—the individualized sensitivity of the photographic artist."[17]

Photography eventually gained institutional legitimacy, but not without setbacks, and never unconditionally. The tale is most convincingly related by Christopher Phillips, who takes discontinuities

in the policy towards photography at the Museum of Modern Art in New York as a key to the fluctuating fortunes of photography as art in the mid-twentieth century. Under the guidance of Beaumont Newhall as director of photography from 1940 to 1948, MoMA embraced the idea of the fine art photographic print, but with the arrival of Edward Steichen in the role, questions of aesthetic value were sidelined at the expense of the information-value of the photographic image, that is, its usefulness. Only with the arrival of John Szarkowski at MoMA in 1962 did photography return to the gallery as an aesthetic object after a time in the wilderness, presaging its wider triumphant entry "into the museum, the auction house, and the corporate boardroom" in the 1970s.[18] This triumph in turn generated heated polemics about the way in which, as critic Abigail Solomon-Godeau has put it, there is "a great deal of conversation about photography-in-the-art-world," at the expense of the vast majority of photographic production in the world, which is not aesthetic in intention. We should spend less time talking about photography as art, she argues, and much more about its industrial, commercial, and technological basis.[19] She takes for granted, however, the separation of art and industry, those two areas Polaroid hoped might fruitfully meet.

During its time of exclusion from MoMA, between the late 1940s and early 1960s, fine art photography did not simply vanish. Banished from the temple of art for a time, the partisans of this aesthetic took shelter in fine arts colleges, financially strapped little magazines, George Eastman House, Yosemite workshops, but also, more surprisingly, with Polaroid Corporation, an industrial and technological giant engaged in the sort of mass photo production that might seem most inimical to the idea of the photograph as art object. In fact, Polaroid engaged, from the 1950s onwards, in a range of activities—creative photography workshops, collecting, publishing, exhibitions, sponsorship—that sustained fine art photography in its wilderness years and after. Contrary to what some narratives from within the company suggest, this was not an unbroken story, but was also marked by interesting discontinuities. In addition, Polaroid's longstanding commitment to aesthetics *and* utility did not always square well with a fine art tradition keen to put the useful to one side. Productive tensions, unresolved contradictions, and new formations arose when Polaroid tried to join together what were more usually cut apart.

Back Cover Story: Adams, *Aperture*, Advertising

We have learned through the years that if the photographer's statement about his work lists his cameras, there is no need to waste time on the photographs. Currently, it is fashionable to include a clutch of Polaroid prints, and even photographers who know better—Ansel Adams and Imogen Cunningham—have fallen into this trap. Adams' bias is understandable.[20]

MARGERY MANN and SAM EHRLICH in *Aperture*, 1968

After Edwin Land met Ansel Adams, the inventor wrote to the photographer saying, "My own admiration for your combination of aesthetic and technical competence is complete," and soon offered Adams a post at Polaroid.[21] He clearly saw in Adams an embodiment of the ideal union of art and science. Adams may have been a technophile, but he was also a leading figure in the attempt to separate fine art photography from all other types, especially the commercial advertising work which he of necessity engaged in himself. It is curious therefore that one of Adams' first key successes as a Polaroid employee was to secure an advertisement in the avant-garde photo-magazine *Aperture*, which itself became instrumental in carving an independent space for fine art photography. Sean Latham and Robert Scholes, in their manifesto for the study of periodicals, insist that when we study magazines and journals we ignore at our peril the advertisements that punctuate the main text, but should see them as integral with each other. Modern culture, they argue, emerged "from a still-obscure alchemy of commercial and aesthetic impulses," that was at its most visible in magazines.[22] In the case of Polaroid and *Aperture*, that alchemy is critical, if nearly invisible.

The story of Polaroid's involvement with *Aperture* begins before the influential little magazine existed, with Polaroid's advertising campaign in the summer of 1949 for the Model 95. As I have noted previously, this campaign emphasized the novelty value of the camera and confirmed as its target audience the affluent consumer at play. Among the slogans coined and repeated in the first years of publicity: "Polaroid's picture-in-a-minute camera" (July 1949); "See beautiful prints sixty seconds after you snap" (August 1949); "Move your darkroom into the daylight" (October 1949); and "You're the life of the party with a Polaroid Land Camera" (February 1950). This last advertisement, re-

produced in chapter 1, featured the most famous of Polaroid ad-copy, and is illustrated by an image of five well-dressed young white people admiring a just-produced Polaroid print of themselves (see Figure 1.5). The same ad promises "More FUN with a Camera—There's no thrill like seeing your pictures 60 seconds after you shoot them." The words "fun" and "thrill" come up again and again in these early ads, and the five affluent-looking models are typical of the ads' protagonists. In its first manifestation, the Polaroid camera was primarily promoted as a kind of frivolous diversion for leisured classes unskilled in complex camera work. In other words, the first ad campaign fit well with the picture I have been painting in this book of the camera as toy and attraction, as well as luxury object.

Then in 1950 there came an odd twist to this thus far consistent campaign. In the November issue of the *Camera* could be found a Polaroid advertisement featuring a photo of "Dody" (Warren) by Ansel Adams on Polaroid Type 41 black and white film.[23] The textual support for the image includes the standard "there's no thrill like seeing your pictures *on the spot* at the very moment they mean the most, while everyone is there to share the fun," but also the decidedly more ambitious claim that "photographers everywhere are finding in the Polaroid . . . camera a powerful new medium for artistic expression. . . . in brilliance of highlights and depth of shadows, the new black and white film gives results that challenge comparison with expert darkroom production."[24]

This was followed by an ad in June 1951 in the same format, but this time with a portrait of Brett Weston by Warren, giving details about the photo being made "in natural north light, using close-up lens . . . and time exposure."[25] Brett Weston then went behind the camera himself to take a portrait of his father Edward Weston, again on Type 41 film, but this time in the *PSA Annual* for 1951. The accompanying text notes that the photo was "Taken indoors in naturally diffused light. Exposure: 2 seconds, at shutter setting #7." As with the image by Dody Warren, the ad emphasizes that the photograph is "unretouched." This short-lived departure from the main campaign appears to have ended with an ad in *Modern Photography* in January 1952. In this case, the photo by Bradford Washburn of a Mt. McKinley base camp is provided "courtesy of Boston Museum of Science" and we are told that the camera "operated perfectly under tough conditions."[26] Unlike the other

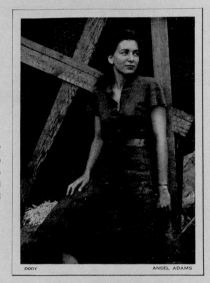

Figure 6.2: "Dody." Polaroid Land Camera advertisement, *Camera*, November 1950. Photograph by Ansel Adams.

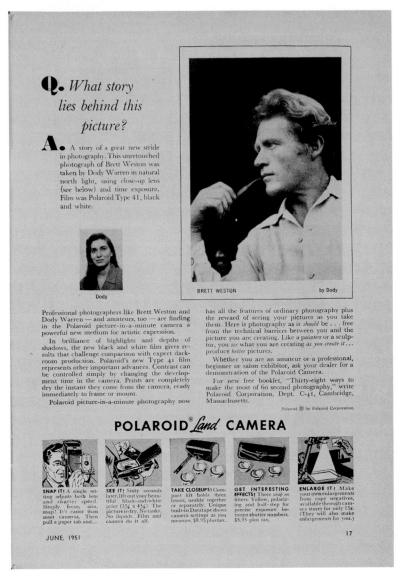

Q. *What story lies behind this picture?*

A. A story of a great new stride in photography. This unretouched photograph of Brett Weston was taken by Dody Warren in natural north light, using close-up lens (see below) and time exposure. Film was Polaroid Type 41, black and white.

Dody

BRETT WESTON by Dody

Professional photographers like Brett Weston and Dody Warren — and amateurs, too — are finding in the Polaroid picture-in-a-minute camera a powerful new medium for artistic expression.

In brilliance of highlights and depths of shadows, the new black and white film gives results that challenge comparison with expert darkroom production. Polaroid's new Type 41 film represents other important advances. Contrast can be controlled simply by changing the development time in the camera. Prints are completely dry the instant they come from the camera, ready immediately to frame or mount.

Polaroid picture-in-a-minute photography now has all the features of ordinary photography plus the reward of seeing your pictures as you take them. Here is photography as it *should* be . . . free from the technical barriers between you and the picture you are creating. Like a painter or a sculptor, you *see* what you are creating *as you create it* . . . produce *better* pictures.

Whether you are an amateur or a professional, beginner or salon exhibitor, ask your dealer for a demonstration of the Polaroid Camera.

For new free booklet, "Thirty-eight ways to make the most of 60 second photography," write Polaroid Corporation, Dept. C-41, Cambridge, Massachusetts.

Polaroid ® by Polaroid Corporation

POLAROID *Land* CAMERA

SNAP IT! A single setting adjusts both lens and shutter speed. Simply focus, aim, snap! It's easier than most cameras. Then pull a paper tab and...

SEE IT! Sixty seconds later, lift out your beautiful black-and-white print (3¼ x 4¼). The picture is dry. No tanks. No liquids. Film and camera do it all.

TAKE CLOSEUPS! Compact kit holds three lenses, usable together or separately. Unique built-in Datatape shows camera settings as you measure. $8.95 plus tax.

GET INTERESTING EFFECTS! Three *snap on* filters. Yellow, polarizing and half-step for precise exposure between shutter numbers. $5.95 plus tax.

ENLARGE IT! Make your own enlargements from copy negatives, available through camera stores for only 15¢. (They will also make enlargements for you.)

JUNE, 1951 17

Figure 6.3: Polaroid Land Camera advertisement, *Camera*, June 1951.

ads, which trade almost exclusively on instantaneity, novelty, and fun, these four comment on technical matters such as lighting and exposure time, on the qualities of the film itself, and above all, they *name* the photographers involved.

Since being hired by Land in 1949 as a technical consultant to Po-

laroid, Adams had been responsible for field testing new cameras and film and had been instrumental in the development of the new Type 41 film promoted in this short series of ads. Dody Warren was a founding member, with Adams, of *Aperture*, and Brett Weston, another early consultant at Polaroid, was a member, like Adams, of Group f/64, a West Coast group devoted to a "straight photography" free from the manipulations of pictorialism, and known for deep and sharp focus, as well as high-contrast landscapes tending toward abstraction. Washburn, a friend of Adams, was a New England explorer and photographer who worked out of the Cambridge area where Polaroid was based. The *PSA Annual*, along with the quarterly *PSA Journal*, was the publication arm of the Photographic Society of America, a noncommercial organization that had evolved, in 1934, from the Associated Camera Clubs of America (formed 1919). It was far from avant-garde in its outlook, but the Society had a strong investment in the idea of photography as an art, reflecting the camera clubs' preference for romantic pictorialism. The *PSA Journal* and *Annual* accordingly contained their fair share of tasteful nudes and landscape studies. Adams joined the Society in 1944 and was made a Fellow in 1949. In 1950, in order to fund a new headquarters in Philadelphia, the PSA put out a call for "Cornerstone Members" to make substantial contributions, a call to which Edwin Land responded. Within a year, Land had also been made a Fellow of the Society.[27] This series of advertisements should therefore be read as an attempt to broaden the appeal of Polaroid photography, still in its infancy, beyond the unskilled affluent amateur and into the fields of professional and fine art photography; but it should also be seen as part of a broader strategy by Polaroid to infiltrate America's established photographic institutions. The small number of ads and quick termination of the series suggest that this specific attempt at legitimation was abandoned early on, but it signals the presence within Polaroid of a lobby oriented towards the "great aesthetic potential"[28] of instant photography, and not just any lobby, but one dedicated to the ideals of straight photography in its most ideologically austere manifestation.

This first foray into advertising by Adams at Polaroid was followed by a more modest but much more successful and longstanding initiative. In his capacity as consultant Adams negotiated for images taken on Polaroid film to appear on the back cover of the fledgling *Aperture*

magazine from its sixth issue (2: 2) onwards in 1953. Every subsequent issue of *Aperture* until the 134th (Winter 1994) contained a reproduction of a Polaroid print. Until 1960 these images were mainly by Adams himself, with two contributions each by Adams' assistant Gerry Sharpe and Nick Dean (also a Polaroid employee/consultant). For the next decade Adams provided more or less every second picture, and in the latter years images were selected for the ad from the Polaroid Collections, which had been formally founded in 1973. The intermediary in the first instance was Meroë Morse, who acted as the main point of contact for consultant photographers in the field. With her background in art history at Smith College, Morse was particularly sympathetic to Adams' photography-as-art program, and to the placing of an advertisement in a low-circulation avant-garde magazine.

But this so-called advertisement was hardly of the same category as the ones found in other magazines. The images were reproduced to the highest standard, and had very little by way of textual accompaniment. For instance, the image on the back of issue 2:3 has as a caption only its title, "Poplars, Owens Valley, 1952," Adams' name, and the following information in small print: "Polaroid Land Camera Model 110, Standard Polaroid Film (Engraving made direct from original print)" and beneath this "Polaroid Corporation" in bold and "Cambridge, Massachusetts." In other words, no slogans, no direct plugs for specific merchandise, and from Issue 3:1 (1955), even the words "Polaroid Corporation" were no longer in bold face.[29] These very muted ads cost Polaroid $100 per issue in the first instance (rising to $3,500 for the final one),[30] not including engravers' expenses.[31]

Given *Aperture*'s low circulation and precarious financial situation, this arrangement was closer to a form of patronage than formal advertising. Nor was the back cover agreement the only monetary contribution made by Polaroid to the perennially cash-strapped magazine. Edwin Land was a "sustaining subscriber" to *Aperture* for Issues 1–4, while from 1955 to 1967 Polaroid Corporation acted as a named "retaining subscriber." These subscriptions, at $25 and $10, were of course over and above the official rate of $4.50, and the only other institutional sponsor of *Aperture* in the 1950s was the U.S. Camera Publishing Co. Others joined once *Aperture*'s reputation and influence were cemented, but only Polaroid was there from the start.

Photograph by Linda Connor
Engraved from an 8 × 10 chrome of an original 20 × 24 Polaroid image
Polaroid Corporation
Cambridge, Massachusetts 02139

$12.50 ISBN 0-89381-129-7

Figure 6.4: Back cover, *Aperture* 93 (1983).

Aperture is known for continuity (of editor Minor White from 1952–75 and publisher Michael Hoffman from 1965–2001), but also discontinuity (suspending production and threatening to disappear on two occasions, in 1953 and 1964). In its history, the unbroken 40-year relationship with Polaroid has to be seen as one of the greatest elements of continuity, with the understated style of captioning never changing in the over 125 issues in which a Polaroid image appeared on the back cover, even though well before 1994 the magazine had begun selling conventional advertising space inside its covers.[32] Indeed, by the time

Figure 6.5: Back cover, *Aperture* 145 (1996).

of its discontinuation, the Polaroid ad had become quaintly anach-
ronistic in its mutedness relative to the rest of the magazine (it was
replaced on the back by, among others, Evian and Adobe Photoshop).

And yet, even with this 40-year arrangement there for anybody to
see, it makes no appearance in the official history of the magazine by
R. H. Cravens that was published as part of the 50th anniversary issue
in 2002. There are good reasons for this oversight: as Cravens' subtitle
("A Celebration of Genius in Photography") makes clear, the emphasis
in the founding myths of the magazine is very much on "profoundly
gifted individuals" with "no money"[33]; and when money is mentioned,

it is long-term donor Shirley Burden who is credited, rather than the makers of frivolous party cameras. The contributions by Polaroid of artwork and cash would only cloud the narrative and even compromise *Aperture*'s self-proclaimed independence from commercial interests in its early days. Nor does the official website that outlines *Aperture*'s history, "Aperture Foundation: A History of Excellence," make any mention of Polaroid, although it does of course reproduce many *front* covers of the magazine.[34] There is a sense here in which the reverse side always remains invisible, even if it is out in the open.

Fortunately, the record of these dealings is available in the correspondence of Ansel Adams with Meroë Morse. This correspondence reveals that the relations between *Aperture* and Polaroid were by no means straightforward, and in fact threw up a range of interesting tensions and contradictions in relation to the magazine's stated aims and overall project. The minutes of the meeting to found *Aperture* state very clearly the magazine's policy on advertising: the new periodical "should depend almost solely on subscription for its existence, and that such advertising as there might discreetly be, would not be of a strictly commercial nature."[35] This bias against advertising was typical of avant-garde little magazines in the twentieth century, and was shared with other periodicals that sought to remain independent from outside influence.[36] As a point of comparison, the *PSA Journal* had tried in the 1930s to get by on subscription alone, although by the 1950s it had completely given up on this ambition.[37]

When Ansel Adams first communicated with Polaroid about the ad, such considerations were to the fore:

APERTURE is now taking advertisements of dignified quality [....] The usual commercial type work is not desired—the advertisements would be simple and direct, and attractive.[38]

Writing many years later about *Aperture*, one of its founders, Beaumont Newhall, was still using Adams' telling term, "dignified": "It was Ansel Adams," he writes, "who clarified our ideas, expressing the need for a professional society with a dignified publication."[39] (Newhall, by this time curator at George Eastman House, was also a Polaroid consultant in the mid-1950s. He sent in enthusiastic reports about how "fun" the camera was, and that it was giving great pleasure to

his mother-in-law.[40] He also recruited in the summer of 1957 one of his Eastman House charges, Robert Doty, who had not used a camera before, but found it to be a tremendous "instrument of goodwill" at a vintage car rally, where he gave away many prints.[41] Doty went on to write, among other texts, *Photo-Secession: Photography as a Fine Art*, while Newhall, in the revised edition of his standard and canonical *History of Photography*, called the Polaroid Land process "the most innovative contribution" to photographic technology in the post–World War II epoch.[42])

If the photographs of the *Aperture* school were "dignified," the implication was that most other photography lacked dignity: photojournalism was attention-seeking, snapshot photography was trite and clichéd, and advertising photography, the greatest enemy, sacrificed aesthetic for commercial values, or worse, manipulated aesthetic codes for monetary gain. Another way of putting it, of course, is that all these other modes of photography were in some way useful, whereas in its original sense, "dignity" was the prerogative of nobility, who disdain utility. There can be no doubt that the founders of *Aperture* saw themselves in that light: aristocrats of photography, and like all good aristocrats, impoverished.

In spite of Adams' persistence, the negotiations with Polaroid were protracted, and he had regularly to remind both Morse and Land himself that the ad would reach "a considerable audience—highly selective," "a highly selective group."[43] Clearly, there was no great urgency within Polaroid about this project, with Adams complaining to Morse at one point that Richard Kriebel (chief of publicity) was too preoccupied with conventional advertising to pay attention to a range of projects Adams had proposed.[44] Adams was therefore treading a fine line between protecting *Aperture*'s quarantine zone against commercial photography whilst pitching the ad to Polaroid as a way for it to acquire cultural capital and attract the notice of professional photographers.

By July 1953 the issue had been resolved and Adams had submitted to Polaroid an image of river foam for engraving, noting that "It is hardly a 'National Ad for U.S. Camera' but it suggests great possibilities."[45] At the same time, as is implied by this comment, Adams had been waging a campaign against the Polaroid advertising department. For instance, he questions in one letter the stress on the amateur uses

of the camera, and complains in others that many ads are misleading about the capacities of the cameras, or making false claims about the conditions under which photos reproduced in ads have been made.[46]

Adams continued to advocate tirelessly for *Aperture*, taking every opportunity to highlight its ideals and its financial predicament, as in this letter to Land: "It is important that it preserve complete independence. It can use advertisements of the quality of Polaroid's. But it should never get mixed up with the commercial photo rackets."[47] Nevertheless, compromises were made in the *Aperture*-Polaroid relationship. As John Szarkowski points out, *Aperture* saw itself as the inheritor of Stieglitz and *Camera Work* in its "love for the eloquently perfect print" and "intense sensitivity to the mystical content of the natural landscape."[48] Certainly, Adams was extremely exacting in the reproduction of his Polaroid images for the back cover of *Aperture*, and many of the images he provided were of outdoor subjects where tonal qualities and texture are privileged. In a number of cases Adams appears to have adapted to the restricted small print format of the singular Polaroid print by making close shots, such as "Engineer's Center Mark, Golden Gate Bridge Pier" (Issue 2: 4), "Seaweed and white feather" (3: 1), "Detail, Tiburon Church, Calif." (4: 1), and "Close detail, Burned Tree" (4: 2).

Among the early issues were none of the large-scale landscapes for which Adams was (and is) best known. Even more strikingly, among these images were a number that might not be associated at all with the Adams signature style. These are the portraits of "Mr and Mrs Wilson, Napa, Calif." (3:4), "Charles Sheeler" (4:3), and "Rod La Rocque" (5:1). The atypicality of portrait photographs in Adams' oeuvre is attested to by their extreme rarity among the over 700 Adams prints formerly held by the Polaroid Collections.[49] This is not to say that Adams never did portraits, but that they were not what defined his body of work.[50] Once again, the small print size may have been a contributing factor, but the result, like the pictures of Dody Warren, Brett Weston and Edward Weston in the earlier campaign, is a closer proximity to Polaroid's main business—snapshot photography—than Adams might have intended or desired.

The editor of *Aperture*, Minor White, also had direct dealings with Polaroid, working in a consultant capacity in 1956–57, around the same time as Newhall. White was leader, at Rochester Institute of

Technology, of a "Pilot Project" into the use of Polaroid materials in the teaching of photography, a project for which Polaroid provided free cameras and film. In his reports back to Polaroid, White was largely positive about instant film, and he also published an article about the experience in *Aperture*, "Pilot Project RIT: On the Trail of a Trial Balloon." White's correspondence shows, however, that he did not have a free hand in this article, since Richard Kriebel insisted on changes, wanting to know "what actually happened *after you got over the novelty phase*; about the effects of each successive print on the photographer, the sitter and the next print."[51]

White agreed to make the changes, even echoing Kriebel directly in this passage:

> When we first started with the Polaroid Land system, that "one minute" seemed an insurmountable obstacle; but *once we had gotten over the novelty*, fitted ourselves to the camera and the camera to us, picture taking fused to pondering over pictures became a self-contained experience such as is impossible with the conventional system.[52]

Taking dictation from an advertising executive, White at the same time produces a sentence so convoluted as to subvert the punch line. He also pointedly notes that the Project participants had replaced the advertising slogan of "Pictures in a Minute" with their own: "the immediate image."[53] He was not shy of gently mocking the process either, writing of how the prints "dropped from the camera like newborn kittens."[54] Most importantly, perhaps, he makes no mention at all in the article about the quality of the images as images, in stark contrast to Adams, who always went out of his way to do so. All this may have been a way of reasserting *Aperture*'s independence, but there is no hiding the fact that White was working for Polaroid, and it was the company that had commissioned the article. In 1959, the magazine published another article by White on Polaroid photography, this time emphasizing its usefulness in "Photographic feedback." Once again, White finds ways of being enthusiastic about the process while at the same time subtly undermining the product. At the outset he explains that it is to be an "Unillustrated Article," with the implication that none of the images were of a standard to reproduce in *Aperture*.[55]

It could be argued, of course, that far from compromising *Aper-*

ture's aspirations to freedom from commercial contamination, this story of its involvement with Polaroid simply illustrates the conditions under which it heroically labored for the idea of a pure photography. There is something in this argument, but only if we accept the possibility of a fundamental fissure between aims and outcomes. Photography theorists in the 1980s identified *Aperture* as one of the key early proponents of a concerted effort to *narrow* photography by emphasizing the aesthetic properties of the image over its manifold other uses[56]; more specifically the magazine valued individual artistic genius at the expense of political and social concerns. In this capacity, the magazine was one of a number of cultural agents instrumental in getting the institutional and cultural stamp of approval for photography as an autonomous fine art.[57] *Aperture* in the 1950s should from this perspective be seen as a forerunner to photography's entry into the art gallery and the art market in the 1970s. The legitimation of fine art photography coincided with its acceptance as a commodity for exchange.

The paradox here is that the commercial photography *Aperture* so steadfastly opposed already took for granted the commodity status of the photograph in its most common manifestation—in advertising. The vanguardist purity of the likes of Minor White required that the aesthetic value of the photograph be promoted without an eye to the financial compensation of exhibition value, but holding out for the high ground of aesthetic value ultimately meant that *Aperture*'s inheritors could reap far greater rewards than they might have expected from the regular commercial work disdained by the magazine. As for the Polaroid ads that placed aesthetic considerations above the imperatives of the "commercial photo rackets," do they not in fact anticipate a time when fine art and advertising photography have become indistinguishable, indeed symbiotic?[58]

Collecting and Continuity

The case of Polaroid and *Aperture* shows a greater interaction between the manufacturing base of photography and photography-as-art than is normally taken to be the case, but it is far from exceptional in the history of the instant photo company. Indeed, where *Aperture*'s official history fails to acknowledge Polaroid's close involvement in its

origins, Polaroid itself eventually seized on such activities, especially from the 1970s onwards, to retrospectively narrate its own development as a company sympathetic to photographer-artists. They had an eloquent spokesman in Ansel Adams, who in an interview shortly before his death called Polaroid the "only photographic corporation in this country that really supports creative photography." For him, Kodak is "just a big corporation whose interest is mass production," and "only Polaroid is actively concerned with photography as an art."[59] The relations with Adams were of course especially valuable in this exercise, for Adams' stock rose exponentially with the legitimation of photography and its entry into art galleries, and Adams took pride of place in any display of Polaroid's cultural credentials.

This was not simply corporate window dressing on the part of Polaroid: in the late 1960s Polaroid developed a very generous Artist Support Program, which donated film and equipment to photographers, expecting in return feedback, publicity, and a varying number of prints. This latter arrangement was formalized in 1972 with the opening of the Clarence Kennedy Gallery at Polaroid HQ, and with the establishment of the Polaroid Collections in 1973. The Collections, which became the repository of work from the Artist Support Program, had as its foundation the "Library Collection," a set of (non-Polaroid) prints purchased by Adams on behalf of Polaroid in 1956, including images by Edward Weston, Dorothea Lange, Eliot Porter, Margaret Bourke-White, Eugene Smith, and Minor White.[60]

Also in the late 1960s, Eelco Wolf, working at Polaroid's European headquarters in Amsterdam, approached a number of European photographic artists to ask them to investigate the potential of Polaroid film. This led to a special issue of the Swiss photo-art magazine *Camera* in 1974, with the body of work from the project forming the basis of the International Collection, which was originally housed in Amsterdam, before being moved in 1983 to the Polaroid Gallery in Offenbach, Germany. In 1988, some of these Collections were transferred to the Musée de L'Elysée in Lausanne, Switzerland, while others went in 1997 to the Maison Européene de la Photographie in Paris. The bulk of the International Collection was acquired in 2011 by the WestLicht Museum in Vienna, with the assistance of the Impossible Project, during the dispersal of Polaroid assets.

The activities of the Artist Support Program and the Polaroid Collections have been ably documented by photographer Arno Rafael Minkkinen as a shining example of what he calls "artist-corporation collaboration."[61] He emphasizes especially the ways in which the Program supported young as well as established photographers, encouraged experimentation and risk-taking, and bravely opposed censorship during the epoch of Jesse Helms and Co. in the 1980s. The origins of the Collections lie with Meroë Morse, who, ill with cancer, moved to establish a committee to oversee the Artist Support Program in the late '60s, including Jon Holmes, Bill Wray, Jim Martrett, Inge Reethof, Bill Buckley, Jeanne Benton, J. J. Scarpetti, William Field, and Lucretia Weed.[62] Accounts of the Collection's history, including Minkkinen's, tend to construct a direct line of continuity between Adams' suggestion to Land in 1949 that he acquire a set of exemplary photos, the acquisition of those photos in 1956, and the formal inauguration of the Collections in 1973. By the 1980s, this was the official line at Polaroid, with the *Polaroid Newsletter* in 1984 claiming that "From its inception" the company "has been deeply committed to supporting art and photography."[63]

Although it is true that Morse figures throughout most of this process, and that the Artist Support Program emerged organically from relations Polaroid had with consultant photographers, this story is far from seamless. Polaroid may have been collecting photographs throughout the 1950s and 1960s, but the source of those photographs and the motivations for collecting them were not the same as they were in the era of the formal Collections. In the earlier period, Polaroid recruited art-photographers such as Ansel Adams, Brett Weston, Minor White, and Nick Dean not in order to collect their work, but because it was thought they would make special demands on the film and bring a different set of insights to its development. In other words, they were hired primarily for their technical know-how, and their photos, when kept, were technical evidence. The consultants may have considered themselves first and foremost artists, but in this case they were artists in the service of industry. It takes only a cursory glance through Brett Weston's highly detailed technical reports for the company to see how different this arrangement was from the system of patronage represented by the Artist Support Program.[64] Nor was this sort of arrange-

ment specific to Polaroid. Kodak had long operated similar schemes, with for example, Adams, Edward Weston, Charles Sheeler, and Paul Strand being given Kodachrome film to experiment with in the 1940s on the understanding that the company could use some of the results for advertising purposes.[65]

In addition to the valuable feedback from highly trained specialists that the earlier consultancy system brought, there was a secondary aim: to spread the word among the wider professional photographic community about the new product. In a letter to Morse and Land dated November 25, 1954, Ansel Adams alludes to this aim as "the idea of Dr. Land's that we could put a few photographers 'in business' in order to expand the awareness of the new medium." Adams may have used the consultancy for his own purposes, to forward the project of art photography, but it is clear that for Polaroid he was in the first instance a researcher who could recruit other researchers who would in turn provide testimonials on behalf of the infant instant film. This arrangement is a long way from the model of corporate donation and patronage at work in the Artist Support Program and the Polaroid Collections, which should instead be seen as part of a general trend towards corporate philanthropy in the 1970s and 1980s, a trend that coincided with a sharp increase in the collection of photography in general, including by Kodak.[66]

If we take at face value Polaroid's official statements in the 1970s and 1980s, then we must accept a story of uninterrupted and unqualified support for art and artists. As the uneven development of the Collections and the less than perfectly smooth dealings with *Aperture* suggest, however, Polaroid's attitude to the aesthetic dimension of photography was neither consistent nor entirely coherent.

If for Ansel Adams, Minor White, and *Aperture*, the task was very clearly to carry out the separation of fine art photography from all other commercial forms, the situation within Polaroid itself was rather more complex and changeable, with competing imperatives, some of them of course commercial. Rather than looking at what Polaroid said retrospectively about itself, it is much more instructive to look at the company's practices over a longer period. It is possible to see these changing practices at work in two further periodicals, this time published inside the company: the *Polaroid Annual Report* and

the magazine *Close-Up*. They reveal a much more interesting situation than the simple severing of fine art photography from all other photographic forms so ardently sought by the fine art camp at *Aperture*.

Illustrating the Annual Reports

An annual report is not just a summary of facts and figures for the financial year, but also gives an indication of a company's general aims and priorities at any given moment. In the late 1970s and into the 1980s Polaroid began claiming that its support for fine art photography had been continuous and uninterrupted from the beginning of its entry into the photographic field, but its annual reports tell a different story. Polaroid was originally formed in 1937 to manufacture and sell polarizing filters, but by 1952, 81% of its turnover was in camera and related sales, a figure that had risen to almost 97% by 1958.[67] For a company almost exclusively devoted to photography, it therefore made sense that its annual reports featured examples of finished products in the form of Polaroid images. However, as Ansel Adams noted with concern after he saw the 1953 version, many of the images in the Report were not in fact made on Polaroid film, although he thought it essential that they should be.[68]

Adams' advice appears to have been taken, and over the years the reports become assiduous in detailing the types of Polaroid film on which reproduced photos had been taken. His advocacy also appears to have enabled the introduction in the late 1950s of fine art photographs into the annual report, where they rubbed shoulders with other kinds of photograph, an incursion which was short-lived, although the 1970s saw their return under new conditions. Even then, the annual reports at no point allowed for the *narrowing* of photography sought by the fine art lobby.

Over the period 1955–1985, *Polaroid Annual Reports* make use of four basic types of image:

1. The purely illustrative image that displays a new piece of merchandise: a camera, a roll of film, a pair of sunglasses, or other product. In these images, the photograph *as photograph* is rarely at stake, for it is the content of the picture which matters most.

This is not the case for the other three types, which all appear as examples of photographs as photographs, whatever their content.

2. The vernacular or amateur snapshot. This type of photography of course formed Polaroid's main business, and the annual reports feature innumerable images where domestic happiness prevails and children, pets, babies, and families are the protagonists.
3. Examples of the professional, industrial, and business uses of Polaroid photography, ranging from real estate, photojournalism, and police work through to highly specialized scientific applications in stereoscopy and micrography. These images are often identified as taken on a special camera, for example, the ED-10, MP-3, or CU-5.
4. The photograph as aesthetic object. In this case, the photographer is always named and the image itself is usually framed in such a way as to call attention to its status as art-image.

Inevitably, these categories often overlap and are regularly porous with each other. For example, more than one annual report featured images from a Polaroid photo contest organized by John Wolbarst at *Modern Photography*. The four winning pictures from the 1956 contest, showing a girl with a banjo, a butterfly, a still life, and a girl in a field, appeared on the inside back cover of that year's annual report. These images are neither snapshots, nor art images. They partake of the mixed aesthetic of the hobbyist or camera club, which combines technical challenges with clichéd themes.

More of the results of Wolbarst's photo contest could be found on the front and back cover of the 1959 report. This time, they were shown as part of *Polaroid Portfolio #1*, a book edited by Wolbarst which mixed images from the photo contest with photos made by Polaroid employees (Dick Solomon, Inge Reethof, among others) and others by professional photographers, including Adams, Philippe Halsman, Bert Stern, and Peter Gowland. On the inside of the 1959 report, meanwhile, there is a 1¾ page spread by Nick Dean of a "Snowbank, Malden."[69] Dean's image clearly aspires to the Adams school of American landscape photography, with the sharply focused scene disclosing a varied tonal scale in a natural environment devoid of human presence. It is not easy, however, to simply separate this image from the ones on the front and back cover, to place it in a privileged category. The images

In over a million families, Polaroid Land Cameras now add new pleasure to picture-taking. These shots were among the prize-winners of a recent contest sponsored by Modern Photography Magazine.

Figure 6.6: Back cover, *Polaroid Annual Report*, 1956.

from the *Polaroid Portfolio* by amateurs and Polaroid employees clearly also have aesthetic pretensions, even if they might not meet the strict criteria of the f/64 group. The "straight photography" advocated by Adams and his fellow travelers aimed at purity, at the separation of an elite photography from the rest, but in this annual report, there is instead a prodigious and democratic mixing of images, and a productive confusion of categories.

The image by Nick Dean in the 1959 Report was the second in a

series that started with a 1½ page spread by Adams of Yosemite Falls in the 1958 Report, and was followed by a similarly presented image by Paul Caponigro in the 1961 Report.[70] Even if the 1958 Report had a boy with an ice cream cone on the front and a clown face (good for illustrating contrast) on the back, fine art photography would therefore appear to have secured a privileged place within Polaroid's self-presentation in this epoch. However, and in spite of what the in-house histories might state, from 1962 and for about the next decade and a half, the Adams brand of photography was completely pushed aside in the annual reports. Initially this was because of the introduction of instant color film, which was formally announced in 1962 and first sold in 1963. Subsequent annual reports emphasized above all the possibilities of color film in snapshot photography as well as a range of business and science uses, such as the front cover in 1963 with its array of Polacolor snaps, the image of a photoelectric stress pattern on the 1964 cover, or the cover in 1967 featuring a cross-section of unexposed Polacolor positive sheet magnified 320 times. Color film at this point was of course absolutely inimical to those in the photograph-as-fine-art camp, since its use had been pioneered above all in advertising.[71] For an annual report lushly illustrated in color, and therefore tainted with commercial values, there would have been no place for Adams and his fellow travelers. Instead, it was the usefulness of photography that was conveyed by the images in the annual reports, as well as its popular, vernacular side.

There was one very interesting exception to this rule. In 1963 Polaroid hired a Boston-based painter, Marie Cosindas, to experiment with Polacolor, and in the years that followed she built up a large body of color Polaroid work, mainly still lifes and portraits. Her first touring exhibition of Polaroid color prints was in 1966, starting at MoMA in April, moving on to the Museum of Fine Arts in Boston in November, and finishing up at the Art Institute of Chicago in January 1967. Given that MoMA's William Eggleston exhibit in 1976 is usually taken to be the watershed event for the acceptance of color photography as art, Polaroid, which discovered Cosindas, can rightly claim to have been ahead of the curve. Certainly Cosindas' experiments in the early 1960s coincided with those of other early pioneers of color photography, such as William Christenberry and Joel Meyerowitz. Images by

Cosindas appeared in a special color section in the annual report for 1969, alongside photos by the celebrity portrait photographers Yousuf Karsh and Philippe Halsman, Polaroid designer Paul Giambarba, and the fashion photographer Melvin Sokolsky. Impressive company, but not the sort that you would find in the pages of *Aperture*.

It is important to note the long-term *exclusion* of photography as aesthetic object from Polaroid's official public documents, because it gives a more objective position from which to view its gradual return in the mid-1970s. The 1976 report has on its front and back cover a reproduction of a section of tapestry from the Boston Museum of Fine Art, photographed on a prototype 20 × 24 inch camera, but it is the 1977 report that really signals a change of strategy. Here there are four images from the *Faces and Facades* book and exhibition, with the following text: "The contemporary emergence of our large format materials has produced a surge of photographs uniquely fresh and beautiful both because of their striking sharpness and because distinguished artists are responding freshly to their own art when the results are immediate."[72] On the next page, the report then makes a claim for the basic continuity of this strategy in Polaroid's history: "For a long time after the Land concepts were first introduced, many professional photographers were reluctant to consider one-step photography a medium of high artistic expression. We at Polaroid, on the other hand, have from the start believed in the great expressive potential of our kind of photography."[73]

Faces and Facades was the first national tour of Polaroid photography as art-object, and coincided with the more general ascension of photography to the gallery in this epoch. In subsequent annual reports, starting with the one in 1978 containing five images by Ansel Adams, Polaroid's association with art was consolidated as one of the basic strands of its commercial activity. At the same time, in its *Scientific American* ads in 1977 and 1978, Polaroid reproduced prints by Cosindas, Lucas Samaras, and Rosamund Purcell, explaining that they had been recently acquired by the Museum of Fine Arts in Boston, with the same ads appearing in the *New Yorker*. Where the March 1964 *Scientific American* ad had proudly displayed twenty-five brightly colored and heterogeneous Polaroid images jostling without hierarchy, the Cosindas Polacolor print on show in the May 1977 issue appears

The photographer is Marie Cosindas. **This** The medium is Polaroid's Polacolor Land film. The result is the **Polaroid** remarkable photograph at the right, "Dolls," a work **Polacolor** of art recently acquired by the Museum of Fine Arts in Boston. **photograph** Now, Polacolor 2 film has the same unique metallized dyes found in **was** Polaroid's SX-70° film. It has the same **acquired by** exceptional clarity and sta- bility. And its brilliant colors **Boston's** are among the most permanent and fade **Museum of** resistant ever developed in photography. Polacolor **Fine Arts** film is used by amateur, profes- sional and scientific photograph- **for its** ers throughout the world. Polaroid, the **permanent** choice of the artist in the creation of her art. **collection.**

© 1977 Polaroid Corporation

Figure 6.7: Polaroid advertisement in *Scientific American*, August 1978.

centrally, in splendid isolation, and with an added golden frame that oozes cultural distinction. The accompanying text assures us that "its brilliant colors are among the most fade resistant ever developed in photography."

So, the *Aperture* dream of photography as autonomous art was belatedly given full recognition at Polaroid, but in a form that never quite allowed for the fundamental *separation* of useful from aesthetically-oriented photography. The annual reports acknowledge art photos as a distinct category, but they share the stage, and on equal terms, with diagnostic imaging of blood flow (1980), micrography of a butterfly wing (1984), or images of magnified silver halide (1987). Official company statements now insisted on "high artistic expression" and "great expressive potential," but the juxtaposition of images "authored" by artists with images "authored" by a powerful magnifying lens suggested a bold interpretation of what might count as expressive or artistic. The photomicrograph of the retina of a toad on the front cover

Figure 6.8: *Polaroid Annual Report,* 1977.

of the 1977 report is there to display the technical accomplishments of the film and its great indexical value, but it is also obviously meant to be beautiful, irrespective of its usefulness.

Polaroid Close-Up: The Protean In-House Journal

The inclusion and exclusion of fine art photography from *Polaroid Annual Reports* tells a different story from the one Polaroid tells about

Figure 6.9: *Polaroid Close-Up*, Winter 1983.

itself. It suggests that there was a brief moment in the late 1950s when it looked as if Adams and his fellow fine art photographers had secured a place at the top table, only to drop down the list of priorities for at least a decade and a half, followed by a resurgence in the 1970s and 1980s. An interesting by-product of this rediscovery by Polaroid of its tradition of support for art photography was the magazine *Close-Up*, or *Polaroid Close-Up*. This periodical, which took on a number of forms, was published inside Polaroid, and is described by A. D. Coleman as

"a journal of substance [...] the most serious and [...] content-heavy photography journal ever published by a corporation in the United States."[74]

Coleman's view squares with a statement issued by *Close-Up*'s editor Constance Sullivan in the Spring 1984 issue. In a special insert, Sullivan locates *Close-Up* "in the tradition of *Camera Work*" and claims that Polaroid is "dedicated to publishing the preeminent photo journal of the day."[75] In an important form of code, she also makes an appeal for "charter subscribers." As we have seen in the case of *Aperture*, artistic little magazines sought to survive on subscription alone as a way of securing independence from commercial constraints. Given that *Close-Up* was funded by Polaroid, it could not claim such independence, but Sullivan's appeal nevertheless alludes to such traditions, as well as sending out signals to potential patrons seeking to swap cash for cultural capital.

Sullivan's manifesto statement, presented for what was in effect a re-launch, might have applied to *Close-Up* in 1984, but not to the magazine's earlier history, which can only be described as highly changeable. It began as the short-lived newspaper-format *Polaroid Industrial Close-Up*, launched in 1963 to "feature short case histories on actual applications of Polaroid Land Photography in industry."[76] These roots of the magazine in Polaroid's attempts to promote the "useful image" are clear in the first issue of *Close-Up* in 1970, which concentrated on technical and industrial applications of instant photography and announced its aim to "establish an effective means of communication between Polaroid Corporation and the owners and users of Polaroid industrial photographic equipment."[77] An editorial in the following year claimed a circulation of 25,000 and identified its readership as taking in pathologists, industrial photographers, engineers, editors, research technicians, radiologists, and commercial artists.[78]

The magazine's understanding of professional applications of instant photography, broad enough to include commercial art, clearly also took in the fine artist, for it was soon including work by and commentary on Lucas Samaras, Rosamund Purcell, and Walker Evans among others. Purcell and Evans appeared in issue 6:1 (1975) in a portfolio on Type 105 black and white positive/negative professional pack film. In that same issue there were stories on Polaroid photography at crime scenes, in the film industry (for checking continuity), and in

education, while on the cover there was a photomacrograph of a spent shotgun shell magnified fourteen times. In this early incarnation of the magazine, the aesthetic and the useful shared the same space, just as they were shortly to do in the annual reports.

By the late 1970s the editorial policy had settled on a standard statement that "instant photography sits in a vastly interesting position at the intersection of art and science," using the same phrase found in the 1979 prospectus for potential employees cited at the start of this chapter.[79] The intersection of art and science was capacious enough to allow issue 10:1 (1979) to include articles on new books by Ansel Adams and Marie Cosindas; on holography; on a rephotographic survey project; on large format cameras; on Arnold Newman portraits; and on macrophotography, as well as a portfolio of images of "Women in Jazz" by Barbara Bordnick on 8 × 10 Polacolor 2.

If an editorial from 1981 is anything to go by, some inside the company took this eclecticism for a kind of schizophrenia:

> an advertising executive remarked the other day that the only thing that hasn't changed from issue to issue is the name of the magazine. In trying a variety of approaches, we have inevitably failed in some of our efforts, and it is likely to be some time before *Close-Up* is the blend of photographic science and art that we are trying to achieve.[80]

The identity of the magazine was clearly up for grabs, with the subsequent issue publishing the results of a survey in which readers were asked whether they thought *Close-Up* was "too fine-arts oriented," or "too technical" (they thought neither, as it happened). Sullivan's touchstone may have been *Camera Work*, but that periodical, like *Aperture*, is strongly associated with a single and single-minded editor (Alfred Stieglitz). In contrast, the editorship at *Close-Up* changed regularly. Between 1979 and 1984, Marnie Samuelson, Henry Horenstein, Abigail Potter, Susan Weiley, and Constance Sullivan all occupied the position, with the added complication that the VP for marketing, Peter Wensberg, secured for himself in 1982 a special technical section at the back (he soon left Polaroid for Atari and the section disappeared). The editorial statement in that year reiterated the commitment to the full range of photographic practice:

Close-Up, the magazine of instant photography, includes illustrated articles which address photography as it relates to science and to medicine, on aspects of the history of the medium, and on commercial and advertising as well as fine art photography.[81]

In this period *Close-Up* also had a strong writers policy, commissioning texts as a way of supporting a community that still had a relatively precarious existence, and to mark its ambitions as what Sullivan called a "preeminent photo journal."[82]

The move in 1984 to situate *Close-Up* in the tradition of *Camera Work* (and therefore *Aperture*) hinted at an abandonment of the longstanding ambition of the magazine to be comprehensive in its coverage of the heterogeneity of photographic practice. A. D. Coleman claims that *Close-Up* in its earlier incarnations had been little more than a product promotion vehicle but that under the editorship of Samuelson and Sullivan it became a serious independent journal.[83] However, it could equally be argued that the gradual emphasis in the magazine on fine art photography was not to escape a promotional function but to intensify it. As Abigail Solomon-Godeau argued around the same time, the role of much photography criticism is to act as a thinly disguised form of publicity machine for art photography.[84] It did not matter if a particular article was critical of this or that artist or exhibition, because the overall effect was to affirm the intrinsic value of photography as autonomous aesthetic medium. Instead, the case could be made that *Close-Up* was most interesting in its moment of eclecticism, when it made no value judgments in favor of any single type of photographic practice. In its hybridity it was distinctive, but if it tried to be *Camera Work*, it would be just another photo-art magazine in an increasingly crowded marketplace.

Polaroid's presence in the art world stretched beyond in-house activities. Among other projects, in the early 1980s Sam Yanes established and funded Oracle, the influential conference of photography curators that continues to meet today. And yet, Coleman has noted how Polaroid's intense generosity from the mid-70s to the mid-80s was followed by a "belt-tightening phase" in its dealing with artists. It became more selective in its dispensation of free cameras and film, cut heavily its support for the Photographic Resource Center in Bos-

ton, and instead of just inviting artists into the 20 × 24 studios to experiment at the company's expense, began to rent out the studios.[85] There is other evidence that Polaroid's patronage of the arts peaked during the photo-boom and diminished thereafter. *Close-Up*, in spite of the fanfare of its *Camera Work* relaunch, printed its last issue in 1985; after seventeen years of operation, Polaroid shut the Clarence Kennedy Gallery in 1990; and of course the *Aperture* back cover ad was pulled in 1994.

Coleman makes the convincing case that much of the work done on free Polaroid materials was "aesthetically and conceptually conservative" and wonders whether artists felt inhibited by their patrons or whether Polaroid implicitly or explicitly discouraged genuine risk-taking.[86] But as well as asking whether artists were compromised by their involvement with the corporate donor, we might ask whether Polaroid's commitment to art *and* science was fundamentally at odds with an art world intent on building perimeter fences around the aesthetic. At the very least, this relatively short period of high-intensity participation in the art world had a strongly distorting effect on accounts of Polaroid's history, obscuring the ways in which the aesthetic dimension at Polaroid was intimately connected with the industrial.

In the 1950s especially, Polaroid provided funding and refuge for an idea of fine art photography whose time was yet to come, without fully sharing the ideological precepts of that idea. When its time did come, Polaroid discovered that it had been quietly supporting this project in a small way for a long time, and accordingly adjusted part of the company history. The result was a number of publications and activities in the 1970s and 1980s that reflected rather than led wider developments in the photo-art-world. In some of these interactions with the art world, Polaroid found itself in the odd position of endorsing as valid the divorce of photographic industry and art, in direct contradiction to its stated commitment to utility *and* aesthetics.

Meanwhile, the Polaroid of the 1960s *Scientific American* ads and of *Close-Up* at its most eclectic is beginning to look ahead of its time. In critical writing on photography, the perimeter fence around art photography has been coming down, with the art photograph now taken to be just one part of a rich plurality of photographies. In its editorial relaunch in 2013, *Aperture* magazine, once the guardian of a narrow idea of art photography, affirmed a pluralist approach to the photo-

graphic in all its manifestations, and announced future explorations of a "multivalent" field.[87] Taking a more polemical stance, the Smithsonian Institution ran from 2007 to 2010 the online project *Photography Changes Everything*, which started from the premise that "most of the billions of pictures that are taken with cameras every year are made for purposes that have nothing to do with art," and set out to explore the dizzying array of intentions with which photographs have been, are being, and may be made.[88] The survey of the Smithsonian's photographic archives showed to what extent photographs do things, and make things happen, whether it is in medicine, surveillance, warfare, or countless other realms. Curator Marvin Heiferman, in his introduction to the project's book (published by Aperture Foundation), puts it this way: "We should spend less time focusing on what makes photographs good and more time figuring out how they do their work."[89] I could not agree more, and if at the end of this book you know more about how a Polaroid does its work than what makes a good Polaroid, then I have accomplished what I set out to do.

Conclusion

When Polaroid announced in 2008 that it was permanently ceasing production of instant film, campaigning groups quickly formed on the internet calling for the film to be saved, and for Polaroid to reverse its decision.[1] Flickr, Facebook, and Photobucket groups uploaded thousands of favorite and "last" Polaroids. The fashion among art students and hipsters for retro and obsolete analog photographic forms was given further fuel, and inevitably, software applications for digitally generating the supposed Polaroid look sprang up like mushrooms. An Austrian entrepreneur, Florian Kaps—once manager of the Lomographic Society, and a founder of polanoid.net, an online archive of Polaroid photography—bought what remained of a Polaroid plant in Enschede, Holland, and teamed up with the former plant manager, André Bosman, and other ex-Polaroid employees from Enschede to form the Impossible Project, with the stated objective of reinventing Polaroid film, more or less from scratch. This audacious venture, with its highly polished publicity machine and loft shop on Broadway in New York, drip fed information to an eager constituency about the progress of its experiments while selling to that same constituency reconditioned cameras and some of the last Polaroid film inventory. Meanwhile, in this febrile atmosphere, most of the familiar myths and semi-truths about the film were given an airing—that the film quality was terrible but more loveable as a result, that the image was wet and needed to be shaken dry or stuck under an armpit, that the colors of the film were highly saturated, and of course, the most widely circulated, that the images soon faded away.

Polaroid's decision to quit the business may have briefly brought

the technology more attention than it had enjoyed for many years, but the combination of nostalgia and dismay distorted as much as it illuminated. This situation was compounded by another quirk of the technology. Unlike most amateur photographic systems, which get their energy source from a standard exchangeable battery inserted in the camera, in Polaroid photography of the integral SX-70 type, the battery was in the film. In 1972 this was a great innovation, the wafer-thin battery incorporated into the film pack ensuring that users never had to worry about their camera going dead—if there was film in the camera, the camera was charged and ready to go. But batteries do not have an indefinite lifespan, and each pack came with an expiration date, beyond which the film was no longer guaranteed to charge the camera. All film expires eventually, but the idea of the battery's life ebbing away as well added to the urgency. On the last packs that Polaroid produced, the latest expiry date was October 2009. Such dates usually err on the side of caution, and some packs dated as early as 2002 were still giving a faint charge as late as 2010, with strange blue-ish images the result.[2] Nevertheless, for a Polaroid fanatic whose supply was cut off, there was no point in stockpiling and refrigerating film for future use over many years. Even if you got your hands on every single last pack on sale in Wal-Mart or on eBay, you would have to use it within three years to be certain the battery would work. And then after that, nothing, unless the Impossible Project succeeded in reproducing the film's complex chemistry. As a result, Polaroid film—a mundane, mass-produced object—briefly became disproportionately precious. At the end, scarcity and the film packs' internal countdown meant that Polaroid film was much more highly valued than it had been prior to its discontinuation, an effect familiar to anyone who attends funerals or monitors the obituary pages.

Commentators on the decline and disappearance of Polaroid film almost uniformly agreed that it was the victim of technological change, that "digital did it in."[3] I have already explored in depth the similarities and differences between Polaroid and digital photography, but on this specific question—"What killed Polaroid?"—the case is not as self-evident as it might appear. After all, while Polaroid pulled the plug for good, Japanese photo-company Fuji continued to quietly produce instant film for its Instax series of cameras that it had been making for about a decade, and within two years had entered into a

licensing agreement with Polaroid to allow the original instant com-
pany to put its name on Instax cameras and film, although, in this
case, the battery was not in the film. (See Figures 7.1 and 7.2.) Besides
the rise of digital photography, what else contributed to the abrupt
end to Polaroid film production? If the events of 2008 and 2009 had
brought about an intense round of speculation on the symbolic value
of Polaroid photography, the previous decade had seen some rather
more prosaic calculations about its monetary worth.

Selling "Polaroid"

The decade prior to the discontinuation of its famous film had been
turbulent for Polaroid. Carrying heavy debts from fending off a hostile
takeover bid in 1988, it had received a windfall payment in 1991 of
$925 million from its patent suit with Kodak, but rather than paying
off debts, the company used that money to shore up its stock price
and invest in research and development for the Captiva camera, which
was an expensive failure.[4] Sales peaked at $3 billion in 1991, and 1994
was the last year of profitability before the I-Zone and the Joycam in
1999 and 2000 gave sales a brief bounce. By the end of 2000, Polaroid
was again making a loss, and its poor earnings outlook and debts of
$950 million saw its credit rating downgraded by Fitch to BB-. Unable
to service its loans and bonds, in July 2001 it received temporary waiv-
ers from bondholders on interest payments. Its share price, which had
been as high as $60.51 in July 1997, had fallen to $20 by April 1999,
sliding to $1.20 on July 19, 2001, and $0.49 on October 3, a week before
the waivers were due to expire.

This was the background against which Polaroid filed for Chapter
11 bankruptcy protection on October 12, 2001. In its filing the company
listed $1.81 billion in assets and $948.4 million in debts. Having al-
ready reduced its workforce drastically that year, it announced further
redundancies, as well as cuts to severance packages and health and life
insurance for retirees. After selling off its Digital Solutions and ID Sys-
tems units and setting aside $19 million in bonuses for executives, the
slimmed-down Polaroid was put up for sale. In April 2002, One Equity
Partners, the private equity arm of Bank One Corp. of Chicago, put in
a successful bid of $265 million, which was finalized in bankruptcy
court on July 29, when Polaroid became a private entity, no longer

Figure 7.1: Fuji Instax prints, 2012.

Figure 7.2: Fuji Instax Mini prints, 2012.

stock market-listed. One Equity declined to take on Polaroid's pension fund, which was taken over by the federal government, with pensions capped in the process. Maintaining a 53% stake in the new entity, One Equity allowed the core business in instant film to continue while it concentrated on licensing out the Polaroid name for use on a range of electronic goods. Among the licensees was the Petters Group World-wide, a consumer brands business based in Minnetonka, Minnesota. Petters acquired DVD-players in China, imported them to Europe and the USA, and paid One Equity for the right to put the Polaroid name on them. Having expanded in this manner its range of "Polaroid" prod-ucts to include flat-screen televisions and digital cameras, Petters took the next logical step and purchased Polaroid outright from One Equity in January 2005 for $426 million. The short-term CEO and the Chair-man of Polaroid from 2002 to 2005 were given one-off payments of $8.5 million and $12.8 million, respectively, while the ongoing dispute with approximately 6,000 retirees who had lost benefits was settled favorably for the company: each retiree was sent a check for $47 to compensate for legal expenses incurred in their failed lawsuit against Polaroid.

It was Polaroid under Petters that brought film production to a halt in 2008, closing factories in Holland, Mexico, and Massachusetts. Rather than an abrupt action, these closures were of a piece with Petters' handling of Polaroid. Within a few months of acquiring the company, Petters had shut down the research and development division, laying off 100 staff in the process. This sent out a very clear signal that Polaroid would not be developing any new products of its own. Its innovative PoGo printer, released in 2008, was developed by Zink Imaging Inc., a stand-alone Massachusetts company that owned the rights to the printer technology and to the heat-sensitive paper embedded with colored crystal dyes on which these new instant prints were made. Any Polaroid real estate or plant that Petters could dispose of it did, including the warehoused Polaroid archives, which were donated to the Baker Library at Harvard Business School. This gradual process would no doubt have continued if the Petters Group ownership had not come crashing down in late 2008 with the arrest of Tom Petters, the chairman of the group, for financial fraud. As the tide went out on the credit crunch, it was revealed that Petters had been presiding over a $3.65 billion Ponzi scheme; he was duly sentenced in a Minnesota court to 50 years for conspiracy, mail fraud, and wire fraud. While Petters was awaiting trial, his creditors circled about salvageable parts of his mainly virtual empire, and Polaroid was forced for a second time into Chapter 11 filing in order to avoid being sold off piece by piece.

Rather than undergo reorganization, Polaroid was auctioned in a "363 sale" that stretched over three weeks in March and April of 2009, during which time two separate private equity groups were pronounced winners in the bidding.[5] When the dust finally settled, Patriarch Partners had been defeated by a joint bid of $85.9 million by Hilco Consumer Capital of Toronto and Gordon Brothers Brands of Boston, which both had experience in buying distressed companies. Following the pattern established by Petters, Polaroid's latest owners moved quickly to exploit the possibilities for the franchising and licensing of Polaroid's name and intellectual property rights. In June 2009, PLR IP Holdings, the entity that now owned Polaroid, completed a 5-year licensing agreement with the Summit Global Group to produce and distribute Polaroid-branded digital still cameras, digital video cameras, digital photo frames, and Polaroid PoGo products.

Shortly thereafter, Lady Gaga was signed on as Creative Director for a company that itself no longer made anything at all.

This sequence of events tells a familiar story about the outsourcing of manufacturing, about the profiteering opportunities offered by generous bankruptcy laws, and about the ways in which money is too tight to mention when it comes to compensating workers, but can always be found when it comes to executive pay-offs.[6] It is also very much to the point that in the back and forth selling of Polaroid over its final decade, what was being bought and sold was above all the company's *name*, which is to say, the many meanings of Polaroid condensed in that name. Everything else was considered a burden to be dispensed with (or turned into cash on a one-time basis). This is why each purchase or reorganization of the company saw the shedding of fixed costs or obligations (employees, the R&D division, pension funds and retiree benefits, company archives, manufacturing plants) and the sale of assets (real estate, inventory, the Polaroid Collections, business units that were still going concerns). The ultimate aim was to whittle Polaroid down to those parts that took up very little space, but that remained very valuable—the name and the huge intellectual property rights accumulated by the company over the years.

The principals involved in the buying and selling were generally quite open about their plans to make use of Polaroid in this way. Even as it went through its first bankruptcy, Polaroid was being paid $6 million on a three-year licensing deal on rights to use its name on cameras in China, and private equity experts were recommending that "it should simply sell anything [. . .] that can't be licensed."[7] When asked in 2005 about Polaroid's future under Petters Group Worldwide, the new chairman Stewart L. Cohen at first insisted that "Polaroid still has a multi-million-dollar instant film business that is still profitable," but then explained that "the most important thing is that Polaroid keep shifting its paradigm away from manufacturing, with its huge fixed costs," and by the end of the interview was claiming that "there's not much life left in the business. People just aren't buying a lot of instant cameras."[8] Cohen's plan should have come as no surprise to Polaroid employees, who had been told in an email earlier that year by then CEO J. Michael Pocock, that Petters was "essentially a holding company."[9] By the time of the second bankruptcy, Petters had got-

ten rid of those manufacturing plants with their "huge fixed costs," leaving behind what really interested the private equity firms. Jamie Salter, CEO of Hilco, admitted Polaroid was attractive because it "is 'iconic' and has '100-per-cent brand awareness' in North America and very high awareness worldwide."[10] Stephen Weintraub, CEO of Counsel Corp., Hilco's parent company, enthused that "Polaroid is a great name. Plus it has technology, it has lots of intellectual property. . . . We believe there are a lot of opportunities to utilize that."[11] As Salter put it in his official statement, Hilco and Gordon Brothers' aim was to "unlock Polaroid's brand value."[12]

To the idealist for whom "Polaroid" refers exclusively to the magic cameras that produced instant prints or to those prints themselves, it might seem the height of cynicism to source a DVD player in China and pay for the right to put Polaroid's name on it even if "Polaroid" had nothing to do with its design or manufacture. To those many admirers of Polaroid as a company, who still remember it as the very prototype of a research and innovation-led corporation, which unveiled astonishing new inventions every year, it might appear perverse to find "Polaroid" licensing back from Fuji a technology that Polaroid invented in the first place, a technology which was in fact Polaroid's most famous invention. For such observers, the new products bearing the name Polaroid—flat-screen TVs, digital photoframes, and so on— profit from the meanings built up around that name over many years, even whilst they hollow out those meanings from the inside. But for the private equity investors who market rather than make "Polaroid" products, the idea that a brand name is transferable is precisely the principle on which they make their wager: they dare to dream that Polaroid might become a byword for high quality DVD-players and LCD televisions. As Hilco's Jamie Salter said, the much sought-after commodity in his business is "brand awareness," an area in which Polaroid always punched above its weight.[13]

Polaroid 2.0

The Dutch-Austrian venture, the Impossible Project, made the opposite calculation. Even without the Polaroid name to put on products, Florian Kaps and André Bosman wagered that the *idea* of Polaroid photography would be enough to drive analog film sales. Polaroid under

Petters abandoned the film business as a shrinking market, and so decommissioned factories and scrapped machinery in order to write it off, but the Impossible Project saw a niche market, shrunken but not extinguished. Impossible started as Unsaleable.com in 2005 and then turned into PolaPremium, an online merchant of Polaroid film and other products in the waning days of the company. As well as sourcing from around the world, they bought the last production line of 500,000 Polaroid films in 2008 and commissioned the former Polaroid designer, Paul Giambarba, to produce new packaging for it. At first, the Project was not much more than a system of warehouses with Internet merchandising, buying bulk and distributing the remnants of a discontinued product, but Kaps' ambitions extended much further, and he leapt at the opportunity to save the Enschede plant from the scrapyard, purchasing it in late 2008 from Polaroid, while also acquiring the rights to produce Polaroid film (but not to use the name).

Kaps' rescue act made for good headlines, and Polaroid fanatics waited eagerly for the production lines to start up again. For a number of reasons, however, it was not a case of simply turning the machines back on. For starters, Polaroid's global distribution network of chemicals, parts and paper had been dismantled. Nor could that distribution network be easily reconstructed, because the other two main plants in Mexico and Massachusetts had already been scrapped. The Mexico plant produced peel-apart film, while the one in Massachusetts made the paper and the negative for the integral film. Enschede had been primarily an assembly site for integral film, and without the basic ingredients produced in Massachusetts, it was not of much use. To make matters worse, some of the chemicals in the film, already hard to source, had fallen foul of European environmental laws and their use was no longer permitted. These included the opacifying element that made it possible for the integral film to develop in direct light.

Undaunted by such obstacles, and with an evangelizing attitude to analog photography, the newly rebranded Impossible Project set out to reinvent integral film at the Enschede plant. In under two years, on March 22, 2010, the small team was able to debut a new film at the Impossible Project's New York Space. Although the print looked familiar, with its square image and white border, it was, as promised, an entirely new film, not least because it was sepia. A color version soon followed at the end of July, but so did a legion of problems. Most of

Figure 7.3: Impossible Project print, 2014.

these were to do with image stability, an age-old difficulty of chemical photography. The images were low contrast, they sometimes had spots or streaks from unevenly spread chemicals, and the opacifier leaked light, so the image had to be covered immediately after it emerged from the camera. The sepia images had an appealing antique look to them, but the look never lasted long: the prints allowed humidity in, producing on the image what the Impossible Project called "killer crystals." They also faded. The color film, meanwhile, had a sickly bluish hue, and worked best, which was not very well, in only a very narrow range of temperatures.

In the following months and years the Impossible Project regularly released new batches of film, each one a little better than the previous, and including a black and white version with moderately good contrast. As new lines came on stream, old lines were sold off at discount rates, even batches which the company acknowledged had a very high chance of containing flaws.

At the same time, the business started by PolaPremium continued. The Impossible Project was sitting on a large volume of old Polaroid stock, including final batches of Type 100, Type 53, and Type 809 film, as well as a range of novelty films with unusual color palettes. There were also expired "edge cut" films which Polaroid would not normally have sold because of the high probability of lines in the image, but which in times of scarcity evidently found willing buyers. They even dug out some old Polaroid dental cameras from the back of a warehouse and offered them up to their followers as curiosities of a bygone era. The final element in Impossible's business model was the merchandise and refurbishment program. There were Impossible cold clips to keep prints at the right temperature, Impossible "frog tongues" to protect the image as it came out of the camera, Impossible picture frames, Impossible t-shirts, and a range of Impossible-sponsored publications. Of the millions of old Polaroid cameras knocking around the globe, Impossible took in those for which they made film—Spectras, SX-70s, Polaroid 600s—cleaned them up, serviced them, and offered them for sale online and in their dedicated Impossible spaces and partner stores.

None of this came cheap. Film packs of 8 images went for between $22 and $24, meaning about $3 a shot. A refurbished secondhand Spectra with two packs of Impossible film cost $160, and a gold edition SX-70 (also with two packs of film) was $540. If you wanted a Polaroid Macro 5 camera to take close-ups of your teeth, it would set you back $249. Clearly, there was an appetite for these products, as well as enthusiastic support for Impossible's wider mission, because at the end of 2012 Kaps' enterprise raised almost $560,000 in a Kickstarter campaign to fund a new camera design, the Instant Lab for turning iPhone images into SX-70 style prints. The puzzle is why. For a generation of amateur photographers long accustomed to high-resolution digital imagery, and a dizzying array of apps and software with which to modify and improve that imagery, even the best Impossible Proj-

ect film was of a very poor standard. Digital photography is far from cheap: the networked image is sustained by a complex and expensive apparatus of software, hardware, and apps, and the largest part of digital image-making perches parasitically on top of costly cellphone contracts. However, if you want to take as many images on Impossible Project film as you take on your cell phone or Digital SLR, it will help to have a hefty trust fund to back up the habit. The answer to the puzzle must lie in the appeal of analog forms in a digital age, whether this is nostalgia in old Polaroid users, or curiosity among those for whom the experience is new. Yet this hardly accounts for the specific appeal of Impossible Project film. If a photographer after 2010 wanted an instant analog print, there was no need to use the unpredictable and often unsatisfying film coming out of Enschede, because at the same time Fuji was making stable, perfectly serviceable instant film for its Instax and Instax mini cameras. Polaroid nostalgists could even buy the latter branded with the Polaroid name if they wished. So, why Impossible?

One explanation could be that the Fuji instant film is rectangular in format, whereas the Impossible Project print is square, and looks exactly like a Polaroid print. It must help that Instagram, with its range of faux-vintage looks, also uses a square format, thus smoothing the way for younger users from app to Impossible.[14] Fuji instant film does not work in Polaroid cameras, in the 600 models, the Spectra, or the SX-70, the last a true SLR for which there remains intense affection in the photographic world. The Fuji instant cameras have nothing near the level of controls that are found in the SX-70 or Spectra, nor anything like the elegance of the former. It might be that such factors outweighed questions of image quality. It is also the case that the poor image quality of Impossible Project film was not a deterrent to its use, but paradoxically, one of its attractions. Certainly, the company had no trouble finding users who praised the quirks and imperfections of the earliest batches of film (although there were plenty of complaints as well). Digital photography is too perfect and too predictable, these testimonials suggested, and the pleasure of Impossible Project film was precisely in not knowing what might come out of the camera. The element of chance was for some a welcome challenge. Impossible's marketing material made a virtue of necessity, claiming that shooting the film was an "adventure," that each picture was a potential surprise,

and even suggested that "defects . . . might enhance the roughness and beauty of your imagery."[15] Never hiding that their film was experimental, Impossible enlisted photographers as participants in that experiment, and asked for their feedback, including them as part of the Project. To shoot on Impossible film was almost to be there at the invention of photography. If the prints ever did get to look exactly like the old Polaroid film, many of the Impossible disciples might actually be disappointed.

There was another unexpected advantage in the film's instability and many defects. In order to have any chance of getting an image of even moderate quality, the photographer had to go through a series of careful steps—making sure to overexpose or underexpose depending on the film type; shielding the film from the light by shooting into a homemade box, or with a specially adapted "frog tongue"; shooting only within a certain temperature range; cooling the film on a hot day, or warming it on a cold one; developing the film upside down; and so on. The Impossible website and email updates were filled with cheerful advice and tutorials on how to beat all the tricky eccentricities of the system. Consumers spoilt by black-boxed technology now got to play at techno-austerity, forced into the fine art of maintenance and obliged to understand the guts of the machine they were using, instead of just its inputs and outputs. Ritual actions had always been central to Polaroid photography, and in reinventing the film, Impossible had, intentionally or not, reinvented its ritual qualities as well.

Polaroid's great triumph, its real arrival on the scene as a major player in photography, was when it got beyond the department store photo counter or specialty photo shop and into the drugstores. Getting into the drugstores meant it was no longer a niche or exclusive product, but one with genuine mass distribution. This happened with the Swinger in 1965, and in 2008 when the last packs were being sold, the film could still be found in drugstores, in Wal-Mart in the US, in Boots in the UK. You can tell a lot about film (and about who is using it) by where it is sold. In my city in 2010, you would never have found Impossible Project film in Boots or in a shopping mall. Instead, if you didn't buy it online—the main method—you had to make a trip to Fred Aldous, the main art supply store in the city center, where you could also pick up a Lomo, a Holga, or a fish-eye camera. Like Polaroid in the early days, instant film was an exclusive item again, this time

apparently favored by a youthful artistic customer for whom it was half toy, half paintbrush. Impossible Project encouraged this image of its users, calling them "reckless, creative and artistic" and enlisted Zurich University of the Arts to design the dark slide—the cardboard cover that automatically ejects when the film is first loaded—and later solicited design ideas from their users for the second version of this slide.[16] They hosted exhibitions and published catalogues, collaborated with Japanese and Hong Kong style magazines, and commissioned established Polaroid photo-artists, such as Mary Ellen Mark and David Levinthal, to shoot on Impossible film.[17] They also promoted the various modes of image vandalism discovered by artists back in the 1970s: manipulation of the print's chemistry, lifting the emulsion to make image transfers, and peeling the image apart to create transparencies. All these things lent themselves well to those old stand-bys of amateur photography magazines—the photo competition and the reader's gallery. When Impossible published online the results of its competitions, the locations of the winners read like a checklist of global cosmopolitanism—Barcelona, Brooklyn, Tokyo, Milan, Portland, L.A., Amsterdam, San Francisco.

At the heart of all this was an almost religious zeal for analog photography in the face of digital ubiquity. As one of their newsletters put it, the Impossible Project was devoted to "Real analog originals that develop in the palm of your hand. Distinctive, one-of-a-kind images that are real and intense. Images that you can touch, smell, caress."[18] The appeal to the tangible, the tactile, the real, is a familiar one in a virtual world, but it would be a mistake to think that the Impossible Project was some sort of refuse-nik movement of analog purists rejecting digital imagery in favor of photo-objects that you could hold in your hand, write on, or even sniff if you wanted to. After all, the origins of the Project lay in Florian Kaps' "Polanoid," a photo-sharing website that appeared not long after Photobucket and Flickr. The Impossible Project itself proved highly web-savvy, with a small team running a slick Internet operation, and cannily drawing on user-generated content for its imagery. The business was heavily dependent on posting photos online, and in that sense no different from other photo-sharing platforms such as Facebook, Flickr, and Instagram. The Impossible image was a highly networked image, not a rejection of the networked image. For those who signed up to its fervent analog ideology (and had

the necessary cash), it offered a sort of Polaroid 2.0: a digitally medi-ated photography, but for a small and exclusive community of users.

Who isn't a photographer now? Photography is no longer the special domain of the "serious amateur" with darkroom skills, never mind the professional or commercial photographer. It is mobile, con-venient, and ubiquitous.[19] It makes Polaroid photography look quaint and unwieldy, even if Polaroid was once itself a crucial step in pho-tography's path to ubiquity. But now that the power and pleasure of image-making are in so many hands, it may be that its value has di-minished. So in the first decades of the twenty-first century analog has found a new function. Everyone can do photography, but not everyone, in fact hardly anyone, is doing analog. In its very obsolescence lies the secret of its continuing survival. This is just one of the reasons why you aren't likely to find Impossible Project film in your local Wal-Mart any time soon.

Epilogue

In the latter stages of the research for this book I embarked on a hunt for ordinary Polaroid images to reproduce in these pages. I already had numerous images of my own, as well as those of generous friends, and donations from former Polaroid employees. Many of these have already appeared as illustrative of types of film, or to demonstrate the limitations or potential of Polaroid images. But to stick solely to my circle of acquaintances would hardly be representative, and I was in any case looking for anonymous images. Many of these are posted online on photo-streaming websites, some of them devoted exclusively to Polaroid imagery, but it is not always easy to contact those who have posted such images, and I wanted to get them in my hand rather than just be sent an electronic version with permission to reproduce. I found eBay a disappointment: there one can find a surprisingly small number of images at surprisingly high minimum offer prices. Pictures by artists are more readily available, but they are far from representative, and can cost inordinate amounts to reproduce, especially now that the Polaroid Collections, once a generous provider of images, has closed its doors for good.

The search was slightly quixotic anyway, going against a key principle of this book. As I have already argued in the introduction and in chapter 2, the idea that there should be some sort of representative or typical Polaroid image is dubious. In 1974 alone there were about 1 billion Polaroid images made, and by 1976, according to Edwin Land himself, 15 billion in total, and this before the real explosion in Polaroid photography in the late 1970s and early 1980s.[1] The multitudinous nature of snapshot photography makes it impossible to general-

ize about the typical contents or style of those images, and I long ago accepted that this book would never pin down the chimerical ordinary Polaroid image. Still, I didn't want to abandon the hunt so easily. If I could get my hands on a large enough sample, I could at least have a stab at testing out some of the contradictory claims made by various parties over the years about Polaroid images: they fade quickly, they fade less quickly, they have saturated colors, they have muted colors, they have high resolution, they are grainy, they tend towards the yellowy part of the spectrum, and so on.

The search therefore went on, and I fruitlessly scoured flea markets in hopes of finding that elusive shoe-box overflowing with Polaroids, or a family album crammed with them. Photo albums on sale in flea markets have generally come by way of house clearances, which means that they are the possessions of the recently deceased that no relative has seen fit to claim. Perhaps it is too soon to find such albums with images from the 1970s or 1980s, or perhaps it is a measure of the low esteem in which Polaroid images are held—their diminished cultural value—that they are less likely to make it into a carefully ordered family album. Whatever the reason, my searches came up empty, although I did find all manner of old Polaroid cameras, and albums full of Kodak Instamatic and other sorts of prints. Even this late in the book, it is worthwhile remembering again that the Kodak Instamatic of 1963 was not an "instant" camera like the Polaroid. Kodak's instant cameras of the mid-1970s were the EK line—EK1, EK2, EK4, EK6, and so on.

During my failed trawl through flea markets in my region, I picked up a useful tip from an experienced vendor. If I was interested in finding old photos, she told me, the Salford Local History Library had a vast collection and sometimes even disposed of some of them. This Library was right under my nose, located about 300 yards from my office on the Salford University Campus. It houses over 50,000 photographs relating to the neighborhoods of Salford, a borough of Greater Manchester. Those photographs are very loosely stored, uncatalogued, in ten filing cabinets, where they are arranged according to street names and noteworthy Salford citizens. Many of the photographs, which stretch back to the nineteenth century, come from the studios of professional photographers in Salford and Manchester, but a large number of them are also amateur photographs donated to the Library. The professional and the amateur photographs are all mixed

Figure 8.1: Trimmed integral Polaroid, ca. 1991.

in together, but it was from among the latter that I hoped to encounter some of those elusive ordinary Polaroids.

I am by no means confident that I didn't miss something in my slow progress through those tightly packed filing cabinets, but at the end of my search I came up virtually empty-handed. Much of the archive is of older photos, which were unlikely to be Polaroids, since these would have made it to Britain only in the hands of American tourists in the 1950s and early 1960s.[2] From among all the color images in the files, my haul of undamaged Polaroids came to a grand total of two. I say undamaged, because before I found these, I hit a string of Polaroids which had been cropped, the wider part of their characteristic white frames trimmed so that they were more or less the same width as the other three borders, making them look more like Kodak 129 color prints of the late 60s or early 70s. The unevenness

Figure 8.2: Back of trimmed integral Polaroid, ca. 1991.

of the cut and the slightly pimpled three-dimensionality of the bor-
ders were clues that they were Polaroids. Pulling them away from the
card they had been stuck to and turning them over disclosed their
tell-tale matte black backs and the Polaroid name printed on what re-
mained of the white border. These damaged Polaroids did not appear
all together in a group, having been filed according to the street they
pictured, but I could only assume that they were all the work of the
same photographer.

It is not possible to work on the history of Polaroid photography
for almost ten years and not feel that this careless chopping of the
white border was a kind of desecration of the integrity of the Polaroid
image. How could someone do such a thing? It was added insult that I
had come so close in my hunt, only to be thwarted by some vandal with
a pair of scissors. Was the trimming the work of the original photog-

rapher, or of the library staff who had filed it, perhaps to remove some private inscription that had been included on the wider part of the frame? I approached one of the librarians on duty, described to her my project and what I was looking for, showed her one of the damaged images and explained how I could tell nonetheless that it was a Polaroid. Did the library have a policy, I asked, of filing photos in the exact state in which they were donated, or was there a possibility that the images had been cropped once they had arrived in the collection? She thought it highly unlikely that the staff would make any modification to images before they were filed, and made the highly sensible suggestion that the original photographer had probably trimmed them so that they would fit better into the sleeves of an album. I accepted that this must have been the case, but continued to complain that it was a shame that anyone would cut off part of the print that was integral to the overall Polaroid image, and that I couldn't imagine how they could do it. Giving me a look that suggested that the conversation was nearing its natural end, the librarian simply replied, "Well, they probably didn't have your interests, did they?" Working in a local history library, she had no doubt encountered more than her fair share of obsessive types.

Three lessons, I think, can be drawn from this experience. The first is about perspective. When I see a Polaroid photograph, I see above all . . . a Polaroid photograph. Others who do not share my interest, however, may not see a Polaroid photograph at all, but just another photograph. For them, if the photo has any value it is not because it is a Polaroid, but because it shows a view, for example, of Chapel Street in Salford in 1981. In other words, it is the indexical or evidential qualities of the image which give it its interest, and it does not matter one way or another what sort of film it has been taken on. Obviously, in the museum of local history this tendency will be stronger than in the local art gallery next door, but even there, to start pedantically insisting on the importance of film types is to risk slipping into the narcissism of minor differences. That many Polaroids are instantly recognizable as Polaroids is not necessarily the sign of any profound identity or great difference. On the contrary, as I said at the very outset, recognition can obscure as much as it reveals.

The second lesson is the corollary of the first. The librarian's indifference to the specificity of the Polaroid image supports my thesis, as worked out in chapter 2, and then elaborated upon in all subsequent

chapters, that the distinctiveness of Polaroid photography does not lie primarily in its qualities as an image. If Polaroid photography is significantly different from other kinds of photography, and all the evidence collected in this book suggests that that is indeed the case, then that difference comes mainly from the act of taking a Polaroid picture. The marvel of a Polaroid was in its making, with all the attendant rituals: the waiting, the shaking, the showing. None of that is visible, thirty years on, when I dig one out of a filing cabinet in the local history museum, so is it any wonder that the librarian should shrug at my dismay?

The final lesson lies in that dismay. It is one thing to determine objectively that a Polaroid photo is not all that different from other photos, quite another to actually accept that fact. The casual cropping of the Polaroid border was of no consequence to the librarian, since it left the photographic image intact and did not damage the view of Chapel Street. Yet there are plenty of us who would never dream of defacing that iconic white border. Every photographic print is a material object, but a Polaroid is somehow more so. This is down to what I've called the perversity of the technology, the way in which it thwarts the basic photographic potential for making copies. The absence of a negative makes each Polaroid print a singular artifact, and without the white border, that artifact is simply incomplete.

It may be part hallucination to think that those stiff square images are radically different from other forms of photograph, but that makes the feeling no less real. Like many Polaroid enthusiasts, I stocked up on film in the months after the company's announcement that it was discontinuing production, and I waited hopefully for the Impossible Project to reinvent the film. As my stockpile dwindled, I rationed my film, chose more carefully what I photographed, and became more reluctant to give away prints, or let others take pictures, even if the technology in some ways demands that one should. Under such circumstances of scarcity and disappearance, it became even harder not to hallucinate unique qualities for these image-objects, and I was far from alone in that feeling. And as for the Polaroid images I found in the Salford Local History Library? Were they faded as the legend dictates? Some of them were, and some were not. One had yellow chemical leakage in a corner. Among the non-Polaroid color photos in the filing cabinets, some were less faded than the Polaroid prints, and others more.

Acknowledgments

This book would not have been possible without the generous support of the British Academy, the Arts and Humanities Research Council UK, and the Leverhulme Trust. Thanks to Fred Botting and Julia Thomas who wrote references for the grant applications. I am also indebted to the archivists and curators who have assisted me on this project. I am grateful to Colin Harding at the National Media Museum, Bradford, Debbie Douglas at the MIT Museum, Barbara Hitchcock and Jennifer Uhrhane at the Polaroid Collections, and above all Tim Mahoney at the Baker Library Historical Collections, Harvard Business School. On my two long visits to HBS Tim gave generously of his knowledge and time, and continued to do so afterwards. Thanks as well to Laura Linard, Katherine Fox, Melissa Murphy, and Abby Thompson at the Baker.

I have learnt a great deal from audiences who have listened to me speak about Polaroid. For the invitations, thanks to Dianne Chisholm (University of Alberta), Jerome De Groot (University of Manchester), Sharon Ruston (University of Keele), Ben Harker (Salford University), Sam Perry (G39, Cardiff), Andrew Stott (SUNY Buffalo), Noelle Gallagher (University of Manchester), Christine Ferguson (University of Glasgow), Susan Oliver (University of Essex), Stephen Clucas (Birkbeck College, London), Bill Ewing and Todd Brandow (the Todi Circle), Annebella Pollen (University of Brighton), Natalya Rulyova (University of Birmingham), and Mark Goodall and Ben Roberts (University of Bradford). Work in progress on the book was also delivered at a number of conferences and annual meetings: Media, Communication and Cultural Studies Association (MECCSA) at the University of Cardiff, MECCSA at the University of Bradford, European Society for the

Study of English at Aarhus, Society for the History of Technology at Tacoma, and at the Institute for Historical Research in London.

I was very fortunate in the astute and exacting readers for the University of Chicago Press: Geoffrey Batchen, Alan G. Thomas, and the two anonymous readers. The manuscript was also commented on in whole or in part by Manu Basile, Adolf Buse, Dani Caselli, Ken Hirschkop, Scott McCracken, Rajeet Pannu, Andy Stott, and Nuria Triana-Toribio. And I could not have wished for a better reader than my excellent editor, Karen Merikangas Darling, who has been calm and patient throughout, and helped me see the way through. Thanks also to Evan White at the Press, who saw the book safely into production.

Many of my ideas on Polaroid were workshopped in shorter pieces, and then reworked or rejected for this book. Traces of them, sometimes small, remain as follows: "40,000 Roses, or, the Perversity of Polaroid" in *The Polaroid Years*, ed. Mary-Kay Lombino (chapter 2), "Polaroid after Digital: Technology, Cultural Form, and the Social Practices of Snapshot Photography," *Continuum: Journal of Media and Cultural Studies* 24:2 (chapter 3); "The Polaroid Image as Photo-Object," in *Journal of Visual Culture* (chapter 4); "Surely Fades Away: Polaroid Photography and the Contradictions of Cultural Value," *Photographies* 1:2 (chapter 5); "Polaroid, *Aperture*, and Ansel Adams: Rethinking the Industry-Aesthetic Divide," *History of Photography* 33:4 (chapter 6).

For sustenance of all sorts: Janice Allan, Margaret Beetham, Anke Bernau, Rob Duggan, Rainer Emig, Kristin Ewins, John Fyfe, Jeff Geiger, Hal Gladfelder, Melissa Jacques, Rob Lapsley, Brian Maidment, David Matthews, Martin McQuillan, Frances Piper, Antony Rowland, Scott Thurston, Anastasia Valassopoulos, Andy Willis, and my colleagues at *New Formations*. Finally, thanks to Jo-Ann Wallace, who encouraged me early on and pointed me in the right direction, to George McKay at Salford for pushing, to Rajeet and Shanu for their Spectra, to Matthew Frost for being irrepressible, and most of all to Nuria, whom I will also thank in person.

Notes

Introduction

1. Cited in Elizabeth Church, "Polaroid Pictures a New Image," *Globe and Mail*, September 13, 2000; cited in Noel Young, "How Polaroid Lost Sight of the Bigger Picture," *Scotland on Sunday*, October 28, 2001.

2. The case is nonetheless defensible. The Polaroid Mio of 2001, although marketed as a Polaroid camera, was in fact a rebranded Fuji Instax Mini. The Polaroid name appeared on the camera through a licensing agreement with Fuji, which entered the integral instant film business in 1999 after Polaroid's patents expired. The Polaroid 300, launched in 2010, was simply a slightly modified Mio, still made by Fuji and using Fuji Instax Mini film, and once again bearing the Polaroid name under a licensing agreement with the Japanese company. In early 2010 Polaroid's new owners PLR IP Holdings, announced the imminent launch of a redesigned OneStep camera, to be named the PIC 1000. At the time of writing, there was no sign of this camera on the market; it was in any case no more than a repackaging of a camera first released in 1977, this time with, for example, a new "wood effect." The Impossible Project, striving to recreate Polaroid film, was mainly in the business of renovating and maintaining old cameras, although in 2013 it released the Instant Lab, which allowed users to re-photograph iPhone images with instant film.

3. Sandy Lawrence, cited in Joy Dietrich and Jon Herskovitz, "Polaroid Imports Ideas from Japan," *Advertising Age International*, April 12, 1999.

4. Sandy Lawrence, cited in Jonathan Takiff, "Point, Click and Print: Instant Camera Is Made to Appeal to the Youth Market," *Philadelphia Daily News*, April 5, 2000.

5. Phil Patton, "Style Team Reinvents Polaroid as a Toy," *New York Times*, May 18, 2000.

6. The major statement on the relations between old and new media, and the ways in which they "mediate" each other, is J. David Bolter and Richard Grusin, *Remediation: Understanding New Media* (Cambridge, MA: MIT Press, 1999).

7. "Topics of the Times: Camera Does the Rest," *New York Times*, February 22, 1947.

8. "Polaroid Announces Beautifully Simple Instant Pictures," 1978, Polaroid Corporation Administrative Records, Box I.321, f. 13 Product information files—SX-70 Sonar OneStep, 1978, Baker Library, Harvard Business School (hereafter HBS). A brochure for the SX-70 also used the phrase, advising "squeeze the red button—the camera does the rest," but this did not become standard in publicity materials until 1978. "The World of SX-70," Polaroid Corporation Administrative Records, Box I.248, f. 12 Product information—consumer—SX-70 camera—"The World of SX-70," May 1974, HBS.

9. Edwin Herbert Land, *Selected Papers on Industry* (Cambridge, MA: Polaroid Corporation, 1983), 28.

10. Land, *Selected Papers*, 28.

11. See James E. Paster, "Advertising Immortality by Kodak," *History of Photography* 16, no. 2 (1992), 138.

12. Edwin Herbert Land, "Absolute One-Step Photography," *Photographic Journal* 114 (1974), 338.

13. Douglas Collins, *The Story of Kodak* (New York: Harry N. Abrams, 1990), 214.

14. Edwin Herbert Land, "A New One-Step Photographic Process," *Journal of the Optical Society of America* 37, no. 2 (1947), 66.

15. Land, "Absolute One-Step Photography," 338.

16. Land, "A New One-Step Process," 61.

17. For those interested in the science, Land's essays of 1947 and 1974, already cited, are the best place to start. For a meticulous account of all the science behind Polaroid's inventions, see Victor K. McElheny, *Insisting on the Impossible: The Life of Edwin Land* (Cambridge: Perseus, 1998).

18. The photobooth, or Photomaton, is another interesting case that, like Polaroid, provides its images quickly and without the intervention of a professional photographer or developer (but is immobile and does not put the camera in the hands of the user). The technology of the "automatic portrait" first appeared in New York in 1926 and spread quickly. Raynal Pellicer has traced the very specific cultures and rituals that built up around this technology. Raynal Pellicer, *Photobooth: The Art of the Automatic Portrait*, trans. Anthony Shugaar (New York: Abrams, 2010).

19. Mark Olshaker's *The Instant Image*, written at the height of Polaroid's popularity in the late 1970s, is a work of investigative journalism that pieces together the key facts about a man who was highly protective of his private life. *Land's Polaroid* (1987), by Peter C. Wensberg, a company insider, is rich with anecdotes about advertising campaigns, business decisions, and personalities, and is a great resource. Mark Olshaker, *The Instant Image: Edwin Land and the Polaroid Experience* (New York: Stein and Day, 1978); Peter C. Wensberg, *Land's Polaroid: A Company and the Man Who Invented It* (Boston: Houghton Mifflin, 1987). More recently this story has been brought up to date, taking in the demise of the company and the revival of the film by The Impossible Project, in Christopher Bonanos, *Instant: The Story of Polaroid* (Princeton: Princeton Architectural Press, 2012). One of the company's

patent lawyers has published another biography of Land, with an account of Polaroid's patent dispute with Kodak at its heart: Ronald K. Fierstein, *A Triumph of Genius: Edwin Land, Polaroid, and the Kodak Patent War* (Washington, DC: American Bar Association, 2015).

20. In the novel Thomas Harris is careful to identify it as the CU-5 to satisfy those readers who crave and expect such technical details. Thomas Harris, *The Silence of the Lambs* (New York: St. Martin's, 1989), 64.

21. See, for example, Giovanni Chiaramonte and Andrey A. Tarkovsky, eds., *Instant Light: Tarkovsky Polaroids* (London: Thames and Hudson, 2004); Steve Crist, ed., *The Polaroid Book: Selections from the Polaroid Collections of Photography* (Cologne: Taschen, 2005); Robert Mapplethorpe, *Mapplethorpe: Polaroids* (New York: Prestel, 2007); Helmut Newton, *Polaroids* (Cologne: Taschen, 2011); Mary-Kay Lombino, ed., *The Polaroid Years: Instant Photography and Experimentation* (New York: Prestel, 2013).

22. Sam Yanes, in charge of Corporate Communications at Polaroid between 1977 and 1995, told me that artistic use made up a tiny proportion of Polaroid photography, well below 1%, and this at a time (the 1970s and 1980s), when that sort of use was on the increase.

23. Cited in Allan Porter, "Evolution of One-Step Photography," *Camera* 53, no. 10 (1974), 11.

24. "Polaroid Corporation: A Statement of Dealer Policies," 1970, Polaroid Corporation Administrative Records, Box I.68, f. 17–18 Publicity—Dealer mailings—form letters, bulletins, contracts, etc., 1970, HBS.

25. In his brilliant account of Polaroid branding in the 1950s and 1960s, Paul Giambarba comments acidly on the obstacle the name—regularly misspelt and mispronounced—posed for marketers. Giambarba designed much of Polaroid's iconic packaging between 1957 and 1977. Paul Giambarba, *The Branding of Polaroid* (Cape Cod: Capearts, 2010), 8.

26. Elizabeth Brayer, *George Eastman: A Biography* (Baltimore: Johns Hopkins University Press, 1996), 72. On Kodak advertising, see Nancy Martha West, *Kodak and the Lens of Nostalgia* (Charlottesville: University of Virginia Press, 2000).

27. Douglas Coupland, *Polaroids from the Dead* (Toronto: HarperCollins, 1996); Mark Ravenhill, *Some Explicit Polaroids* (London: Methuen, 1999); Mar Coll, dir. *La última polaroid* (2004); Nicky Wire, *Death of a Polaroid: A Manics Family Album* (London: Faber and Faber, 2011).

28. A. D. Coleman, "Polaroid: The Good Old Story," *Katalog* 10, no. 2 (1998), 40.

29. The key texts are cited in chapter 1, but a few more of the recent ones could be noted here: Jose van Dijk, *Mediated Memories in the Digital Age* (Stanford: Stanford University Press, 2007); Damian Sutton, *Photography, Cinema, Memory: The Crystal Image of Time* (Minneapolis: Minnesota University Press, 2009); Mary Bergstein, *Mirrors of Memory: Freud, Photography and the History of Art* (Ithaca: Cornell University Press, 2010); Audrey Linkman, *Photography and Death* (London: Reaktion,

2011); Geoffrey Batchen, Mick Gidley, Nancy K. Miller, and Jay Prosser, eds., *Picturing Atrocity: Photography in Crisis* (London: Reaktion, 2012).

30. Batchen makes this case in "Snapshots: Art History and the Ethnographic Turn," *Photographies* 1, no. 2 (2008). See also his earlier book, *Each Wild Idea: Writing, Photography, History* (Cambridge, MA: MIT Press, 2002), 56–81.

31. Susan Sontag, *On Photography* (Harmondsworth: Penguin, 1977); Roland Barthes, *Camera Lucida: Reflections on Photography*, trans. Richard Howard (London: Flamingo, 1984).

32. See Risto Sarvas and David Frohlich, *From Snapshots to Social Media: The Changing Picture of Domestic Photography* (London: Springer, 2011), 103.

33. Catherine Zuromskis, "On Snapshot Photography: Rethinking Photographic Power in Public and Private Spheres," in *Photography: Theoretical Snapshots*, ed. J. J. Long, Andrea Noble, and Edward Welch (London: Routledge, 2009), 61.

34. Richard Chalfen, *Snapshot Versions of Life* (Bowling Green: Bowling Green State University Popular Press, 1987), 13; Collins, *The Story of Kodak*, 311; Geoffrey Crawley, "Colour Comes to All," in *The Kodak Museum: The Story of Popular Photography*, ed. Colin Ford (London: Century, 1989), 153; Graham King, *Say Cheese! The Snapshot as Art and Social History* (London: William Collins, 1986), xi; Martha Langford, *Suspended Conversations: The Afterlife of Memory in Photographic Albums* (Montreal: McGill-Queens University Press, 2001), 78.

35. Chalfen, *Snapshot Versions of Life*, 2.

36. Annebella Pollen, "Visual Economies of Scale: Making Sense of Majority Photography" (paper presented at the Contemporary Vernacular Photographies Colloquium, University of Westminster, London, September 3, 2011).

37. Walter Benjamin, *The Arcades Project*, ed. Rolf Tiedemann, trans. Howard Eiland and Kevin McLaughlin (Cambridge, MA: Belknap Press, 1999), 473. In a book I wrote with three colleagues, we put it this way: "Benjamin does not set out to save ephemeral phenomena for proper appreciation, but from such appreciation: salvation leads away from heaven, not towards it." Peter Buse, Ken Hirschkop, Scott McCracken, Bertrand Taithe, *Benjamin's Arcades: An Unguided Tour* (Manchester: Manchester University Press, 2005), 73.

Chapter One

1. Interview with Evans in *Yale Alumni Magazine*. Cited in *Polaroid Newsletter*, April 1, 1974.

2. For Land's account, see Edwin Land, *Selected Papers*, 19–22. A detailed version of the story can also be found in Wensberg, *Land's Polaroid*, 81–85.

3. See Susan J. Douglas, "Some Thoughts on the Question, 'How Do New Things Happen?'" *Technology and Culture* 51, no. 2 (2010): 294.

4. Land, *Selected Papers*, 21.

5. For an account of the desires leading to the invention of photography, see

Geoffrey Batchen, *Burning with Desire: The Conception of Photography* (Cambridge, MA: MIT Press, 1997).

6. Meatyard's practices are reported by Guy Davenport in his portrait of the photographer in *The Geography of the Imagination: Forty Essays* (London: Pan Books, 1984), 370. On Winogrand, see Arthur Lubow, "Looking at Photos the Master Never Saw: When Images Come to Life After Death," *New York Times*, July 3, 2014.

7. See John Maloof, ed., *Vivian Maier: Street Photographer* (New York: power-House, 2011).

8. Barthes, *Camera Lucida*, 94–97.

9. Sontag, *On Photography*, 15; Jo Spence, *Putting Myself in the Picture: A Political, Personal and Photographic Autobiography* (Seattle: Real Comet Press, 1988); Annette Kuhn, *Family Secrets: Acts of Memory and Imagination* (London: Verso, 1995); Marianne Hirsch, *Family Frames: Photography, Narrative and Postmemory* (Cambridge, MA: Harvard University Press, 1997); Ulrich Baer, *Spectral Evidence: The Photography of Trauma* (Cambridge, MA: MIT Press, 2002); Geoffrey Batchen, *Forget Me Not: Photography and Remembrance* (New York: Princeton Architectural Press, 2004); Brian Dillon, *In the Dark Room: A Journey in Memory* (London: Penguin, 2005); Jay Prosser, *Light in the Dark Room: Photography and Loss* (Minneapolis: University of Minnesota Press, 2005).

10. West, *Kodak and the Lens of Nostalgia*, 1.

11. Commenting on the obligatory optimism of the snapshot mode, the historian of Kodak, Douglas Collins, helpfully explains that in the early days "most amateur film was sensitive only to bright daylight," a fact which "conspired to make snapshot content inevitably glowing, even luminous." Collins, *The Story of Kodak*, 121. Postmortem photography was quite common in North America up until the end of the nineteenth century. See Stanley B. Burns, *Sleeping Beauty: Memorial Photography in America* (Santa Fe: Twelvetrees/Twin Palms Press, 1990) and Jay Ruby, *Secure the Shadow: Death and Photography in America* (Cambridge, MA: MIT Press, 1995) and Linkman, *Photography and Death*. Traditions of photographing the dead continued to flourish in some cultures in the twentieth century and even in Kodak subcultures. In 1969, my grandmother, a German immigrant to Canada from Poland, obliged her five sons to pose alongside my grandfather's coffin, and also had a portrait made of him in his coffin.

12. West, *Kodak and the Lens of Nostalgia*, 13. In a brief earlier analysis of changing Kodak advertising strategies, James E. Paster anticipated West's research, also showing that the emphasis on memory came only in the twentieth century. In addition, Paster identifies the "instantaneous" as a key selling term in the first Kodak advertising campaigns. Not instant prints of the Polaroid variety, of course, but the instantaneous *capture* of images. Thanks to faster emulsions and shutters, from the late 1870s photography was able to stop motion, whereas before it had required long exposures in strong light of unmoving subjects. The novelty of instant capture, in other words, was a key attraction for the first mass amateur cameras,

although this quickly passed once it had become the norm, and "By the 1950s the snapshot was presented almost exclusively as a means of dealing with the inexorable passage of time." Paster, "Advertising Immortality by Kodak,"138.

13. See Brayer, *George Eastman*, 59.

14. West, *Kodak and the Lens of Nostalgia*, 88, 95.

15. West, *Kodak and the Lens of Nostalgia*, 105–8.

16. Barthes, *Camera Lucida*, 9. Commenting on *Camera Lucida*, Ron Burnett claims, "The notion of instant development, the instant print, runs counter to the 'value' of the photograph as a vehicle of preservation, as a special moment during which an event or person has been captured for the family album." Ron Burnett, "Further Notes on Roland Barthes from Cultures of Vision." Accessed October 9, 2011. http://rburnett.ecuad.ca/roland-barthes-photographs/.

17. Commentators have noted that the book identifies the image as *Polaroïd* (1979), but that it is in fact untitled. They also note the importance of the image's placement, the fact that it is the only color photo in the book, and that Barthes makes no mention of it in his text. They draw conclusions about its blue-green hue, about its veil-like qualities, and about its connections with other images in *Camera Lucida* and with the questions of mother-son relations the book emphasises. No one has much to say about the fact that it is a Polaroid. Failing my suggestion that the image alludes to the "light chamber" of Barthes' title, I would argue that this is not necessarily an oversight, but in fact perfectly appropriate. Reproduced in the frontispiece of a book, this Polaroid image has already left behind those qualities that make it distinctive as a Polaroid, the process by which it was made. See *Photography Degree Zero: Reflections on Roland Barthes' Camera Lucida*, ed. Geoffrey Batchen (Cambridge, MA: MIT Press, 2009), especially the introduction by Batchen and the essay by Carol Mavor. See also W. J. T. Mitchell, *Picture Theory: Essays on Verbal and Visual Representation* (Chicago: University of Chicago Press, 1994), 302.

18. It is hard not to conclude that Barthes' professed impatience is in fact disingenuous. From Barthes' earlier text, *A Lover's Discourse* (1977), we know that what desire wants is *not* satisfaction, but more desire. Barthes may protest that he wants immediate gratification from image-production, but this is not really true, or possible. What he wants is to want immediate gratification but not to get it, to be always frustrated in his desire for immediate gratification, to have that gratification put off, agonizingly delayed, held up by the gap that is the non-coincidence of the event and its image. This is because, in the Lacanian terms in which Barthes was heavily steeped at this point, once you get what it is you're after, have it in your hand, precisely at this point, as Lacan puts it in *Seminar 11*, it dissolves into shit. The Polaroid image just gets you into that situation faster, although Barthes doesn't exactly put it like this. See Roland Barthes, *A Lover's Discourse*, trans. Richard Howard (New York: Vintage, 2002); and Jacques Lacan, *The Four Fundamental Concepts of Psychoanalysis*, ed. Jacques-Alain Miller, trans. Alan Sheridan (Harmondsworth: Penguin, 1977), 268.

19. "Polaroid Model 20 Land Camera," 1965, Polaroid Corporation Administrative Records, Box I.318, f. 4 Product information files—Swinger (Model 20), 1960s, HBS.

20. Robert D. Buzzell and M. Jean-Louis Lecocq, "Polaroid France (S.A.) Marketing Planning in a Multinational Company," Harvard Business School Case Study 513–119, (1968), 3.

21. "Polaroid," *Forbes*, June 15, 1969.

22. "June 1 On-Sale Date . . . Distributors Get Swinger Kick-Off Plans," *Intercom: Polaroid International Communique*, March 1966, Polaroid Corporation Administrative Records, Box I.65, f. 22 Publicity—"Intercom: Polaroid Internal Communique," Vol. 1, No.1, 2, 3, 5, 1965–1966, HBS.

23. "Polaroid's in the Toy Business," 1967, HBS.

24. "Press release, October 20, 1966—Polaroid Mounts Saturation Ad Campaign for Christmas," 1966, Polaroid Corporation Administrative Records, Box I.175, f. 10 Press releases, 1966, HBS.

25. "Hi, Swinger," 1965, Polaroid Corporation Administrative Records, Box I.62, f. 5 Publicity—Cameras—Model 20 Swinger—product brochures, price lists, etc., 1965, HBS.

26. Thanks to Melissa Jacques for calling this to my attention.

27. For instance, the main glossy brochure for the SX-70 states, "We could not have known, and have only just learned—perhaps mostly from children from two to five—that a new kind of relationship between people in groups is brought into being by SX-70." "The SX-70 Experience," 1974 Polaroid Corporation Administrative Records, Box I.265, f. 2 Product information—"The SX-70 Experience," 1974, HBS.

28. "Polaroid introduces an instant camera so remarkable it even develops children," 1988, Polaroid Corporation Administrative Records, Box I.326, f. 14 Product information files—Cool Cam, 1987–1991, HBS.

29. Gary Cross, *Kids' Stuff: Toys and the Changing World of American Childhood* (Cambridge, MA: Harvard University Press, 1997), 3, 139.

30. *Popular Photography*, March 1967.

31. See, for example, "R and D Scoreboard: 12 Leisure Time Products," *Business Week*, June 28, 1993; or "Who's Where in the Stock Market: Consumer Nondurables," *Forbes*, January 4, 1993.

32. Patton, "Style Team Reinvents Polaroid as a Toy."

33. Sharon M. Scott, *Toys and American Culture: An Encyclopedia* (Santa Barbara: Greenwood, 2010), xviii.

34. "Press release February 22, 1978—Polaroid Earnings Climb 18% for FOURTH QUARTER, 16% FOR YEAR," Polaroid Corporation Administrative Records, Box I.178, f. 13 Press releases, 1978, HBS; Mitchell C. Lynch, "Selling New Polaroid 600 Line May Require Teaching Camera Users Why They Need It," *Wall Street Journal*, June 29, 1980.

35. As advertised in July 1949 issue of *American Photography*.

36. Sarvas and Frohlich, *From Snapshots to Social Media*, 68.

37. Robert Casselman, "Letter to Polaroid Dealers," 1955, Polaroid Corporation Administrative Records, Box I.50, f. 2 Publicity—Consumer info—brochures and mailings, 1955, HBS.

38. Jack Reynard, "60 Second Miracle," *Minicam Photography*, January 1949.

39. Olshaker, *The Instant Image*, 62, 82.

40. J. H. Booth, "How Polaroid Captured a Leading Position in the Camera Market," *Printer's Ink*, June 24, 1949.

41. See Francis Bello, "The Magic that Made Polaroid," *Fortune*, April 1959.

42. See *Polaroid Annual Report 1954*, 6. Ansel Adams did Jimmy Carter's official portrait on the 20 × 24 inch Polaroid camera, and William Wegman went to the White House in 1989 with the same camera to photograph Barbara Bush and her puppies. "'First Puppies' Photographed by Polaroid," *Update Supplement*, Summer 1989, Polaroid Corporation Collection, HBS.

43. Wensberg, *Land's Polaroid*, 211; Liz Roman Gallese, "I Am a Camera," *Boston Business*, Fall 1986.

44. Patti Smith, *Just Kids* (London, Bloomsbury, 2010), 154, 190.

45. "Polaroid," *Forbes*, June 15, 1969.

46. Lawrence M. Hughes, "The Swinger," *Sales Management*, September 17, 1965.

47. *Wall Street Journal*, August 19, 1982.

48. Nicholas D. Kristof, "Polaroid Bets on New Camera," *New York Times*, April 3, 1986.

49. "Welcome to the Photography of the Future," 1986, Polaroid Corporation Administrative Records, Box I.257, f. 6 Product information—consumer—Spectra System, March 1986, HBS.

50. "Spectra Promotional Images," 1986, Polaroid Corporation Administrative Records, Box I.215, f. 11 Press release, August 1991, HBS.

51. "Spectra System," 1986, Polaroid Corporation Administrative Records, Box I.332, f. 11 Product information files—Spectra manual, 1986, HBS.

52. As is made clear in Brian O'Connor, "Spectra Dealer Mailing: Dealer Letter," April 1, 1986, Polaroid Corporation Administrative Records, Box I.277, f. 22 Product information—"The Spectra System is Here!," 1986, HBS.

53. Pierre Bourdieu, *Photography: A Middle-Brow Art*, trans. Shaun Whiteside (Stanford: Stanford University Press, 1990), 64.

54. "Presidential Endorsement," *Polaroid Update*, July 13, 1989.

55. Robert McDonald, "New Polaroid Camera Is No 'Toy,'" *Gannett News Service*, November 8, 1972.

56. Ansel Adams, *An Autobiography* (Boston: Little, Brown, 1985), 254–55.

57. Ansel Adams, Letter to M. M. Morse, April 22, 1953.

58. Wensberg, *Land's Polaroid*, 97–98.

59. Edwin Land, "Chairman's Letter," *Polaroid Annual Report 1981*, 3.

60. Douglas Collins notes that the first Kodak cameras, even before the Brownie, were frequently disparaged as toys. Collins, *The Story of Kodak*, 97. Early Kodak and Polaroid of course do not have a monopoly on toy or novelty cameras. There are many other examples bridging the gap between them, with the Diana camera, the Holga, the Lomographic cameras, all considered, depending on the context, to be cameras primarily for play and experiment rather than more serious matters, whether it be professional photography or sober memory work. *Aperture* magazine brings out the ludic dimension of photography in its special "Playtime" issue. The emphasis here is primarily on the humorous content of images, on playfulness in front of the camera rather than toy cameras or the act of photographing as a form of play. Nor does the issue broach vernacular photography, focusing instead on examples from commercial and art photography. See *Aperture* 212 (Fall 2013).

61. Ian Christie, "Toys, Instruments, Machines: Why the Hardware Matters" in *Multimedia Histories: From the Magic Lantern to the Internet*, ed. James Lyons and John Plunkett (Exeter: University of Exeter Press, 2007), 5.

62. Christie, "Toys, Instruments, Machines," 8, 11.

63. See Jeff L. Rosenheim, *Walker Evans: Polaroids* (Zurich: Scalo, 2002), 8.

64. Sean Cousin writes at length about what he calls the indestructibility of the SX-70 print in his excellent blog on the integral Polaroid, *Pentimento/Polarama*. http://pentimento.squarespace.com/journal/

65. Lombino, *The Polaroid Years*, 176.

66. Lombino, *The Polaroid Years*, 204.

67. Smith, *Just Kids*, 22.

68. Sarah Hall, "'Headless Men' in Sex Scandal Finally Named," *Guardian*, August 10, 2000. In late 2013, another head was thrown in the ring: Bill Lyons, sales director for PanAm Airlines. See Lady Colin Campbell, "The Headless Man Unmasked," *Mail on Sunday*, December 29, 2013.

Chapter Two

1. Douglas, "Some Thoughts on the Question," 298.

2. See *Polaroid Annual Report 1972*, 1–5.

3. This idea was first suggested to me by Helen Stoddart of Glasgow University.

4. Lombino, *The Polaroid Years*, 81.

5. See "Click and Stick with Polaroid's Instant Pocket Camera," *Photo Industry Reporter*, September 6, 1999.

6. Weston Andrews, "Instant Pictures," *Modern Photography*, May 1980.

7. Lombino, *The Polaroid Years*, 78.

8. "Polaroid's 20 × 24 Land Camera," *Studio Photography*, September 1, 1979.

9. Ansel Adams, "Portfolio," *PSA Journal* 21, no. 6 (1955), 23.

10. Christopher Bonanos, "Gone in an Instant: Top Photographers Are Angry over Polaroid's Fade to Black," *New York Magazine*, May 4, 2008.

11. *Polaroid Annual Report 1972*, 13.

12. Ben Lifson, *Samaras: The Photographs of Lucas Samaras* (New York: Aperture Foundation, 1987), 43, 45.

13. Peter Conrad, "Elegy for the Polaroid," *Observer*, May 30, 2010.

14. Geoff Dyer, "Gone in an Instant . . . ," *Guardian*, February 21, 2008.

15. Richard Benson, *The Printed Picture* (New York: Museum of Modern Art, 2008), 208.

16. "The Way Back," 1973, Polaroid Corporation Administrative Records, Box I.322, f. 1 Product information files—SX-70 technical art/ references, 1970s, HBS. One industry observer wrote that 'It shows Polaroid's confidence in the sharpness of their project that they make it with this high gloss finish." Keith Nelson, "Everything Instant," *Amateur Photographer*, December 19, 1981.

17. See for example, "Polaroid 8 × 10" (1980) brochure, which claims that "The metallized dyes used to form the colour images in Polaroid 8 × 10 film are among the most stable and fade-resistant in all of photography. No special storage or handling techniques are required to maintain image stability." Folder KF5 D2, Polaroid 1, National Media Museum archive, Bradford, England.

18. Bob Hering, "Color Photos in 60 Seconds," *Popular Science*, February 1963.

19. Norman Rothschild, "How the SX-70 Film Compares to Others," *Popular Photography*, April 1973.

20. Henry Horenstein, *Color Photography: A Working Manual* (Boston: Little, Brown, 1995), 74.

21. *Eyewitness: Hungarian Photography in the 20th Century*, Royal Academy of Arts, London, June 30–October 2, 2011.

22. Henri Van Lier, "The Polaroid Photograph and the Body," in Stefan de Jaeger, *Stefan de Jaeger* (Brussels: Poot, 1983), xii.

23. See A. D. Coleman, "The Directorial Mode: Notes towards a Definition," in *Photography in Print: Writings from 1816 to the Present*, ed. Vicki Goldberg (New York: Simon and Schuster, 1981).

24. Sigmund Freud, *Civilization, Society and Religion*, trans. James Strachey, ed. Albert Dickson (London: Pelican, 1985), 305.

25. Polaroid photography has never detained theorists of visual and popular culture for very long, as we have already seen with Roland Barthes, and when they do address Polaroid photography it tends to be in passing or as an afterthought, a minor irritation. They too tend to conclude that there is nothing to distinguish Polaroid particularly from other photography. Here are just two examples:

Philippe Dubois opens *L'acte photographique* with an analysis of Michael Snow's *Authorization* (1969), a composite of five black and white Polaroid images that hangs in the National Gallery of Canada in Ottawa. Each photograph taken

into a mirror was subsequently taped to that mirror so that each earlier image appears in subsequent images, generating an effect of photographic *mise-en-abyme* that Dubois takes to be exemplary of photography in general, or what he calls the "photographic act." For the subject standing in front of this work, there are two images and two temporalities. The image given by the mirror "offers a representation directly," and then

> There is the photo, always deferred, always taking us back to an anteriority, which has been stopped, congealed, in its own time and place (and Polaroid photography makes no difference at all to the ineluctable delay of the photographic; on the contrary, it only exacerbates the photo's inability to catch up to time).
>
> PHILIPPE DUBOIS, *L'acte photographique et autres essais* (Brussels: Labor, 1990), 12. My translation, with thanks to Renaud Olivero.

For Dubois, a photo is a shearing off of time and space that can never be regained, whatever glimpses it might give us of that from which we have been separated. Photography, unlike the mirror, is defined by its unavoidable delay (*retard*), and however "instantaneous" its processes, Polaroid photography is in no way exempt from this rule. If anything, its apparent instantaneity only makes more palpable its failure to coincide with the subject it pictures. No question, then, of different kinds of photography having different relations to time: there is simply photographic time *tout court*.

A similar point is made by Régis Durand. Commenting on the fugitive nature of photographs, on the way they embody a crisis or "disaster" in time, Durand emphasises that this disaster is not a function of speed:

> For photography is only fast in appearance. Even in its most instantaneous forms (the polaroid, for instance), it functions as a kind of *delayed action* in relation to the actual present. It is a doubling, a retentive or echoing gesture which bespeaks the failure to keep time.
>
> RÉGIS DURAND, "How to See (Photographically)," in *Fugitive Images: From Photography to Video*, ed. Patrice Petro (Bloomington: Indiana University Press, 1995), 147.

Durand's theory of photography, like Dubois', hinges on delay, on a gap in time that the photograph, *any* photograph, opens up. And like Dubois, Durand does not allow for instant photography as an exception. Neither of them is swayed, in other words, by instant photography's promise to close the gap between event and image. The general principle of photographic temporality trumps any specific attributes of the Polaroid, and to stand in front of a Polaroid photograph in a gallery is no different from standing in front of the "same" photo made with different materials or methods. Durand and Dubois may be hasty in their outright

dismissal of speed as a factor which differentiates Polaroid from other forms of photography, and in their willingness to generalize about photography as a single and undifferentiated field. Nevertheless, it is hard to dispute their claim that it little matters how quickly a picture has been made when we stand contemplating it long after the fact.

26. As the President of the Royal Photographic Society had predicted. See Percy W. Harris, "The Year's Progress," *Photographic Journal* 89 (1949): 62.

27. I owe this observation to Jonathan White of the University of Essex.

28. Jim Hughes, "The Instant and Beyond: In Some Photographers' Hands, Polaroid's SX-70 System Transcends Time and Place," *Popular Photography*, January 1979.

29. See West, *Kodak and the Lens of Nostalgia*, 35.

30. Hughes, "The Instant and Beyond"; Conrad, "Elegy for the Polaroid."

31. Alan Woods, *The Map Is Not the Territory* (Manchester: Manchester University Press, 2000), 166; Max Kozloff, "Introduction," in *SX-70 Art*, ed. Ralph Gibson (New York: Lustrum, 1979), 13.

32. Peter Schjeldahl, "The Instant Age," in *Legacy of Light*, ed. Constance Sullivan (New York: Alfred A. Knopf, 1987), 11, 12. See also "People and Ideas," *Aperture* 78 (1977): 3. In this review of the touring show "In Just Seconds," it is observed that "If SX-70 has any influence on its own, it is that of stimulating the growth of more personal, more intimate photography. The qualities of the camera and film seem to lend themselves to this type of seeing."

33. Richard W. Young, "Overview," 1981. Polaroid Corporation Collection, HBS, 2.

34. "Photo Tips," *Polaroid Newsletter*, October 1981, Polaroid Corporation Collection, HBS.

35. *Polaroid Annual Report 1990*, 10.

36. Young, "Overview," 2.

37. Cited in Porter, "Evolution of Polaroid One-Step Photography," 11.

38. William J. McCune and Bernadine Cassell, "Simplifying Camera Technology: Polaroid's Pioneering Efforts," *Journal of Imaging Technology* 17, no. 2 (1991): 62.

39. McCune and Cassell, "Simplifying Camera Technology," 62; Patricia Holland, "Introduction," in *Family Snaps: The Meanings of Domestic Photography*, ed. Jo Spence and Patricia Holland (London: Virago, 1991). According to A. D. Coleman, underlying Land's rhetoric of barriers is a whole set of unexamined assumptions about photo-making: "that the meditative relationship to materials of the photographer–as–printmaker is a 'barrier'; that the emphasis in photography should be on 'taking' rather than 'making'; that process is to be truncated, production accelerated; that the 'what' of one's subject matter is more important than the 'how' of one's representation." Coleman, "Polaroid: The Good Old Story," 38.

40. Bonanos, "Gone in an Instant."

41. As Graham King says, "The ultimate private snapshot is, of course, the Polaroid or instant photograph, a truly unique image which need be seen only by the consenting parties [. . . .] and because of their very nature I confess to having seen few examples." King, *Say Cheese!*, 46–47. I once asked a well-known and highly respected political photographer what he thought of Polaroid photography and he was unequivocally negative: "It's crap, isn't it?" He also confessed to me that the first thing that he did when he got a Polaroid camera was to take a picture of his genitals and send the result to his wife. Even among the earnest, the technology seems to bring out playful, puerile behavior.

42. Samaras was not alone in this. Peter Schjeldahl notes that many artists unschooled in photography profited from the ease of use of Polaroid systems, citing in particular Samaras, Andy Warhol, David Hockney, Chuck Close, and William Wegman. Schjeldahl, "The Instant Age," 11.

43. Lucas Samaras, "Autopolaroid," *Art in America* 58, no. 6 (1970): 66.

44. Samaras, "Autopolaroid," 66.

45. Woods, *The Map Is Not the Territory*, 149.

46. Alice Munro, *The Progress of Love* (London: Vintage, 1986), 69–70; David Foster Wallace, *Infinite Jest* (New York: Little, Brown, 1996), 56.

47. DBC Pierre, *Vernon God Little* (New York: Canongate, 2003), 140–41.

48. Lauren Berlant, "Intimacy: A Special Issue," *Critical Inquiry* 24, no. 2 (Winter 1998): 281.

49. John Updike, *Rabbit Is Rich* (New York: Ballantine Books, 1981), 276–77.

50. Updike, *Rabbit Is Rich*, 278–79. Ten years later, in a striking reversal of this scenario, the compromising Polaroids that tipped Mia Farrow off to Woody Allen's affair with Soon-Yi were reportedly in open view on the mantelpiece. It is tempting to view this incident (in January 1992) as crystalizing a historical shift, from the private, furtive home pornographer, to the exhibitionist Internet era of sexual display that was about to dawn. No doubt the counterparts to the explicit Polaroids, the sentimental happy family snaps, were hidden away in some cupboard, objects of shame.

51. Updike, *Rabbit Is Rich*, 369.

52. Joyce Carol Oates, *Give Me Your Heart: Tales of Mystery and Suspense* (New York: Houghton Mifflin Harcourt, 2011), 22, 27, 32, 46.

53. James Ellroy, *American Tabloid* (London: Arrow, 1995), 541; James Ellroy, *The Cold Six Thousand* (London: Arrow, 2002), 118. The Hong Kong gangster film *Vengeance* (Johnnie To, 2009) combines the uses of Polaroids found in *Memento* and in Ellroy's novels. Its protagonist, who is losing his memory, uses the prints to remember the faces and names of the hitmen he has hired to avenge the slaughter of his daughter's family. The hitmen, in turn, use the camera to gather grisly evidence of killings they carry out.

54. Jean Baudrillard, *America*, trans. Chris Turner (London: Verso, 1988), 37.

55. See Max Weber, *General Economic History*, trans. F. H. Knight (New York: Collier, 1961), 260–65, and Keith Thomas, *Religion and the Decline of Magic* (Harmondsworth: Penguin, 1973), 775.

56. Retort, *Afflicted Powers: Capital and Spectacle in a New Age of War* (London: Verso, 2005), 181–82.

Chapter Three

1. Chris Swingle, "Captiva Is Polaroid's Photo Finish," *USA Today*, July 21, 1993.

2. McElheny, *Insisting on the Impossible*, 3. In his 1978 letter to shareholders, Land wrote "This is a 'long term' company in which programs are selected on the basis of their long term significance, demanding scientific achievement over many years, demanding training people for decades, calling for development programs taking years." In his letter in 1980 he claimed that Polaroid operated on the basis of certain "quasimoral maxims: Do not undertake the program unless the goal is manifestly important and its achievement nearly impossible; Do not do anything that anyone else can do readily." Land, *Selected Papers*, 30, 31.

3. McElheny, *Insisting on the Impossible*, 433. See also Liz Czach, "Polavision Instant Movies: Edwin Land's Quest for a New Medium," *Moving Image* 2, no. 2 (2002).

4. In his telling of this story, Edwin Land within the same paragraph claims that Rogers "[f]or several years [. . .] simply sat, and saying very little, assimilated the techniques we were using in black-and-white," but then adds "we created an environment, in which a man was *expected* to sit and think for two years." Either way, Rogers must have been there for some time: when he started his vigil, it was a sepia lab, and he was still there when it had become the black and white lab. Land, *Selected Papers*, 22. See also McElheny, *Insisting on the Impossible*, 221–25.

5. See for example, "Hands-On Report: Polaroid's Joshua Praised by Photodealer," *Photo Business*, August 4, 1992.

6. Conor O'Clery, "Polaroid Shutter Closes for Last Time as Debt Reaches $1Bn," *Irish Times*, November 17, 2001.

7. Herbert Keppler, "For Land's Sake, Doc, What Cooks Now?," *Photo Weekly*, February 25, 1980.

8. *Polaroid Annual Report 1981*, 5.

9. E. F. Hutton Equity Research, "Birth of the Electronic Image Processing Industry: The Road to Electronic Photography," Polaroid Corporation Administrative Records, Box I.367, f. 2 Electronic imaging—Polaroid, 1984–1985, HBS.

10. *Polaroid Annual Report 1986*, 2; *Polaroid Annual Report 1989*, 7–8. The concept of media convergence is usually thought to have originated with Ithiel de Sola Pool, a political scientist at Polaroid's close neighbour MIT. See Ithiel de Sola Pool, *On Free Speech in an Electronic Age: Technologies of Freedom* (Cambridge, MA: Harvard University Press, 1983).

11. Mary Tripsas and Giovanni Gavetti, "Capabilities, Cognition, and Inertia: Evidence from Digital Imaging," *Strategic Management Journal* 21 (2000), 1156.

12. This was the argument made in *Business Nightmares*, BBC1, May 12, 2011, which took Polaroid as one of its case studies of failed enterprises. The razor/blade model is also explored in Tripsas and Gavetti, "Capabilities, Cognition," 1151–52; Philip Siekman, "Kodak and Polaroid: An End to Peaceful Coexistence," *Fortune*, November 1970; and Elkan Blout, "Polaroid: Dreams to Reality," *Daedalus* 125, no. 2 (1996): 46.

13. See chapter 5 for a detailed discussion of Polaroid's fluctuating cultural value.

14. "Press release–Polaroid Introduces New Spectra High Definition Film; Offers Consumers Sharper, Brighter Instant Photos," Sept 19, 1991, Polaroid Corporation Administrative Records, Box I.216, f. 1 Press releases—Spectra High Definition Film, September 19, 1991, HBS, 1, 3.

15. "Buyers Guide 1992," *Advanced Imaging*, December 1991.

16. E. F. Hutton, "Birth of the Electronic Image," 57.

17. Sean Callahan, "Eye Tech," *Forbes*, June 1993, 64.

18. Callahan, "Eye Tech," 66.

19. "Photo-Document Integration," 1991, Polaroid Corporation Administrative Records, Box I.29, f. 8 Annual meeting and report literature, 1991, HBS.

20. "Polaroid's Broad Approach to Imaging," 1985(?), Polaroid Corporation Administrative Records, Box I.243, f.10 Product information—consumer—general products, undated, HBS.

21. "Digital Still Video Image System," 1991, Polaroid Corporation Administrative Records, Box I.367, f. 9 Electronic imaging—art, 1987–1991, HBS.

22. John Larish, "Interviews Conrad Biber," *Electronic Photography News*, November 1990. At this point, the technology for viewing digital images was oriented towards the television rather than the computer screen.

23. Tom Ehrenfeld, "No Land in Sight," *Boston Business*, August–September 1990, 27.

24. Peter O. Kliem, "Remarks, Stockholders Meeting," May 8, 1990, 4, Polaroid Corporation Administrative Records, Box I.367, f. 12 Electronic imaging—speeches/annual report, 1988–1990, HBS.

25. "Polaroid and Electronic Imaging," 1987, Polaroid Corporation Administrative Records, Box I.367, f. 8 Electronic imaging, 1987–1988, HBS, 5.

26. Kliem, "Remarks," 5.

27. *1980–1990 Fact Book and Financial Summary* (1991), Box 19–4-1, Polaroid Corporation Collection, HBS, 2.

28. *Polaroid Annual Report 1987*, 5.

29. "Magic! Polaroid's New Vision Camera Takes the Thrill of Instant Photography One Step Further," *Amateur Photographer*, October 31, 1992.

30. Not quite invariably. Sometimes integral Polaroid prints are reproduced minus the white borders. For example, the last four images in a catalogue of an André Kertész show are almost certainly Polaroids from the period just before his death, but only the image is given, and not the border. It is an interesting curatorial decision, one that says only the photographic part of the image-object matters, and we should not be distracted by the border that reminds us this was made on a popular snapshot camera. See Sarah Greenough, Robert Gurbo, and Sarah Kennel, *André Kertész* (Princeton: Princeton University Press, 2005).

31. Schjeldahl, "The Instant Age," 9; Van Lier, "The Polaroid Photograph and the Body," xii.

32. See for instance *Inside Man* (Spike Lee, 2006) in which police use black and white integral film to snap suspects in a bank heist (artistic license on Lee's part—the Impossible Project later released black and white integral film, but Polaroid never did). Also on *The Wire*, Polaroids were a regular feature. In season 1, Lieutenant Cedric Daniels even rips one up with non-verisimilitudinous ease (they are very resistant to tearing and only scissors will do the job).

33. "ShakeIt Photo: Instant Photo for your iPhone." Accessed February 10, 2011. http//shakeitphoto.com/.

34. Banana Camera Company claimed that for the December 2010 upgrade to the "app" they made the image "more faded, more authentic." "ShakeIt Photo Update News." Accessed February 20, 2011. http://bananacameraco.com /shakeitphoto-update-news. See chapter 5 for a discussion of Polaroid film's supposed propensity for fading, which sometimes even translates into the myth that it is pre-faded.

35. Susan Murray, "Digital Images, Photo-Sharing, and Our Shifting Notions of Everyday Aesthetics," *Journal of Visual Culture* 7, no. 1 (2008): 160.

36. Bonanos, *Instant*, 163.

37. The simulation of snapshots in advertising is not new. As Julia Hirsch pointed out in 1981, simulated snapshots were regularly used in advertising to signify idealized families, sentimental themes, and so on. Julia Hirsch, *Family Photographs: Content, Meaning and Effect* (Oxford: Oxford University Press, 1981). In such cases it is not primarily the photograph as object that is being simulated, but the content of the image.

38. The logic of this chapter dictates that I point out the continuities of the photo apps with photographic history. What are they, after all, but types of lenses, filters, exposure control? Such devices long pre-date digital and Polaroid as modes for modifying the visible world as it imprints itself in the photographic.

39. Michael Kimmelman, "Imperfect, yet Magical," *New York Times*, December 28, 2008.

40. Sean O'Hagan, "Now Smile . . . It's the Last Polaroid Picture Show," *Observer*, September 6, 2009.

41. Michael Bywater, "The End of Polaroid?," *Independent*, September 23, 2009.

Accessed January 13, 2011. http://www.independent.co.uk/life-style/gadgets-and
-tech/features/the-end-of-polaroid-1791629.html.

42. Conrad, "Elegy for the Polaroid"; Kate Day, "Goodbye Polaroid," *Tele-graph*, October 9, 2009. Accessed January 13, 2011. http://blogs.telegraph.co.uk
/culture/kateday/100003920/goodbye-polaroid/.

43. Bywater, "The End of Polaroid"; Day, "Goodbye Polaroid"; Conrad, "Elegy
for the Polaroid"; Bonanos, "Gone in an Instant."

44. Day, "Goodbye Polaroid."

45. David Edgerton, *The Shock of the Old: Technology and Global History since 1900*
(London: Profile, 2006), ix–xviii. See also David Edgerton, "Innovation, Technol-
ogy, or History: What is the Historiography of Technology About?," *Technology
and Culture* 51, no. 3 (2010).

46. Edgerton, *Shock of the Old*, xi. The continued presence of the ancient tech-
nology of the horse in much world agriculture and of nineteenth-century railway
technology in transportation are two obvious examples. Similar points are made
in *Residual Media*, ed. Charles R. Acland (Minneapolis: University of Minnesota
Press, 2007). See especially the introduction by Acland and the essay by Michelle
Henning.

47. Edgerton, *Shock of the Old*, 75–102.

48. William Boddy, *New Media and Popular Imagination: Launching Radio, Televi-
sion, and Digital Media in the United States* (Oxford: Oxford University Press, 2004),
68. See also Henry Jenkins, *Convergence Culture: Where Old and New Media Collide*
(New York: New York University Press, 2006), 13–14.

49. Graham Clarke, *The Photograph* (Oxford: Oxford University Press, 1997),
218–20.

50. For a nice summary of the concerns raised by image manipulation see An-
drew Murphie and John Potts, *Culture and Technology* (Basingstoke: Palgrave, 2003),
75–6. For an interesting survey of the possibilities opened up by image manipu-
lation see Fred Ritchin, *After Photography* (New York: W. W. Norton, 2009), 25–68.

51. William J. Mitchell, *The Reconfigured Eye: Visual Truth in the Post-Photographic
Era* (Cambridge, MA: MIT Press, 1992), 225.

52. The following all take issue with Mitchell as a central part of their argu-
ments: Sarah Kember, "'The Shadow of the Object': Photography and Realism,"
Textual Practice 10, no. 1 (1996); Martin Lister, "Introductory Essay," in *The Photo-
graphic Image in Digital Culture*, ed. Martin Lister (London: Routledge, 1995); Lev
Manovich, "The Paradoxes of Digital Photography," in *The Photography Reader*, ed.
Liz Wells (London: Routledge, 2003); Kevin Robins, "Will Image Move Still?," in
The Photographic Image in Digital Culture (1995). The complaint against Mitchell is
fairly uniformly that he exaggerates the extent of change inaugurated by the digital
and thereby grants too much historical agency to it. In other words, he is accused
of technological determinism.

53. See, for instance, Arthur Goldsmith, "Photos Always Lied," *Popular Photog-*

raphy, November 1991, or Manovich, "The Paradoxes of Digital Photography," 244–45. See also Tom Gunning, "What's the Point of an Index? or, Faking Photographs," in *Still Moving: Between Cinema and Photography*, ed. Karen Beckman and Jean Ma (Durham: Duke University Press, 2008), 25–26.

54. Kember, "'The Shadow of the Object,'" articulates these objections very clearly, and is also good on "the paradox of photography's fading but always mythical realism" (146). See also Lister, "Introductory Essay." Although the arguments made by Kember, Lister, and others are vital to counteract the still powerful realist stance regarding the photographic image, they do not really progress beyond the ground-breaking case made by Roland Barthes in 1961. See Roland Barthes, *Image, Music, Text*, trans. Stephen Heath (London: Fontana 1977), 15–31. The subsequent chorus in the 1960s and 1970s denouncing photography's "effect of the real" is consummately summarized by Dubois, *L'acte photographique*, 31–40.

55. Gunning, "What's the Point of an Index?," 24. Gunning's case rests on the claim that all photographs are indexical, that there is a physical relation between the photo and whatever has been photographed: "the fact that rows of numbers do not resemble a photograph, or what the photograph is supposed to represent, does not undermine any indexical claim. An index need not (and frequently does not) resemble the thing it represents." Gunning, 25. He is very careful not to mix up the "index" with truth in his intervention into a debate on the indexicality of photography that dates back at least as far as Barthes, *Camera Lucida*, and Rosalind Krauss, *The Originality of the Avant-Garde and Other Modernist Myths* (Cambridge, MA: MIT Press, 1985), 196–220, where the case for indexicality was put so compellingly. Every generation of photography critics seems to rediscover the problem, as exemplified by the fiery and ultimately inconclusive exchanges in James Elkins, ed., *Photography Theory* (London: Routledge, 2007), where Krauss and Abigail Solomon-Godeau square off against Joel Snyder, defender of the "iconicity," or aesthetic value of photography. Although I am on the side of the indexicalists, my view is that to fight over the indexical status of the photographic image is a distraction from addressing the heterogeneous uses to which photographs are put, irrespective of their indexical status.

56. Gunning, "What's the Point of an Index?," 37.

57. Gunning, "What's the Point of an Index?," 38.

58. Jeffrey Sconce, "Tulip Theory," in *New Media: Theories and Practices of Digitextuality*, ed. Anna Everett and John Thorton Caldwell (London: Routledge, 2003), 181.

59. Susan Murray, "Digital Images, Photo-Sharing"; Daniel Palmer, "Emotional Archives: Online Photo Sharing and the Cultivation of the Self," *Photographies* 3, no. 2 (2010). Perhaps the most comprehensive survey of online photo-sharing practices is Daniel Rubinstein and Katrina Sluis, "A Life More Photographic: Mapping the Networked Image," *Photographies* 1, no. 1 (2008).

60. Lisa Gye, "Picture This: the Impact of Mobile Camera Phones on Personal

Photographic Practices," *Continuum: Journal of Media and Cultural Studies* 21, no. 2 (2007).

61. Richard Chalfen, "'It's Only a Picture': Sexting, 'Smutty' Snapshots and Felony Charges," *Visual Studies* 24, no. 3 (2009).

62. Sarvas and Frohlich, *From Snapshots to Social Media*.

63. Chalfen, "'It's Only a Picture,'" 259.

64. Murray, "Digital Images, Photo-Sharing," 156, 160.

65. Palmer, "Emotional Archives," 163. The addition of text to photographs is as old as photography. See Batchen, *Forget Me Not*, 41–48.

66. Warhol was visiting the Polaroid 20 × 24 studio in New York when he said "We call it shoot and show. It's great. Instant portraits." Thomas Sabulis, "Andy Warhol at Polaroid," *Boston Globe*, August 18, 1979.

67. August 1949 and November 1951 campaigns in *Camera* and *Modern Photography*.

68. Don Slater, "Domestic Photography and Digital Culture," in Lister, *The Photographic Image in Digital Culture*, 138.

69. Slater, "Domestic Photography and Digital Culture," 138–39.

70. Chalfen, *Snapshot Versions of Life*, 129–35; Jo Spence, "Soap, Family Album Work . . . and Hope," in Jo Spence and Patricia Holland, ed., *Family Snaps: The Meanings of Domestic Photography* (London: Virago, 1991), 200–207; Batchen, *Each Wild Idea*, 68–69; Langford, *Suspended Conversations*.

71. Slater, "Domestic Photography and Digital Culture," 141.

72. September 1949 and November 1949 campaigns in *Camera* and *U.S. Camera*.

73. Nat Trotman, "The Life of the Party: The Polaroid SX-70 Land Camera and Instant Film Photography," *Afterimage* 29, no. 6 (2002): 10.

74. Murray, "Digital Images, Photo-Sharing," 151.

75. Palmer, "Emotional Archives," 159. In one of the most thorough-going analyses of changing practices of domestic photography in the wake of digital, Sarvas and Frohlich argue that the "memory and reminiscing" functions of photography have diminished: "Because digital technology shows the images immediately after capture, major businesses in personal imaging, such as Facebook, focus less on reminiscing and more on immediate social interaction and communication of identity." Sarvas and Frohlich, *From Snapshots to Social Media*, 149.

76. Rubinstein and Sluis, "A Life More Photographic," 13.

77. Minor White, "Learning with Polaroid," in Ansel Adams, *Polaroid Land Photography*, 2nd ed. (Boston: New York Graphic Society, 1978), 239.

78. Minor White, "Polaroid Land Photography and the Photographic 'Feedback' Employed with Informal Portraits," *Aperture* 7, no. 1 (1959), 29.

79. Estelle Jussim, "A Celebration of Redheads," *Polaroid Close-Up* 14, no. 2 (1983).

80. Peggy Sealfon, *The Magic of Instant Photography* (Boston: CBI, 1983), 6.

81. O'Hagan, "Now Smile."

82. Retort, *Afflicted Powers*, 182–83.

83. Clearly there is a major difference here between Polaroid and digital. While the obscene digital image can spread virally through networked systems, with the obscene Polaroid, there was not even a "compromising negative" to allow for further easy copying.

84. Geoffrey Crawley, "SX-70 Camera and Film—A Review," *British Journal of Photography* 123, no. 46 (1976), 1003.

85. On the face of it, the individual digital photograph costs infinitely less than any conventional photographic print, but Sarvas and Frohlich point out that it is in fact very difficult to measure the cost of a single digital image, since this image requires for support an expensive computing and software apparatus that demands frequent upgrading, not to mention an electricity supply. Sarvas and Frohlich, *From Snapshots to Social Media*, 99. The not insignificant implications for cultural value of the singularity of the Polaroid print are taken up in detail in chapter 5.

Chapter Four

1. Margaret Olin, *Touching Photographs* (Chicago: University of Chicago Press, 2011), Location 218 Kindle edition.

2. Batchen, *Forget Me Not*, 94.

3. Elizabeth Edwards, "Photographs as Objects of Memory," in *Material Memories: Design and Evocation*, ed. Marius Kwint, Christopher Breward, and Jeremy Aynsley (Oxford: Berg, 1999), 228.

4. Elizabeth Edwards and Janice Hart, "Introduction: Photographs as Objects," in *Photographs Objects Histories: On the Materiality of Images*, ed. Elizabeth Edwards and Janice Hart (London: Routledge, 2004), 2.

5. Edwards and Hart, "Introduction," 3.

6. This leads to a striking anthropomorphizing of photographs, most evident when Edwards and Hart call for an "ongoing investigation into the lives that photographs lead after their initial point of inception," dubbing this activity a "social biography" of objects. Edwards and Hart, "Introduction," 9–10. They are adapting here a phrase of Igor Kopytoff's, who, in "The Cultural Biography of Things," demonstrates the tension existing between commoditization and singularization (or sacralization) in all systems of exchange. While they adopt the phrase, Edwards and Hart do not take on Kopytoff's analytic vocabulary. Indeed, it could be argued that the photo-materialist project leans heavily towards "singularization" in its efforts to rescue photographs from their commoditization as images, and is therefore part of what Kopytoff calls the "yearning for singularization in complex societies." The photo-materialists' preference for older, usually nineteenth-century photographs is a typical strategy of singularization, which is often achieved, as Kopytoff says, "by reference to the passage of time." Igor Kopytoff, "The Cultural Biography of Things: Commoditization as Process," in *The Social Life of Things:*

Commodities in Cultural Perspective, ed. Arjun Appadurai (Cambridge: Cambridge University Press, 1986), 80.

7. Edwards and Hart, "Introduction," 9.

8. Elizabeth Edwards, "Thinking Photography beyond the Visual?," in *Photography: Theoretical Snapshots*, ed. J.J. Long, Andrea Noble, and Edward Welch (London: Routledge, 2009), 31.

9. Christopher Pinney, "Piercing the Skin of the Idol," in *Beyond Aesthetics*, ed. Christopher Pinney and Nicholas Thomas (Oxford: Berg, 2001).

10. Trotman, "The Life of the Party," 10.

11. Trotman, "The Life of the Party," 10.

12. "Time-Zero Supercolor: Polaroid's Dazzling New SX-70 Film and the Cameras that Bring It to Life," 1980, Polaroid Corporation Administrative Records, Box I.321, f. 11 Product information files—Time-Zero cameras, 1980s, HBS.

13. Eric C. Shiner, "Mirror, Mirror off the Wall," 2007. Accessed December 28, 2013. http://jeremykost.com/bio/

14. Jeremy Kost, "Bioroid," 2006. Accessed July 31, 2008. http://www.roidrage.com/about.php

15. Jeremy Kost, "Profile," 2008. Accessed July 31, 2008. http://profile.myspace.com/index.cfm?fuseaction=user.viewprofile&friendid=21512814

16. Cody Lyon, "Shooting Glitz with a Polaroid, Jeremy Kost Is Gracious in a Galling Trade," Columbia News Service, February 14, 2006. Accessed July 31, 2008. http://jscms.jrn.columbia.edu/cns/2006-02-14/lyon-antipaparazzo

17. "Snapping the Stars: Shooting from the Hip," *Marie Claire*, August 2008, 94.

18. Lyon, "Shooting Glitz."

19. Kost was certainly not the first to photograph celebrities with a Polaroid camera. Sharon Smith did it on the New York club scene in the early 1980s, taking Polaroids of Mick Jagger, David Bowie, Iggy Pop, Madonna, Chuck Berry, Cab Calloway, Andy Warhol, among others; and French designer Maripol also did it on the New York underground scene in the 1980s, photographing Madonna, Grace Jones, Jean-Michel Basquiat. Warhol himself did it with his SX-70 and his Big Shot. More recently, professional photographer Henny Garfunkel did it in a systematic way at film festivals from around 2000 onwards.

20. *Polaroid Minute Man* 1, 1950, Polaroid Corporation Administrative Records, Box I.319, f. 7 Product information files—Polaroid Minute Man, 1950, HBS, 6.

21. "What Owners Say NOW about the Polaroid Land Camera," 1949 Polaroid Corporation Administrative Records, Box I.48, f. 14 Publicity—SX-70 (1940s)—Publicity correspondence, etc., 1949, HBS.

22. "Q and A about the Most Talked-About Camera in America," 1949, Polaroid Corporation Administrative Records, Box I.243, f. 16 Product information—consumer—Model 95, 1949, HBS.

23. "Now . . . You Can Improve Your Pictures on the Spot" *Camera*, October 1949.

24. See "Here Is Polaroid's Good Time Camera" brochure, 1972, Polaroid Cor-

poration Administrative Records, Box I.71, f. 24 Publicity—Dealer mailings—promotion plans—"Polaroid Announces the Good Time Camera," 1972, HBS. See also "We Call It the Good Time Camera," 1972, Polaroid Corporation Administrative Records, Box I.71, f. 24 Publicity—Dealer mailings—promotion plans—"Polaroid Announces the Good Time Camera," 1972, HBS.

25. "Here and Now: Wedding Trends . . . Timely Tips . . . Bright Ideas," *Just for Brides*, Fall 1999.

26. This is perhaps what Dave Kenyon is hinting at when he remarks apropos of the instant print that "Instant reorganization of the event around the production of a print is unlikely to be experienced positively." Dave Kenyon, *Inside Amateur Photography* (London: Batsford, 1992), 94. Photographer Philip-Lorca diCorcia is a little less ambiguous on this front. Here he is on Andy Warhol's love of the SX-70: "The camera made him the life of the party, peopled by ugly, cheap-looking poseurs who thought that that was a virtue, and validated his own self-image, which I would guess was something like ugly and cheap, but super-expensive. Very American, very POP." Artist's statement in Lombino, *The Polaroid Years*, 94.

27. John Wolbarst, *Pictures in a Minute*, 3rd ed. (New York: American Photographic Book, 1960), 121.

28. "27 Summer Picture-in-a-Minute Ideas," *Popular Photography*, May 1959, 101.

29. Langford, *Suspended Conversations*, 19. As Richard Chalfen puts it, "Visual renditions of life experiences that appear in family albums, slide shows, or home movies are inevitably accompanied by parallel verbal accounts." *Snapshot Versions of Life*, 129.

30. "60-Second Excitement," "Britannica Home Library Service" brochure, 1971. Polaroid Corporation Administrative Records, Box I.71, f. 10 Publicity—Polaroid/ Britannica Home Library Service brochure, 1971, HBS.

31. Sealfon, *Magic of Instant Photography*, 100.

32. Michael Freeman, *Instant Film Photography: A Creative Handbook* (London: Macdonald, 1985), 118.

33. Freeman, *Instant Film Photography*, 118.

34. Jack Parry, "Polaroid Cameras on an Alaskan assignment," *U.S. Camera*, March 1959.

35. Sealfon, *Magic of Instant Photography*, 70.

36. Cited by Hughes, "The Instant and Beyond," 158.

37. See "Press release—Polaroid Land Cameras Soon Available in Sweden," 1956, Polaroid Corporation Administrative Records, Box I.50, f. 17 Publicity—Press release—Picture-in-a-Minute Polaroid Land Camera soon available in Sweden, 1956, HBS, 13; Catherine Motz, "World Friends via Polaroid Photography," *Polaroid Land Photography Magazine*, 1966; Arno Minkkinen, "Treasures of the Moment: Thirty Years of Polaroid Photography in Boston," in *Photography in Boston: 1955–1985*, ed. Rachel Rosenfield Lafo and Gillian Nagler (Cambridge, MA: MIT

Press, 2000), 139; and Terri Hughes-Lazzell, "Access via Polaroid," *Mining Journal*, October 6, 1991.

38. "Background Notes: Polaroid Land Cameras," 1960, Polaroid Corporation Administrative Records, Box I.243, f. 7 Product information—consumer—general information—"Background Notes," circa 1960s, HBS.

39. William Attwood, "Instant Snapshots Help Break Ice in China," *Los Angeles Times*, July 14, 1971.

40. "American Newspaperman Charms Red Chinese with His SX-70 Camera," *Polaroid Newsletter*, October 28, 1975, 5.

41. From this point of view it is tempting to read Edwin Land's invention as part of a general culture of acceleration where the imperatives of a rapidly expanding consumer society post-WWII dictated "instant gratification" as the order of the day. Might not the instantaneousness of Polaroid photography be seen as a leisure-world complement to the "contraction of time, the disappearance of [...] territorial space" brought about since the 1950s by a range of mainly military technologies of acceleration? Paul Virilio, *Speed and Politics: An Essay on Dromology*, trans. Mark Polizzotti (New York: Semiotext(e), 1986), 140–41. Certainly, Polaroid image-making may contribute to, but certainly cannot be credited with producing, this state of affairs. It is therefore worth remarking that the ingenious gimmick camera that ensured for fifty years the fortunes of the Polaroid Corporation was preceded by six years of wartime work by the company on various military visual technologies, work carried out for the United States government and armed forces. Victor McElheny credits Land with this sentence in Vannevar Bush's collectively written postwar strategy document "Science: The Endless Frontier" (1945): "What is required is the rapid invention and evolution of the peacetime analogues of jet-propelled vehicles, bazookas, and the multiplicity of secret, bold developments of the war." Cited in McElheny, *Insisting on the Impossible*, 159. In the light of this immediate pre-history it suddenly seems more plausible that Polaroid's cameras should subsequently become minor weapons in the arsenal of the Cold War.

42. It could be argued that in their "social catalytic" function instant cameras anticipate camera phones. As Kato, Okabe, Ito, and Uemoto note, "camera users often described the act of taking and viewing photos when gathered with friends as itself a focus of social activity." Fumitoshi Kato et al., "Uses and Possibilities of the *keitai* Camera," in *Personal, Portable, Pedestrian: Mobile Phones in Japanese Life*, ed. Mizuko Ito et al. (Cambridge, MA: MIT Press, 2005), 305. However, camera phones do not appear to have the same "ice-breaking" potential as Polaroid cameras: the same study observes that the mobile phone "reinforces ties between close friends and families rather than communal or weaker and more dispersed social ties." Mizuko Ito, "Introduction: Personal, Portable, Pedestrian," in *Personal Portable, Pedestrian*, ed. Ito et al., 9.

43. A study in 1973 showed that Polaroid cameras were much more quickly set aside by their owners than other sorts of amateur camera, with a 50% "decay

rate" year-on-year, compared to 9% for Kodak Instamatics. See Richard Karp, "The Clouded Picture at Polaroid," *Dun's*, November 1973, 61.

44. "Another European Invasion," *Sunday News* (New York), August 15, 1971.

45. Adams, *Autobiography*, 254.

46. Harris, "The Year's Progress."

47. André Gaudreault, "Showing and Telling: Image and Word in Early Cinema," in *Early Cinema: Space, Frame, Narrative*, ed. Thomas Elsaesser (London: British Film Institute, 1990); Tom Gunning, "'Now You See It, Now You Don't': The Temporality of the Cinema of Attractions," *Velvet Light Trap* 32 (1993).

48. Tom Gunning, "The Cinema of Attractions: Early Film, Its Spectator and the Avant-Garde," in *Early Cinema*, ed. Elsaesser, 58.

49. Tom Gunning, "'Primitive Cinema': A Frame-Up? Or, the Trick's on Us," in *Early Cinema*, ed. Elsaesser, 96.

50. Nicolas Dulac and André Gaudreault, "Circularity and Repetition at the Heart of the Attraction: Optical Toys and the Emergence of a New Cultural Series," in *The Cinema of Attractions Reloaded*, ed. Wanda Straven (Amsterdam: Amsterdam University Press, 2007), 228.

51. The Kodak Carousel's name invokes the fairground, but when television series *Mad Men* fictionalized the creation of an ad campaign for the slide projector, it emphasized it not as a photographic "attraction," but instead for the more familiar nostalgic, memorializing aspects of snapshot photography ("The Wheel," *Mad Men*, Season 1, episode 13, 2007). In contrast, in "Christmas Comes but Once a Year" (*Mad Men*, Season 4, episode 2, 2010), when the ad agency Sterling Cooper Draper Pryce gives a prize client, Lee from Lucky Strike, a Polaroid camera at the company Christmas party, the element of attractions comes to the fore. Lee forces Roger to dress as Santa and be photographed with all the partygoers. Doyle Dane Bernbach, one of the ad agencies that inspires *Mad Men*, and is mentioned in it, represented Polaroid for many years.

52. Sealfon, *Magic of Instant Photography*, 70.

53. Thomas Elsaesser, "General Introduction: Early Cinema: From Linear History to Mass Media Archaeology," in *Early Cinema*, ed. Elsaesser, 13.

54. A. A. Goessling, Letter to Harold Booth, July 27, 1949, Polaroid Corporation Administrative Records, Box I.48, f. 14 Publicity—SX-70 (1940s)—Publicity correspondence, etc., 1949, HBS.

55. R. C. Casselman, "Sales Autotype Letter no. 32H-1," November 30, 1955, Polaroid Corporation Administrative Records, Box I.49, f. 29 Publicity—Dealer mailings and information, 1955, HBS.

56. R. S. Evans, "Land and Polaroid," *Perspective: Quarterly Review of Progress*, 3, no. 3 (1961): 178.

57. *Polaroid Annual Report 1952*, 3.

58. *Garry Moore* ad transcript, November 15, 1960, Polaroid Corporation Ad-

ministrative Records, Box I.56, f. 23 Publicity—Television commercial scripts—The Garry Moore Show, 1960, HBS.

59. "Demonstrator Program," 1959, Polaroid Corporation Administrative Records, Box I.55, f. 11 Publicity—Dealer mailings—Advertising—form letters, etc., 1959, HBS.

60. "Polaroid Corporation Demonstrator Checklist," 1965, Polaroid Corporation Administrative Records, Box I.62, f. 2 Publicity—Dealer mailings—Promotions, etc.—form letters, announcements, etc., 1965, HBS.

61. The Polaroid Camera Girl is obviously the descendant of the Kodak Girl, who dates from 1893, and featured heavily in Kodak advertising for many years, becoming an ideal of the fashionable female photographer. There was never any suggestion that the iconic Kodak Girl would be employed on the business side of selling and demonstrating cameras. The gendering of Polaroid cameras is discussed in more detail in chapter 5.

62. "Press release, October 30, 1972—Polaroid Unveils Unique Marketing Plans for SX-70 Camera and Film System," 1972, Polaroid Corporation Administrative Records, Box I.322, f. 4 Product information files—SX-70 press releases, 1972, HBS.

63. "A Salesman's Guide to the Polaroid SX-70 Land Camera," 1975, Polaroid Corporation Administrative Records, Box I.321, f. 5 Product information files—SX-70 Land camera Models 2 & 3, circa 1970s, HBS, 5.

64. Tom Gunning, "An Aesthetic of Astonishment: Early Film and the (In)credulous Spectator," *Art and Text* 34 (1989), 42.

65. "Steal the Show: Polaroid's Convention Service Can Pack Them in at Your Next Exhibit," 1960, Polaroid Corporation Administrative Records, Box I.56, f. 29 Publicity—Convention package brochures, 1960, HBS.

66. "60-Second Photography on the Job . . . How Polaroid Land Cameras Are Used in Sales Promotion," 1956, Polaroid Corporation Administrative Records, Box I.50, f. 14 Publicity—Industrial Sales—"60-second Photography on the job . . . ," (brochures), 1956, HBS.

67. "Steal the Show."

68. "Notes from the Editor's Desk," *Polaroid Minute Man*, Fall 1959, Polaroid Corporation Administrative Records, Box I.319, f. 8 Product information files—Polaroid Minute Man, Fall 1959, HBS.

69. In 1952, ignoring Polaroid patents, the Soviets copied the Model 95 Land Camera, calling their version The Moment. This camera was reportedly hampered by poor film quality, but was still in existence when Polaroid finally set up shop in post-Soviet Russia in 1991.

The link between photography and exhibitions was longstanding. Kodak had a major presence at most World's Fairs, notably at the World's Columbian Exhibition in Chicago in 1893. Kodak saw such massive tourist events as an opportunity to encourage their photographers to take more pictures. In this sense, Kodak amateur

photography was a way of standing outside the spectacle, gaining a perspective on it, whereas Polaroid picture-making was one attraction among many. See West, *Kodak and the Lens of Nostalgia*, 61–63.

70. See "Polaroid Fun with Disney," *Photo Weekly*, June 2, 1980; and "Polaroid to Open Fun Centers," *Photo Trade News*, June 23, 1980.

71. See "Special Events System: New Feature for the Amusement Industry," 1975, Box 4.23, folder 14; and Carl J. Yankowski, "Remarks, Stockholders Meeting, May 8, 1990," Polaroid Corporation Administrative Records, Box I.367, f. 12 Electronic imaging—speeches/annual report, 1988–1990, HBS, 5.

72. Susan Nielsen, "Newest 'For Instants' Store Opens in Atlantic City," *Polaroid Newsletter*, September 1984.

73. "Ideas for Generating Traffic at Your Center after the Holidays," *National Mall Monitor*, July/August 1979.

74. "Polaroid 'Face Place' Grows in Parks and Malls," *Vending Times*, July 1979; "Polaroid 'Face Place' Gains Strength in Parks, Attractions, and Arcades," *Vending Times*, May 1979.

75. "Launched!," *RePlay*, March 1978.

76. "Polaroid Unveils 30-Ton Spectra Camera," 1986, Polaroid Corporation Administrative Records, Box I.215, f.11 Press release, August 1991, HBS. See also Liz Burpee and Mason Resnick, "The Greatest Photography Promotions of All Time," *Photo Business*, September 1993.

77. The term "showman" was widely used to describe Land, including in the following: "The Land Rush," *Newsweek*, May 8, 1972; David Brand and Liz Roman Gallese, "Polaroid's Image: Company Proves Adept at Ballyhoo in Putting New Camera on Market: Mr Land's 'Wonderful Toy,'" *Wall Street Journal*, October 23, 1972); Siekman, "Kodak and Polaroid"; and "Dr. Land Redesigns His Camera Company," *Business Week*, April 15, 1972.

78. Donald White, "The Polaroid Picture: Profits up 137 Percent," *Boston Globe*, April 13, 1966.

79. See "Stockholders Meeting," *Polaroid Newsletter*, April 20, 1960.

80. Edwin Herbert Land, "Letter from Dr. Land," *Polaroid Newsletter*, April 8, 1958.

81. "Polaroid's New Wallet-Size Camera Delights Shareholders," *Polaroid Newsletter*, May 12, 1971.

82. "Annual Meeting, 1972," *Polaroid Newsletter*, April 26, 1972, Polaroid Corporation Collection, HBS.

83. "35th Annual Meeting," Polaroid Newsletter, May 16, 1972, Polaroid Corporation Collection, HBS.

84. "36th Annual Shareholders Meeting," Polaroid Newsletter, May 7, 1973, Polaroid Corporation Collection, HBS.

85. Siekman, "Kodak and Polaroid;" "Polaroid's Big Gamble on Small Cameras," *Time*, June 26, 1972.

86. Richard Kostelanetz, "A Wide-Angle View and Close-Up Portrait of Edwin Land and His Polaroid Cameras," *Lithopinion* 9, no. 1 (1974), 54; Jack Murphy, "More Magic from the Miracle Worker," *Du Pont Magazine*, March-April 1974.

87. White, "The Polaroid Picture."

88. Ehrenfeld, "No Land in Sight," *Boston Business*, August-September 1990; David Warsh, "Polaroid Has 1-Minute Film," *Boston Globe*, April 25, 1979.

89. Weston Andrews, "Instant Pictures," *Modern Photography*, July 1979.

90. Gunning, "Primitive Cinema," 96.

91. Gunning, "Primitive Cinema," 99.

92. Gunning, "Aesthetic of Astonishment," 36.

93. Gaudreault, "Showing and Telling," 276.

94. Ed Scully, "Speed 20,000 . . . Well, Sort of," *Modern Photography*, September 1968.

95. Andrews, "Instant Pictures," July 1979.

96. There are further connections between the traditions of the circus and the Polaroid annual meetings. Land seems to have regularly performed on circular stages, and as Helen Stoddart explains, the "ring" or circular performing space is one of the foundational elements of the circus as form; Helen Stoddart, *Rings of Desire: Circus History and Representation* (Manchester: Manchester University Press, 2000), 3. What is more, the circus was always a secular and modern form, embracing new technologies such as electric lighting, and using it not only for illumination, but incorporating it directly as an element of the spectacle. See Stoddart, *Rings of Desire*, 35–36.

97. According to McElheny, *Insisting on the Impossible*, 161.

98. Kostelanetz, "A Wide-Angle View," 54; "Dr. Land Redesigns"; "The Land Rush"; Siekman, "Kodak and Polaroid."

99. Ralph Samuels, "A New One-Minute Process," *Minicam Photography*, May 1947.

100. The full story is told by Wensberg, *Land's Polaroid*, 41–47; and McElheny, *Insisting on the Impossible*, 63–64.

101. Ruth Schwartz Cowan, *A Social History of American Technology* (New York: Oxford University Press, 1997), 124.

102. Cowan, *Social History of American Technology*, 128.

103. People often remark on the parallels between Land and Steve Jobs, Apple's charismatic CEO, who also presented new products with theatrical flourishes at annual meetings. Jobs was in fact "an intense admirer of Land," whom he considered "a national treasure." McElheny, *Insisting on the Impossible*, 376, 455. The parallel is also pursued in Bonanos, *Instant*, 11–13.

104. Thanks to Helen Stoddart, who suggested this phrase to me.

105. See Stoddart, *Rings of Desire*, 79–82.

106. Peter MacGill, "Introduction," in *20 × 24 Light*, ed. Peter MacGill (Philadelphia: Pennsylvania Council of the Arts, 1980), 2.

107. "The Land Rush."

108. Jule Eisenbud, *The World of Ted Serios: "Thoughtographic" Studies of an Extraordinary Mind* (New York: Morrow, 1967), 13.

109. There are precedents for this term. In the late nineteenth century, Spiritualists Hippolyte Baraduc and Louis Darget produced the "Portable Radiographer," "a primitive device with a head strap for securing a photographic plate to a subject's forehead" which produced "thought photographs." See Erin O'Toole, "Spirit Photography," in *Brought to Light: Photography and the Invisible 1840–1900*, ed. Corey Keller (New Haven: Yale University Press, 2009), 185. And as Andreas Fischer explains, the specific term "thoughtography" was introduced in 1910 by Tomokichi Fukurai, a professor of psychology at the Imperial University of Tokyo. Fischer, "'La lune au front': Remarks on the History of the Photography of Thought," in *The Perfect Medium: Photography and the Occult*, ed. Clément Chéroux (New Haven: Yale University Press, 2005), 141.

110. Stephen E. Braude, "The Thoughtography of Ted Serios," in Chéroux, ed., *The Perfect Medium*, 155.

111. Michael Kimmelman, "Ghosts in the Lens, Tricks in the Darkroom," *New York Times*, September 30, 2005.

112. Mark Alice Durant, "The Blur of the Otherworldy," *Art Journal* 62, no, 3 (2003), 14.

113. María del Pilar Blanco, "The Haunting of the Everyday in the Thoughtographs of Ted Serios," in *Popular Ghosts: The Haunted Spaces of Everyday Culture*, ed. María del Pilar Blanco and Esther Peeren (London: Continuum, 2010), 256.

114. Blanco, "Haunting of the Everyday," 260.

115. Blanco, "Haunting of the Everyday," 258.

116. The representative of the Illinois Society for Psychic Research who first uncovered Serios argued that use of a Polaroid camera made fraud more difficult. See Pauline Oehler, "A Report on the Psychic Photography of Ted Serios," *Fate*, December 1962.

117. Eisenbud, *World of Ted Serios*, 126.

118. Sealfon, *Magic of Instant Photography*, xiii.

119. For anyone who has used a Polaroid camera and been frustrated by the regular discrepancy between what they expect the resultant image to look like and what it actually looks like, this account by Eisenbud of the paranormal peculiarities of Serios' image-making will seem all too familiar: "The camera does not register what it 'sees' but what it could not possibly take in were it behaving as a camera should in the physical world." Eisenbud, *World of Ted Serios*, 223. This observation could be extended even further. Commenting on scientific photography in the nineteenth century, Tom Gunning has noted that it "intertwined with other visual devices not simply to record a recognizable world, but also to provide images of a previously invisible one." Tom Gunning, "Invisible Worlds, Visible Media," in Keller, ed., *Brought to Light*, 54.

120. Sealfon, *Magic of Instant Photography*, 85.

121. Campaigns in popular photography magazines 1949–51. When Kodak produced its own instant cameras in the 1970s, it resorted to exactly the same language. After advising owners to use the camera at parties, the Kodak manual says, "There's a certain thrill involved in watching your own image slowly appear in the print." "Better Instant Pictures with Kodak Instant Cameras" (1976), Folder Instant EK1, EK2, EK4, EK6, EK8, EK20, National Media Museum archive, Bradford.

122. Eisenbud, *World of Ted Serios*, 89.

123. Eisenbud, *World of Ted Serios*, 84, 90, 94, 99.

124. Charles Reynolds, "An Amazing Weekend with the Amazing Ted Serios: Part I," *Popular Photography*, October 1967, 137. The *Popular Photography* team felt that the key to what they assumed was a fraud was the "gismo" that Serios held against the lens when the shutter was triggered. Serios used different "gismos" over the years, each one basically a small tube of one sort or another. If a small optical device were slipped inside the gismo undetected, it would be possible to produce blurry reproductions of existing photos of the sort Serios specialized in. At the session in 1967 at the KOA TV studios in Denver, two trained magicians in the team thought they saw Serios "handling the gismo in a way well known to sleight-of-hand men that indicated a transfer of a gimmick from hand to hand. ('Gimmick' is the magician's term for any device unseen by the audience and used to accomplish a magic trick.)" Reynolds, "An Amazing Weekend with Ted Serios: Part I," 139. As I have already made clear, I am not concerned with making judgments about the supposed veracity of Serios' images. I simply note here the proximity, yet again, of the Polaroid camera and "gimmickry."

125. Simon During, *Modern Enchantments: The Cultural Power of Secular Magic* (Cambridge, MA: Harvard University Press, 2002), 19, 46.

126. Eisenbud, *World of Ted Serios*, 75.

127. Eisenbud, *World of Ted Serios*, 75.

128. The Aladdin tradition was already very strong in pantomime in the nineteenth century, and starting with the Pathé Brothers' version, *Aladin, ou la lampe merveilleuse* (Albert Capellani, 1906), saw many variations in the early years of cinema: *A New Aladdin* (Frank Wilson, 1912), *Aladdin Up-to-Date* (J. Searle Dawley, 1912), *Aladdin; or, a Lad Out* (Hay Plumb, 1914), *Aladdin and the Wonderful Lamp* (Chester M. and Sidney Franklin, 1917), *Aladdin from Broadway* (William Wolbert, 1917).

129. Eisenbud, *World of Ted Serios*, 300.

130. Jule Eisenbud, "Observations on a Possible New Thoughtographic Talent," *Journal of the American Society for Psychical Research* 71 (1977), 299.

131. During, *Modern Enchantments*, 27.

132. Steven Connor, "The Machine in the Ghost: Spiritualism, Technology and the 'Direct Voice,'" *Ghosts: Deconstruction, Psychoanalysis, History*, ed. Peter Buse and Andrew Stott (Basingstoke: Macmillan, 1999), 206.

133. Eisenbud, *World of Ted Serios*, 60, 74.

134. On the importance of the photographer-medium's bodily presence, note these comments by Tom Gunning on the notorious nineteenth-century spirit-photographer William H. Mumler: "Like a medium at a séance, a photographer like Mumler was a 'sensitive' who 'channeled' supernatural influences into the camera. In fact, the sensitized photographic plate played a more crucial role than the camera itself; some photographers claimed to be able to produce spirit images simply by resting a hand—or their subject's—on a plate." Gunning, "Invisible Worlds," 62. On the ways in which the effects of séances mirrored the operations of new technologies such as the telephone, see Connor, "The Machine in the Ghost."

135. Gunning, "Invisible Worlds," 60.

136. Eisenbud, *World of Ted Serios*, 126.

137. Eisenbud, *World of Ted Serios*, 88.

138. After listening to this description of Serios, Robert Polito suggested to me that Serios' display shared something with the bohemian outrages of the beatnik, with the bell-hop a sort of cut-rate Ginsberg putting on a show for the straights. A similar case is made by Durant, who argues that Serios' "role was that of an urban primitive [. . .] tapping into some ancient, deeply buried power source to which the civilized no longer have access." "Blur of the Otherworldy," 13. While it is probably the case that Serios' behavior was recognizably subcultural, neither Eisenbud nor his colleagues drew any conscious lessons about its significance. Indeed, what is so striking about Eisenbud and many other contemporary parapsychologists is their disinclination to draw any profound conclusions about the phenomena they investigate, contenting themselves with proving its existence and starting arguments with those doubters who fail to acknowledge the empirical "evidence."

139. Freeman, *Instant Film Photography*, 118.

140. Eisenbud, *World of Ted Serios*, 67.

141. Stephen E. Braude, *The Gold Leaf Lady and Other Parapsychological Investigations* (Chicago: University of Chicago Press, 2007), 116.

Chapter Five

1. Part of Calderwood's response is cited by Pauline Oehler in her report on Serios for *Fate* magazine. He wrote that "tampering with the film would be a long and complicated procedure and nothing that could be done by sleight-of-hand, especially if he had to photograph two or three pictures (or thoughts) on the same roll without reloading the camera and without an opportunity to substitute something in front of or behind the lens." Oehler, "A Report on Ted Serios," 77.

2. Adams, *Autobiography*, 247–60. Adams and Land met in 1949, at a time when Adams did a range of commercial photographic work to subsidize what he considered his main work in fine art photography. The consultancy for Polaroid provided him with a stable and guaranteed income testing and reporting on new film and cameras and advising Polaroid on developmental strategy. That he took this role

very seriously is attested to by the hundreds and hundreds of detailed memos and letters he wrote to the company. This correspondence was formerly held at the Polaroid Collections, Waltham, MA, which have subsequently been closed. Carbons are held at the Center for Creative Photography in Tucson, AZ.

3. For example, in one of his textbooks he writes, "the print itself is somewhat of an interpretation, a performance of the photographic idea." Ansel Adams, *The Print: Contact Printing and Enlarging* (New York: Morgan and Morgan, 1968), v.

4. Thanks to Annebella Pollen for reminding me of these lyrics.

5. See, for example, "Polaroid Dye Stability," *Studio Photography*, June 1980, or "Instant Picture Cameras," *Consumer Reports*, February 1978.

6. Freeman, *Instant Film Photography*, 84. Freeman also notes: "To some extent instant film prints are susceptible to the normal causes of deterioration that affect all photographs. Light, chemicals, humidity, heat and rough handling are the main reasons for the loss of image quality over the years. All, however, can be guarded against." See also Victor K. McElheny, "The Techniques of SX-70," in *SX-70 Art*, ed. Ralph Gibson, 121–32.

7. Henry Wilhelm, "Color Print Instability," *Modern Photography*, February 1979.

8. Arthur M. Louis, "Polaroid's OneStep Is Stopping Kodak Cold," *Fortune*, February 13, 1978. Christopher Bonanos argues that the integral print's reputation for fading is in fact vestigial, and can be traced back to earlier black and white Polaroid films, which did fade if not treated with a smelly and sticky "print coater." Bonanos also convincingly suggests that the myth that Polaroid prints need to be shaken is also due to the print coater, which stayed wet for a time, encouraging users to shake prints dry. *Instant*, 50. Bonanos also cites Billy Bragg's "St. Swithin's Day" and draws some of the same conclusions about it that I did in "Surely Fades Away: Polaroid Photography and the Contradictions of Cultural Value," *Photographies* 1, no. 2 (2008).

9. Land commented in his 1976 letter to shareholders, "To say that all men are mortal does not imply that living men are partly dead, and to say that all pictures fade is that much of a traduction of the vitality of photography. Every great photographic manufacturer has been involved with successful programs for endowing ordinary prints with impressive degrees of permanence. I think it is sad to castigate these historic achievements by blurring the line between the impressively stable and the impressively unstable with the observation that all prints fade." Land, *Selected Papers*, 27–28. The timing of these remarks—the latter would have been published for the annual meeting in the spring of 1977—suggests a veiled comment on Kodak's new instant prints, and their notorious lack of stability.

10. Walter Benjamin, *One-Way Street and Other Writings*, trans. Edmund Jephcott and Kingsley Shorter (London: Verso, 1979), 241.

11. West, *Kodak and the Lens of Nostalgia*, 45.

12. Cited in Colin Ford and Karl Steinorth, ed., *You Press the Button—We Do the Rest: The Birth of Snapshot Photography* (London: Dirk Nishen, 1988), 16.

13. Cited in Ford and Steinorth, *You Press the Button*, 23.

14. See West, *Kodak and the Lens of Nostalgia*, 41, 53.

15. Nick Dean, who worked as a consultant for Polaroid between 1956 and 1966, was attending a photography workshop at Yosemite run by Ansel Adams. This letter was held by the Polaroid Collections. Reproduced by permission of Zibette Dean.

16. See, for example, Aileen Fyfe, *Steam-Powered Knowledge: William Chambers and the Business of Publishing, 1820–1860* (Chicago: University of Chicago Press, 2012).

17. Carolyn Marvin, *When Old Technologies Were New: Thinking About Electric Communication in the Late Nineteenth Century* (Oxford: Oxford University Press, 1988), 61.

18. Marvin, *When Old Technologies Were New*, 56–58.

19. John Szarkowski, *Mirrors and Windows: American Photography since 1960* (New York: MOMA, 1978), 14.

20. Rubinstein and Sluis, "A Life More Photographic," 13.

21. "Polaroid President Invents New Camera That Produces Finished Print in One Minute," *Camera*, April 1947.

22. Samuels, "A New One-Minute Process."

23. "The Sensational One-Step Process," *U.S. Camera*, April 1947.

24. "Notes and News," *American Photography*, April 1947.

25. "The Land Camera," *American Photography*, March 1949; "One-Minute Photography," *U.S. Camera*, January 1949.

26. "We Try the Polaroid Land Camera," *Camera*, October 1949.

27. Harris, "The Year's Progress."

28. See, for example, William J. Sumits, "What They Might Have Done," *Popular Photography*, October 1963; or Paul Wahl, "Revolution in Photography!: Exciting New Cameras and Films Are Now Available," *Science and Mechanics*, September 1965.

29. *Jack Paar Show* script, December 16, 1960, Polaroid Corporation Administrative Records, Box I.56, f. 24 Publicity—Television commercial scripts—Jack Paar Show, 1960, HBS.

30. Herbert Keppler, "Kookie Camera: Ideal's Answer to Polaroid?????," *Modern Photography*, March 1969.

31. On the mutual interdependence of educational institutions, galleries, museums, and Polaroid in the Greater Boston area see Rachel Rosenfield Lafo and Gillian Nagler, ed., *Photography in Boston: 1955–1985* (Cambridge, MA: MIT Press, 2000). On Edwin Land's association with Harvard and MIT, see Olshaker, *The Instant Image*, 109–16.

32. John Wolbarst, "Instant Color," *Modern Photography*, March 1963.

33. Wolbarst, *Pictures in a Minute*, 6–7; John Dickson, *Instant Pictures* (London: Pelham Books, 1964), 39; Ansel Adams, *Polaroid Land Photography*, rev. ed. (Bos-

ton: New York Graphic Society, 1978), ix, 34. Polaroid brand designer Paul Giambarba also produced one of these books, in 1970. He takes the more pragmatic view that they were published to stimulate film sales. See Giambarba, *Branding of Polaroid*, 68.

34. Wolbarst, *Pictures in a Minute*, 6.

35. John Wolbarst, "Pictures in a Minute," *Modern Photography*, June 1959.

36. Dickson, *Instant Pictures*, 7.

37. There were of course manuals devoted to integral instant photography. I have already had occasion to cite two of them, by Freeman and Sealfon, a number of times in previous chapters.

38. Crawley, "SX-70 Camera and Film—a Review," 1003; Norman Goldberg, "Polaroid SX-70: The Facts behind the Ballyhoo: From the Inside Out," *Popular Photography*, April 1973; Ernest Reshovsky, "Polaroid SX-70 System," *Rangefinder*, September 1973.

39. Rothschild, "How SX-70 Film Compares," 121.

40. "Comment," *British Journal of Photography* 123, no. 17 (1976): 359.

41. Hal Denstman, "Polaroid SX-70 Land Camera," *Industrial Photography*, August 1973; Douglas Kirkland, "The SX-70 as a Tool for Creativity," *Popular Photography*, April 1973.

42. Goldberg, "Polaroid SX-70."

43. The addressee may have been masculine, but at the level of the magazine staff there two especially interesting exceptions. Throughout the 1950s and 1960s, Cora Wright Kennedy (originally just Cora Wright) was a key staff writer for *Modern Photography* and *Popular Photography*, often taking responsibility for the most technical writing assignments. Julia Scully, who worked first for *U.S. Camera* and *Camera 35*, joined *Modern Photography* in 1966 and worked there for 20 years as a writer and editor.

44. Wensberg, *Land's Polaroid*, 92.

45. "Polaroid Publicity Brochure," 1954, Polaroid Corporation Administrative Records, Box I.49, f. 11 Publicity—"Questions and Answers about the Most Talked-About Camera in America," brochure, 1954, HBS.

46. Wolbarst, *Pictures in a Minute*, 161.

47. Don Slater, "Consuming Kodak," in *Family Snaps: The Meanings of Domestic Photography*, ed. Jo Spence and Patricia Holland (London: Virago, 1991), 54–55.

48. When designer Paul Giambarba asked Polaroid why they produced so many different camera models, he was told that it was to hit all the price points. Giambarba, *Branding of Polaroid*, 21.

49. Slater, "Consuming Kodak," 54.

50. "Polaroid Publicity Brochure," 1955, Polaroid Corporation Administrative Records, Box I.49, f. 13 Publicity—"Care and Handling of Polaroid Land Cameras and Accessories," brochures, etc., ca. 1954, HBS.

51. "Polaroid Cooperative Advertising Plan," 1954, Polaroid Corporation Administrative Records, Box I.49, f. 16 Publicity—Polaroid cooperative advertising plan, 1954, HBS.

52. See *Ingenue*, December 1965; and especially "For Men: Play Santa," *Seventeen*, December 1965.

53. "Genovese Taps Boom in Photography," *Drug Topics*, January 1, 1979.

54. Madeline Rogers, "How Ads Woo Women," *New York Daily News*, March 30, 1980.

55. "PTN Dealers Rap Session San Francisco," *Photo Trade News*, February 19, 1979.

56. "Model 350," 1970, Polaroid Corporation Administrative Records, Box I.69, f. 1 Publicity—Cameras—product brochures, manuals, etc., 1970, HBS.

57. Bourdieu, *Photography: A Middle-Brow Art*, 64.

58. Bourdieu, *Photography: A Middle-Brow Art*, 68.

59. "The SX-70 Experience."

60. *Polavision*, directed by Charles Eames, 1977.

61. *Polaroid Newsletter*, November 6, 1972, Polaroid Corporation Collection, HBS.

62. *Saturday Night Live* episode of December 11, 1976.

63. The difference in class meanings between *La caza* and *Five Easy Pieces* shows that Polaroid's luxury status did not vary uniformly across time, but was also dependent on different territories. The camera is luxurious in *La caza* because Spain under Franco's dictatorship was poor and underindustrialized, and still only gradually modernizing. What's more, Polaroid had opened their Spanish subsidiary only in the mid-1960s, so the cameras and film had only just become available when Saura was filming.

64. "Polaroid Spectra System Onyx Camera," 1987, Polaroid Corporation Administrative Records, Box I.367, Box I.257, f. 14 Product information—consumer—Spectra System Onyx camera, April 1987, HBS.

65. Cited in Porter, "Evolution of Polaroid One-Step Photography," 11.

66. Edwin Land, "Chairman's Letter," *Polaroid Annual Report 1976*, 8.

67. Wolbarst, *Pictures in a Minute*, 7.

68. Wolbarst, *Pictures in a Minute*, 148–58. The first post-Polaroid manual of instant photography appeared in 2012: Jennifer Altman, Susannah Conway, and Amanda Gilligan, *Instant Love: How to Make Magic and Memories with Polaroids* (San Francisco: Chronicle Books, 2012). Like Wolbarst, these writers have favored themes or subject matter, in this case, "pretty" things, urban scenes, nature, travel, and food. Although they devote part of their book to the specifics of using different Polaroid cameras, and comment interestingly on some of the consequences of shooting in a square format, what is perhaps most striking is that by far the largest portion of the book is devoted to photographic tips that are not specific to Polaroid photography, and which can be found in many other general guides to

photographic technique: the rule of thirds, the rule of odds, depth of field, framing, positive and negative space, handling movement, patterns and shapes, color, the golden hour, and so on.

69. Tomas Kulka, *Kitsch and Art* (University Park: Pennsylvania State University Press, 1996), 43–44.

70. Theodor W. Adorno, "Kitsch," in *Essays on Music*, trans. Susan H. Gillespie (Berkeley: University of California Press, 2002), 501.

71. Adorno, "Kitsch," 502.

72. Jenny Diski, "Don't Die," *London Review of Books*, November 1, 2007. See also Dana Thomas, *Deluxe: How Luxury Lost its Lustre* (London: Allen Lane, 2007).

73. "Centuries-Old Tapestry Replicated in a Minute," *Polaroid Newsletter*, October 14, 1977. Polaroid Corporation Collection, HBS.

74. See Umberto Eco, *Faith in Fakes: Essays*, trans. William Weaver (London: Secker and Warburg, 1986); and Jean Baudrillard, *Simulacra and Simulation*, trans. Sheila Faria Glaser (Ann Arbor: University of Michigan Press, 1994).

75. "The Polaroid Museum Replica Collection Presents: Monet Master of Light," 1986–7, Polaroid Corporation Administrative Records, Box I.303, f. 46 Product information—industrial—20 × 24 film—Polaroid replicas, circa 1980s, HBS.

76. William Wegman, *Man's Best Friend* (New York: Harry N. Abrams, 1982), 47.

77. Wegman, *Man's Best Friend*, 27.

78. Wegman, *Man's Best Friend*, 62.

79. Nicole Columbus, *Innovation/Imagination: 50 Years of Polaroid Photography* (New York: Harry N. Abrams, 1999), 116.

Chapter Six

1. Stephen Perloff of *The Photograph Collector* gives a detailed account. "Guest Post 6(a): Stephen Perloff on the Polaroid Auction." Accessed December 12, 2013. http://www.nearbycafe.com/artandphoto/photocritic/2010/07/18/guest-post-6a -stephen-perloff-on-the-polaroid-auction/

2. Joseph Pereira, "Polaroid Points a Smaller Instant Camera at 35mm Users," *Wall Street Journal*, September 16, 1992.

3. R. S. Evans, "Land and Polaroid," 172.

4. H. C. Wainwright and Co., Audit/Report, 1962, Polaroid Corporation Administrative Records, Box I.15, f. 8 Operating Policy Committee—engineering/finance, 1962, HBS; Siekman, "Kodak and Polaroid."

5. "Merrill Lynch Institutional Report of Polaroid Corporation," 1979, Polaroid Corporation Administrative Records, Box I.322, f. 5–6 Product information files— Polaroid OneStep, 1970s, HBS. In 1981, when it founded its TechPhoto division to deal with "non-amateur photographic markets," Polaroid reported that 30% or $480 million of its revenue came from this area. See "Polaroid Technology,"

Close-up 12, no. 1 (1981), 22. The discrepancy between 20% of film units and 30% of revenue is explained by the higher cost of the professional film units.

6. Kenneth G. Slocum, "Simpler Snapshots: Easier-to-Use Cameras Help Spur Record Sales of Amateur Photo Gear," *Wall Street Journal*, September 13, 1960.

7. Nancy Mass, "Flash Dance: Will Kodak Find New Life by Finally Acting Its Age?," *Financial World*, February 6, 1993.

8. The 85% figure was given by Joseph Pereira, "Wall Street Sees a Turnaround Developing at Polaroid," *Wall Street Journal*, July 13, 1993; 90% by Chris Swingle, "Captiva Is Polaroid's Photo Finish."

9. "The Polaroid Challenge," 1979, Polaroid Corporation Administrative Records, Box I.243, f. 3 Product information—consumer—The Polaroid Challenge, June 1979, HBS.

10. Interview with author, July 16, 2013.

11. About 30% of Kodak's business was in these fields in 1960. Collins, *The Story of Kodak*, 298.

12. See McElheny, *Insisting on the Impossible*, 86–107.

13. Thanks to Sam Yanes for providing the background to these ads.

14. "Polaroid's Big Gamble on Small Cameras."

15. Land used the phrase in an address at the Mellon Institute in 1963. Land, *Selected Papers*, 16.

16. Anne McCauley, "The Trouble with Photography," in *Photography Theory*, ed. Elkins, 409.

17. Peter C. Bunnell, *Degrees of Guidance: Essays on Twentieth-Century Photography* (Cambridge: Cambridge University Press, 1993), xvi.

18. Christopher Phillips, "The Judgment Seat of Photography," *October* 22 (1982), 28.

19. Abigail Solomon-Godeau, "Ontology, Essences, and Photography's Aesthetic: Wringing the Goose's Neck One More Time," in *Photography Theory*, ed. Elkins, 269.

20. Margery Mann and Sam Ehrlich, "The Exhibition of Photographs: Northern California," *Aperture* 13, no. 4 (1968), 13.

21. Cited in Barbara Hitchcock, "When Land Met Adams," in *The Polaroid Book*, ed. Crist, 24.

22. Sean Latham and Robert Scholes, "The Rise of Periodical Studies," *PMLA* 121, no. 2 (2006), 521.

23. Dody Warren subsequently married Brett Weston and is better known as Dody Weston Thompson.

24. Polaroid ad, *Camera*, 73, no. 11 (1950), 11.

25. Polaroid ad, *Camera*, 74, no. 6 (1951), 17.

26. Polaroid ad, *Modern Photography*, 16, no. 1 (1952), 3.

27. See *PSA Journal* 16, no. 5 (1950), *PSA Journal* 17, no. 5 (1951), 303.

28. The favored terminology of Adams in his correspondence with Polaroid

and in his publications on instant photography. See, for instance, Adams, *Polaroid Land Photography*, 34.

29. Thanks to Jennifer Uhrhane of the Polaroid Collections for pointing this out to me.

30. Thanks to Barbara Hitchcock of the Polaroid Collections for this information.

31. Ansel Adams, Letter to M. M. Morse, June 8, 1953, Polaroid Collections, Concord, MA.

32. From 1989, Rollei and Linhof cameras, Rodenstock lenses, and eventually Kodak film were advertised in the final pages of each issue. Before 1989, only photographic books and galleries were promoted in this special advertising quarantine zone at the back of each issue.

33. R. H. Cravens, "Visions and Voices: A Celebration of Genius in Photography," *Aperture* 168 and 169 (Fall and Winter 2002), Parts I and II, 5–11, 42–51, and 4–13, 38–45.

34. "Aperture Foundation: A History of Excellence." Accessed March 9, 2008. http://www.aperture.org/store/pdfs/timeline.pdf.

35. Cited in Peter C. Bunnell, *Minor White: The Eye that Shapes* (Princeton: Art Museum, Princeton University, 1989), 28.

36. Latham and Scholes, "The Rise of Periodical Studies," 521.

37. Elena McTighe, "The *PSA Journal*," *PSA Journal*, October 2009, 16.

38. Ansel Adams, Memo to M. M. Morse and Richard Kriebel, 29 January 1953, Polaroid Collections, Concord, MA.

39. Beaumont Newhall, *Focus: Memoirs of a Life in Photography* (Boston: Little, Brown, 1993), 210.

40. Beaumont Newhall, Letter to M. M. Morse, July 29, 1955, Polaroid Collections, Concord, MA.

41. Robert Doty, Letter to Beaumont Newhall, n.d. (Summer 1957), Polaroid Collections, Concord, MA.

42. Robert Doty, *Photo-Secession: Photography as a Fine Art* (Rochester: George Eastman House, 1960); Beaumont Newhall, *The History of Photography from 1839 to the Present*, rev. ed. (New York: MOMA, 1982), 281.

43. Ansel Adams, Letter to Edwin H. Land, April 14, 1953; Letter to Morse, June 8, 1953, Polaroid Collections, Concord, MA.

44. Ansel Adams, Letter to M. M. Morse, April 22, 1953, Polaroid Collections, Concord, MA, 2.

45. Ansel Adams, Letter to M. M. Morse, July 14, 1953, Polaroid Collections, Concord, MA.

46. Adams, Letter to Morse, April 22, 1953; Memo to M. M. Morse, May 1, 1953; Letter to M. M. Morse, July 10, 1953, Polaroid Collections, Concord, MA.

47. Ansel Adams, Letter to Edwin H. Land, September 25, 1953, Polaroid Collections, Concord, MA.

48. Szarkowski, *Mirrors and Windows*, 17.

49. Again, I am grateful to Jennifer Uhrhane for pointing out to me the oddity of these portraits within Adams' work for Polaroid and in general.

50. John Szarkowski goes as far as to say that Adams' "handling of human models was stiff and unpersuasive, even by the low standards of most advertising photography." *Ansel Adams at 100* (New York and Boston: Little, Brown, 2001), 36. Adams' longtime assistant, Andrea G. Stillman, confirms that Adams was not known for portraits or close detail work, but points out that in Adams' breakthrough show at Stieglitz's American Place in 1936, only seven of forty-five images were landscapes, and that Adams felt that it was the public that had made him a landscape photographer. *Looking at Ansel Adams: The Photographs and the Man* (New York: Little, Brown, 2012), 83–88.

51. Richard Kriebel, Letter to Minor White, July 23, 1957, Polaroid Collections, Concord, MA. My emphasis.

52. Anon. (Minor White), "Pilot Project RIT: On the Trail of a Trial Balloon," *Aperture* 5, no, 3 (1957), 107–11, 111. My emphasis.

53. Minor White, "Pilot Project RIT," 107.

54. Minor White, "Pilot Project RIT," 109.

55. White, "Polaroid Land Photography and Photographic 'Feedback,'" 26. Clearly, another way in which White distanced himself from Polaroid was by publishing both of these articles anonymously.

56. Richard Bolton, "Introduction," in *The Contest of Meaning: Critical Histories of Photography*, ed. Richard Bolton (Cambridge, MA: MIT Press, 1989), ix.

57. See Abigail Solomon-Godeau, "Living with Contradictions: Critical Practices in the Age of Supply-Side Aesthetics," *Social Text* 21 (1989), 191–213, 194.

58. Solomon Godeau dates the "collapse of any hard-and-fast distinction between art and advertising" to the mid-1980s. "Living with Contradictions," 204–5. It was also during this time that *Aperture* began to take advertising in addition to the back cover Polaroid image. Subsequently *Aperture* has loosened its strict policy even further, and its relations with Polaroid came full circle in 2010 when it joined with Summit Global Group, distributor of "Polaroid" products in the wake of the second bankruptcy, in the Polaroid brand relaunch that culminated with the issue of the Polaroid 300 camera. *Aperture* produced for the occasion a special supplement to its summer issue, with images by Chuck Close, Mary Ellen Mark, Joel Meyerowitz, and Maurizio Galimberti. The Polaroid 300, and its film, as I have noted before, are manufactured by Fuji.

59. Ansel Adams, "Playboy Interview: Ansel Adams," *Playboy*, May 1983.

60. Hitchcock, "When Land Met Adams," 26.

61. Minkinnen, "Treasures of the Moment."

62. Rhonda Barton, "Program Aids Promising Photographers," *Polaroid Newsletter*, June 1981.

63. "Polaroid's Photography Collection on Display Worldwide," *Polaroid Newsletter*, December 1984, Polaroid Corporation Collection, HBS.

64. This correspondence was held by the Polaroid Collections in Waltham, MA, before the dissolution of the Collections. It has been transferred to the Polaroid Corporation archive at the Baker Library, Harvard, but had not yet been catalogued at the time of writing.

65. Collins, *The Story of Kodak*, 290.

66. A. D. Coleman argues that Kodak copied Polaroid's model from the mid-1980s onwards in its support for photo festivals, especially the flagship Rencontres d'Arles in France. Coleman, "Polaroid: The Good Old Story," 38.

67. *Polaroid Annual Report 1952*, 3; *Polaroid Annual Report 1958*, 5.

68. Ansel Adams, Memo to M. M. Morse, March 23–25, 1954, Polaroid Collections, Concord, MA, 1.

69. *Polaroid Annual Report 1959*, 8–9.

70. *Polaroid Annual Report 1958*, 8–9; *Polaroid Annual Report 1961*, 8–9.

71. See Naomi Rosenblum, *A World History of Photography*, 3rd ed. (New York: Abbeville Press, 1997), 597.

72. *Polaroid Annual Report 1977*, 27.

73. *Annual Report 1977*, 28.

74. A. D. Coleman, "Writing and Publishing about Photography in the Boston Area, 1955–1985," in *Photography in Boston*, ed. Rosenfield Lafo and Nagler, 119–35, 127.

75. Constance Sullivan, "Letter to Subscribers," n.d. (Spring 1984).

76. Polaroid Press release, September 18, 1963, Polaroid Corporation Administrative Records, Box I.175, f. 7 Press releases, 1963, HBS.

77. *Close-Up* 1, no. 1 (1970).

78. "Editorial," *Close-Up* 2, no. 3 (1971), 2.

79. "Editorial statement," *Close-Up* 10, no. 1 (1979), inside cover.

80. "Editorial," *Close-Up* 12, no. 1 (1981), inside cover.

81. "Editorial," *Close-Up* 13, no. 1 (1982), inside cover.

82. Thanks to Sam Yanes for this information.

83. Coleman, "Writing and Publishing about Photography," 127.

84. Solomon-Godeau, "Living with Contradictions," 191.

85. Coleman, "Polaroid: The Good Old Story," 39.

86. A.D. Coleman, *Tarnished Silver: After the Photo Boom: Essays and Lectures 1979–1989* (New York: Middlemarch Arts Press, 1996), 62–68.

87. "Hello Photography," *Aperture* 210, 11.

88. Merry A. Foresta, "Foreword," in *Photography Changes Everything*, ed. Marvin Heiferman (New York: Aperture Foundation, 2012), 7.

89. Marvin Heiferman, "Photography Changes Everything," in *Photography Changes Everything*, 15.

Conclusion

1. For example, savepolaroid.com and savethepolaroid.com.

2. This fact was related to me by Mikael Kennedy.

3. Kimmelman, "Imperfect, yet Magical."

4. Claudia H. Deutsch, "Two Images of Polaroid, but Which Is Sharper?," *New York Times*, March 21, 1999.

5. Under US bankruptcy law, a Section 363 sale allows the debtor to sell assets "free and clear" of the company's liabilities, rather than going through the more complex process of reorganization. A 363 sale generally opens with the debtor finding a "stalking horse" bidder and negotiating an asset purchase agreement. In the case of the 363 sale of Polaroid in 2009, the stalking horse was PHC holdings, an affiliate of Genii Capital, a private equity group based in Luxembourg.

6. At least one report was suspicious of the large gap between assets and debts in the 2002 sale, and argued that One Equity got a cut-rate deal "behind the drawn curtains" of the Delaware bankruptcy court. See Christopher Byron, "The Rape of Polaroid—Shareholders Watch as $1.1B in Assets Disappears," *New York Post*, July 22, 2002. *The Boston Globe* was particularly critical of the treatment of Polaroid retirees living in the Massachusetts area. See "Bad Image for Polaroid," *Boston Globe*, May 2, 2005.

7. Henry L. Druker of private equity firm Questor Management, cited in Claudia H. Deutsch, "Fiscal and Technical Advice for Ex-Ford Chief as He Arrives at Polaroid," *New York Times*, November 18, 2002.

8. In Claudia H. Deutsch, "Big Picture beyond Photos," *New York Times*, October 1, 2005.

9. Cited in Jeffrey Krasner, "Minnesota Firm to Acquire Polaroid," *Boston Globe*, January 8, 2005.

10. Janet McFarland, "Canadians Snap Up Polaroid," *Globe and Mail*, April 18, 2009.

11. Cited in McFarland, "Canadians Snap Up Polaroid."

12. Cited in Donna Block, "Hilco-Gordon Wins Polaroid," *Daily Deal*, April 20, 2009.

13. For instance, in a worldwide survey of brand recognition conducted by Landor in 1989, Polaroid came 21st overall. Kodak, a much larger company, both in photography and in general, did not feature in the top 25.

14. Thanks to Marvin Heiferman, who drew my attention to the current popularity of square format film.

15. IP *Newsletter*, June 6, 2010. Bill Ewing suggested to me that Impossible, in the early period, was cleverly making the best of a bad job in their marketing.

16. IP *Newsletter*, April 8, 2010.

17. The style magazines were *HUGE* from Tokyo, and *Milk-X* from Hong Kong. The Westlicht Gallery, Vienna, which purchased in its entirety the European section

of the Polaroid Collections, put on an exhibition in 2011 of selections from the Collection and images taken on Impossible Project film. See Achim Heine, Rebekka Reuter, Ulrike Willingman, eds., *From Polaroid to Impossible: Masterpieces of Instant Photography* (Stuttgart: Hatje Kantz, 2011).

18. IP *Newsletter*, November 6, 2011.

19. See Martin Hand, *Ubiquitous Photography* (Cambridge: Polity, 2012).

Epilogue

1. Sean O'Hagan, "Now Smile."

2. The UK subsidiary of Polaroid opened in 1963 in Hertfordshire.

Bibliography

1980–1990 Fact Book and Financial Summary. 1991. Box 19-4-1, Polaroid Corporation annual reports, Polaroid Corporation Collection, Baker Library, Harvard Business School.

"27 Summer Picture-in-a-Minute Ideas." *Popular Photography*, May 1959.

"35th Annual Meeting." *Polaroid Newsletter*, May 16, 1972. Polaroid Corporation Collection, Baker Library, Harvard Business School.

"36th Annual Shareholders Meeting." *Polaroid Newsletter*, May 7, 1973. Polaroid Corporation Collection, Baker Library, Harvard Business School.

"60-Second Excitement." Britannica Home Library Service brochure, 1971. Polaroid Corporation Administrative Records, Box I.71, f. 10 Publicity—Polaroid/Britannica Home Library Service brochure, 1971. Baker Library, Harvard Business School.

"60-Second Photography on the Job . . . How Polaroid Land Cameras Are Used in Sales Promotion." 1956. Polaroid Corporation Administrative Records, Box I.50, f. 14 Publicity—Industrial Sales—"60-Second Photography on the Job . . . ," (brochures), 1956. Baker Library, Harvard Business School.

Acland, Charles R. "Introduction: Residual Media." In *Residual Media*, edited by Charles R. Acland, xiii–xxvii. Minneapolis: Minnesota University Press, 2007.

Adams, Ansel. *An Autobiography*. Boston: Little, Brown, 1985.

Adams, Ansel. Letter to Edwin H. Land, April 14, 1953.

Adams, Ansel. Letter to Edwin H. Land, September 25, 1953.

Adams, Ansel. Letter to M. M. Morse, April 22, 1953.

Adams, Ansel. Letter to M. M. Morse, June 8, 1953.

Adams, Ansel. Letter to M. M. Morse, July 10, 1953.

Adams, Ansel. Letter to M. M. Morse, July 14, 1953.

Adams, Ansel. Memo to M. M. Morse, May 1, 1953.

Adams, Ansel. Memo to M. M. Morse, March 23–25, 1954.

Adams, Ansel. Memo to M. M. Morse and Richard Kriebel, January 29, 1953.

Adams, Ansel. "Playboy Interview: Ansel Adams." *Playboy*, May 1983.

Adams, Ansel. *Polaroid Land Photography*. Rev. ed. Boston: New York Graphic Society, 1978.

Adams, Ansel. "Portfolio." *PSA Journal* 21, no. 6 (1955): 20–27.

Adams, Ansel. *The Print: Contact Printing and Enlarging*. New York: Morgan and Morgan, 1968.

Adorno, Theodor W. "Kitsch." In *Essays on Music*, translated by Susan H. Gillespie. Berkeley: University of California Press, 2002.

Aladdin and the Wonderful Lamp. Directed by Chester M. and Sidney Franklin. 1917.

Aladdin from Broadway. Directed by William Wolbert. 1917.

Aladdin Up-to-Date. Directed by J. Searle Dawley. 1912.

Aladdin; or, a Lad Out. Directed by Hay Plumb, 1914.

Aladin, ou la lampe merveilleuse. Directed by Albert Capellani. 1906.

Almost Famous. Directed by Cameron Crowe. 2000.

Altman, Jennifer, Susannah Conway, and Amanda Gilligan. *Instant Love: How to Make Magic and Memories with Polaroids*. San Francisco: Chronicle Books, 2012.

"American Newspaperman Charms Red Chinese with His SX-70 Camera." *Polaroid Newsletter*, October 28, 1975. Polaroid Corporation Collection, Baker Library, Harvard Business School.

Andrews, Weston. "Instant Pictures." *Modern Photography*, July 1979.

Andrews, Weston. "Instant Pictures." *Modern Photography*, May 1980.

"Annual Meeting, 1972." *Polaroid Newsletter*, April 26, 1972. Polaroid Corporation Collection, Baker Library, Harvard Business School.

"Another European Invasion." *Sunday News* (New York), August 15, 1971.

"Aperture Foundation: A History of Excellence." Accessed September 3, 2008. http://www.aperture.org/store/pdfs/timeline.pdf.

Attwood, William. "Instant Snapshots Help Break Ice in China." *Los Angeles Times*, July 14, 1971.

"Background Notes: Polaroid Land Cameras." 1960. Polaroid Corporation Administrative Records, Box I.243, f. 7 Product information—consumer—general information—"Background Notes," circa 1960s. Baker Library, Harvard Business School.

"Bad Image for Polaroid." *Boston Globe*, May 2, 2005.

Baer, Ulrich. *Spectral Evidence: The Photography of Trauma*. Cambridge, MA: MIT Press, 2002.

Barthes, Roland. *A Lover's Discourse*. Translated by Richard Howard. New York: Vintage, 2002.

Barthes, Roland. *Camera Lucida: Reflections on Photography*. Translated by Richard Howard. London: Flamingo, 1984.

Barthes, Roland. *Image, Music, Text*. Translated by Stephen Heath. London: Fontana 1977.

Barton, Rhonda. "Program Aids Promising Photographers." *Polaroid Newsletter*, June 1981.

Batchen, Geoffrey. *Burning with Desire: The Conception of Photography*. Cambridge, MA: MIT Press, 1997.

Batchen, Geoffrey. *Each Wild Idea: Writing, Photography, History*. Cambridge, MA: MIT Press, 2002.

Batchen, Geoffrey. *Forget Me Not: Photography and Remembrance*. New York: Princeton Architectural Press, 2004.

Batchen, Geoffrey. "Palinode: An Introduction to *Photography Degree Zero*." In *Photography Degree Zero: Reflections on Roland Barthes'* Camera Lucida, edited by Geoffrey Batchen, 3–30. Cambridge, MA: MIT Press, 2009.

Batchen, Geoffrey. "Snapshots: Art History and the Ethnographic Turn." *Photographies* 1, no. 2 (2008): 121–42.

Batchen, Geoffrey, Mick Gidley, Nancy K. Miller, and Jay Prosser, ed. *Picturing Atrocity: Photography in Crisis*. London: Reaktion, 2012.

Baudrillard, Jean. *America*. Translated by Chris Turner. London: Verso, 1988.

Baudrillard, Jean. *Simulacra and Simulation*, translated by Sheila Faria Glaser. Ann Arbor: University of Michigan Press, 1994.

Bello, Francis. "The Magic that Made Polaroid." *Fortune*, April 1959.

Benjamin, Walter. *The Arcades Project*. Edited by Rolf Tiedemann, translated by Howard Eiland and Kevin McLaughlin. Cambridge, MA: Belknap, 1999.

Benjamin, Walter. *One-Way Street and Other Writings*, translated by Edmund Jephcott and Kingsley Shorter. London: Verso, 1979.

Benson, Richard. *The Printed Picture*. New York: Museum of Modern Art, 2008.

Bergstein, Mary. *Mirrors of Memory: Freud, Photography and the History of Art*. Ithaca: Cornell University Press, 2010.

Berlant, Lauren. "Intimacy: A Special Issue." *Critical Inquiry* 24, no. 2 (Winter 1998): 281–88.

"Better Instant Pictures with Kodak Instant Cameras." 1976. Folder Instant EK1, EK2, EK4, EK6, EK8, EK20. National Media Museum archive, Bradford.

Blanco, María del Pilar. "The Haunting of the Everyday in the Thoughtographs of Ted Serios." In *Popular Ghosts: The Haunted Spaces of Everyday Culture*, edited by María del Pilar Blanco and Esther Peeren, 253–67. London: Continuum, 2010.

Block, Donna. "Hilco-Gordon Wins Polaroid." *Daily Deal*, April 20, 2009.

Blout, Elkan. "Polaroid: Dreams to Reality." *Daedalus* 125, no. 2 (1996): 39–53.

Boddy, William. *New Media and Popular Imagination: Launching Radio, Television, and Digital Media in the United States*. Oxford: Oxford University Press, 2004.

Bolter, J. David, and Richard Grusin. *Remediation: Understanding New Media*. Cambridge, MA: MIT Press, 1999.

Bolton, Richard. "Introduction." In *The Contest of Meaning: Critical Histories of Photography*, edited by Richard Bolton, ix–xix. Cambridge, MA: MIT Press, 1989.

Bonanos, Christopher. "Gone in an Instant: Top Photographers Are Angry over Polaroid's Fade to Black." *New York Magazine*, May 4, 2008. Accessed January 13, 2011. http://nymag.com/news/intelligencer/46655/.

Bonanos, Christopher. *Instant: The Story of Polaroid*. Princeton: Princeton Architectural Press, 2012.

Boogie Nights. Directed by Paul Thomas Anderson. 1997.

Booth, J. H. "How Polaroid Captured a Leading Position in the Camera Market." *Printer's Ink*, June 24, 1949.

Bourdieu, Pierre. *Photography: A Middle-Brow Art*. Translated by Shaun Whiteside. Stanford: Stanford University Press, 1990.

Brand, David, and Liz Roman Gallese. "Polaroid's Image: Company Proves Adept at Ballyhoo in Putting New Camera on Market: Mr Land's 'Wonderful Toy.'" *Wall Street Journal*, October 23, 1972.

Braude, Stephen E. *The Gold Leaf Lady and Other Parapsychological Investigations*. Chicago: University of Chicago Press, 2007.

Braude, Stephen E. "The Thoughtography of Ted Serios." In *The Perfect Medium: Photography and the Occult*, edited by Clément Chéroux, 155–157. New Haven: Yale University Press, 2005.

Brayer, Elizabeth. *George Eastman: A Biography*. Baltimore: Johns Hopkins University Press, 1996.

Bunnell, Peter C. *Degrees of Guidance: Essays on Twentieth-Century Photography*. Cambridge: Cambridge University Press, 1993.

Bunnell, Peter C. *Minor White: The Eye that Shapes*. Princeton: Art Museum, Princeton University, 1989.

Burnett, Ron. "Further Notes on Roland Barthes from Cultures of Vision." Critical Approaches to Culture and Media. Accessed October 9, 2011. http://rburnett.ecuad.ca/roland-barthes-photographs/.

Burns, Stanley B. *Sleeping Beauty: Memorial Photography in America*. Santa Fe: Twelvetrees/Twin Palms Press, 1990.

Burpee, Liz, and Mason Resnick. "The Greatest Photography Promotions of All Time." *Photo Business*, September 1993.

Buse, Peter, Ken Hirschkop, Scott McCracken, and Bertrand Taithe. *Benjamin's Arcades: An Unguided Tour*. Manchester: Manchester University Press, 2005.

Buse, Peter. "Surely Fades Away: Polaroid Photography and the Contradictions of Cultural Value." *Photographies* 1:2 (2008): 221–38.

Business Nightmares. BBC1. May 12, 2011.

"Buyers Guide 1992." *Advanced Imaging*, December 1991.

Buzzell, Robert D., and M. Jean-Louis Lecocq. "Polaroid France (S.A.) Marketing Planning in a Multinational Company." Harvard Business School Case Study 513–119, 1968.

Byron, Christopher. "The Rape of Polaroid—Shareholders Watch as $1.1B in Assets Disappears." *New York Post*, July 22, 2002.

Bywater, Michael. "The End of Polaroid?" *Independent*, September 23, 2009. Accessed January 13, 2011. http://www.independent.co.uk/life-style/gadgets-and-tech/features/the-end-of-polaroid-1791629.html.

Callahan, Sean. "Eye Tech." *Forbes*, June 1993.

Campbell, Lady Colin. "The Headless Man Unmasked." *Mail on Sunday*. December 29, 2013.

Casselman, R. C. "Sales Autotype Letter no. 32H-1," November 30, 1955. Polaroid Corporation Administrative Records, Box I.49, f. 29 Publicity—Dealer mailings and information, 1955. Baker Library, Harvard Business School.

Casselman, Robert. "Letter to Polaroid Dealers." 1955. Polaroid Corporation Administrative Records, Box I.50, f. 2 Publicity—Consumer info—brochures and mailings, 1955. Baker Library, Harvard Business School.

"Centuries-Old Tapestry Replicated in a Minute." *Polaroid Newsletter*, October 14, 1977. Polaroid Corporation Collection, Baker Library, Harvard Business School.

Chalfen, Richard. "'It's Only a Picture': Sexting, 'Smutty' Snapshots and Felony Charges." *Visual Studies* 24, no. 3 (2009): 258–68.

Chalfen, Richard. *Snapshot Versions of Life*. Bowling Green: Bowling Green State University Popular Press, 1987.

Chiaramonte, Giovanni, and Andrey A. Tarkovsky, eds. *Instant Light: Tarkovsky Polaroids*. London: Thames and Hudson, 2004.

Christie, Ian. "Toys, Instruments, Machines: Why the Hardware Matters." In *Multimedia Histories: From the Magic Lantern to the Internet*, edited by James Lyons and John Plunkett. Exeter: University of Exeter Press, 2007.

Church, Elizabeth. "Polaroid Pictures a New Image." *Globe and Mail*, September 13, 2000.

Clarke, Graham. *The Photograph*. Oxford: Oxford University Press, 1997.

"Click and Stick with Polaroid's Instant Pocket Camera." *Photo Industry Reporter*, September 6, 1999.

Close-Up 1, no. 1 (1970).

Coleman, A. D. "Polaroid: The Good Old Story." *Katalog* 10, no. 2 (1998): 37–44.

Coleman, A. D. *Tarnished Silver: After the Photo Boom: Essays and Lectures 1979–1989*. New York: Middlemarch Arts Press, 1996.

Coleman, A. D. "The Directorial Mode: Notes towards a Definition." In *Photography in Print: Writings from 1816 to the Present*, edited by Vicki Goldberg, 480–91. New York: Simon and Schuster, 1981.

Coleman, A. D. "Writing and Publishing about Photography in the Boston Area, 1955–1985." In *Photography in Boston: 1955–1985*, edited by Rachel Rosenfield Lafo and Gillian Nagler, 119–35. Cambridge, MA: MIT Press, 2000.

Collins, Douglas. *The Story of Kodak*. New York: Harry N. Abrams, 1990.

Columbus, Nicole, ed. *Innovation/Imagination: 50 Years of Polaroid Photography*. New York: Harry N. Abrams, 1999.

"Comment." *British Journal of Photography* 123, no. 17 (1976): 359.

Connor, Steven. "The Machine in the Ghost: Spiritualism, Technology and the 'Direct Voice.'" In *Ghosts: Deconstruction, Psychoanalysis, History,* edited by Peter Buse and Andrew Stott, 203–25. Basingstoke: MacMillan, 1999.

Conrad, Peter. "Elegy for the Polaroid." *Observer,* May 30, 2010. Accessed January 13, 2011. http://www.guardian.co.uk/artanddesign/2010/may/30/polaroid -auction-peter-conrad.

Coupland, Douglas. *Polaroids from the Dead.* Toronto: HarperCollins, 1996.

Cowan, Ruth Schwartz. *A Social History of American Technology.* New York: Oxford University Press, 1997.

Cravens, R. H. "Visions and Voices: A Celebration of Genius in Photography." *Aperture* 168 (Fall 2002), Part I: 5–11, 42–51.

Cravens, R. H. "Visions and Voices: A Celebration of Genius in Photography." *Aperture* 169 (Winter 2002), Part II: 4–13, 38–45.

Crawley, Geoffrey. "Colour Comes to All." In *The Kodak Museum: The Story of Popular Photography,* edited by Colin Ford, 128–53. London: Century, 1989.

Crawley, Geoffrey. "SX-70 Camera and Film—A Review." *British Journal of Photography* 123, no. 46 (1976): 998–1003.

Crist, Steve, ed. *The Polaroid Book: Selections from the Polaroid Collections of Photography.* Cologne: Taschen, 2005.

Cross, Gary. *Kids' Stuff: Toys and the Changing World of American Childhood.* Cambridge, MA: Harvard University Press, 1997.

Czach, Liz. "Polavision Instant Movies: Edwin Land's Quest for a New Medium." *Moving Image* 2, no. 2 (2002): 1–24.

Davenport, Guy. *The Geography of the Imagination: Forty Essays.* London: Pan Books, 1984.

Day, Kate. "Goodbye Polaroid." *Telegraph,* October 9, 2009. Accessed January 13, 2011. http://blogs.telegraph.co.uk/culture/kateday/100003920/goodbye -polaroid/.

"Demonstrator Program." 1959. Polaroid Corporation Administrative Records, Box I.55, f. 11 Publicity—Dealer mailings—Advertising—form letters, etc., 1959. Baker Library, Harvard Business School.

Denstman, Hal. "Polaroid SX-70 Land Camera." *Industrial Photography,* August 1973.

Deutsch, Claudia H. "Big Picture beyond Photos." *New York Times,* October 1, 2005.

Deutsch, Claudia H. "Fiscal and Technical Advice for Ex-Ford Chief as He Arrives at Polaroid." *New York Times,* November 18, 2002.

Deutsch, Claudia H. "Two Images of Polaroid, but Which Is Sharper?" *New York Times,* March 21, 1999.

Dickson, John. *Instant Pictures.* London: Pelham Books, 1964.

Dietrich, Joy, and Jon Herskovitz. "Polaroid Imports Ideas from Japan." *Advertising Age International*, April 12, 1999.

"Digital Still Video Image System." 1991. Polaroid Corporation Administrative Records, Box I.367, f. 9 Electronic imaging—art, 1987–1991. Baker Library, Harvard Business School.

Dillon, Brian. *In the Dark Room: A Journey in Memory*. London: Penguin, 2005.

Diski, Jenny. "Don't Die." *London Review of Books*, November 1, 2007.

Doty, Robert. Letter to Beaumont Newhall, Summer 1957. Polaroid Collections, Concord, MA.

Doty, Robert. *Photo-Secession: Photography as a Fine Art*. Rochester: George Eastman House, 1960.

Douglas, Susan J. "Some Thoughts on the Question, 'How Do New Things Happen?'" *Technology and Culture* 51, no. 2 (2010): 293–304.

"Dr. Land Redesigns His Camera Company." *Business Week*, April 15, 1972.

Dubois, Philippe. *L'acte photographique et autre essais*. Brussels: Labor, 1990.

Dulac, Nicolas, and André Gaudreault. "Circularity and Repetition at the Heart of the Attraction: Optical Toys and the Emergence of a New Cultural Series." In *The Cinema of Attractions Reloaded*, edited by Wanda Straven, 227–44. Amsterdam: Amsterdam University Press, 2007.

Durand, Régis. "How to See (Photographically)." In *Fugitive Images: From Photography to Video*, edited by Patrice Petro, 141–51. Bloomington: Indiana University Press, 1995.

Durant, Mark Alice. "The Blur of the Otherworldly." *Art Journal* 62, no. 3 (2003): 6–17.

During, Simon. *Modern Enchantments: The Cultural Power of Secular Magic*. Cambridge, MA: Harvard University Press, 2002.

Dyer, Geoff. "Gone in an Instant . . ." *Guardian*, February 21, 2008.

Eco, Umberto. *Faith in Fakes: Essays*, translated by William Weaver. London: Secker and Warburg, 1986.

Edgerton, David. "Innovation, Technology, or History: What is the Historiography of Technology About?" *Technology and Culture* 51, no. 3 (2010): 680–97.

Edgerton, David. *The Shock of the Old: Technology and Global History since 1900*. London: Profile, 2006.

"Editorial." *Close-Up* 2, no. 3 (1971): 2.

"Editorial." *Close-Up*, 12, no. 1 (1981): inside cover.

"Editorial." *Close-Up*, 13, no. 1 (1982): inside cover.

"Editorial Statement." *Close-Up*, 10, no. 1 (1979): inside cover.

Edwards, Elizabeth. "Photographs as Objects of Memory." In *Material Memories: Design and Evocation*, edited by Marius Kwint, Christopher Breward, and Jeremy Aynsley, 221–36. Oxford: Berg, 1999.

Edwards, Elizabeth. "Thinking Photography beyond the Visual?" In *Photography:*

Theoretical Snapshots, edited by J. J. Long, Andrea Noble, and Edward Welch, 31–48. London: Routledge, 2009.

Edwards, Elizabeth, and Janice Hart. "Introduction: Photographs as Objects." In *Photographs Objects Histories: On the Materiality of Images*, edited by Elizabeth Edwards and Janice Hart, 1–15. London: Routledge, 2004.

E. F. Hutton Equity Research. "Birth of the Electronic Image Processing Industry: The Road to Electronic Photography." Polaroid Corporation Administrative Records, Box I.367, f. 2 Electronic imaging—Polaroid, 1984–1985. Baker Library, Harvard Business School.

Ehrenfeld, Tom. "No Land in Sight." *Boston Business*, August–September 1990.

Eisenbud, Jule. "Observations on A Possible New Thoughtographic Talent." *Journal of the American Society for Psychical Research* 71 (1977): 299–304.

Eisenbud, Jule. *The World of Ted Serios: "Thoughtographic" Studies of an Extraordinary Mind*. New York: Morrow, 1967.

Elkins, James, ed. *Photography Theory*. London: Routledge, 2007.

Ellroy, James. *American Tabloid*. London: Arrow, 1995.

Ellroy, James. *The Cold Six Thousand*. London: Arrow, 2002.

Elsaesser, Thomas. "General Introduction: Early Cinema: From Linear History to Mass Media Archaeology." In *Early Cinema: Space Frame Narrative*, edited by Thomas Elsaesser, 1–8. London: British Film Institute, 1990.

Evans, R. S. "Land and Polaroid." *Perspective: Quarterly Review of Progress* 3, no. 3 (1961): 169–85.

Fierstein, Ronald K. *A Triumph of Genius: Edwin Land, Polaroid, and the Kodak Patent War*. Washington, DC: American Bar Association, 2015.

"'First Puppies' Photographed by Polaroid." *Update Supplement*, Summer 1989. Polaroid Corporation Collection, Baker Library, Harvard Business School.

Fischer, Andreas. "'La lune au front': Remarks on the History of the Photography of Thought." In *The Perfect Medium: Photography and the Occult*, edited by Clément Chéroux, 139–46. New Haven: Yale University Press, 2005.

Five Easy Pieces. Directed by Bob Rafelson. 1970.

Ford, Colin, and Karl Steinorth, ed. *You Press the Button—We Do the Rest: The Birth of Snapshot Photography*. London: Dirk Nishen, 1988.

Foresta, Merry A. "Foreword." In *Photography Changes Everything*, edited by Marvin Heiferman, 7–9. New York: Aperture Foundation, 2012.

"For Men: Play Santa." *Seventeen*, December 1965.

Freeman, Michael. *Instant Film Photography: A Creative Handbook*. London: Macdonald, 1985.

Freud, Sigmund. *Civilization, Society and Religion*. Translated by James Strachey. Edited by Albert Dickson. London: Pelican, 1985.

Fyfe, Aileen. *Steam-Powered Knowledge: William Chambers and the Business of Publishing, 1820–1860*. Chicago: University of Chicago Press, 2012.

Gallese, Liz Roman. "I Am a Camera." *Boston Business*, Fall 1986.

Garry Moore Show, November 15, 1960. Polaroid Corporation Administrative Records, Box I.56, f. 23 Publicity—Television commercial scripts—The Garry Moore Show, 1960. Baker Library, Harvard Business School.

Gaudreault, André. "Showing and Telling: Image and Word in Early Cinema." In *Early Cinema: Space, Frame, Narrative*, edited by Thomas Elsaesser, 274–81. London: British Film Institute, 1990.

"Genovese Taps Boom in Photography." *Drug Topics*, January 1, 1979.

Giambarba, Paul. *The Branding of Polaroid*. Cape Cod: Capearts, 2010.

Goessling, A. A. Letter to Harold Booth, July 27, 1949. Polaroid Corporation Administrative Records, Box I.48, f. 14 Publicity—SX-70 (1940s)—Publicity correspondence, etc., 1949. Baker Library, Harvard Business School.

Goldberg, Norman. "Polaroid SX-70: The Facts behind the Ballyhoo: From the Inside Out." *Popular Photography*, April 1973.

Goldsmith, Arthur. "Photos Always Lied." *Popular Photography*, November 1991.

The Greatest Show on Earth. Directed by Cecil B. DeMille. 1952.

Greenough, Sarah, Robert Gurbo, and Sarah Kennel. *André Kertész*. Princeton: Princeton University Press, 2005.

Gunning, Tom. "An Aesthetic of Astonishment: Early Film and the (In)credulous Spectator." *Art and Text* 34 (1989): 31–45.

Gunning, Tom. "The Cinema of Attractions: Early Film, Its Spectator and the Avant-Garde." In *Early Cinema: Space Frame Narrative*, edited by Thomas Elsaesser, 56–63. London: British Film Institute, 1990.

Gunning, Tom. "Invisible Worlds, Visible Media." In *Brought to Light: Photography and the Invisible 1840–1900*, edited by Corey Keller, 51–63. New Haven: Yale University Press, 2009.

Gunning, Tom. "'Now You See It, Now You Don't': The Temporality of the Cinema of Attractions." *Velvet Light Trap* 32 (1993): 3–12.

Gunning, Tom. "'Primitive Cinema': A Frame-Up? Or, the Trick's on Us." In *Early Cinema: Space Frame Narrative*, edited by Thomas Elsaesser, 95–103. London: British Film Institute, 1990.

Gunning, Tom. "What's the Point of an Index? Or, Faking Photographs." In *Still Moving: Between Cinema and Photography*, edited by Karen Beckman and Jean Ma, 23–40. Durham: Duke University Press, 2008.

Gye, Lisa. "Picture This: The Impact of Mobile Camera Phones on Personal Photographic Practices." *Continuum: Journal of Media and Cultural Studies* 21, no. 2 (2007): 279–88.

Hall, Sarah. "'Headless Men' in Sex Scandal Finally Named." *Guardian*, August 10, 2000.

Hand, Martin. *Ubiquitous Photography*. Cambridge: Polity, 2012.

"Hands-On Report: Polaroid's Joshua Praised by Photodealer." *Photo Business*, August 4, 1992.

Harris, Percy. "The Year's Progress." *Photographic Journal* 89 (1949): 62.

Harris, Thomas. *The Silence of the Lambs*. New York: St. Martin's, 1989.

H. C. Wainwright and Co., Audit/Report. 1962. Polaroid Corporation Administrative Records, Box I.15, f. 8 Operating Policy Committee—engineering/finance, 1962. Baker Library, Harvard Business School.

Heiferman, Marvin. "Photography Changes Everything." In *Photography Changes Everything*, edited by Marvin Heiferman, 11–21. New York: Aperture Foundation, 2012.

Heine, Achim, Rebekka Reuter, and Ulrike Willingman, eds. *From Polaroid to Impossible: Masterpieces of Instant Photography*. Stuttgart: Hatje Kantz, 2011.

"Hello Photography." *Aperture* 210 (Spring 2013): 11–12.

Henning, Michelle. "New Lamps for Old: Photography, Obsolescence and Social Change." In *Residual Media*, edited by Charles R. Acland, 48–65. Minneapolis: Minnesota University Press, 2007.

"Here and Now: Wedding Trends . . . Timely Tips . . . Bright Ideas." *Just for Brides*, Fall 1999.

"Here Is Polaroid's Good Time Camera." 1972. Polaroid Corporation Administrative Records, Box I.71, f. 24 Publicity—Dealer mailings—promotion plans—"Polaroid Announces the Good Time Camera," 1972. Baker Library, Harvard Business School.

Hering, Bob. "Color Photos in 60 Seconds." *Popular Science*, February, 1963.

"Hi, Swinger." 1965. Polaroid Corporation Administrative Records, Box I.62, f. 5 Publicity—Cameras—Model 20 Swinger—product brochures, price lists, etc., 1965. Baker Library, Harvard Business School.

Hirsch, Julia. *Family Photographs: Content, Meaning and Effect*. Oxford: Oxford University Press, 1981.

Hirsch, Marianne. *Family Frames: Photography, Narrative and Postmemory*. Cambridge, MA: Harvard University Press, 1997.

Hitchcock, Barbara. "When Land Met Adams." In *The Polaroid Book: Selections from the Polaroid Collections of Photography*, edited by Steve Crist, 24–35. Cologne: Taschen, 2005.

Holland, Patricia. "Introduction." In *Family Snaps: The Meanings of Domestic Photography*, edited by Jo Spence and Patricia Holland, 1–7. London: Virago, 1991.

Horenstein, Henry. *Color Photography: A Working Manual*. Boston: Little, Brown, 1995.

Hughes, Jim. "The Instant and Beyond: In Some Photographers' Hands, Polaroid's SX-70 System Transcends Time and Place." *Popular Photography*, January 1979.

Hughes, Lawrence M. "The Swinger." *Sales Management*, September 17, 1965.

Hughes-Lazzell, Terri. "Access via Polaroid." *Mining Journal*, October 6, 1991.

"Ideas for Generating Traffic at Your Center after the Holidays." *National Mall Monitor*, July/August 1979.

Ingenue, December 1965.

"Instant Picture Cameras." *Consumer Reports*, February, 1978.

Ito, Mizuko. "Introduction: Personal, Portable, Pedestrian." In *Personal, Portable, Pedestrian: Mobile Phones in Japanese Life*, edited by Mizuko Ito, Daisuke Okabe, and Misa Matsuda, 1–16. Cambridge, MA: MIT Press, 2005.

Jack Paar Show script, December 16, 1960, Polaroid Corporation Administrative Records, Box I.56, f. 24 Publicity—Television commercial scripts—Jack Paar Show, 1960. Baker Library, Harvard Business School.

Jenkins, Henry. *Convergence Culture: Where Old and New Media Collide*. New York: New York University Press, 2006.

"June 1 On-Sale Date . . . Distributors Get Swinger Kick-Off Plans." *Intercom: Polaroid International Communique*, March 1966. Polaroid Corporation Administrative Records, Box I.65, f. 22 Publicity—"Intercom: Polaroid Internal Communique," Vol. 1, No.1, 2, 3, 5, 1965–1966. Baker Library, Harvard Business School.

Jussim, Estelle. "A Celebration of Redheads." *Polaroid Close-Up* 14, no. 2 (1983): 15–23.

Karp, Richard. "The Clouded Picture at Polaroid." *Dun's Magazine*, November 1973.

Kato, Fumitoshi, Daisuke Okabe, Mizuko Ito, and Ryuhei Uemoto. "Uses and Possibilities of the *keitai* Camera." In *Personal, Portable, Pedestrian: Mobile Phones in Japanese Life*, edited by Mizuko Ito, Daisuke Okabe, and Misa Matsuda, 301–10. Cambridge, MA: MIT Press, 2005.

Kember, Sarah. "'The Shadow of the Object': Photography and Realism." *Textual Practice* 10, no. 1 (1996): 145–63.

Kenyon, Dave. *Inside Amateur Photography*. London: Batsford, 1992.

Keppler, Herbert. "For Land's Sake, Doc, What Cooks Now?" *Photo Weekly*, February 25, 1980.

Keppler, Herbert. "Kookie Camera: Ideal's Answer to Polaroid?????" *Modern Photography*, March 1969.

Kimmelman, Michael. "Ghosts in the Lens, Tricks in the Darkroom." *New York Times*, September 30, 2005.

Kimmelman, Michael. "Imperfect, yet Magical." *New York Times*, December 28, 2008.

King, Graham. *Say Cheese! The Snapshot as Art and Social History*. London: Williams Collins, 1986.

Kirkland, Douglas. "The SX-70 as a Tool for Creativity." *Popular Photography*, April 1973.

Kliem, Peter O. "Remarks, Stockholders Meeting." May 8, 1990. Polaroid Corporation Administrative Records, Box I.367, f. 12 Electronic imaging—speeches/annual report, 1988–1990. Baker Library, Harvard Business School.

Kopytoff, Igor. "The Cultural Biography of Things: Commoditization as Process."

In *The Social Life of Things: Commodities in Cultural Perspective*, edited by Arjun Appadurai, 64–91. Cambridge: Cambridge University Press, 1986.

Kost, Jeremy. "Bioroid: Roidrage.com." Accessed July 31, 2008. http://www .roidrage.com/about.php.

Kost, Jeremy. "Profile." Accessed July 31, 2008. http://profile.myspace.com/index .cfm?fuseaction=user.viewprofile&friendid=21512814.

Kostelanetz, Richard. "A Wide-Angle View and Close-Up Portrait of Edwin Land and His Polaroid Cameras." *Lithopinion* 9, no. 1 (1974): 48–57.

Kozloff, Max. "Introduction." In *SX-70 Art*, edited by Ralph Gibson, 10–13. New York: Lustrum, 1979.

Krasner, Jeffrey. "Minnesota Firm to Acquire Polaroid." *Boston Globe*, January 8, 2005.

Krauss, Rosalind. *The Originality of the Avant-Garde and Other Modernist Myths*. Cambridge, MA: MIT Press, 1985.

Kriebel, Richard. Letter to Minor White, 23 July 1957. Polaroid Collections, Concord, MA.

Kristof, Nicholas D. "Polaroid Bets on New Camera." *New York Times*, April 3, 1986.

Kuhn, Annette. *Family Secrets: Acts of Memory and Imagination*. London: Verso, 1995.

Kulka, Tomas. *Kitsch and Art*. University Park: Pennsylvania State University Press, 1996.

La bête. Directed by Walerian Borowczyk. 1975.

Lacan, Jacques. *The Four Fundamental Concepts of Psychoanalysis*. Edited by Jacques-Alain Miller, translated by Alan Sheridan. Harmondsworth: Penguin, 1977.

La caza. Directed by Carlos Saura. 1966.

Land, Edwin Herbert. "Absolute One-Step Photography." *Photographic Journal* 114 (1974): 338–45.

Land, Edwin Herbert. "Chairman's Letter." *Polaroid Annual Report 1976*.

Land, Edwin Herbert. "Chairman's Letter." *Polaroid Annual Report 1981*.

Land, Edwin Herbert. "Letter from Dr. Land." *Polaroid Newsletter*, April 8, 1958.

Land, Edwin Herbert. "A New One-Step Photographic Process." *Journal of the Optical Society of America* 37, no. 2 (1947): 61–77.

Land, Edwin Herbert. *Selected Papers on Industry*. Cambridge, MA: Polaroid Corporation, 1983.

"The Land Camera." *American Photography*, March 1949.

"The Land Rush." *Newsweek*, May 8, 1972.

Langford, Martha. *Suspended Conversations: The Afterlife of Memory in Photographic Albums*. Montreal: McGill-Queens University Press, 2001.

Larish, John. "Interviews Conrad Biber." *Electronic Photography News*, November 1990.

Latham, Sean, and Robert Scholes. "The Rise of Periodical Studies." *PMLA* 121, no. 2 (2006): 517–31.

La última polaroid. Directed by Mar Coll. 2004.

"Launched!" *RePlay*, March 1978.

Le fabuleux destin d'Amélie Poulain. Directed by Jean-Pierre Jeunet. 2001.

Lifson, Ben. *Samaras: The Photographs of Lucas Samaras.* New York: Aperture Foundation, 1987.

Linkman, Audrey. *Photography and Death.* London: Reaktion, 2011.

Lister, Martin. "Introductory Essay." In *The Photographic Image in Digital Culture*, edited by Martin Lister, 1–26. London: Routledge, 1995.

Lombino, Mary-Kay, ed. *The Polaroid Years: Instant Photography and Experimentation.* New York: Prestel, 2013.

Louis, Arthur M. "Polaroid's OneStep Is Stopping Kodak Cold." *Fortune*, February 13, 1978.

Lubow, Arthur. "Looking at Photos the Master Never Saw: When Images Come to Life after Death." *New York Times*, July 3, 2014.

Lynch, Mitchell C. "Selling New Polaroid 600 Line May Require Teaching Camera Users Why They Need It." *Wall Street Journal*, June 29, 1980.

Lyon, Cody. "Shooting Glitz with a Polaroid, Jeremy Kost is Gracious in a Galling Trade." Accessed July 31, 2008. http://jscms.jrn.columbia.edu/cns/2006-02-14/lyon-antipaparazzo.

MacGill, Peter. "Introduction." In *20 × 24 Light*, edited by Peter MacGill, 2. Philadelphia: Pennsylvania Council of the Arts, 1980.

"Magic! Polaroid's New Vision Camera Takes the Thrill of Instant Photography One Step Further." *Amateur Photographer*, October 31, 1992.

Maloof, John, ed. *Vivian Maier: Street Photographer.* New York: powerHouse, 2011.

Mann, Margery, and Sam Ehrlich. "The Exhibition of Photographs: Northern California." *Aperture* 13, no. 4 (1968): 10–17.

Manovich, Lev. "The Paradoxes of Digital Photography." In *The Photography Reader*, edited by Liz Wells, 240–49. London: Routledge, 2003.

Mapplethorpe, Robert. *Mapplethorpe: Polaroids.* New York: Prestel, 2007.

Marvin, Carolyn. *When Old Technologies Were New: Thinking about Electric Communication in the Late Nineteenth Century.* Oxford: Oxford University Press, 1988.

Mass, Nancy. "Flash Dance: Will Kodak Find New Life by Finally Acting Its Age?" *Financial World*, February 6, 1993.

Mavor, Carol. "Black and Blue: The Shadows of *Camera Lucida*." In *Photography Degree Zero: Reflections on Roland Barthes' Camera Lucida*, edited by Geoffrey Batchen, 211–42. Cambridge, MA: MIT Press, 2009.

McCauley, Anne. "The Trouble with Photography." In *Photography Theory*, edited by James Elkins, 403–30. London: Routledge, 2007.

McCune, William J., and Bernadine Cassell. "Simplifying Camera Technology: Polaroid's Pioneering Efforts." *Journal of Imaging Technology* 17:2 (1991): 62–65.

McDonald, Robert. "New Polaroid Camera Is No 'Toy.'" *Gannett News Service*, November 8, 1972.

McElheny, Victor K. *Insisting on the Impossible: The Life of Edwin Land*. Cambridge: Perseus, 1998.

McElheny, Victor K. "The Techniques of SX-70." In *SX-70 Art*, edited by Ralph Gibson, 121–32. New York: Lustrum, 1979.

McFarland, Janet. "Canadians Snap Up Polaroid." *Globe and Mail*, April 18, 2009.

McTighe, Elena. "The *PSA Journal*." *PSA Journal* (October 2009): 16.

"Meeting the Public: A Handbook for Demonstrators of Polaroid Land Cameras." 1965–7? Polaroid Corporation Administrative Records, Box I.243, f. 14 Product information—consumer—general information—"Meeting the Public" handbook, undated. Baker Library, Harvard Business School.

Memento. Directed by Christopher Nolan. 2000.

"Merrill Lynch Institutional Report of Polaroid Corporation." 1979. Polaroid Corporation Administrative Records, Box I.322, f. 5–6 Product information files—Polaroid OneStep, 1970s. Baker Library, Harvard Business School.

Minkkinen, Arno Rafael. "Treasures of the Moment: Thirty Years of Polaroid Photography in Boston." In *Photography in Boston: 1955–1985*, edited by Rachel Rosenfield Lafo and Gillian Nagler, 136–53. Cambridge, MA: MIT Press, 2000.

Mitchell, W. J. T. *Picture Theory: Essays on Verbal and Visual Representation*. Chicago: University of Chicago Press, 1994.

Mitchell, William J. *The Reconfigured Eye: Visual Truth in the Post-Photographic Era*. Cambridge, MA: MIT Press, 1992.

"Model 350." 1970. Polaroid Corporation Administrative Records, Box I.69, f. 1 Publicity—Cameras—product brochures, manuals, etc., 1970. Baker Library, Harvard Business School.

"More FUN with a Camera." *Camera*, February, 1950.

Motz, Catherine. "World Friends via Polaroid Photography." *Polaroid Land Photography Magazine*, 1966. Polaroid Corporation Administrative Records, Box I.230, f. 29 Polaroid Land Photography Magazine Printed by *Popular Photography*, 1966. Baker Library, Harvard Business School.

Munro, Alice. *The Progress of Love*. London: Vintage, 1986.

Murphie, Andrew, and John Potts. *Culture and Technology*. Basingstoke: Palgrave, 2003.

Murphy, Jack. "More Magic from the Miracle Worker." *Du Pont Magazine*, March–April 1974.

Murray, Susan. "Digital Images, Photo-Sharing, and Our Shifting Notions of Everyday Aesthetics." *Journal of Visual Culture* 7, no.1 (2008): 147–63.

Nelson, Keith. "Everything Instant." *Amateur Photographer*, December 19, 1981.

A New Aladdin. Directed by Frank Wilson. 1912.

Newhall, Beaumont. *Focus: Memoirs of a Life in Photography*. Boston: Little, Brown, 1993.

Newhall, Beaumont. *The History of Photography from 1839 to the Present*. Rev. ed. New York: MoMA, 1982.

Newhall, Beaumont. Letter to M. M. Morse, 29 July 1955. Polaroid Collections, Concord, MA.

Newton, Helmut. *Polaroids*. Cologne: Taschen, 2011.

Nielsen, Susan. "Newest 'For Instants' Store Opens in Atlantic City; Offers Instant Costume and Classic Portraits." *Polaroid Newsletter*, September 1984. Polaroid Corporation Collection, Baker Library, Harvard Business School.

"Notes and News." *American Photography*, April 1947.

"Notes from the Editor's Desk." *Polaroid Minute Man*, Fall 1959. Polaroid Corporation Administrative Records, Box I.319, f. 8 Product information files— Polaroid Minute Man, Fall 1959. Baker Library, Harvard Business School.

"Now . . . You Can Improve Your Pictures *on the Spot*." *Camera*, October 1949.

O'Clery, Conor. "Polaroid Shutter Closes for Last Time as Debt Reaches $1Bn." *Irish Times*, November 17, 2001.

O'Connor, Brian. "Spectra Dealer Mailing: Dealer Letter." April 1, 1986. Polaroid Corporation Administrative Records, Box I.277, f. 22 Product information— "The Spectra System Is Here!", 1986. Baker Library, Harvard Business School.

O'Hagan, Sean. "Now Smile . . . It's the Last Polaroid Picture Show." *Observer*, September 6, 2009. Accessed January 13, 2011. http://www.guardian.co.uk /artanddesign/2009/sep/06/polaroid-project-sean-ohagan.

O'Toole, Erin. "Spirit Photography." In *Brought to Light: Photography and the Invisible 1840–1900*, edited by Corey Keller, 184–85. New Haven: Yale University Press, 2009.

Oates, Joyce Carol. *Give Me Your Heart: Tales of Mystery and Suspense*. New York: Houghton Mifflin Harcourt, 2011.

Oehler, Pauline. "A Report on the Psychic Photography of Ted Serios." *Fate*, December 1962.

Olin, Margaret. *Touching Photographs*. Chicago: University of Chicago Press, 2011.

Olshaker, Mark. *The Instant Image: Edwin Land and the Polaroid Experience*. New York: Stein and Day, 1978.

"One-Minute Photography." *U.S. Camera*, January 1949.

Palmer, Daniel. "Emotional Archives: Online Photo Sharing and the Cultivation of the Self." *Photographies* 3, no. 2 (2010): 155–71.

Parry, Jack. "Polaroid Cameras on an Alaskan Assignment." *U.S. Camera*, March 1959.

Paster, James E. "Advertising Immortality by Kodak." *History of Photography* 16, no. 2 (1992): 135–39.

Patton, Phil. "Style Team Reinvents Polaroid as a Toy." *New York Times*, May 18, 2000.

Pellicer, Raynal. *Photobooth: The Art of the Automatic Portrait.* Translated by Anthony Shugaar. New York: Abrams, 2010.

"People and Ideas." *Aperture* 78 (1977): 2–5.

Pereira, Joseph. "Polaroid Points a Smaller Instant Camera at 35mm Users." *Wall Street Journal*, September 16, 1992.

Pereira, Joseph. "Wall Street Sees a Turnaround Developing at Polaroid." *Wall Street Journal*, July 13, 1993.

Perloff, Stephen. "Guest Post 6(a): Stephen Perloff on the Polaroid Auction." Accessed December 12, 2013. http://www.nearbycafe.com/artandphoto /photocritic/2010/07/18/guest-post-6a-stephen-perloff-on-the-polaroid -auction/.

Phillips, Christopher. "The Judgment Seat of Photography." *October* 22 (1982): 27–63.

"Photo-Document Integration." 1991. Polaroid Corporation Administrative Records, Box I.29, f. 8 Annual meeting and report literature, 1991. Baker Library, Harvard Business School.

"Photo Tips." *Polaroid Newsletter*, October 1981. Polaroid Corporation Collection, Baker Library, Harvard Business School.

Pierre, DBC. *Vernon God Little.* New York: Canongate, 2003.

Pinney, Christopher. "Piercing the Skin of the Idol." In *Beyond Aesthetics*, ed. Christopher Pinney and Nicholas Thomas, 157–80. Oxford: Berg, 2001.

"Playtime." *Aperture* 212 (Fall 2013).

"Polaroid 8 × 10." 1980. Folder KF5 D2, Polaroid 1. National Media Museum archive, Bradford, England.

"Polaroid and Electronic Imaging." 1987. Polaroid Corporation Administrative Records, Box I.367, f. 8 Electronic imaging, 1987–1988. Baker Library, Harvard Business School.

"Polaroid Announces Beautifully Simple Instant Pictures." 1978. Polaroid Corporation Administrative Records, Box I.321, f. 13 Product information files—SX-70 Sonar OneStep, 1978. Baker Library, Harvard Business School.

Polaroid Annual Report 1952.

Polaroid Annual Report 1954.

Polaroid Annual Report 1958.

Polaroid Annual Report 1959.

Polaroid Annual Report 1961.

Polaroid Annual Report 1972.

Polaroid Annual Report 1977.

Polaroid Annual Report 1981.

Polaroid Annual Report 1986.

Polaroid Annual Report 1987.

Polaroid Annual Report 1989.

Polaroid Annual Report 1990.

"The Polaroid Challenge." 1979. Polaroid Corporation Administrative Records, Box I.243, f. 3 Product information—consumer—The Polaroid Challenge, June 1979. Baker Library, Harvard Business School.

"Polaroid Cooperative Advertising Plan." 1954. Polaroid Corporation Administrative Records, Box I.49, f. 16 Publicity—Polaroid cooperative advertising plan, 1954. Baker Library, Harvard Business School.

"Polaroid Corporation Demonstrator Checklist." 1965. Polaroid Corporation Administrative Records, Box I.62, f. 2 Publicity—Dealer mailings— Promotions, etc.—form letters, announcements, etc., 1965. Baker Library, Harvard Business School.

"Polaroid Corporation: A Statement of Dealer Policies." 1970. Polaroid Corporation Administrative Records, Box I.68, f. 17–18 Publicity—Dealer mailings— form letters, bulletins, contracts, etc., 1970. Baker Library, Harvard Business School.

"Polaroid Dye Stability." *Studio Photography*, June 1980.

"Polaroid 'Face Place' Gains Strength in Parks, Attractions, Arcades." *Vending Times*, May 1979.

"Polaroid 'Face Place' Grows in Parks and Malls." *Vending Times*, July 1979.

"Polaroid Fun with Disney." *Photo Weekly*, June 2, 1980.

"Polaroid Introduces an Instant Camera So Remarkable It Even Develops Children." 1988. Polaroid Corporation Administrative Records, Box I.326, f. 14 Product information files—Cool Cam, 1987–1991. Baker Library, Harvard Business School.

Polaroid Minute Man 1, 1950. Polaroid Corporation Administrative Records, Box I.319, f. 7 Product information files—Polaroid Minute Man, 1950. Baker Library, Harvard Business School.

"Polaroid Model 20 Land Camera." 1965. Polaroid Corporation Administrative Records, Box I.318, f. 4 Product information files—Swinger (Model 20), 1960s. Baker Library, Harvard Business School.

"The Polaroid Museum Replica Collection Presents: Monet Master of Light." 1986–7. Polaroid Corporation Administrative Records, Box I.303, f. 46 Product information—industrial—20 × 24 film—Polaroid replicas, circa 1980s. Baker Library, Harvard Business School.

Polaroid Newsletter, April 1, 1974. Polaroid Corporation Collection, Baker Library, Harvard Business School.

Polaroid Newsletter, November 6, 1972. Polaroid Corporation Collection, Baker Library, Harvard Business School.

"Polaroid President Invents New Camera That Produces Finished Print in One Minute." *Camera*, April 1947.

Polaroid press release. September 18, 1963. Polaroid Corporation Administrative Records, Box I.175, f. 7 Press releases, 1963. Baker Library, Harvard Business School.

"Polaroid Publicity Brochure." 1954. Polaroid Corporation Administrative Records, Box I.49, f. 11 Publicity—"Questions and Answers about the Most Talked-About Camera in America," brochure, 1954. Baker Library, Harvard Business School.

"Polaroid Publicity Brochure." 1955. Polaroid Corporation Administrative Records, Box I.49, f. 13 Publicity—"Care and Handling of Polaroid Land Cameras and Accessories," brochures, etc., ca. 1954. Baker Library, Harvard Business School.

"Polaroid Spectra System Onyx Camera." 1987. Polaroid Corporation Administrative Records, Box I.367, Box I.257, f. 14 Product information—consumer— Spectra System Onyx camera, April 1987. Baker Library, Harvard Business School.

"Polaroid Technology." *Close-up* 12, no. 1 (1981).

"Polaroid to Open Fun Centers." *Photo Trade News*, June 23, 1980.

"Polaroid Unveils 30-Ton Spectra Camera." 1986. Polaroid Corporation Administrative Records, Box I.215, f.11 Press release, August 1991. Baker Library, Harvard Business School.

"Polaroid." *Forbes*, June 15, 1969.

"Polaroid's 20 × 24 Land Camera." *Studio Photography*, September 1, 1979.

"Polaroid's Big Gamble on Small Cameras." *Time*, June 26, 1972.

"Polaroid's Broad Approach to Imaging." 1985(?). Polaroid Corporation Administrative Records, Box I.243, f.10 Product information—consumer—general products, undated. Baker Library, Harvard Business School.

"Polaroid's in the Toy Business." 1967. Polaroid Corporation Collection, Baker Library, Harvard Business School.

"Polaroid's New Wallet-Size Camera Delights Shareholders." *Polaroid Newsletter*, May 12, 1971. Polaroid Corporation Collection, Baker Library, Harvard Business School.

"Polaroid's Photography Collection on Display Worldwide." *Polaroid Newsletter*, December 1984. Polaroid Corporation Collection, Baker Library, Harvard Business School.

Polavision. Directed by Charles Eames. 1977.

Pollen, Annebella. "Visual Economies of Scale: Making Sense of Majority Photography." Paper presented at the Contemporary Vernacular Photographies Colloquium, University of Westminster, London, September 3, 2011.

Polyester. Directed by John Waters. 1981.

Pool, Ithiel de Sola. *On Free Speech in an Electronic Age: Technologies of Freedom*. Cambridge, MA: Harvard University Press, 1983.

Porter, Allan. "Evolution of Polaroid One-Step Photography." *Camera* 53, no. 10 (1974): 11–58.

"Presidential Endorsement." *Polaroid Update*, July 13, 1989. Polaroid Corporation Collection, Baker Library, Harvard Business School.

"Press release, February 22, 1978—Polaroid Earnings Climb 18% for FOURTH QUARTER, 16% FOR YEAR." 1978. Polaroid Corporation Administrative Records, Box I.178, f. 13 Press releases, 1978. Baker Library, Harvard Business School.

"Press release, October 20, 1966—Polaroid Mounts Saturation Ad Campaign for Christmas." 1966. Polaroid Corporation Administrative Records, Box I.175, f. 10 Press releases, 1966. Baker Library, Harvard Business School.

"Press release, October 30, 1972—Polaroid Unveils Unique Marketing Plans for SX-70 Camera and Film System." 1972. Polaroid Corporation Administrative Records, Box I.322, f. 4 Product information files—SX-70 press releases, 1972. Baker Library, Harvard Business School.

"Press release—Polaroid Introduces New Spectra High Definition Film; Offers Consumers Sharper, Brighter Instant Photos." September 19, 1991. Polaroid Corporation Administrative Records, Box I.216, f. 1 Press releases—Spectra High Definition Film, September 19, 1991. Baker Library, Harvard Business School.

"Press release—Polaroid Land Cameras Soon Available in Sweden." 1956. Polaroid Corporation Administrative Records, Box I.50, f. 17 Publicity—Press release—Picture-in-a-Minute Polaroid Land Camera soon available in Sweden, 1956. Baker Library, Harvard Business School.

Prosser, Jay. *Light in the Dark Room: Photography and Loss.* Minneapolis: University of Minnesota Press, 2005.

PSA Journal 16, no. 5 (1950).

PSA Journal 17, no. 5 (1951).

"PTN Dealers Rap Session San Francisco." *Photo Trade News*, February 19, 1979.

"Q & A about the Most Talked-About Camera in America." 1949. Polaroid Corporation Administrative Records, Box I.243, f. 16 Product information—consumer—Model 95, 1949. Baker Library, Harvard Business School.

"R and D Scoreboard: 12 Leisure Time Products." *Business Week*, June 28, 1993.

Ravenhill, Mark. *Some Explicit Polaroids.* London: Methuen, 1999.

Reshovsky, Ernest. "Polaroid SX-70 System." *Rangefinder*, September 1973.

Retort (Iain Boal, T. J. Clark, Joseph Matthews, and Michael Watts). *Afflicted Powers: Capital and Spectacle in a New Age of War.* London: Verso, 2005.

Reynard, Jack. "60 Second Miracle." *Minicam Photography*, January 1949.

Reynolds, Charles. "An Amazing Weekend with the Amazing Ted Serios: Part I." *Popular Photography*, October 1967.

Ritchin, Fred. *After Photography.* New York: W. W. Norton, 2009.

Robins, Kevin. "Will Image Move Still?" In *The Photographic Image in Digital Culture*, edited by Martin Lister, 29–50. London: Routledge, 1995.

Rogers, Madeline. "How Ads Woo Women." *New York Daily News*, March 30, 1980.

Rosenblum, Naomi. *A World History of Photography*. 3rd ed. New York: Abbeville Press, 1997.

Rosenfield Lafo, Rachel, and Gillian Nagler, ed. *Photography in Boston: 1955–1985*. Cambridge, MA: MIT Press, 2000.

Rosenheim, Jeff L. *Walker Evans: Polaroids*. Zurich: Scalo, 2002.

Rothschild, Norman. "How the SX-70 Film Compares to Others." *Popular Photography*, April 1973.

Rubinstein, Daniel, and Katrina Sluis. "A Life More Photographic: Mapping the Networked Image." *Photographies* 1, no. 1 (2008): 9–28.

Ruby, Jay. *Secure the Shadow: Death and Photography in America*. Cambridge, MA: MIT Press, 1995.

Sabulis, Thomas. "Andy Warhol at Polaroid." *Boston Globe*, August 18, 1979.

"A Salesman's Guide to the Polaroid SX-70 Land Camera." 1975. Polaroid Corporation Administrative Records, Box I.321, f. 5 Product information files—SX-70 Land camera Models 2 & 3, circa 1970s. Baker Library, Harvard Business School.

Samaras, Lucas. "Autopolaroid." *Art in America* 58, no. 6 (1970): 66–83.

Samuels, Ralph. "A New One-Minute Process." *Minicam Photography*, May 1947.

Sarvas, Risto, and David M. Frohlich. *From Snapshots to Social Media: The Changing Picture of Domestic Photography*. London: Springer, 2011.

Saturday Night Live, December 11, 1976.

Schjeldahl, Peter. "The Instant Age." In *Legacy of Light*, edited by Constance Sullivan, 8–13. New York: Alfred A. Knopf, 1987.

Sconce, Jeffrey. "Tulip Theory." In *New Media: Theories and Practices of Digitextuality*, edited by Anna Everett and John Thornton Caldwell, 179–93. London: Routledge, 2003.

Scott, Sharon M. *Toys and American Culture: An Encyclopedia*. Santa Barbara: Greenwood, 2010.

Scully, Ed. "Speed 20,000 . . . Well, Sort of." *Modern Photography*, September 1968.

Sealfon, Peggy. *The Magic of Instant Photography*. Boston: CBI, 1983.

"The Sensational One-Step Process." *U.S. Camera*, April 1947.

"ShakeIt Photo: Instant Photo for your iPhone." Accessed February 10, 2011. http://shakeitphoto.com/.

"ShakeIt Photo Update News." Accessed February 20, 2011. http://banana cameraco.com/shakeitphoto-update-news.

Shiner, Eric C. "Mirror, Mirror off the Wall." Accessed July 31, 2008. http://www.jeremykost.com/bio/bio.html.

Siekman, Philip. "Kodak and Polaroid: An End to Peaceful Coexistence." *Fortune*, November 1970.

The Silence of the Lambs. Directed by Jonathan Demme. 1991.

Slater, Don. "Consuming Kodak." In *Family Snaps: The Meanings of Domestic Photography*, edited by Jo Spence and Patricia Holland, 49–59. London: Virago, 1991.

Slater, Don. "Domestic Photography and Digital Culture." In *The Photographic Image in Digital Culture*, edited by Martin Lister, 129–46. London: Routledge, 1995.

Slocum, Kenneth G. "Simpler Snapshots: Easier-to-Use Cameras Help Spur Record Sales of Amateur Photo Gear." *Wall Street Journal*, September 13, 1960.

Smile. Directed by Michael Ritchie. 1975.

Smith, Patti. *Just Kids*. London: Bloomsbury, 2010.

"Snapping the Stars: Shooting from the Hip." *Marie Claire*, August 2008.

Solomon-Godeau, Abigail. "Living with Contradictions: Critical Practices in the Age of Supply-Side Aesthetics." *Social Text* 21 (1989): 191–213.

Solomon-Godeau, Abigail. "Ontology, Essences, and Photography's Aesthetic: Wringing the Goose's Neck One More Time." In *Photography Theory*, edited by James Elkins, 256–69. London: Routledge, 2007.

Sontag, Susan. *On Photography*. Harmondsworth: Penguin, 1977.

"Special Events System: New Feature for the Amusement Industry." 1975. Polaroid Corporation Administrative Records, Box I.265, f. 14 Product information—Special Events System, 1975. Baker Library, Harvard Business School.

"Spectra Promotional Images." 1986. Polaroid Corporation Administrative Records, Box I.215, f. 11 Press release, August 1991. Baker Library, Harvard Business School.

"Spectra System." 1986. Polaroid Corporation Administrative Records, Box I.332, f. 11 Product information files—Spectra manual, 1986. Baker Library, Harvard Business School.

Spence, Jo. *Putting Myself in the Picture: A Political, Personal and Photographic Autobiography*. Seattle: Real Comet Press, 1988.

Spence, Jo. "Soap, Family Album Work . . . and Hope." In *Family Snaps: The Meanings of Domestic Photography*, edited by Jo Spence and Patricia Holland, 200–207. London: Virago, 1991.

"Steal the Show: Polaroid's Convention Service Can Pack Them In at Your Next Exhibit." 1960. Polaroid Corporation Administrative Records, Box I.56, f. 29 Publicity—Convention package brochures, 1960. Baker Library, Harvard Business School.

Stillman, Andrea G. *Looking at Ansel Adams: The Photographs and the Man*. New York: Little, Brown, 2012.

"Stockholders Meeting." *Polaroid Newsletter*, April 20, 1960. Polaroid Corporation Collection, Baker Library, Harvard Business School.

Stoddart, Helen. *Rings of Desire: Circus History and Representation*. Manchester: Manchester University Press, 2000.

Sullivan, Constance. "Letter to [*Close-Up*] Subscribers." n.d. (Spring 1984).

Sumits, William J. "What They Might Have Done." *Popular Photography*, October 1963.

Sutton, Damian. *Photography, Cinema, Memory: The Crystal Image of Time*. Minneapolis: Minnesota University Press, 2009.

Swingle, Chris. "Captiva Is Polaroid's Photo Finish." *USA Today*, July 21, 1993.

"The SX-70 Experience." 1974. Polaroid Corporation Administrative Records, Box I.265, f. 2 Product information—"The SX-70 Experience," 1974. Baker Library, Harvard Business School.

SX-70. Directed by Charles and Ray Eames. 1972.

Sympathy for Mr. Vengeance. Directed by Chan-wook Park. 2002.

Szarkowski, John. *Ansel Adams at 100*. New York: Little, Brown, 2001.

Szarkowski, John. *Mirrors and Windows: American Photography since 1960*. New York: MoMA, 1978.

Takiff, Jonathan. "Point, Click and Print: Instant Camera Is Made to Appeal to the Youth Market." *Philadelphia Daily News*, April 5, 2000.

The Texas Chainsaw Massacre. Directed by Tobe Hooper. 1974.

Thomas, Dana. *Deluxe: How Luxury Lost Its Lustre*. London: Allen Lane, 2007.

Thomas, Keith. *Religion and the Decline of Magic*. Harmondsworth: Penguin, 1973.

"Time-Zero Supercolor: Polaroid's Dazzling New SX-70 Film and the Cameras That Bring It to Life." 1980. Polaroid Corporation Administrative Records, Box I.321, f. 11 Product information files—Time-Zero cameras, 1980s. Baker Library, Harvard Business School.

Toccata for Toy Trains. Directed by Charles and Ray Eames. 1957.

Top Gun. Directed by Tony Scott. 1986.

"Topics of the Times: Camera Does the Rest." *New York Times*, February 22, 1947.

Toy Story 2. Directed by John Lasseter. 1999.

Tripsas, Mary, and Giovanni Gavetti. "Capabilities, Cognition, and Inertia: Evidence from Digital Imaging." *Strategic Management Journal* 21 (2000): 1147–61.

Trotman, Nat. "The Life of the Party: The Polaroid SX-70 Land Camera and Instant Film Photography." *Afterimage* 29, no. 6 (2002): 10.

Updike, John. *Rabbit Is Rich*. New York: Ballantine Books, 1981.

van Dijk, Jose. *Mediated Memories in the Digital Age*. Stanford: Stanford University Press, 2007.

Van Lier, Henri. "The Polaroid Photograph and the Body." In *Stefan de Jaeger* by Stefan de Jaeger. Brussels: Poot, 1983.

Vengeance. Directed by Johnnie To. 2009.

Virilio, Paul. *Speed and Politics: An Essay on Dromology*. Translated by Mark Polizzotti. New York: Semiotext(e), 1986.

Wahl, Paul. "Revolution in Photography! Exciting New Cameras and Films Are Now Available." *Science and Mechanics*, September 1965.

Wall Street Journal, August 19, 1982.

Wallace, David Foster. *Infinite Jest*. New York: Little, Brown, 1996.

Warsh, David. "Polaroid Has 1-Minute Film." *Boston Globe*, April 25, 1979.

"The Way Back." 1973. Polaroid Corporation Administrative Records, Box I.322, f. 1 Product information files—SX-70 technical art/references, 1970s. Baker Library, Harvard Business School.

"We Call It the Good Time Camera." 1972. Polaroid Corporation Administrative Records, Box I.71, f. 24 Publicity—Dealer mailings—promotion plans— "Polaroid Announces the Good Time Camera," 1972. Baker Library, Harvard Business School.

"We Try the Polaroid Land Camera." *Camera*, October 1949.

Weber, Max. *General Economic History*. Translated by F. H. Knight. New York: Collier, 1961.

Wegman, William. *Man's Best Friend*. New York: Harry N. Abrams, 1982.

"Welcome to the Photography of the Future." 1986. Polaroid Corporation Administrative Records, Box I.257, f. 6 Product information—consumer— Spectra System, March 1986. Baker Library, Harvard Business School.

Wensberg, Peter C. *Land's Polaroid: A Company and the Man Who Invented It*. Boston: Houghton Mifflin, 1987.

West, Nancy Martha. *Kodak and the Lens of Nostalgia*. Charlottesville: University of Virginia Press, 2000.

"What Owners Say NOW about the Polaroid Land Camera." 1949. Polaroid Corporation Administrative Records, Box I.48, f. 14 Publicity—SX-70 (1940s)— Publicity correspondence, etc., 1949. Baker Library, Harvard Business School.

White, Donald. "The Polaroid Picture: Profits up 137 Percent." *Boston Globe*, April 13, 1966.

White, Minor. "Learning with Polaroid." In *Polaroid Land Photography*, by Ansel Adams, 2nd ed., 225–39. Boston: New York Graphic Society, 1978.

White, Minor. "Pilot Project RIT: On the Trail of a Trial Balloon." *Aperture* 5, no. 3 (1957): 107–11.

White, Minor. "Polaroid Land Photography and the Photographic 'Feedback' Employed with Informal Portraits." *Aperture* 7, no. 1 (1959): 26–30.

"Who's Where in the Stock Market: Consumer Non-durables." *Forbes*, January 4, 1993.

Wilhelm, Henry. "Color Print Instability." *Modern Photography*, February, 1979.

Wire, Nicky. *Death of a Polaroid: A Manics Family Album*. London: Faber and Faber, 2011.

Wolbarst, John. "Instant Color." *Modern Photography*, March 1963.

Wolbarst, John. *Pictures in a Minute*. 3rd ed. New York: American Photographic Book, 1960.

Wolbarst, John. "Pictures in a Minute." *Modern Photography*, June 1959.

Woods, Alan. *The Map Is Not the Territory*. Manchester: Manchester University Press, 2000.

"The World of SX-70." 1974. Polaroid Corporation Administrative Records, Box I.248, f. 12 Product information—consumer—SX-70 camera—"The World of SX-70," May 1974. Baker Library, Harvard Business School.

Yankowski, Carl J. "Remarks, Stockholders Meeting, May 8, 1990." Polaroid Corporation Administrative Records, Box I.367, f. 12 Electronic imaging— speeches/annual report, 1988–1990. Baker Library, Harvard Business School.

Young, Noel. "How Polaroid Lost Sight of the Bigger Picture." *Scotland on Sunday*, October 28, 2001.

Young, Richard W. "Overview." 1981. Polaroid Corporation Collection, Baker Library, Harvard Business School.

Zuromskis, Catherine. "On Snapshot Photography: Rethinking Photographic Power in Public and Private Spheres." In *Photography: Theoretical Snapshots*, edited by J. J. Long, Andrea Noble, and Edward Welch. London: Routledge, 2009.

Index

Page numbers in italics indicate figures.